SHAKER VILLAGE VIEWS

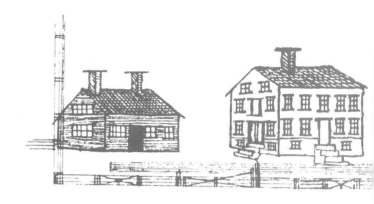

Published with the assistance of the J. Paul Getty Trust

Supported by the National Endowment for the Humanities,
a federal agency which supports the study of such fields
as history, philosophy, literature, and languages.

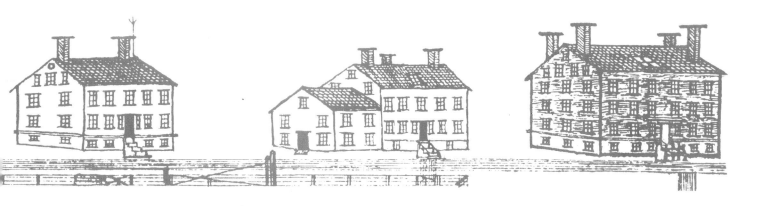

SHAKER VILLAGE VIEWS

Illustrated Maps and Landscape Drawings by
Shaker Artists of the Nineteenth Century

ROBERT P. EMLEN

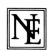 **UNIVERSITY PRESS OF NEW ENGLAND**
HANOVER AND LONDON, 1987

UNIVERSITY PRESS OF NEW ENGLAND

BRANDEIS UNIVERSITY	UNIVERSITY OF CONNECTICUT	UNIVERSITY OF RHODE ISLAND
BROWN UNIVERSITY	DARTMOUTH COLLEGE	TUFTS UNIVERSITY
CLARK UNIVERSITY	UNIVERSITY OF NEW HAMPSHIRE	UNIVERSITY OF VERMONT

Printed in Japan

∞

5 4 3 2 1

Library of Congress Cataloging-in-Publication Data

Emlen, Robert P.
 Shaker village views.

 Includes index.
 1. Shakers—United States—Maps—19th century.
2. United States—Description and travel—Views—
19th century. 3. Cartography—New Hampshire—
History—19th century. I. Title.
G1201.E423E7 1987 912′.74′088288 86−40393
ISBN 0−87451−397−9
ISBN 0−87451−420−7 (pbk.)

CONTENTS

PREFACE

The first Shaker village view I ever saw was a mid-nineteenth-century drawing of the community at Poland Hill, Maine. It was unlike anything I'd ever seen before, and I didn't know what to make of it. It was not merely a landscape view with a slightly peculiar perspective—it was filled with colorful buildings, each numbered and identified by an explanatory key that floated in the sky above the village. The scene was animated, with figures walking about, driving carriages and coaches, or just conversing in the lane. An enormous bird soared over the place, a smiling sun beamed rays down upon it, and a comet-like device pointed the way north. It was strange and wonderful, and I was fascinated.

I'd stopped at the Shaker village at Sabbathday Lake on my way home from a week in the woods of Maine, to stretch my legs and to visit the museum. I didn't know much about the Shakers, only that they viewed art as superfluous. Yet there I stood, looking at an extraordinary drawing by the Shaker artist Joshua H. Bussell. I wanted to know what sort of a person would create a picture that looked like that, and why, and how such a

thing could be permitted in a society that discouraged decorative art. Answering those questions took me down a road that, I was surprised to find, led to this book.

I have Daniel Patterson to thank. After I had answered the questions to my own satisfaction, Professor Patterson encouraged me to publish my findings—at which point I discovered that I'd only scratched the surface, and started again from the beginning. I am indebted to him for his support of my undertaking, and for providing me with a manuscript copy of his parallel study of Shaker gift drawings, upon which I relied heavily in the course of writing this book, while his book was at press.

As I corresponded with libraries, museums, and private collectors, I met other students of Shaker culture who shared their time and their knowledge with me, and whose ideas contributed to my own understanding of my subject. Many of them had personal knowledge of individual Shaker communities, and helped me to interpret obscure details of the views of those villages. In particular, I am grateful to Sandy Farnsworth and Katharine Finkelpearl for information about the Shaker vil-

lages at Shirley and Harvard; to John Martin Smith for information about West Union; to Virginia Atkinson and William R. Van Aken for information about North Union; to Elva R. Adams and Victoria Visintainer for information about Union Village; to Melba Hunt for information about Watervliet, Ohio; to Steven Kistler for information about Whitewater; to Susan Jackson Keig for information about Pleasant Hill; to Julia Neal, John Campbell, and Br. Thomas Whitaker, OSB, for information about South Union; to Mary Lyn Ray, William Copeley, Charles F. Thompson, Emily Van Hazinga, and David Starbuck for information about Canterbury; to A. Donald Emerich and Dorothy M. Filley for information about Watervliet, New York; and to Marius B. Peladeau for information about Alfred.

Often I had specific questions about the provenance of individual village views, and J. J. G. McCue, Arthur S. Liverant, Edward F. Little, A. Donald Emerich, Jan Plog Christman, A. Hayward Benning, John L. Scherer, Milton Sherman, Charles R. Muller, Nancy Druckman, Olive Hayden Austin, E. Ray Pearson, Richard Rasso, Robert F. W. Meader, and James B. Casey all answered my inquiries and provided helpful information.

Conversations with friends have also found their way into this book. A passing observation from Robert St. George started me thinking about the similarities in appearance between Shaker villages and company mill towns. Robert Chappelle explained traditional methods of teamstering, and tried to teach me to drive his oxen. It was Michael Taylor who pointed out to me that we don't outlaw anything until it becomes a problem—and that the Shakers' 1845 prohibition against decorating rooms with pictures was probably a reaction to a worldly trend that had already made its way into their villages. And one evening at Sabbathday Lake, as we were speculating about the chronology of Joshua Bussell's last, undated group of landscape views, the late Br. Theodore Johnson and I suddenly realized just when they had been drawn, and thus, why they looked so different from other Shaker village views.

When I visited research libraries and Shaker sites, I was extended many courtesies by patient and helpful colleagues. I am particularly indebted to Patricia and Peter Lascovski and to Claire L. Wheeler at the Emma B. King Library of the Shaker Museum at Old Chatham; to Richard S. Reed at the Fruitlands Museums; to James Flatness at the Geography and Maps Division of the Library of Congress; to Nancy Verrill Huntington and Br. Arnold Hadd at the Shaker Library at Sabbathday Lake; to Frank H. Sommer, Elizabeth H. Hill, Beatrice K. Taylor, Christine Edmonson and Jennifer K. Plummer at the Henry Francis du Pont Winterthur Museum Library; to John Harlow Ott, June Sprigg, Robert F. W. Meader, and Jerry V. Grant at Hancock Shaker Village; to Sarah A. Kinter at Canterbury Shaker Village, Inc.; to Jairus B. Barnes at the Western Reserve Historical So-

ciety; and to Stanley W. Brown at the Baker Library of Dartmouth College. Edward E. Nickels walked the length of the village at Pleasant Hill with me, interpreting Isaac Youngs' plan of that community so clearly that I have been unable to improve on his description in my text.

Many other friends encouraged my research. Whether they realized it or not, their invitations to lecture about a work in progress quickened my ideas and compelled me to resolve ambiguities in my thinking. Gerard C. Wertkin's invitation to participate in the 1979 seminar "Shakers In American Life" at the Museum of American Folk Art provided a seminal occasion to meet with other students of Shakerism. Thanks to Peter Benes of the Dublin Seminar for New England Folklife, I learned something about Shaker village views in the context of other early maps at the 1980 conference "New England Prospect." James C. Thomas's invitation to address the Friends of Pleasant Hill in 1983 opened the west for me. Richard Kathmann's invitation to speak at Canterbury Shaker Village, Inc., gave me the opportunity to think about the maps of New Hampshire, and Phoebe Bender's invitation to address the Shaker Heritage Society's 1983 conference "Shakers: Aspects of the Culture of an American Society" focused my attention on the New York State Shakers. Herbert W. Wisbey Jr.'s invitations to speak to several Elmira College Shaker Seminars provided the chance to explore some ideas in the early stages of my research.

I am indebted to Wendell Garrett, editor and publisher of the magazine *Antiques*, for encouragement in writing "The Early Drawings of Elder Joshua Bussell," which appeared in *Antiques* 113 (March 1978), 632–37, and later became a chapter in this book.

Assembling 148 photographs of these works was a big job. Manuscript maps and watercolor drawings are by nature fragile, delicate in appearance, and notoriously hard to photograph. Of the many photographers who went out of their way to make the best possible image, special thanks are due to Paul Rocheleau and John Miller. Above all, I am grateful to Br. Thomas Whitaker, O.S.B., for entrusting me with the only known photographs of a map of South Union that has not been seen in twenty years. His willingness to share them has made its publication possible.

When it came time to write the manuscript, Samuel Allen Streit, Special Collections Librarian at Brown University, made the rich collections of the John Hay Library accessible to me. Richard Harrington, Curator of the Anne S. K. Brown Military Collection, made room for me in his visiting scholars' office, and on many an occasion provided just the word or phrase I was groping for. And with the assistance of Peter Harrington, Assistant Curator of the Anne S. K. Brown Military Collection, I unravelled the mysteries of word processing.

Most of all I want to thank Bob and Co Emlen, in

whose quiet farmhouse I found the inspiration to write much of this book; and Julia and Nicky Emlen, who over the years did without me during the long research trips that took me away from home, and worse, suffered with me while I wrote at the kitchen table.

Throughout this book I have referred to Shaker communities and Shaker life in the past tense. It is confusing to do otherwise, for the times have changed, and Shaker villages today are very different places from the settlements pictured in nineteenth-century views. But while they are twentieth-century villages, the communities at Canterbury and at Sabbathday Lake continue the living history of two centuries of Shaker life, and it was my introduction to the Shaker families in those places that enabled me to appreciate the personal dimensions of these drawings.

At Canterbury, Eldress Bertha Lindsay and Eldress Gertrude Soule invited me for lunch and talked with me about the Shakers they had known, Believers who had known Elder Henry Blinn, who in turn had known Br. Peter Ayers, who in turn had known Mother Ann Lee. Sabbathday Lake soon became a familiar place to me. After the museum closed for the season I returned to talk with the Shaker family there, and over tea in the kitchen I began to learn something about the spiritual side of Shakerism. I came to live with the Sabbathday Lake Shakers for a season, and there I made lifelong friends. None was more influential than Sr. R. Mildred Barker, who admonished me from the beginning to look beyond the Shakers' material creations if I were to understand the meaning of their lives. This book is dedicated to her.

SHAKER VILLAGE VIEWS

1 INTRODUCTION

During the years in which their society grew to be the largest and most successful communal religious group in America, Shaker artists drew elaborate pictures of the villages in which they worked and worshipped. Gathered together in these communities, Shakers attempted to shield themselves from the worldly distractions of nineteenth-century America. Not only were most of the artists unfamiliar with the "correct" rules of drawing, they were generally unconcerned with popularly acceptable styles of art. As a result, they pictured their homes in original and unconventional ways.

These self-taught artists did feel some influence from the various pictorial sources—surveyors' plans, architects' drawings, or illustrated periodicals—that found their way into Shaker villages. But while they borrowed from an artistic tradition they found in the world beyond their villages, these Shaker artists were not confined by it. They were part of a new social order whose purpose was to search, to innovate and refine, and to strive constantly for a more perfect life. The Shakers' villages reflect this originality, both in the way the communities were organized and in the way that the artists chose to depict them. It can be demonstrated that Shaker artists customarily shared their drawings with one another, and that the drawings developed not in isolated instances but as a society-wide phenomenon. Thus, their illustrated

maps and landscape views form a distinct artistic genre with no exact equivalent in the history of American art.

To be sure, there were other painters equally innocent of artistic training who developed similar ways to picture the farms and villages of nineteenth-century America. But the house portraits and townscapes they painted are not truly comparable to the Shaker village views. There was far less communication among these folk artists than there was among Shaker artists, and consequently there was far less stylistic connection among their drawings. Now, disassociated from their original contexts of ownership and place, these pictures lack the connective tissue of a common body of work. In fact, through the study of the development of the Shaker village views, other folk landscapes of nineteenth-century America can be better understood.

Shaker village views were created in various forms over the years, ranging from simple notebook sketches to elaborate scrolls composed of several individual drawings. Depending on an artist's inclination, they could measure anywhere from eight or ten inches in the largest dimension to six or seven feet or more in length. They were rudimentary outlines of farmlands, or they were complex portraits of densely grouped buildings. They could be staid, monochromatic diagrams, or expressive, colorful illustrations. Over the course of the nineteenth century they reflected the progress of the Shaker experience as it evolved from mainstream American culture, growing into a separate society and then back again closer to the mainstream of late nineteenth-century life. But despite their varied appearance, the Shaker village views maintained their distinctive function: they were created to be used, not as decoration, but as documents of Shaker life. And so, while they cannot always be distinguished stylistically from the drawings of contemporary artists, they can be recognized as Shaker drawings through an understanding of their distinctive function.

The earliest of the Shaker village views appeared at the beginning of the nineteenth century. They were elementary surveyors' maps, consisting of outlines and boundaries drawn in iron gall ink on small sheets of hand-made paper, and illustrated with sketches of the buildings and trees that served as landmarks in the fledgling communities. Little more than diagrams, early maps such as Richard McNemar's 1806 plan of Union Village (fig. 11) were accompanied by explanatory text that was often as descriptive as the drawings themselves. Over time, as Shaker villages became larger and more complex, the artists placed less emphasis on measuring the topography. By the 1820s, Shaker maps such as the plan of Hancock by an unknown hand (fig. 16) portrayed village property in grid-like plans, with land divisions labelled as woodlots or pastures. Three-dimensional structures such as buildings or bridges were shown standing within dooryards or beside stream banks.

In the 1830s the built environment began to dominate the village views. Shaker artists concentrated on illustrating individual buildings in specific detail. Drawings like Charles Priest's 1833 plan of Harvard (fig. 22) served as a means of recording the village architecture, surrounded by some significant features of the landscape. In order to represent the buildings accurately, Shaker artists had to picture them in their varied and distinctive colors, and it was during this period that colored inks and watercolor washes were first commonly used in Shaker drawings. Despite the fact that the drawings had developed a more pictorial appearance, though, they were still intended to be documents, not decorations, and they were still accompanied by written

explanation. As has been noted with other forms of Shaker graphic art, Shaker artists did not discriminate between verbal and graphic illustration.[1]

It was in the 1840s that the most illustrative of the Shaker village views appeared. The large, ambitious drawings of Henry Blinn and Joshua Bussell combined meticulous organization and draftsmanship with mystical symbols and whimsical expressions of personal interests. It is apparent in such works as Blinn's 1848 plan of Canterbury (fig. 63) or Bussell's ca. 1848 plan of Alfred (fig. 80) that the Shaker penchant for illustrating maps had evolved to the point that these artists were creating a genre of pictures without any precedent in the American experience.

In the last quarter of the nineteenth century, as the sharp distinctions between the Shakers and their neighbors began to blur, Shaker village views began to resemble the landscape drawings of professional artists, both in style and in content. Shaker drawings were no longer made by culturally isolated pictographers who had developed unconventional ways to represent major growth and innovative changes in the villages they knew. Joshua Bussell became an amateur illustrator, and in his ca. 1880 view of West Gloucester (fig. 112) he adapted a popular artistic style to draw scenes of a Shaker village with old buildings updated to new uses. By this time, as the Shakers grew fewer and the movement grew less ambitious, the artists' perception of a Shaker community was also reduced, from a panoramic view stretching farther than the eye could see to a much narrower vision of sedate buildings grouped in a village center.

Such categorization and analysis is possible because the Shaker village views tend to be precisely documentable artifacts. In most cases they are either signed and dated or can be reliably attributed to an individual marker working in a specific place at a given time—a remarkable exception to the generally anonymous work of Shaker artisans.

When these drawings are examined as artifacts of Shaker culture, it will become apparent that the richest ones abound in personal references and unexplained symbols. It is unlikely that such references were put there to make a point to a viewer. No spiritual value was assigned to the drawings within the Shaker society and no public benefit was expected to derive from them outside of it. Instead, they seem to reflect the private expressions of artists working without the constraints of deadlines or need for popular approval.

Few other artifacts of Shaker life are so revealing. Unencumbered by Shaker dogma, the drawings were not filtered through the constant re-evaluation that underlay the creation of other forms of the Shakers' material culture. Jules Prown's observation, "in some ways artifacts that express culture unconsciously are more useful as objective cultural indexes,"[2] seems to apply to Shaker village views. Seen in this light, their illustrated maps and landscape views can be interpreted as primary documents for the cultural investigation of nineteenth-century Shakerism. Thus, in order to understand how this artistic form arose, flourished, and then receded, it is necessary to understand the Shaker culture that produced it.

> In the spring of 1780, I heard of a strange people living above Albany, who said they served God night and day and did not commit sin. . . . I went to see these remarkable strangers.
> *Thankful Barce, 1824*[3]

In the fall of 1776, eight English immigrants established a religious

community at Niskayuna, New York, a few miles north of Albany. Fueled by their faith and the religious prophecies of their visionary leader, Mother Ann Lee,[4] they founded a "Millennial Church," which came to be called "The United Society of Believers in Christ's Second Appearing," and which, in the next fifty years, would establish twenty more settlements ranging from Maine to Kentucky. The Believers tried to lead a simple, righteous life, practicing pacifism and confession of sins, and recognizing the equality of all mankind. Because their religious worship was expressed in ecstatic movement and inspired dance, their neighbors called them, erroneously, "Shaking Quakers," and soon they came to be known, even among themselves, simply as "Shakers."

The first Shakers congregated in small, informal communities of friends, neighbors, and families, where they concentrated on attaining spiritual grace and attempted to create their heaven in the lives they led on earth. As their religious precepts were developed and clarified, the practical applications of their faith became defined in more specific terms. For the Shakers, leaving behind the sins of avarice and pride meant relinquishing the private ownership of their earthly goods. Freedom from jealousy and lust meant separating the sexes and practicing sexual abstinence. To resist the temptation of these worldly evils, the Shakers needed more than the occasional company of kindred spirits. They needed each other's constant support, encouragement, and admonition. And so, beginning in the 1780s, they began to dissolve their natural families and to consecrate their property to the common good. They organized themselves into Shaker families and lived and worked in communal villages removed from the rest of the world.

> The domain of the Shakers was marked by striking peculiarities. The fences were higher and stronger than those on the adjacent farms; the woods were cleared of underbrush; the tillage was of extraordinary neatness . . .
>
> *Thomas Low Nichols, 1864*[5]

For the next century Shaker communities had much in common with other rural villages of nineteenth-century America. Their simple buildings, surrounded by fields, pastures, woodlots, and orchards, provided shelter and workplaces for a community of a self-sufficient people who made their living by working the land. But, in fact, Shaker villages worked in different ways from the neighboring farms and the neighboring towns, and as a result they bore an entirely different appearance. The distinctive form of a Shaker village was dictated by the way it functioned as a communal society.[6]

SHAKER VILLAGES

The difference in appearance between a Shaker community and a neighboring farm was manifested in several ways. The most obvious was size: Shaker communities tended to be much larger. They were created by the pooled resources of all their members to serve the needs of everyone in the Society. At their peak several Shaker villages were the size of small towns, including hundreds of members and encompassing thousands of acres.

But there were more important factors in this difference than just the number of acres the community owned. Unified by a single purpose and coordinated under a central leadership, the Believers used the land differently, too. With individual pieces of property combined under Shaker ownership, a continuous stretch of fertile land did not need to

be arbitrarily interrupted by walls and fences marking the boundaries set by the former private landholders. By using cooperative labor, the Shakers could develop and maintain their properties at a higher standard than their neighbors, and at no greater cost. Large scale physical improvements were more likely to occur in a Shaker village than at a neighboring farm. For instance, a Shaker community was likely to have a mill stream and a good mill seat somewhere on its land. The Family could easily justify the investment of developing mill ponds and buildings on the site, and they would probably have the capital, manpower, and expertise to do so.

There was another consideration that determined the appearance of the Shaker landscape—religion. Their religion stressed the importance of order, neatness, and cleanliness in daily life. It was, therefore, more than just a nicety that the Shakers constantly mended their fences, trimmed their fields, filled and levelled their roads, and maintained their woodlots. For them, neatness was an article of faith. And so, while they were farmers and small manufacturers like their neighbors, the Shakers developed their land under different social, economic, and philosophical conditions. Some of these conditions could also describe New England's company mill towns. These, too, were communal villages, with shared facilities and multi-family houses. Developed through a central plan, company towns could be as regular and orderly as Shaker villages. But while the capital generated in a mill village was directed elsewhere, the fruits of the Shakers' industry remained in the community, and the difference was immediately obvious. Almost invariably, Shaker villages bore an air of expansiveness and prosperity that distinguished them from the surrounding farms and towns.

> It was a Saturday evening. The weekly toil of the community had ceased, and a Sabbath stillness brooded over the populous town. Immense dwellings filled with men and women, and extensive workshops supplied with the choicest implements, lined the one broad street. Order and Neatness there held high court with a majesty I had never before seen. The very dust in the road seemed pure.
> *Benson J. Lossing, 1857*[7]

The same conditions that distinguished the Shaker landscape governed the development of Shaker architecture. Indeed, the difference between a Shaker village and its neighboring towns was most apparent in the distinctive style and arrangement of its buildings. Like other settlers, the Shakers located their buildings on the best sites to receive the sun's warmth, to command a view, to catch a breeze, or to be sheltered from the wind. They made them from the same materials and in the same tradition as did the people in the communities from which the Shakers had withdrawn. As their patterns of communal living developed, however, they began to devise new kinds of structures and to place them in relation to one another in ways that responded to their own needs, following patterns that would have been irrelevant in the world outside their communities.

One obvious example of the way Shakers developed architectural solutions to community needs was the way they built their meetinghouses. Because the Shakers practiced celibacy, and because they believed in the equality of the sexes, they built their churches with double doors, so that the brethren and the sisters might enter simultaneously, separate but equal. Because their religious worship took the form of fervent dance, they built their churches without interior partitions or supporting posts to divide the space and interfere with the freedom of movement. This posed a structural problem, which the

Shakers in eastern New York State resolved by adopting a local Dutch style of gambrel-roofed building.[8] In these New York Shaker meeting-houses, interior trusses carried ceiling joists that spanned the width of the building without interruption, allowing for unimpeded movement within. So satisfactory was this distinctive construction that it was re-produced by Shaker builders in every Shaker village in New England and became one of the villages' most recognizable features.[9]

Other buildings in Shaker villages met other specialized needs. Large communal dwellings, also with double doorways, housed as many as one hundred Believers, with rooms for food preparation, din-ing, religious meeting, and—up separate, matching flights of stairs—sleeping or "retiring" rooms. A perspective drawing (fig. 1) of the brick dwelling at Hancock, Massachusetts, and the meetinghouse and the dwelling at New Lebanon, New York, illustrates the symmetry of these communal buildings that stood at the center of a Shaker village. Though other Shaker buildings were less elaborate, they, too, were cre-ated in response to the particular needs of a communal society. The Shakers cared for their sick in communal infirmaries called "Nurse Shops," where they could be isolated from the rest of the community, providing a secluded place for them to recuperate and protecting the other members from contagious disease. Wood ash from the Shakers' stoves was dumped in special "Ash Houses" and was collected later to fertilize gardens or to make lye. Ash houses were often made of ma-sonry to protect the densely-built community from fire in case a linger-ing ember rekindled into flame.

A Shaker village also tended to be unlike its neighboring towns in the unusual way its buildings were arranged. They were grouped to-gether by function—the church next to the dwelling, the laundry near the well house, the barns near the brethren's workshops—and for the sake of efficiency in communication, they tended to be set much closer together than buildings in neighboring villages, whose occupants sought privacy and prized the buffering space around them. Shakers, too, needed privacy in some cases, however. The young people lived and worked with their caretakers in separate buildings, where they re-ceived instruction and where their noise and activity would not inter-rupt the adult Shakers. In some instances the oldest Believers also lived apart from the large communal dwelling, which they in turn might find too busy in their advanced years.[10] But the thrust of a Shaker life was to create a family of Shaker brothers and sisters and to draw strength from the closeness of this bond.

> This establishment is immensely rich. Their land extends two or three miles along the road, and there are streets of great houses, painted yellow and topt with red.
>
> *Nathaniel Hawthorne, 1831*[11]

Shaker buildings were colorful, with their exteriors painted in whites, reds, grays, yellows, or browns. Though certain colors held a spiritual significance for the Shakers—white stood for purity, for in-stance, and green for increase[12]—the way they were used around the village was also a matter of practicality. Since darker pigments were the least expensive, they were applied to common farm buildings such as sheds and barns. Workshops and dwellings, which lined the road and were more prominent, were painted yellow. White paint, the most expensive of all, was generally reserved for the community's meet-inghouse.[13] Not only was this combination of colored buildings dis-tinctive to the Shaker village, but, like the appearance of the village's

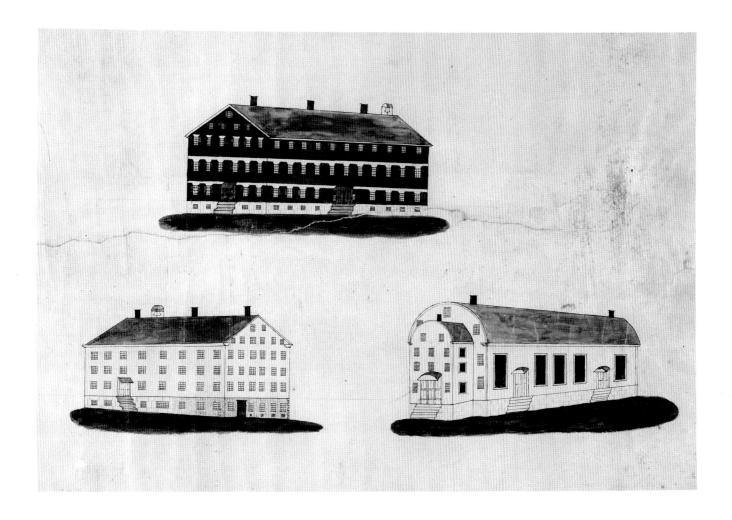

lands or architectural plan, it tended to be consistent from community to community.

The emphasis on conformity pervaded every facet of Shaker life. The Believers' high regard for order and regularity was grounded in their conviction that the rational and spiritual mind could triumph over the passions that disrupted worldly existence. In addition, practically speaking, that ideal of harmonious conformity was virtually a necessary condition for the successful organization and management of a Society that, by the 1820s, embraced thousands of members separated by hundreds of miles.

The first Shaker leaders had defined the doctrines of the faith and prescribed how a Believer should function within the living church. These doctrines were soon spelled out in a contractual "covenant" that Believers signed when they joined the Society. As the membership increased in size, the parent ministry tried systematically to guide the behavior of Believers into perfect gospel union; and as the communities increased in number, they tried to shape them to share a sense of continuity with each other. In time, the precepts of the founders were used as a basis for developing a more specific code called "Orders and Rules of the Church," or as it is commonly known today, the "Millennial Laws."[14]

In the Shakers' communal life, work and worship were intermingled.

Figure 1. "The brick dwelling at Hancock, Massachusetts; and the Church Family dwelling and the meetinghouse at New Lebanon, New York"

Unidentified Shaker artist, possibly David Austin Buckingham (1803–85)

Ca. 1850

At the same time that the Millennial Laws provided spiritual direction, they also functioned as a pragmatic guide to a kind of behavior acceptable in any communal society. Some sections dealt with the necessity of obeying authority, others with the importance of maintaining the separation of the sexes, and still others with the accountability of the Society's business agents to its members. Reflecting the common sense and wise economy that typified Shaker life, a section which first appeared in the Millennial Laws for 1845 described the proper colors for Believers to paint their buildings.

SECTION IX: Concerning Building, Painting, Varnishing and the Manufacture of Articles for Sale, &c. &c.

2. Odd or fanciful styles of architecture, may not be used among Believers, neither should any deviate widely from the common styles of building among Believers, without the union of the Ministry.

3. The meeting house should be painted white without, and of a blueish shade within. Houses and shops, should be as near uniform in color, as consistent; but it is advisable to have shops of a little darker shade than dwelling houses.

4. Floors in dwelling houses, if stained at all, should be of a reddish yellow, and shop floors should be of a yellowish red.

5. It is unadvisable for wooden buildings, fronting the street, to be painted red, brown, or black, but they should be of a lightish hue.

6. No buildings may be painted white, save meeting houses.

7. Barns and back buildings, as wood houses, etc. if painted at all, should be of a dark hue, either red, or brown, lead color, or something of the kind, unless they front the road, or command a sightly aspect, and then they should not be of a very light color.

Millennial Laws of 1845 [15]

Like many Shaker rules, this section of the Millennial Laws has both a spiritual and a practical function. It ensures that the church is the focal point of the village and that its association with the purity of white is not compromised by the presence of any similarly-colored buildings. Typically, at the same time it inhibits any errant tendencies toward expensive and frivolous decoration, making sure that expensive colors are not used on common buildings.

The Shakers apparently found this to be a useful law, for the watercolor views they painted of their villages indicate that it was generally observed over the course of many years. Although the Shakers at Harvard, Massachusetts and at Alfred, Maine painted several of their secular buildings white, those at Canterbury, New Hampshire, did, in fact, paint theirs yellow—a detail that Nathaniel Hawthorne noted in his description of 1831. At the community at New Lebanon, New York, where such matters were subject to the scrutiny of the parent ministry, Benson John Lossing's watercolor sketch of 1856 reveals that some time after the original gambrel-roofed church was deconsecrated in 1824 it was painted yellow. [16]

Miscellaneous Rules & Counsels.

16. When we clasp our hands, our right thumbs and fingers should be above our left, as uniformity is comely.

Millennial Laws of 1845

Unfortunately, not all the Millennial Laws were as useful as the rules concerning building and painting. Some were arbitrary or unreasonable, attempting to instill uniformity into the most minute details of personal behavior for no greater end than to institute a more pervasive regimen. Latter-day students of Shakerism have sometimes cited these particular rules as proof that all Shakers actually behaved in certain bi-

zarre ways, but on the whole the evidence suggests that laws perceived by the membership to be extreme or impractical were observed only briefly or not at all. The dictates of religious custom in a Shaker community were linked to the search for workable and healthy solutions to the challenges of community life.

SHAKER DRAWINGS

The beautiful, as you call it, is absurd and abnormal. It has no business with us. The divine man has no right to waste money upon what you would call beauty, in his house or in his daily life, while there are people living in misery.

Elder Frederick Evans, 1874[17]

The outward appearance of a Shaker village—regular, efficient, and simple—was a good indication of the rest of the Shakers' material creations. Just as the Shakers rid their lives of the folly of worldly ways, they refined their physical environment of the superfluous and irrelevant. When faced with such artistic decisions as choosing the profile of an architectural moulding, the pattern and color of a woven textile, the proportions and weight of a piece of wrought ironware, or the shape of a chair finial, Shaker artisans were urged to temper their creative spirits with a sense of reserve and humility. They were admonished not to feel pride in their work or to indulge themselves in displays of virtuosity, and to make choices in harmony with the rest of the community. Given the Shakers' imperative, "that which has the highest use has the greatest beauty," it follows that the products of Shaker craftsmanship should always serve some practical function. One consequence of this moral imperative toward utility is that drawings are among the rarest of the Shaker arts.

Graphic art was considered generally unnecessary in a Shaker community. Only rarely could pictures serve a useful or instructive purpose; more often they stimulated idle curiosity and diverted Believers' minds to matters irrelevant to the Millennial Church.

Orders concerning Books, Pamphlets, and Writings in General.

1. Believers are allowed to make plain bound books for writing hymns, anthems, etc. or for Journals, Records, etc. But very superfluously marbled books, or paper, are not allowed to be used or made among Believers.

4. No books, or pamphlets of any kind, are allowed to be brought into the family, without the knowledge and approbation of the Elders. . . .

5. Almanacs of every kind, must be inspected by the Elders, before they are used in the family.

Orders Concerning Literary Education and the Schooling of Children.

7. Picture books, with large flourished and extravagant pictures in them may not be used by Believers.

Millennial Laws of 1845

The restrictions set forth in the Millennial Laws were based, not on some theoretical disapproval of the nature of graphic art, but on a concern about the content of individual pictures and their effect on the community. Nowhere was it written that the Shakers were forbidden to make their own drawings. Indeed, like the rest of their material creations, the Shakers' drawings were considered appropriate in the community as long as they served its needs.

> I received a draft of a beautiful Tree pencil'd on a large sheet of white paper bearing ripe fruit. . . . I have since learned that this tree grows in the Spirit Land. Afterwards the spirit shew'd me plainly the branches, leaves and fruit, painted or drawn upon paper.
>
> *Sr. Hannah Cohoon, 1854*[18]

In the 1840s and 1850s Shaker artists produced a number of religious pictures. These were "gift drawings," painted by the Believers through the inspiration of deceased Shaker leaders as spiritual gifts or messages for their Shaker brethren and sisters. The drawings, described extensively by Edward Deming Andrews and Faith Andrews in *Visions of the Heavenly Sphere,* ranged in style from simple messages of spiritual encouragement decorated with ornamental calligraphy to elaborate representations of the life awaiting the Shakers in the heavenly kingdom. The Andrewses conclude that these colorful and exotic drawings were anomalies in Shaker society and that their existence was kept a secret from all but a few chosen Believers. However, by explaining their relationship to contemporary Shaker "gift songs," Daniel W. Patterson has demonstrated that the gift drawings served a practical function within the society.[19] These religious pictures appeared during a time of spiritual regeneration for the Shakers. Though they were created under mystical circumstances, they were generally known within individual communities whose members hoped that they would help stimulate a spiritual revival. Patterson concludes that, because gift drawings were ultimately not as effective as gift songs in spreading this zeal, the inspiration to produce them eventually came to an end.

> The Word that comes from the East say [New Lebanon] is the most beautiful place there is on Earth . . . & if I dare use so much freedom as to ask anything of a temporal nature it would be to ask for a map of that place, Buildings, gardens, & Orchards, etc.
>
> *Br. Samuel Turner, 1823*[20]

A parallel body of secular drawings, much smaller in number, was produced by another group of Shaker artists. Unlike the gift drawings, which illustrated the spiritual realm of Shaker life, these drawings depicted the lands and buildings of actual Shaker villages at different times in their evolution, from the first years of their communal settlement until the communities had reached their established and mature form after years of growth.

While village views and gift drawings are virtually the only types of graphic art the Shakers produced in the nineteenth century (with the exception of such utilitarian drawings as patent illustrations, patterns for the construction of furniture and clothing, and architectural renderings) those two major forms do not comprise truly comparable bodies of work. There are far fewer village views than gift drawings, and they were created over a much longer period of time. Moreover, the secular drawings and the religious drawings appear to have been made by different groups of people, working in different places, and motivated by different reasons. Because they were produced within the same unique cultural context, however, some comparison might be useful in understanding the place of village views in Shaker life.

There is no record of how many village views the Shakers created. As is the case with gift drawings, the passing reference to them in Shaker letters and journals gives no real indication how common they once were in community life. Forty-one views made between 1806 and about 1880 have been located in the course of this study, or fewer than

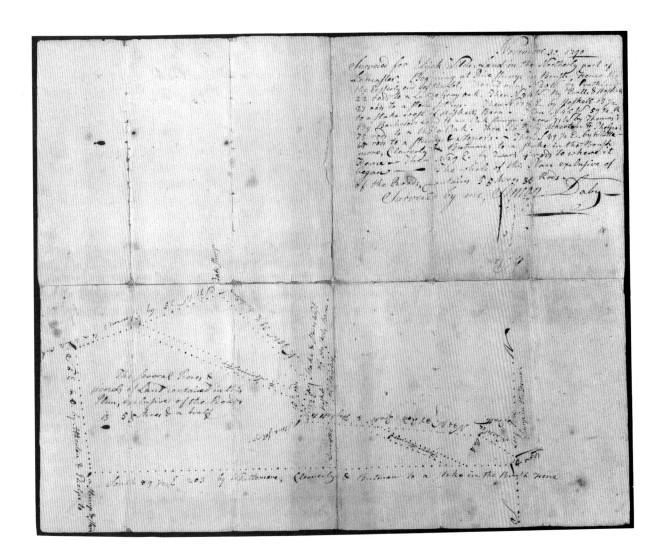

a quarter of the 192 gift drawings Patterson records as having survived from the era of spirit manifestation.[21]

The difference in size between these two groups of drawings may be at least as great as the number of surviving examples suggests. For one thing, it probably took more time to make a village view than to make a gift drawing. The secular pictures tend to be larger and more elaborate than the religious drawings. Because they were representations of actual places the process of making them was slower, as the artists drew from life and had to take time to verify the details of their work. For another thing, they did not suffer the fate of the gift drawings, which were created during a limited and intense period in the Shaker experience, after which they were perceived as irrelevant or even inappropriate. Daniel Patterson has postulated that as few as one-seventh of the gift drawings may have survived. On the other hand, the village views were always useful to the Shakers. Thus, while some of them may have been worn out and discarded, it is likely that a far greater percentage of their original number has actually survived.

The earliest known Shaker map was made in 1790 (fig. 2). Drawn just at the dawning of Shakerism when the first generation of Believers was beginning to congregate on communal farms, it records only the elementary aspects of the property at Shirley, Massachusetts, where a

Figure 2. Map of The Shaker Community at Shirley, Massachusetts

By Simon Daby (1715–1802)

November 30, 1790

Ink on paper

11 7/8″ × 14 7/8″ (30 × 38 cm)

Inscribed: "Surveyed for Elijah Wilds, Land in the Northerly Part of Lancaster."

Courtesy of Fruitlands Museums, Harvard, Massachusetts

John Miller Documents

surveyor named Simon Daby was plotting the outlines of the land Elijah Wilds would deed to the Society.[22] His document was preserved by the Shirley Shakers as part of their legal land evidence. Surveys like this were the models after which Shaker artists developed their own drawings in the next century. Although the map of Shirley is not the work of a Shaker artist, it can be viewed as an antecedent to the Shakers' first drawings, and it may be useful to examine the circumstances under which it was made.

In the summer of 1781 Elijah Wilds encountered Ann Lee on her missionary tour through New England. A dissenter from the established church in Shirley, Massachusetts, Wilds rode to the nearby town of Harvard, Massachusetts, where Mother Ann was preaching the salvaton of Shakerism. The Word appealed to Elijah Wilds, who confessed his sins to Mother Ann and opened his house to her followers. On her tour she visited him there and received other converts. Two years later, when Mother Ann returned from her travels to her home at Watervliet, New York, a small community had gathered around the Wilds' farm at Shirley.[23]

The United States Census of 1790 recorded a family of twenty-five males and thirty-eight females living at the Wilds' farm. The Shakers' ideas about the establishment of communal societies were becoming focused: the Shakers at New Lebanon, New York, the first to be formally organized, in 1787, were followed in 1792 by the Harvard Shakers. The following year the Shirley Shakers were gathered into gospel order, on land consecrated by Elijah Wilds and his neighbors.

As the new converts prepared to pool their worldly belongings, Elijah Wilds had his land surveyed. In November of 1790, after the trees had shed their leaves but before the snow had covered the ground, his neighbor Simon Daby measured the land and outlined its perimeters in an annotated sketch. Daby recorded his survey of Elijah Wilds' land in two ways. First he described the boundary, from "the pine tree stump in the brush fence" to "a large gray oak" to "a stone set up." Then he illustrated his description with a dotted line around the borders, noting the compass directions and citing the landmark trees and stone cairns (fig. 3). Although he mentioned the presence of "Haskell's Barn," the only physical features he pictured on this map are shown by three double rows of dots crossing the property. Labelled "From Harvard" and "Lancaster to Shirley," they are village roads, illustrated to orient the viewer to his surroundings.

Nothing about Simon Daby's plan indicates that he was surveying a Shaker site. The way that it was drawn and the property that it illustrates are typical of site maps made by other surveyors working in rural New England at the end of the eighteenth century.[24] This was true of everything that the Shakers owned and made in the early years of their existence. The property they brought with them and consecrated to the communal good and the new products of their handiwork tended to be indistinguishable from those of their non-Shaker neighbors. Though their work was of the finest quality, they had yet to develop their own styles and forms.[25] Their houses looked like other houses in Shirley; the furniture they used belonged stylistically to settlements along the Nashua River Valley. For years to come, their belongings would reflect the influence of the local culture from which they had chosen to withdraw. Even if Simon Daby had joined the Shakers, then, it is unlikely that his map would have looked any different.

Simon Daby's map was used by the new Shaker community to plan

Figure 3. Detail of figure 2 showing fence line descriptions.

the development of a village that would grow to include two thousand acres and accommodate 150 members in scores of buildings. By creating a complex of buildings the Shakers changed the appearance of their landscape, and in so doing they created a need for a different kind of map. Their new drawings would have to represent the structures of the built environment in addition to the topography of their natural environment. This they did by sketching elevations of the buildings in combination with a plan of the site. Though they seem to contain inherent visual contradiction—the simultaneous representation of two- and three-dimensional features—these drawings had precedents in the techniques commonly employed to map the villages of colonial America. Like the Shakers, many of these early cartographers conceived of their maps experientially rather than diagrammatically and thought it only reasonable to represent both the structures and the landscape they knew. The earliest American village view, John White's watercolor drawing "Secoton," depicting an Algonkin village some time before 1590, employed this dual perspective.[26] In mid-eighteenth century Connecticut, James Wadsworth used a similar technique to illustrate his 1748 map "A Plan of the Town of New Haven with all the Buildings" (fig. 4). Throughout the first two decades of the nineteenth century, while professional surveyors and illustrators refined their techniques, Shaker cartographers continued to record their own villages in

Figure 4. "A Plan of the town of New Haven with all the Buildings in 1748."

Engraving by L. Schierholz

Ca. 1880

After a drawing of 1748 by James Wadsworth

29" × 21 1/2" (73.6 × 54.6 cm)

Private collection

this old-fashioned style. But in time, as the unusual needs of a Shaker community became clear, and as creative and innovative solutions to communal problems began to emerge, the Shaker village maps began to be drawn in styles that clearly had branched off and away from the mainstream.

Why did the Shakers stop making traditional surveyors' plans and go on to draw large, elaborate, colorful pictures of their villages? Their reasons seemed to them too obvious to mention, apparently, for no explanations have ever been found in their writings. As was the case with so much of their material expression, though, the Shakers' drawings may have been in part a response to a parallel phenomenon in the mainstream of American culture.[27] The flourishing of Shaker village views in the 1830s coincides with the availability of popular engravings of urban American views. But unlike their worldly neighbors, who furnished their homes with prints of landscape scenes, the Shakers did not originally intend their drawings as decoration. Instead, they seem to have been created as documents. Like the surveyors' plans from which they evolved, their purpose was to record and illustrate the physical aspects of the villages.

This was a particularly important function in communal societies in general, both for practical and for personal reasons. Village plans such as Wallrath Weingartner's maps of the communal society at Harmony, Pennsylvania, and New Harmony, Indiana, helped members to visually organize and comprehend a large and complex property,[28] while Olof Krans' paintings of life in the Swedish settlement at Bishop Hill, Illinois, helped serve as a communal memory and a unifying force among the members.[29]

The Shaker village views functioned in both these ways. They served internal needs, assisting in the organization and management of the Society. Shaker law required that records be kept of the temporal progress of each family, and many of the village views made for this purpose stayed at the community in which they were made, apparently for use by the trustees as part of the Society's land evidence and architectural inventories. They also served external needs; drawings, often copies of originals, were sent to New Lebanon, to inform the parent ministry about the appearance of an individual community,[30] or were shared with other kindred Shaker societies, in order to maintain a bond of kinship across long distances and to help promote the sense of uniformity and continuity so valued by Believers.

> After we had eaten our dinner I went to work at my map of Lebanon.
>
> *Br. Isaac Newton Youngs, 1834*[31]

Who made these Shaker village views? It seems to have been the brethren's job. Of the eleven cartographers or landscape artists who signed the drawings or whose names can be associated with them, all are men. This stands to reason: whether the drawing was specifically concerned with architecture, horticulture, mill complexes, granite working, or boundary lines, an artist needed detailed knowledge of the building or farm trades, which Shaker women would not have. By comparison, practical experience was irrelevant in portraying the fantastic scenes of the heavenly sphere. In almost every case the gift drawings were the work of Shaker sisters.

Daniel Patterson has pointed out that the differences between drawings made by Shaker brethren and those made by Shaker sisters parallel the way the Shakers characteristically expressed themselves in

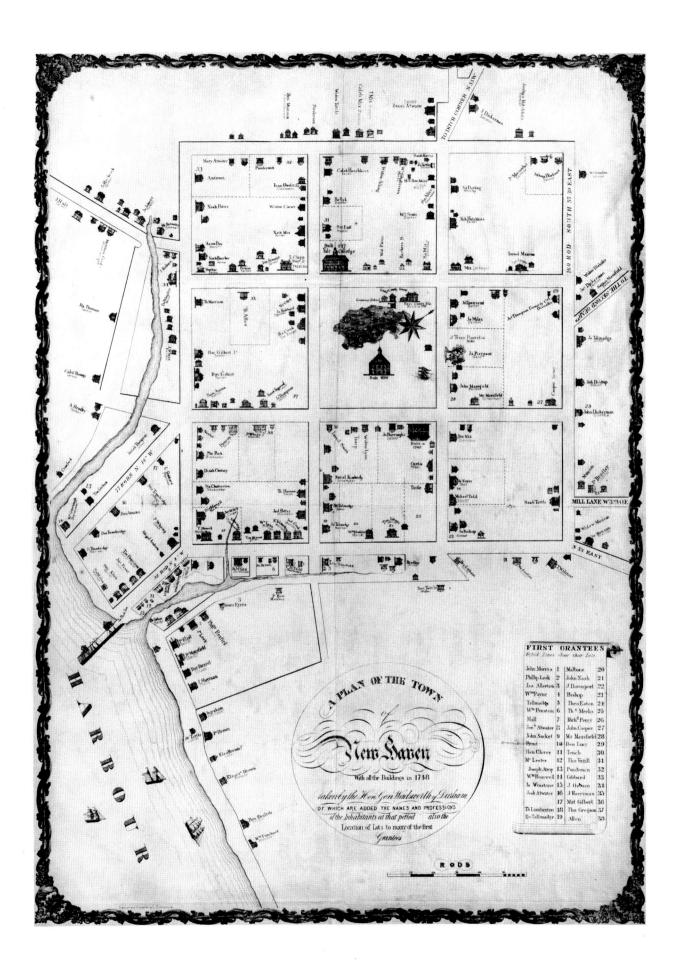

A PLAN OF THE TOWN of New Haven With all the Buildings in 1748 taken by the Hon Gen Wadsworth of Durham OF WHICH ARE ADDED THE NAMES AND PROFESSIONS of the Inhabitants at that period also the Location of Lots to many of the first Grantees

FIRST GRANTEES

Dotted Lines shew their Lots

John Morris	1	Malbone	20
Phillip Leek	2	John Nash	21
Isa. Allerton	3	J. Davenport	22
Wm Payne	4	Bishop	23
Tallmadge	5	Theo Eaton	24
Wm Preston	6	Ths Meeks	25
Hall	7	Richd Perry	26
Jonn Atwater	8	John Cooper	27
John Sacket	9	Mo Mansfield	28
Prout	10	Ben Lino	29
Hen Glover	11	Tench	30
Mr Leetes	12	Tho Fugill	31
Joseph Alsop	13	Punderson	32
Wm Russwell	14	Gibbard	33
Jn Winstone	15	J. Osborn	34
Josh Atwater	16	J Harriman	35
	17	Matt Gilbert	36
Th Lamberton	18	Tho Gregson	37
Ro Tallmadge	19	Allen	38

RODS

speech, writing, and song. While the women tended to express themselves emotively and to foster inspiration, the men tended to express themselves intellectually and to foster the system and structure.[32] Many of the secular artists did, in fact, fit this model—as elders, trustees, or deacons, they were charged with the management of Shaker life. But most of the men who drew these village views also shared another common experience—they had taught in the Shaker schools. They were at least nominally familiar with geography and architecture, and they had practiced the mensuration and penmanship skills needed to draw a village map.[33] More important, however, were the personal qualities that attracted them to teaching in the first place. Their common interest in the educational process suggests that they shared a sensitivity and a propensity for communicating knowledge that gave them a different means of expression from the purely intellectual expressions of other Shaker brethren.

It is possible, of course, that some village views were made by the same Shaker sisters who received the gift drawings. Referring to the New Lebanon artist Polly Reed, Edward Andrews says: "The colored maps executed by this eldress and school teacher reveal the same facility with pen and brush as her more imaginative drawings."[34] But no village views attributable to a Shaker sister have been located in the course of this study, and it may be that Andrews was describing large instructional maps Eldress Polly made for teaching geography in the Shaker school. It is logical to assume that Shaker sisters who had exhibited accomplishment in drawing were employed to make copies of existing village maps, just as village scribes copied letters and journals from other Shaker villages. In 1851, the Maine Shaker Ministry wrote to the Ministry at Harvard that:

Those manuscripts which we borrowed of you when at Lovely Vineyard, have copied and now return them. . . . Also return to Elder Brother Lorenzo those maps which he kindly lent us, our hearty thanks for the same.[35]

Evidently, as with the manuscript texts, Shaker village maps travelled among communities, and it may be that some of the unsigned copies of these drawings were the work of the sisters.

Some communities produced more of these drawings than others, and some, apparently, produced none at all. As is the case with the gift drawings, the few village views made in the western Shaker villages were literal and prosaic. An early plan of West Union, possibly by Richard McNemar, and Lorenzo Martin's copy of Benjamin S. Youngs's map of South Union are both pragmatic and straightforward schemes. In the East, where most of the drawings were made, the artists were more lively and expressive. Those communities that produced gift drawings and those that produced village views are almost mutually exclusive. While most of the religious drawings originated at New Lebanon, only one extant village view can be attributed to that community. The number is equally small for the neighboring communities at Hancock and Watervliet. On the other hand, while only one gift drawing is known to have been made in Canterbury, New Hampshire, at least five village views were made by artists living in that community. In Alfred, Maine, one of the communities most remote from New Lebanon, where no gift drawings were received at all, at least seventeen drawings of Maine and New Hampshire Shaker villages were made by Joshua H. Bussell.

Like all community members, the men who drew the maps and views also practiced mechanical trades that benefited the society, and

were only incidentally employed as limners. Of the eighteen artists who have been identified by name or distinguished by their individual styles, most probably made no more than one or two drawings. That Joshua Bussell created a disproportionately large number of these village views might be explained in part by the relative isolation the Believers at Alfred felt from the rest of the Shaker world. Some of his drawings travelled to other Shaker communities, places so distant that most of their members would never know Alfred except through a picture. At the same time, however, isolation may also have encouraged the Maine and New Hampshire artists for an entirely different reason. Away from the center of Shaker domination at New Lebanon, they were free to engage themselves in a creative expression that at times came perilously close to being art for art's sake.

> The Artist who drew this Diagram, not being acquainted with any rules of drawing, hopes it will be sufficient apology for the imperfections which may be found.
>
> *Br. Peter Foster, 1849*[36]

Any "imperfections" that Peter Foster perceived in his 1849 plan of Canterbury would not have resulted from a lack of technical skill. Shaker schools taught young Believers penmanship and calligraphy, and David Parker's 1840 plans of the Shaker villages at Enfield and Canterbury, New Hampshire, reveal that he had benefited from additional training in drafting. Nor was Br. Peter apologizing for any inaccuracies in his representations. Shaker craftsmen and women felt a moral obligation to produce their work at the highest possible standard, and he apparently felt no qualms about the quality of his delineations. Instead, what he seemed to have sensed was his own artistic limitations and his inability to represent realistically on paper what he saw before him in the community.

In fact, his drawing was no less accomplished than those of the Shaker artists who preceded him. But the apology with which he prefaced his plan reveals his awareness that his drawing, and by implication the other Shaker drawings he had seen, looked different from the maps and pictures drawn by professional artists, and that there might be some more sophisticated and conventional way of presenting that information, which would serve his purpose better.

Br. Peter may have come to this realization by having encountered commercial landscape views by artists who successfully represented three-dimensional subjects on a two-dimensional surface to create the illusion of space. In the second quarter of the nineteenth century, men like John Warner Barber (1798–1885) or Edwin Whitefield (1816–1892) travelled through New England sketching towns and villages and later publishing their drawings as engravings. Other commercial artists, such as Joseph Partridge (1793–ca. 1833) or Gabriel R. Ludlow, would settle temporarily in a community, drawing original townscapes (fig. 5) and teaching classes in watercolor illustration. Both types of artists were trained in the art of landscape drawing and employed their skills to earn their livelihood. By the standard of these professional village views, the village maps and landscape views made by Shaker artists were indeed unconventional, both in style and in content. Drawn with idiosyncratic techniques to illustrate unusual places, they were well out of the mainstream of contemporary American landscape painting. Like the gift drawings, they were products of the singular circumstances of the Shakers' communal life.

These Shaker village views were conceived by men who, through-

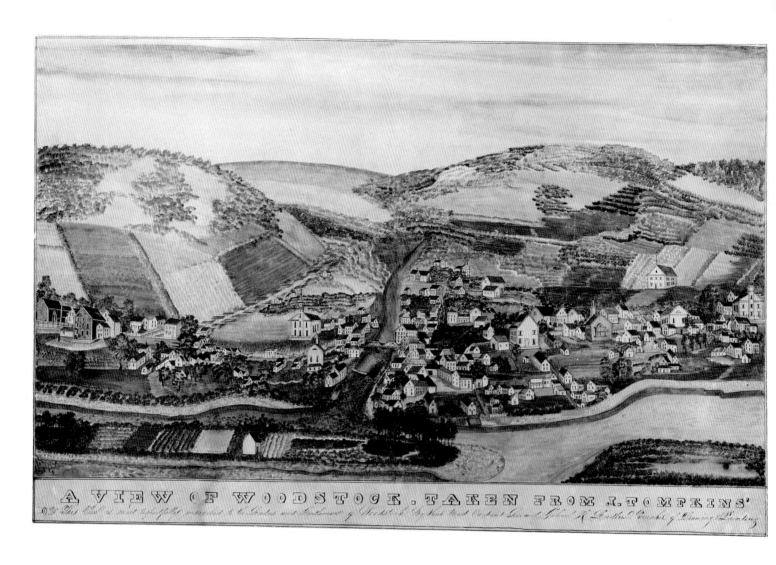

A VIEW OF WOODSTOCK, TAKEN FROM I. TOMPKINS'

Figure 5. "A View of Woodstock"
By Gabriel R. Ludlow
Ca. 1840
Watercolor on paper
18 1/2″ × 26 3/4″ (47 × 67.2 cm)
Private collection

out the period of the Society's greatest growth and prosperity, were shielded from the influences of worldly taste. It would be inaccurate, though, to suppose that Shaker artists created their drawings in absolute cultural isolation, without any stylistic influence from the world beyond their communities. To begin with, in all but the rarest cases converts entered the society with some worldly experience—if only as children—and with some exposure to contemporary design. For example, it has been proposed that Hannah Cohoon's single-image gift drawings bear a distinct resemblance to the patterns of appliqued quilts popular in early nineteenth-century New England.[37] The artists who made the Shaker village views could also draw their inspiration from models available within the community.[38] Shaker trustees hired professional surveyors to measure their lands and professional architects to design their buildings. These people's drawings were kept in the community. Text books used in Shaker schools contained pictorial illustrations, and to judge from the limitations described in the Millennial Laws, adult Believers had some access to popular publications. It stands to reason, therefore, that no Shaker artist could be untouched by the artistic influences of popular culture.[39]

In a society seeking to create a new heaven on earth, however, the idea of adhering to worldly convention was irrelevant. Shaker artisans

were encouraged by their religious precepts to be original and creative. And so, within these secluded villages, a method of drawing village views was developed over the years by trial and experimentation and by sharing solutions among a network of artists, until the Shakers' village views looked very different from their neighbors' drawings.

This is not to say that Shaker artists developed a unique style of drawing. Their stylistic solutions to the problems of drawing villages on the landscape had been independently developed by artists from other cultures throughout history.[40] Still it is clear that when they devised a way to record their built environment in illustrated maps and landscape views, the Shakers created a body of drawings that is distinctive, recognizable, and unparalleled in the history of American art.

Since naive artistic styles were not unique to Shaker artists, what was so distinctive about their drawings? From the 1830s through the 1850s, most Shaker village views were drawn in a manner combining three stylistic elements to produce an effect not ordinarily found in worldly drawings. To begin with, they tended to be extremely precise and literal, as is, for example, Austin Buckingham's delineation of Watervliet (fig. 28). In the manner of other self-taught painters, Shaker artists sought to define individual details—each tree in an orchard, each stone in a wall—reflecting both the didactic uses of the paintings and their makers' lack of sophistication in visual representations. In the last quarter of the nineteenth century, Shaker artists moved beyond this limner-like attention to specific detail to represent their villages in a more generalized manner.

It was also typical for Shaker artists to sketch three-dimensional structures standing on the two-dimensional plane of a village plan. The best example of this peculiar orientation is seen in Joshua Bussell's 1845 plan of Alfred (fig. 76). By recording standing features as elevations and land divisions as plans the artists were able to identify each of those elements the most clearly. Nonetheless, by representing them simultaneously, they created a scene with inherent visual contradictions. Though, like Br. Peter Foster, they might have seen pictures drawn in more convincing ways, Shaker artists were not schooled in the artifice of perspective construction and were left to their own devices for representing a depth of field. Generally, the artist drew the structures as he saw them from his vantage point in the middle of the village. As he turned to sketch different buildings, he turned his map as well. This had the effect of placing the artist in the middle of his own picture. The buildings seemed to lie down flat on the plan, variously facing the nearest road. No one side of the drawing was consistently oriented to the top. Though these topless drawings are confusing to the twentieth-century viewer, the audience for whom they were originally intended was probably unaware of the inherent contradiction in perspective. Like the artists themselves, not being prejudiced toward any particular technique of graphic representation, they found that the stylized clarity of these drawings served their purposes well.

Of course, the propensity to represent specific features in meticulous detail and the inability to draw a landscape scene in realistic perspective are natural tendencies for any novice painter, and can be recognized in unnumerable examples of naive art. One mid-nineteenth-century drawing depicting a Pennsylvania farmhouse surrounded by fences (fig. 6), illustrates how an untrained artist labored in vain to find a unified perspective for his carefully articulated view. As in the

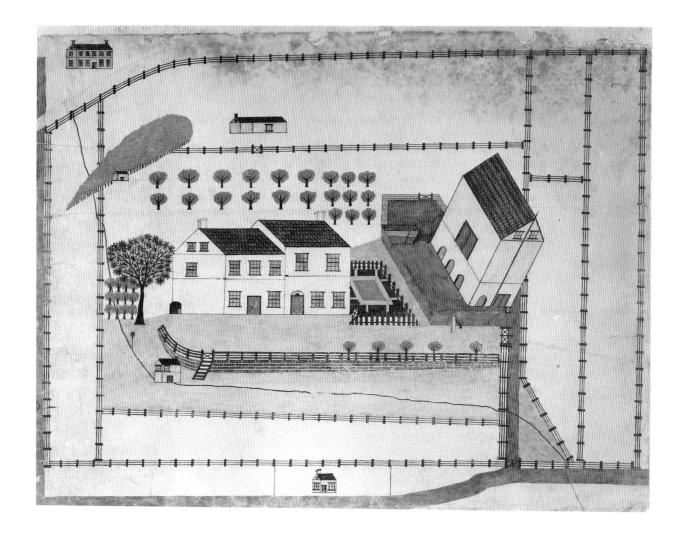

Figure 6. "Pennsylvania Farmhouse with Many Fences"

Attributed to Charles H. Wolf

Ca. 1847

Ink and watercolor on paper

18″ × 23 7/8″ (45.7 × 60.6 cm)

M. & M. Karolik Collection, 56.740, courtesy Museum of Fine Arts, Boston

Shaker village views, there is a personal, intimate quality about this drawing, as though it were made by the farmer himself to portray his own property. No title, date, or signature was ever inscribed on it, perhaps because the artist considered further identification unnecessary.

By contrast, Shaker drawings abound with explanatory comments. This combination of words and pictures is a third characteristic that typifies the artistic technique of Shaker village views. Given the function of these drawings as records and documents, it would seem natural for the Shakers to insert written comments amplifying the meaning of features in a particular scene. Often these annotations took the form of labels on individual buildings or numbers that referred to a descriptive key, which would be drawn on an unavailable spot in a pasture or pictured floating in the sky above the horizon. At South Union, Lorenzo Martin made a sketch of a building and wrote next to it "Rented to a doctor" (fig. 56). At Canterbury, Henry Blinn drew an apple tree that he noted was the "Best of the red cheeks" (fig. 66). At Watervliet, Austin Buckingham labelled a row of stationary drying racks "For drying Weaver's yarn &c." (fig. 29). At Alfred, Joshua Bussell identified "Phileamon's Stone" at the Holy Ground (fig. 84), and at Poland Hill he included cartoon balloons above two figures he drew conversing in the lane (fig. 94). At Harvard, Charles Priest gave instructions on how to view his plan (fig. 22):

This plan should be viewed at the right, in an angle of 45 degrees, the view being taken in that direction.

In the same way that they used written text to supplement their graphic images, Shaker artists used directional arrows to supplement their drawings. These elaborate symbols became prominent features in village views, and, like the explanatory keys, were plotted in open spaces in the fields or suspended in the skies over a road leading north. Only occasionally did these arrows orient the viewer to the top of the page; the convention of placing north at the top seemed to have been an unnecessary one for the Shakers, whose cartographic orientation was dictated instead by the lay of the land.

Both the written comments and the directional arrows on the drawings were vestiges of the explanations and symbols that had appeared earlier on Shaker village maps. They continued to be used in the Shakers' pictorial drawings because they served the important function of disseminating information. A Shaker artist drew, not only for himself and his family, but for thousands of his gospel kindred, present and future, many of whom would be unfamiliar with the site. Having pictured specific details of the village, and often having made reference to his own personal interests, he was obliged to interpret his work for anyone who might view it.

The communal life of a Shaker artist influenced more than his style of drawing. It meant also that his village views were likely to be larger and more complex than the house portraits of his worldly counterpart. A Pennsylvania farmer might try his hand at sketching his homestead, consisting, perhaps, of his house, his barn, and his apple orchard. The local gentry of a small town in southeastern New Hampshire in the 1830s might so highly prize their house portrait that they would have it included in their family portrait (fig. 7). But a Shaker artist making a comparable drawing of his own home would have to picture dozens of buildings on thousands of acres. Mapping and illustrating a community of this size would require a considerable investment of time, particularly for a novice. In the outside world, a professional artist would be employed for an undertaking of equivalent size—a town view, say, or an army encampment. But due to the unique circumstances of their communal life, the Shakers' village views were drawn by avocational artists. Because the Believers were predisposed to do their work according to their own lights, and because this work required intimate knowledge of the community, they saw nothing unusual about assigning such a complex job to untrained amateurs. In creating a new social order, the Shakers were guided by their faith, and they were not encumbered by the customs of the old one. Their unconventional ideas were nourished by the support of their fellow Believers, while their communal life provided the opportunity to give these ideas physical form. As with so many of the Shakers' material creations, their village views emerged as a distinctive form of expression.

Although these drawings were specifically a function of the Shakers' communal life, the same coincidence of an untrained artist being employed to draw an entire village view does also occur outside the Shaker community, in the illustrated maps by Wallrath Weingartner (1795–1873) of the communal societies at Harmony, Pennsylvania, in 1833, and New Harmony, Indiana, in 1832 (figs. 8 and 9). The Harmonist artist pictured his villages in much the same way that the Shakers drew their views, with elevations of buildings and trees laid out on a grid of the town plan interspersed with names of individual members

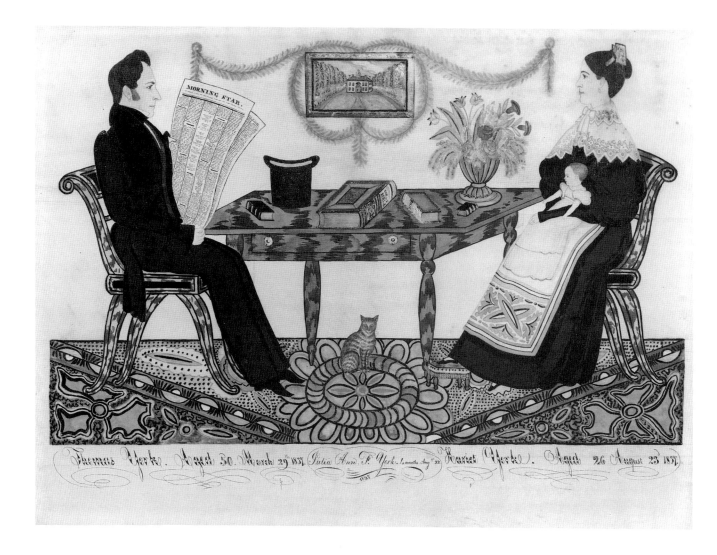

Figure 7. "The York Family at Home"

Attributed to Joseph H. Davis (active 1832–37)

August 1837

Watercolor, pencil, and ink on paper

11 1/16" × 14 7/8" (28.1 × 37.8 cm)

Collection of the Abby Aldrich Rockefeller Folk Art Center

Figure 8. "Map of New Harmony, Indiana"

By Wallrath Weingartner (1795–1873)

1832

Ink and watercolor on paper

21 11/16" × 17 7/8" (55.1 × 45.4 cm)

MG-185, Records of the Harmony Society, Archives, Pennsylvania Historical and Museum Commission

or descriptions of the structures. Indeed, the Weingartner maps are the most closely related of any worldly drawings to the Shaker village views. There is no evidence, however, to suggest that one society may have influenced the other's drawings, even though the Harmonist maps were made in the same years that the Shakers' drawings became so distinctive. Instead, it is far more likely that the similarities in artistic technique and subject matter can be attributed to the fact that both the Harmonist and the Shaker artists shared the unusual experience of having been raised and educated in the insular world of a communal society and then having chosen to portray it in village views.

Despite the similarities in the Harmonist maps and the Shaker village views, they are not entirely alike. The differences that distinguish them reflect the separate natures of the two communal societies. Although the Shaker movement was much larger than the Harmonist experiment, both in the number of members and in the size of land holdings, the Shakers lived in separate families located in individual villages throughout the country, while all Harmonist members lived together in a single community. The two known Harmonist plans are retrospective drawings made after the communal village was transplanted, first from Harmony, Pennsylvania, to New Harmony, Indiana, and then to Economy, Pennsylvania. Shaker village views, on the other hand, were used as planning tools for active villages. Because the

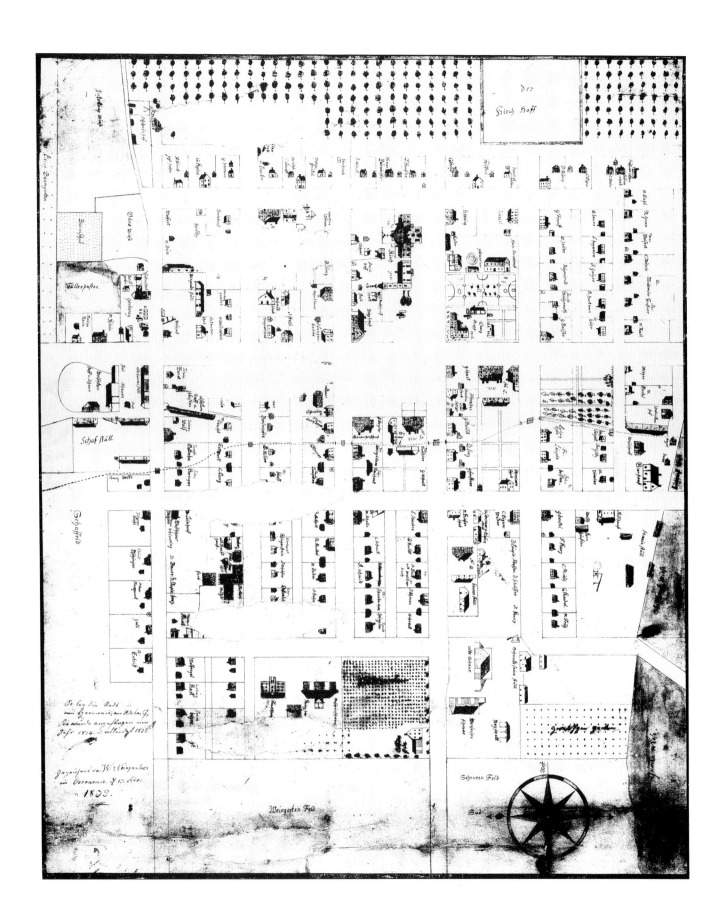

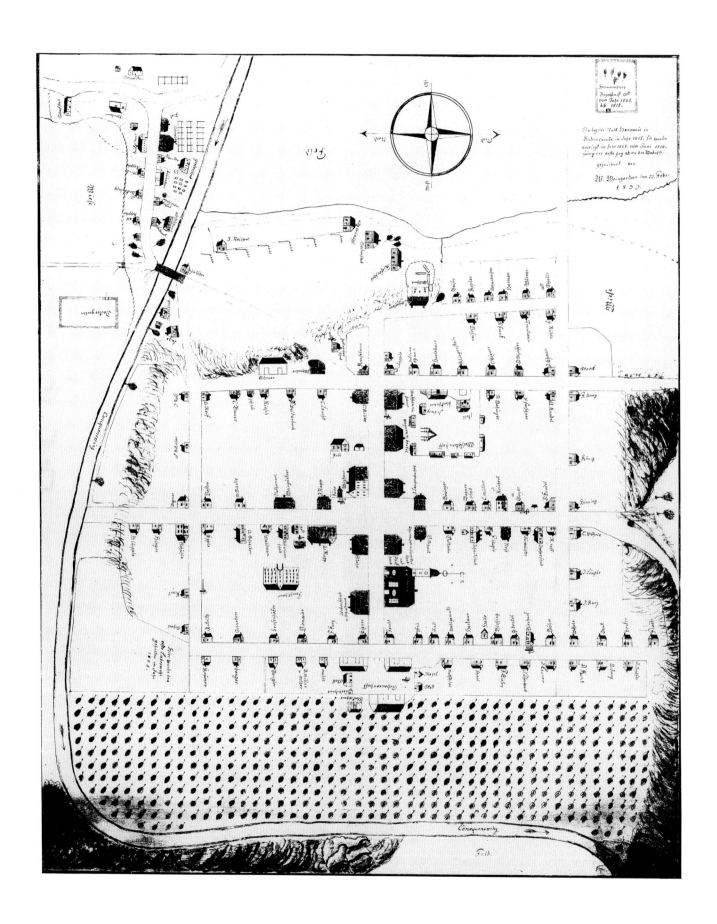

Shakers' settlements were decentralized, the artists show fewer buildings and less property in each of their village views, allowing them to illustrate individual features on a larger scale and in greater detail. The difference in this attention to detail is particularly noticeable in comparing the illustrations of the two societies' dwelling houses. Unlike the Shakers, many Harmonist families lived in individual houses. Scores of simple log cabins formed the majority of the buildings at Harmony and New Harmony. In the village maps they appear small and ordinary and are virtually indistinguishable from one another—in striking contrast to the specific characteristics that can be found in pictures of Shaker buildings, both individual workshops and communal dwellings. Even the Harmonists' communal buildings, which were designed and built with great detail and were illustrated in the maps with great care, are nowhere near as precisely represented as the corresponding structures found in Shaker village views.

The great concentration of members in the Harmonist society, which numbered between seven and eight hundred at the point pictured in these maps, dictated a complex village plan.[41] The streets were laid out in a grid, with houses and quarter-acre plots for individual families, and the church, the store, and other communal services at the center of the rectangle. Shaker villages, on the other hand, were more linear, with communal buildings grouped along one central roadway and with communal land stretching back behind the buildings. The rectilinear plan of the Harmonist community is repeated in the two maps of their villages, which are nearly equilateral, with pictures of buildings distributed throughout them. Shaker views are longer, however, with all the buildings generally concentrated on an axis through the center of the drawing, and flanked only by pastures and woodlots. By the 1830s and 1840s, Shaker artists were plotting these linear villages on drawings so long that they had to be constructed from several pieces of paper pieced together and used as a scroll, a device that was hardly necessary for Wallrath Weingartner's compact drawings. Thus, while they share several traits with the two Harmonist maps, the Shaker village views can be distinguished even from these kindred drawings through a close comparison of their style and content.

> Orders concerning Furniture in Retiring Rooms.
>
> 7. No maps, Charts, and no pictures or paintings, shall ever be hung up in your dwelling rooms, shops, or Office. And no pictures or paintings set in frames, with glass before them shall ever be among you.
>
> *Millennial Laws of 1845*

Not every Shaker village view was made in the unwieldly size and awkward proportions of the elongated scrolls. Some were small enough to be framed behind glass and, despite the proscriptions against superfluous ornamentation, to be displayed discreetly on the walls of the Shakers' workshops or retiring rooms. Apparently this practice was sufficiently common to provoke the stern admonition that appeared for the first time in the Millennial Laws of 1845.

How, then, were the Shakers supposed to use their village views in concordance with gospel order? It appears that the drawings were folded or rolled up and stored away until they were needed, at which point they were laid out flat upon tabletops and read as if they were maps or charts—which, during the first half of the nineteenth century, they actually were. Because they were sketched against the field of an isometric plan, the various three-dimensional features of a Shaker vil-

Figure 9. "Map of Harmony, Pennsylvania"

By Wallrath Weingartner (1795–1873)

1833

Ink and watercolor on paper

20 13/16" × 16 13/16" (52.9 × 42.7 cm)

MG-185, Records of the Harmony Society, Archives, Pennsylvania Historical and Museum Commission

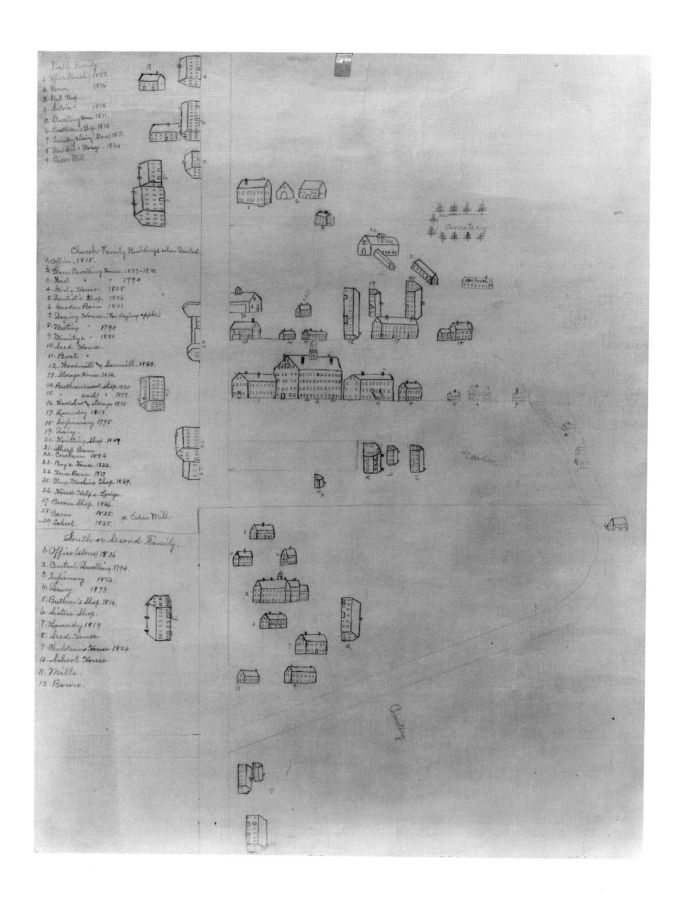

lage were rarely oriented in any single direction. The most practical way of using a map with no "right" side up was to lay it flat, where each feature could be seen by turning it around, or, if it were too large, by walking around it. It was not until the mid-point of the century that Shaker drawings outgrew their cartographic orientation and were conceived with the landscape in perspective and a sky above the horizon. These pictures were designed to be seen vertically.

The idea of displaying them seems to have become acceptable by the last third of the nineteenth century, when the Millennial Laws had relaxed sufficiently to permit picture frames to be used. Though as late as 1860 an English visitor described a Shaker village that had "no flowers, no pictures, no music . . ."[42] it was just thirteen years later that Elder Henry Blinn could admire "Beautifully framed pictures hung from the walls" of the Springfield Armory.[43] From this point on, Shaker village views were designed to be hung in the Shakers' rooms. Shaker sisters and childhood residents of Shaker communities now living remember them being displayed in the early twentieth century on the walls of the Brick Dwelling at Hancock, of Elder Henry Blinn's Museum at Canterbury, of the Ministry's Dwelling at Sabbathday Lake, and at Alfred, where there were more of them than anywhere else, tacked up in outbuildings.[44]

Of course, the forty-one drawings located in the course of this study represent only the survivors. There most certainly were others, about whose appearance and numbers we can only speculate. Some, such as the seventeen-foot-long gift drawing recorded at Watervliet, were imperiled by their very size.[45] Benjamin Seth Youngs's original map of South Union, measuring four feet to a side, has never been found. Lorenzo Martin's copy of Youngs's South Union map was so unwieldy that it was rolled into a scroll for storage. It remained rolled for so long that it was crumbling when it was photographed in 1965, and ten years later it was judged by the Western Reserve Historical Society to be too fragile to be unrolled again and copied for the comprehensive microfilm of its Shaker collection.

Other examples are known only through scattered references. The map of Pleasant Hill Br. Samuel Turner sent to Br. Rufus Bishop at New Lebanon, and the "map of Lebanon" that Isaac Youngs left with Br. Andrew at Union Village have never been located. Even the original notebook of his drawings of western Shaker villages is lost. It is known today only through the manuscript copies made by Br. George Kendall. Some have survived into the twentieth century, only to disappear. Of the three village views presented to the New York State Museum in 1930, one "Colored map of New Lebanon (Shaker) village" cannot now be located. Most tantalizing of all are the persistent rumors of a landscape drawing that had deteriorated to the point of unsightliness and was thus discarded according to Shaker law in the early twentieth century.

On the other hand, the number of drawings included in this study is the end result of a winnowing process. For various reasons, several Shaker village drawings did not fall within the definition of an illustrated map or a landscape view. A rough sketch of Sodus in the collecton of the Western Reserve Historical Society and illustrated in Herbert Wisbey, *The Sodus Shaker Community*, appears to be a survey made in preparation for Shaker settlement. Isaac Youngs's site plans of New Lebanon in the collection of the New York State Museum, one of which is illustrated in Edward Deming Andrews, *The People Called Shakers*, are really just diagrams. An uncompleted drawing by Joshua H. Bussell in

Figure 10. "Plan of Buildings belonging to the Society of Shakers, Enfield N.H., to 1880"

By Marguerite Frost (1892–1971)

Ca. 1938

Pencil on paper

23 3/4" × 20 1/2" (60.3 × 52.1 cm)

Archives, Shaker Village Inc., Canterbury, N.H.

Photography, Bill Finney

the Andrews collection of the Winterthur Museum library is actually a preparatory sketch for his "Plan of New Gloucester" and does not require independent illustration.

After the 1880s the Shakers continued to draw landscape scenes, but for different reasons and in different forms. The "Pen Scetch" of Whitewater, Ohio, by Charles H. Sturr, annotated with measurements, descriptions, and costs of building materials, was made to illustrate an insurance document.[46] The oil paintings of twentieth-century Shakers Br. Delmer Wilson, Sr. Helena Searle, and Sr. Alice Howland display an approach to the Shaker scene typical of other amateur artists of their time. Only Eldress (then Sister) Marguerite Frost's 1938 plan of the Shaker village at Enfield, New Hampshire (fig. 10), seems to bear any relationship to the traditional Shaker village views.

Eldress Marguerite made her plan of the village fifteen years after it was abandoned by the Shakers. It illustrates the community as it appeared in 1880, when Canterbury artist Henry Blinn headed the New Hampshire ministry and was spending half his year living at Enfield. In fact, it bears a slight resemblance to Elder Henry's known work, and Eldress Marguerite may have modeled her drawing after his style, or perhaps copied it directly from one of his maps that is no longer extant.

But it was not a nostalgic or retrospective impulse that made the Shaker village views such an expressive form of art. They grew out of a need for planning and remained vital as long as the society continued to grow. Although the advent of photography overlapped with the last of these drawings, it was not the camera that brought this artistic phenomenon to an end. By then the fortunes of the Society had changed, and the camera merely recorded them in decline. The best and most intimate picture we have of life in Shaker villages in the years of growth, promise, and success are the drawings made by the Shakers themselves.

2 VILLAGES ON THE LANDSCAPE

The first Shaker community was settled in 1776, a few miles north of Albany, New York, on undeveloped land the immigrant Believers had purchased from the family of Stephen Van Rensselaer. Though the Indians called the place "Niskayuna," meaning "the extended corn flats," the property the Shakers bought was both wooded and swampy, and the new settlers had to clear and drain the land in order to establish their community there.[1] As a result, their village developed wholly according to their own design, influenced only by the needs of the community and the topography of the land.

Thereafter, Shaker villages were established on settled land. In the spring of 1780, Shaker missionaries left their home at Niskayuna and started preaching the message of Shakerism. New Believers were attracted to the faith, often landowners whose farmsteads became gathering places for new Shaker families. Typically, Shaker villages evolved on the site of this donated property, though occasionally Shaker converts pooled their resources and bought a nearby farm more suited to the needs of a communal society. In every instance following the settlement at Niskayuna, the development of the land had already been started, and its initial division into roadways, fields, woodlots, and building sites had been accomplished by the time it became a Shaker community.

As a result, newly established Shaker villages did not appear signifi-

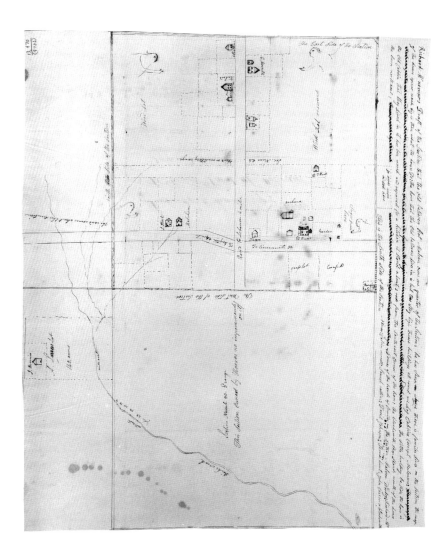

Figure 11. The Shaker Community at Union lage, Ohio

By Richard McNemar (1770–1839)

Ca. 1806

Ink on paper

15 3/8″ × 13 1/8″ (39 × 33 cm)

Inscribed: "Richard Mcnemar's Draft of the Section that the old believers Bot."

Collection of the Shaker Museum, Old Chatham, New York

cantly different from the farmsteads of the non-Shaker neighbors. Within a few years, though, mature communities would evolve from these villages, and the dynamic and visionary people who settled there would extend the boundaries and raise new buildings. They would build with such inspiration and ingenuity that the original appearance of the land would be all but lost. The Shaker village maps alone survive to record the communities at the outset of the Shaker adventure.

The Shaker community at Union Village, Ohio, was still being settled when Richard McNemar made a plan of the site around 1806 (fig. 11). An early proselyte of Shakerism in the West, Elder Richard had gathered with his gospel friends into a loose-knit community around a crossroads on the highway from Dayton to Cincinnati. Some were homesteaders who had settled the land and were subsequently caught up in the great religious revival that swept the region. Others were Shakers before they came to the area, converts who left their homes and moved to the crossroads community. What they would build there would become a society of over eight hundred souls, the center of Shakerism in the West.[2]

Richard McNemar's drawing of the village recorded the topographical features and the individual structures standing on the 640 acre section the Shakers had just purchased. He organized it like a surveyor's plat map, with the range and section lines of the new settlement

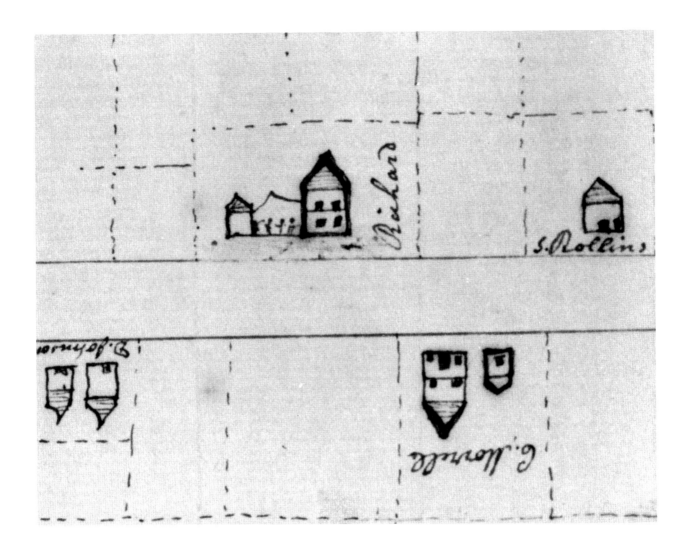

Figure 12. Detail of figure 11 showing
Shakers dancing

plotted in a grid. Its four sides are bounded with the compass direc-
tions—for example, "This is the South side of the Section"—but the
plan does not have a defined bottom or top. Within the grid of the sur-
veyor's boundaries the cartographer has illustrated topographical fea-
tures—roads and waterways—and identified the improvements made
by the settlers—wood lots, a grass lot, an orchard, a garden, and a corn-
field. A "Burying Place" is established, and sites for a "mill seat" are
identified. One lot is labelled "Suger house here." This evidence of the
Shakers' industry stands in contrast to the adjacent land to the west,
labelled "Section Numb. 30 3rd range. This section owned by Harras no
improvements on it."

Upon the land are sketched tiny outlines of individual Believers'
houses, drawn facing the roads nearest to them. The concept of shared
property was not yet expressed in the architecture, and no communal
dwelling existed at Union Village. The Shakers lived in their own
houses, and each little homestead is identified with a name—"Mal-
cham, El. David, C. Morrill." Elder David Darrow moved to Union Vil-
lage in October of 1806. Because his house is illustrated, the map must
have been made between that date and the raising of the Shaker meet-
ing house.[3]

Richard McNemar's own house was a two-story cabin, with a shed
in the back (fig. 12). Connecting the two structures was a dog-leg

breezeway. Elder Richard included this in his sketch, and in minute detail drew in four little figures. They represent the artist and his Shaker brethren, dancing in the ecstatic worship from which the Shakers took their name.

The map is illustrated with four other sketches (fig. 13), and though they are more obvious than the picture of the dancing Shakers, their presence is less explicable. Drawn in the four quadrants of the Believers' section, they appear as spirit-like effigies hovering over the borders of the Shakers' land. Perhaps Elder Richard was motivated to sketch them by the same joyful impulse that caused him to picture himself dancing. It was an exciting time for the Shakers, full of spiritual awakening and the promise of a kingdom on earth.

Years later, for reasons he did not record, Elder Archibald Meacham sent this map to the neighboring Shaker village at Watervliet, Ohio. He revised it a little, noting on the Dayton road to the north, "The road comes about this direction." In the southern margin he added a long explanation, giving a title to the map, and identifying its maker. Elder Archibald did not date his annotations, but he used the term "the old believers," indicating that some years had passed since Union Village had been settled. In his comments he described changes in the village since the map had been made and cautioned the viewers not to be deceived by Richard McNemar's disproportionately large buildings:

. . . he has Shewn where there is families lives on the Section. the map of the houses appear much higer than what the houses Do: The house that the Old believers Lives in is but two Story high these buildings all around are Log Cabbins Except Malcum's. The little building beside the house is the old Cabbin that they lived in. It has ben moved and repaired for a kitchen. It stand about 3 rods from the Southeast corner of the house. The blacksmith Shop stands north of the house; the barn northeast. Names of the heads of families on the Section: Malcum Worley; Richard McNemar; Calvin Morrell; Samuel Rollins; David Johnson; Thomas Hunt; John Carsen a blacksmith.

He folded it like a document into a letter, and on the back addressed it: "Richard Mcnemar Map—To Deacon David at Watervliet From Archibald—" and sent it onward. In the twentieth century it came to the society at Canterbury, New Hampshire, and in 1962 was acquired as part of the Eldress Emma B. King Library for the Shaker Museum at Old Chatham, New York.

In 1807, someone copied Richard McNemar's map of Union Village (fig. 14). An unidentified artist plotted the Shakers' land with the same little illustrations and annotations. He took the opportunity to revise the map. The route of the road north to Dayton is corrected, "Prudence's Grave" is added to the burying ground, and the buildings the Believers raised in the preceding year are illustrated. The largest building in the village was now the meetinghouse (fig. 15), raised on the site of John Carson's blacksmith shop.

As Elder Archibald Meacham had noted, a kitchen now stood southeast of the new dwelling, along with a root cellar. The Shakers now had their own church, their first since they had left the congregation of the Turtle Creek Presbyterian Church, which is drawn on this map on the road south to Cincinnati, and labelled "Turtle Creek old meetinghouse, now forsaken." Elder Richard's own house has not changed; the two cabins are still connected by the protected breezeway. But with the erection of a formal house of worship, the dancing no longer took place at Richard's homestead. In this version of the map, the tiny figures are missing.

So, too, are the four angelic figures Richard McNemar sketched in

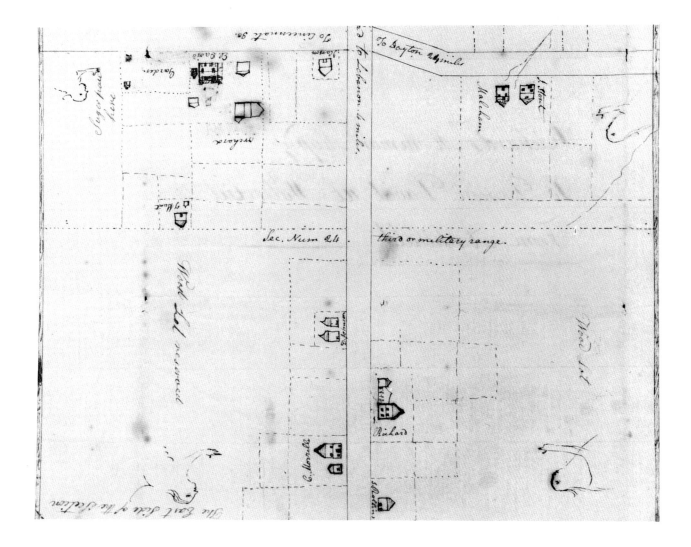

Figure 13. Detail of figure 11 showing spirit effigies

the corners of the Believers' land. The sense of spontaneity and originality that Elder Richard conveyed in his map was not reproduced in the copy. While this is nowhere more evident than in the absence of the guardian spirits, the entire map reflects the same formality. It is better organized and more tightly controlled. There are no mistakes or words misspelled and crossed out; the rows of gentle dots marking individual lot lines have become purposeful, heavy dashes. The maker of this map was motivated by needs different from the artist of the original. The copy was supposed to be a more accurate document than the original.

Why would such a formal version be copied from the original plan, only a year after the first map was finished? An inscription on the reverse gives a clue. Like the original the map was folded into a letter, and labelled on the outside, this time as "A Plan of the section of land on which the Believers live in the State of Ohio." In contrast to Richard McNemar, who did not label his plan at all, and to Archibald Meacham, who labelled it only "A draft of the Section that the Old Believers Bot," the man who prepared this drawing specifically described the site as being in Ohio. It would seem that this map was headed back east to the parent ministry at New Lebanon, to keep them informed of the rise and progress of the Society in the West.

In 1912, the pioneer Shaker bibliographer John P. MacLean who was searching for early Shaker imprints and manuscripts, had expanded

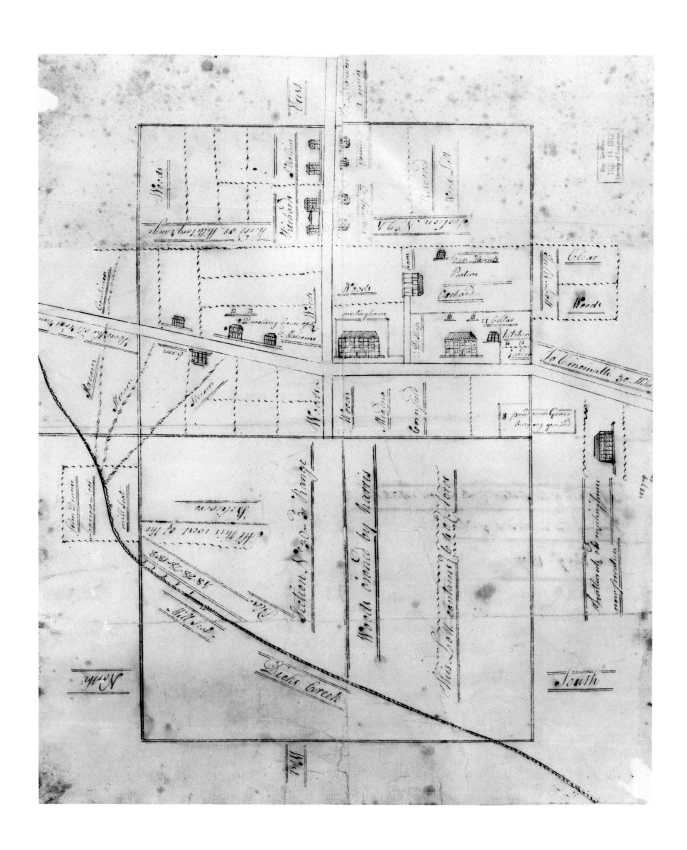

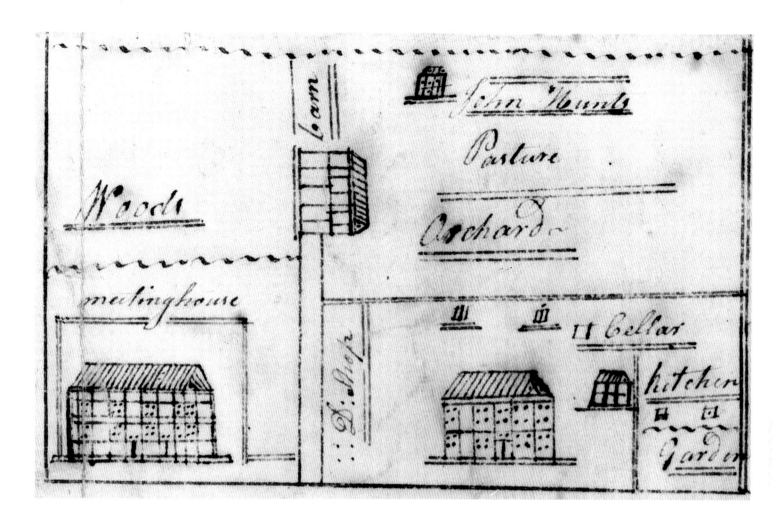

his search beyond his native Ohio. He had formed a friendship with New Lebanon Elder Alonzo Hollister, from whom he puchased Shaker materials for his collection, and from whom he may have acquired this map. Unfortunately, he did not record where he discovered it. It is known only that in June of that year he sold it to the Library of Congress.[4]

By 1820 the Shakers had settled sixteen major communities in nine states stretching from Maine to Kentucky. The establishment of their colonies largely completed, they were now concentrating on developing mechanisms to coordinate their far-flung network of villages. The few Shaker maps that survive from this decade reflect this new stage in the Shakers' growth. They were not created as settlement maps, for the villages they depict were already well established. Instead, their principal function seems to be to illustrate the site, to record it at a given point in its development, and through this picture, to communicate the information to a viewer unfamiliar with the place.

Communication among the villages was essential to maintain the sense of uniformity and the mutual support that bonded the Shaker religion. Above and beyond this communal concern for sharing, however, was the need of the central ministry at New Lebanon, New York, to keep abreast of developments in the individual communities and to maintain its direction over them.

Figure 14. The Shaker Community at Union Village, Ohio

Unidentified artist, after Richard McNemar

November 7, 1807

Ink on paper

15 3/8" × 13" (39 × 33 cm)

Inscribed: "A Plan of the Section of land on which the Believers live in the State of Ohio"

Collection of the Library of Congress

Figure 15. Detail of figure 14 showing Centre Family buildings

One of the most remote communities from New Lebanon was the society at Pleasant Hill, Kentucky, founded in 1806. After fifteen industrious years, the Shakers there had built a substantial village and had just completed work on their new meetinghouse and the adjacent Ministry's workshop. In an 1821 letter to Br. Rufus Bishop and the parent ministry in New York, Br. Samuel Turner discussed a manuscript map of Pleasant Hill that needed to be updated.

Brother Rufus desired me to inform him of the new Buildings we put up, So that he could place them on the map, this I would like to do; but I have no very correct way of doing it, as I kept no copy of the map that was Sent. . . . Kind Brother, there has been Some alteration in the outward order of things here, Since your Map was drawn; so we have calculated on Sending you another one, after things become more Settled, and a way of conveyance be opened for it. Then perhaps we Shall be better able to inform you of the improvements in buildings, and of the place in which they Stand.[5]

This need for information went both ways. The Shakers in remote communities felt removed from New Lebanon, spiritually as well as physically, and sought a way to close that gap. Two years later, in 1823, Br. Samuel wrote again, this time to ask the Ministry at New Lebanon to send a map of that colony to Pleasant Hill, so that the Society in the West might

have a vew of lovely Zion where Mother Gospel was first planted, and it would be a great satisfaction to . . . us, if we could be that much indulged. . . . The Word that comes from the East say it [Mt. Lebanon] is the most beautiful place there is on Earth, which I have no doubt it is both pleasant within and beautifull to behold & if I dare use so much freedom as to ask anything of a temporal nature it would be to ask for a map of that place, Buildings, gardens, & Orchards, etc., etc. . . .[6]

A new map of Pleasant Hill seems to have been completed, for later that month Br. Samuel wrote New Lebanon to ask if it should be sent by post or carried to New York by visiting Shakers:

Now in relation to the Map, I know not how to get it to you, it will be somewhat bulky, and the postage will be considerable, but if it should be your mind to have it sent by post, please to inform us and we will send it on. We should be intirely free to pay the postage here, but we think probably it would not go safe.[7]

Neither map of Pleasant Hill—the old one or the new one—is known to survive. Nor is the map of New Lebanon, if it were ever made at all. In fact, maps of only two Shaker villages are known from the 1820s. From them we get a sense of how the communities were pictured.

By the time the first map of the village at Hancock, Massachusetts, was made, the Church Family had been settled for forty years. Dated 1820, the pen-and-ink drawing (fig. 16) portrays a substantial village of thirty-five buildings, situated along the highway running through the community. Although individual buildings continued to be constructed, demolished, or moved around the village for the next century, the eventual form of the Shaker community at Hancock had been developed by the time this map was drawn. The landscape of the village did not greatly concern the artist. Other than plotting a few lot lines, he made no reference to the ways in which the Shakers had developed the land. His intention here seems to have been only to picture each of the buildings, which he did in exacting detail. At the center of the village is the Shakers' gambrel-roofed meetinghouse, the focus of the spiritual activity from which the Church Family took its name. The large central dwelling stands across the road, flanked by scores of workshops, barns, and utility buildings. As at Union Village, the buildings at Han-

cock were all oriented toward the road, and are drawn facing inward to that central axis.

Because the great majority of the buildings stood on the same side of the road, the artist assigned this side of the map to be the top and labelled all of the features on the map so they would read from the same directon. Unlike the maps of Union Village, therefore, it developed with a single orientation—though with the result that the northerly buildings were stood on their heads. It was a logical way to orient the map—it reads best this way—and it seems not to have troubled the artist that South ended up at the top of the page.

Each of the buildings is represented by a sketch of its principal facade, and most are identified with such labels as "Blacksmiths Shop" or "Cider House." The illustrations are carefully delineated and are easily recognizable by their individual characteristics. Perhaps the artist had participated in the construction of the building, for his sketches reveal a detailed knowledge. With precise strokes of his pen he articulated the bays, types of siding, and number of chimneys on each building, erasing and correcting his work as he went. Then he proceeded to outline those features with a perimeter of tiny dots. A distinctive feature of this artist, these dots are used to surround the walls and roofs of the buildings, to line their doorways, and to fill each pane of glass in their window sash.

A notable omission on this careful drawing is the school house on the northern side of the road (fig. 17). Although its site had been established before this drawing was made, it had not been assembled in time to be sketched in elevation for this architectural inventory. It is represented only by a plan of its foundation, outlined between the blacksmiths' shop and the meetinghouse.

No attempt was made to update this map as the village grew. No elevation of the school house was ever drawn in, and the 1826 Round Stone Barn, certainly the most remarkable structure at Hancock, was never inserted in the pasture to the west of the cow barns. The only alterations to this map occurred when its borders were trimmed. Originally surrounded by a margin, the edges were cut so close that the ends of the barns were lost from the top, as was the right hand edge containing the western edge of the Garden House and the last two letters of the word "House." The title, which was written in the margin above the map, was trimmed off with the border, cut out, and pasted into the lower left-hand corner, in the site of a pasture that would one day be used as the Shakers' burying ground.

At some later date, a second plan of the village at Hancock (fig. 18) was copied from the 1820 map. Its early history is not recorded, but, like the copy of the 1806 map of Union Village, it is the work of another artist, conceivably for use in another Shaker community. While the drawing is undated, it is undoubtedly later. In contrast to the original, it is drawn on pulp paper in cobalt blue ink, and its title, now missing, was once printed in the lower left-hand corner in imitation of the original map after it was trimmed and pasted.

Though faithfully reproduced line for line, the second version was drawn in a tentative, hesitant hand, in obvious contrast to the creative and confident style of the original artist. In some ways the second map, like a second draft of any work, is an improvement. The copyist was able to visualize the extent of the work and to lay it out entirely in pencil before he inked in the lines. He could anticipate and profit from the original mapmaker's problems in crowding and spacing the structures. He was able to avoid errors that appear in the original, such as the mis-

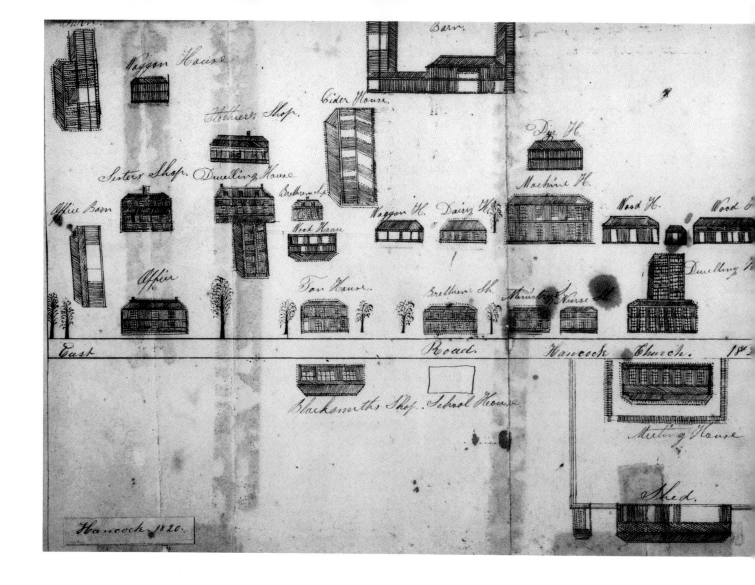

Figure 16. The Church Family at Hancock, Massachusetts

Unidentified artist

After 1820

Ink on paper

11 3/8″ × 25 3/4″ (28.9 × 65.4 cm)

Inscribed: "Hancock Church. 1820."

Collection of the Shaker Museum, Old Chatham, New York

Figure 17. Detail of figure 16 showing Church Family buildings

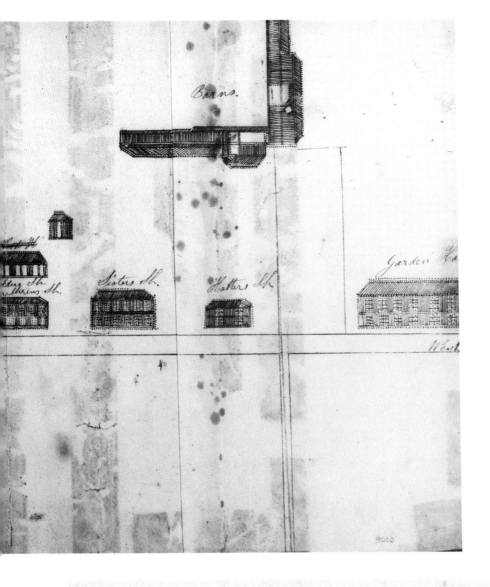

Barns.

Sisters Sh. Hatters Sh. Garden Ha

West

9000

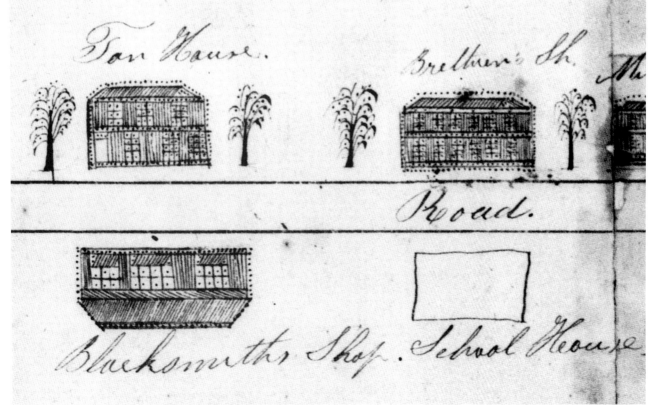

Tan House. Brethren's Sh.

Road.

Blacksmiths Shop. School House

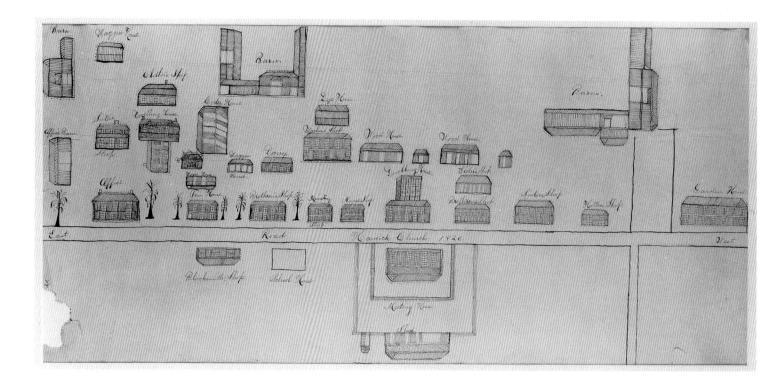

Figure 18. The Church Family at Hancock,
Massachusetts

Unidentified artist

After 1820

12 3/4″ × 27″ (32.4 × 68.6 cm)

Pencil and blue ink on paper

Inscribed: "Hancock Church. 1820."

Collection of Hancock Shaker Village, Inc.

identification of the Elders' shop for the wood house. His copy, however, is derived completely from the original and is devoid of any interpretation.

The problem with this lack of original expression is demonstrated in both aesthetic and substantive ways. For instance, in the later drawing the perimeter of dots has been dutifully copied, but without any appreciation for the graphic purpose they serve. Used by the original artist to define outlines and openings in buildings, they lent a tight, dramatic tension to his little sketches. In the copy they are reduced to meandering dashes, and the effectiveness of this visual idiosyncracy is lost.

More important, however, is the mapmaker's lack of original contribution in his copy. Surely the school house was raised by the time this drawing was made, but it appears in the later drawing as the same unfinished outline (fig. 19). Perhaps this map was copied from the original in some other village, where the mapmaker could not have known what else to draw. Even the famed Round Stone Barn of 1826 might have been omitted if the copyist had not known what it looked like or where it should have been located on the map. Though it records the village as it appeared in 1820, it is likely that this copy was created later as an anachronism, out of date even as it was being made.

A small plan of the short-lived community at West Union, or Busro,

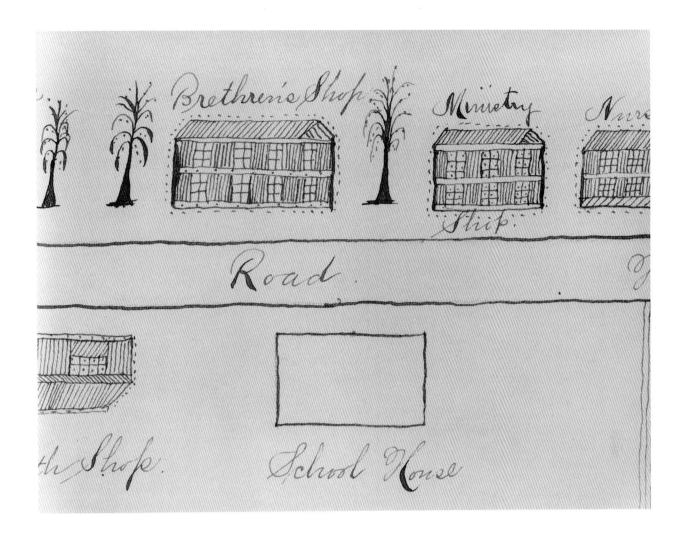

Figure 19. Detail of figure 18 showing Church Family buildings

Indiana, is the earliest Shaker map known to be illustrated in color (fig. 20, Pl. I). On what appears to be a page torn from his notebook, the artist outlined the major features of the village—the rivers, roads, fields, and orchards. Groups of Shaker structures, marked "C" for the centre lot, "O" for office, or "B" for barn, are depicted in the plan. They are seen from directly above, without any attempt to illustrate the buildings by incorporating sketches of their elevations or sides. The corduroy log bridge across the Busro Creek is the only structure to be represented in realistic detail rather than stylized plan—and then only because it lay flat on the landscape and could be drawn to be consistent with the arrangement of the plan.

A wash of watercolor gives this map another dimension for describing the landscape. Over the ink diagram are applied appropriate colors: red for brick buildings, green for the dooryards, brown for the roads and for Busro Creek, and white for the meetinghouse. At the top of the drawing, colored red, is a lively directional arrow. It fixes north at the top of the map, indicating that this artist, unlike the creator of the Union Village and Hancock maps, was familiar with that cartographic convention.

The value of the graphic information in this drawing is matched by the explanatory notes in the corners of the page:

Map of West Union 15 miles N. of Vincennes one mile from the Wabash contain-

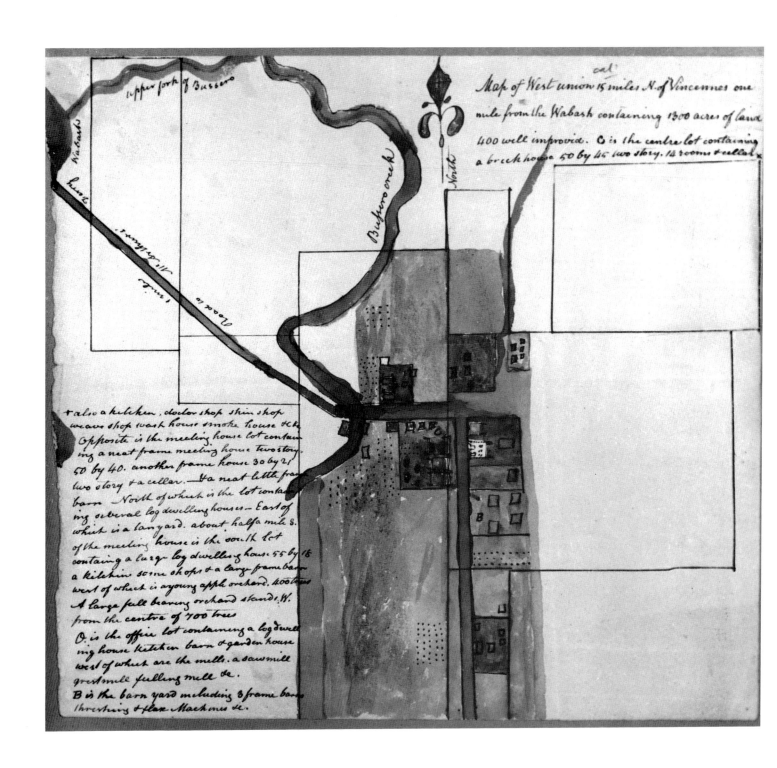

Map of West union 15 miles N. of Vincennes one
mile from the Wabash containing 1300 acres of land
400 well improvd. C is the centre lot containing
a brick house 50 by 45 two story. 14 rooms & cellar

upper fork of Bussero

Wabash

Bussero creek

North

+ also a kitchen, doctor shop shin shop
weavs shop wash house smoke house & &c
Opposite is the meeting house lot contain-
ing a neat frame meeting house two story.
50 by 40. another frame house 30 by 25
two story + a cellar. — + a neat little frame
barn North of which is the lot contain-
ing several log dwelling houses — East of
which is a tanyard. about half a mile S.
of the meeting house is the south lot
containing a large log dwelling house 55 by 18
a kitchin some shops + a large frame barn
west of which is a young apple orchard. 400 trees
A large full bearing orchard stands W.
from the centre of 700 trees
O. is the office lot containing a log dwell-
ing house kitchen barn + garden house
west of which are the mills. a sawmill
gristmill fulling mill &c.
B is the barn yard including 3 frame barns
threshing + flax Machines &c.

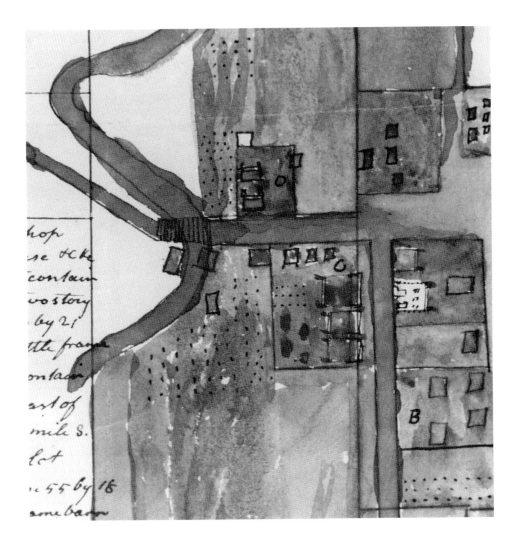

ing 1300 acres of land 400 well improved. C is the centre lot containing a brick house 50 by 45 two story, 14 rooms & cellar.

& also a kitchen, doctor shop, spin shop weave shop, wash house, smoke house, &c &c. Opposite is the meeting house lot containing a neat frame meeting house two story 50 by 40. another frame house 30 by 21 two story & a cellar. & a neat little frame barn. North of which is the lot containing several log dwelling houses—East of which is a tanyard. about half a mile s. of the meeting house is the south lot containing a large log dwelling house 55 by 18 a kitchin some shops & a large frame barn west of which is a young apple orchard, 400 trees A large full bearing orchard stands W. from the centre of 700 trees

O is the office lot containing a log dwelling house kitchen barn & garden house west of which are the mills, a saw mill grist mill fulling mill &c

B is the barn yard including 3 frame barns threshing & flax Machines &c.

The use of such text within the map is consistent with other Shaker village maps, and indicates one of their principal functions. The descriptions are so extensive that it is obvious this map was intended, not for use within the village, but to portray it to those unfamiliar with the site.

The value of the text is equal to if not greater than the value of the diagram itself. Although large and complex structures are represented in the drawing by indistinct marks (fig. 21) and orchards of hundreds of trees by a few dozen dots, the accompanying notes are so thorough and specific that through this description the map can be dated to be-

Figure 20. The Shaker Community at West Union, Indiana

Attributed to Richard McNemar (1770–1839)

Ca. 1824–27

Ink and watercolor on paper

8″ × 8 1/2″ (20.3 × 21.6 cm)

Inscribed: "Map of West Union . . ."

Collection of the Western Reserve Historical Society, Cleveland, Ohio

Figure 21. Detail of figure 20 showing Centre Family

tween 1824, when the meetinghouse was finished, and 1827, when the community was abandoned by the Shakers.[8]

Recent research indicates that this map dates from the last year of the Shakers' residence at West Union.[9] It was Richard McNemar from neighboring Union Village who organized the removal from the failing community. In all likelihood he would have recorded its appearance when the Shakers decided to leave it, for their own information and to aid them in selling the property. It may even be his own work—the inscriptions appear to be in his handwriting—but it is a different kind of map from his plan of Union Village. Despite its colorful appearance, it lacks the intimate visual references that embellished the settlement map of McNemar's home village. Perhaps the artist lacked the personal knowledge of West Union that is associated with these illustrations embellishing Shaker maps. But the probable circumstances behind this drawing suggest another reason for the relative formality of its style. The place it depicted was no longer a spiritual home for the Believers, but just a group of buildings about to be severed from the community of Shakerism.

3 PLANS, VIEWS, AND DELINEATIONS

In the 1830s Shaker mapmaking flourished in expressive and artistic directions. No longer the scant outlines plotted by Shaker surveyors and planners, the new generation of maps was typically the work of brethren with some native artistic ability or a rudimentary knowledge of drawing skills. Like their predecessors, these artists conceived of their drawings as reference documents, and they often signed and dated them. But unlike their predecessors, they also intended them as pictorial illustrations.

These artists plotted their drawings on an increasingly larger scale and the dimensions of their maps expanded accordingly. They experimented with the problems of perspective construction and amplified their inked outlines by highlighting significant features with watercolor washes. In the course of the decade, the scope of these maps expanded to include a fuller picture of life in a Shaker village. Nowhere is this evolution more evident than in a comparison of the two known maps of the Shaker village at Harvard, Massachusetts.

The first map is the work of Charles F. Priest. Little is known about the artist; he is mentioned in scattered references in Harvard journals, working as a cabinetmaker about the village, or travelling abroad on Society business. At the time of his death in 1842, he was serving as an Elder—a designation of authority, not necessarily of age—at the Second Family.[1] Because his wide-ranging responsibilities as a carpenter

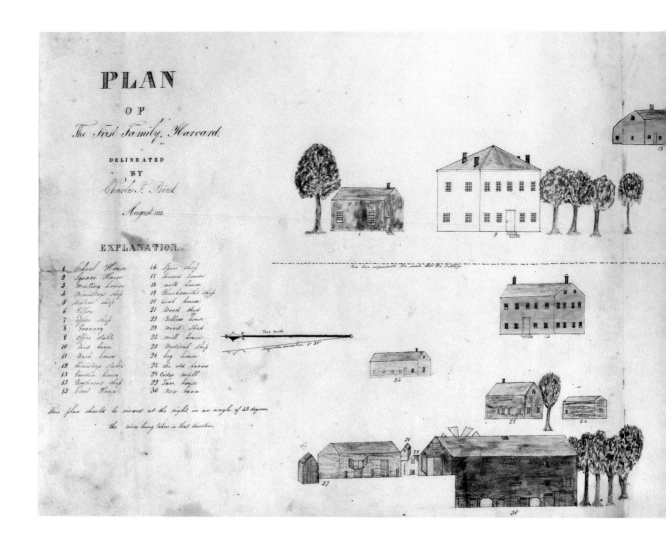

Figure 22. The Church Family at Harvard, Massachusetts

By Charles F. Priest (ca. 1803–42)

August 1833

Pencil, ink, and watercolor on paper

13 1/4″ × 36″ (33.7 × 91.4 cm)

Inscribed: "Plan of the First Family, Harvard"

Collection of the Library of Congress

took him to all corners of the village, he was familiar with buildings throughout the community[2] and was knowledgeable enough to make a plan of the First Family (fig. 22, Pl. II). Indeed, this map, made in the summer of 1833, reveals that he also had an acquaintance with artistic conventions that was unusual in a Shaker village, and suggests that somewhere along the line he had encountered some elementary training in draftsmanship.

For instance, the manner in which he plotted his directional arrow demonstrates some technical experience in cartography. Like the arrow on the ca. 1827 map of the Shaker village at West Union, it is a vernacular interpretation of the elaborate directionals plotted by nineteenth-century engineers and cartographers as a demonstration of their delineators' skills. In this case, it appears as an ornamental spear with spiral quillons at the point and the hilt. But the simplistic and quaint quality of this device is belied by the sophistication of the message that accompanies it. The directional diverges into two arrows, labelled "True North" and "Magnetic Variation 6° 20′." Though few Shakers would have known, or have needed to know, the difference, it is this academic knowledge that makes Charles Priest's map one of the most technically accomplished of any Shaker village drawing.

Br. Charles made his sketch of the First Family from a prospect to the southwest of the village. He laid out the thirty buildings in three-

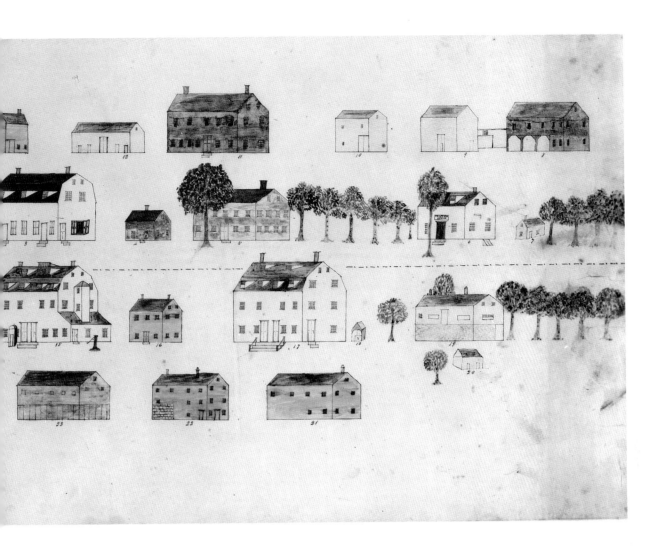

quarters perspective, showing each with a side and a gable end. After labelling each one in a numbered "explanation," he then added some unusual instructions for recreating his vantage point and correctly viewing the perspective on which he had labored: "This plan should be viewed at the right in an angle of forty-five degrees, the view being taken in that direction."

Unlike other Shaker maps, the Charles Priest drawing of Harvard does not place the buildings within the plan of the landscape. There is no patchwork here of pastures, dooryards, meadows, and woodlots, defined by a grid of hedgerows, lanes, and stone walls. The artist understood what the other Shaker cartographers failed to realize; that his three-dimensional structures could not be realistically represented on the two-dimensional plane of an isometric plan. He resolved this dilemma by suspending the buildings on the hillside, without reference to the landscape on which they stood. The viewer is oriented to the site only by a few stands of maple trees and a dotted line across the page with the notation, "This line represents the road through the village."

With no other features to cover the landscape, the buildings stand out prominently. First sketched in pencil, they were then outlined in ink, and finally painted in strong watercolor hues. Yellow identifies the workshops, while the barns are tinted red. Behind the new barn a

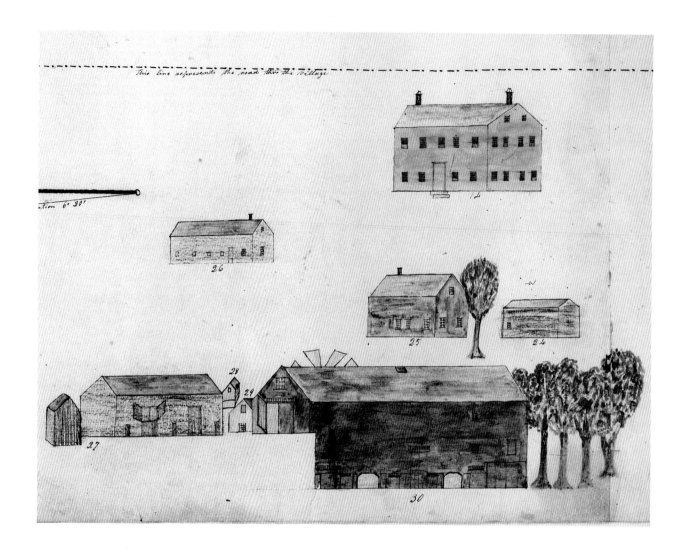

Figure 23. Detail of figure 22 showing tan house and barns

windmill is colored graphite-gray (fig. 23, Pl. III). The gambrel roof of the meetinghouse is brown, while its clapboarded sides are left uncolored to represent white paint (fig. 24, Pl. IV). The first Shaker view known to record the colors of each building in a Shaker village, Br. Charles's plan reveals that at Harvard not only the meetinghouse, but the family dwellings, including the hip-roofed Square House once owned by the mystic and visionary Shadrach Ireland, were painted white. This use of white paint on common buildings did not necessarily contravene Shaker order, however. The Millennial Laws prescribing specific colors for individual buildings were not introduced until 1845.

The effect of these blocks of color is to create an appealing portrait of a group of buildings—which is, in fact, the purpose of this picture. The artist's concern was only to record the appearance of the buildings and the spatial relationship they shared with one another; like the 1820 maps of Hancock, this map was conceived not so much as a plan of the entire First Family as a record of its architecture. Br. Charles gives us no sense of the topography, no reference to agricultural improvements nor industrial development; in short, no indication of the Shakers' use of the land. Because he concentrated exclusively on the buildings, Charles Priest's "Plan of the First Family" is a survival of an earlier tradition, in which Shaker village maps recorded only village architec-

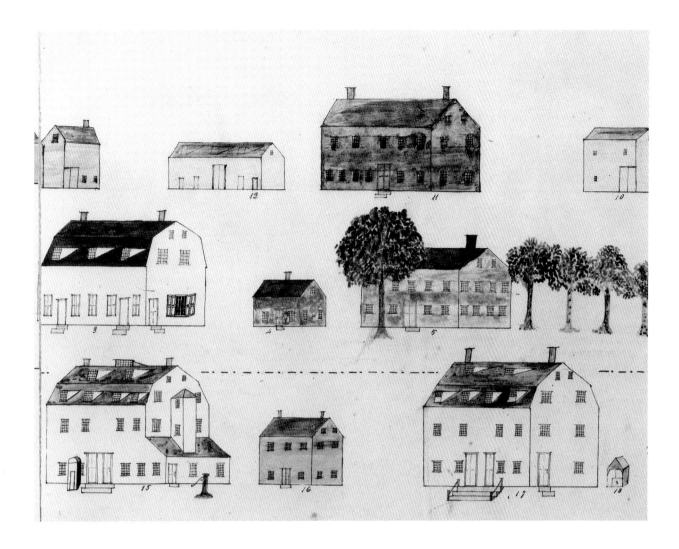

Figure 24. Detail of figure 22 showing
Church Family buildings

ture. In the decade ahead, Shaker drawings would offer greater evidence of land use, industry, and domestic architecture.

On the other hand, Br. Charles's successful attempt to resolve his problems with drawing in perspective was a real breakthrough in Shaker village maps and introduced a new generation of more sophisticated drawings. Although this map was probably unknown to most Shakers—the soiling and wear along its edges suggest that it was rolled into a scroll and stored away from view, while its brilliant color indicates that when unrolled it was not kept exposed to the harsh effects of the sun's light, but was put away after use and thus protected from fading—it can be demonstrated that the Charles Priest plan influenced at least one other Shaker mapmaker.

Although it represents a different way of viewing the village, George Kendall's 1836 map of Harvard (fig. 25, Pl. V) was modeled after Charles Priest's 1833 plan of the same site. It is very likely that in response to a need for a duplicate map, perhaps for the parent ministry at New Lebanon or perhaps as an afterthought, for the use of the family at home, Br. George unrolled the 1833 drawing and started to copy it in his own fashion. The similarities between the two are unmistakable. The choice of words, lettering, and composition in the two titles are identical. Both maps are sited with east at the top. Br. George's direc-

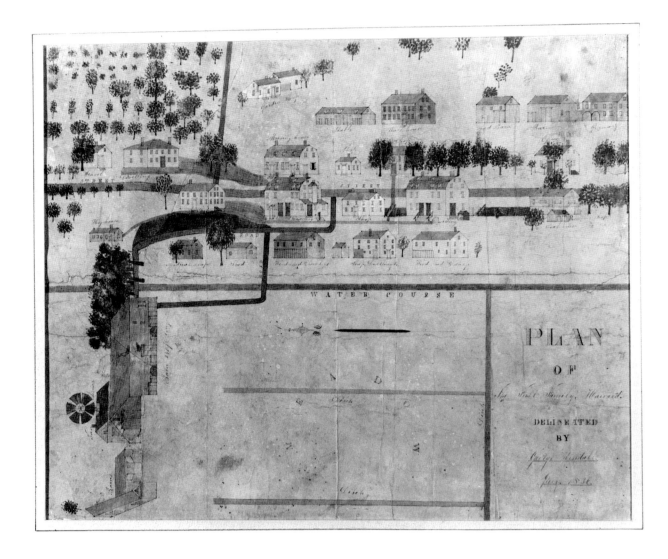

Figure 25. The Church Family at Harvard, Massachusetts

By George Kendall (b. 1813)

July 1836

Pencil, ink and watercolor on paper

24″ × 36″ (61.0 × 91.5 cm)

Inscribed: "Plan of the First Family, Harvard."

Courtesy of Fruitlands Museums, Harvard, Massachusetts

John Miller Documents

tional arrow, pointing left across the page to indicate north, is another stylized spear, employing the same concentric quillons as Br. Charles's.

The most significant similarity, however, is the way in which George Kendall conceptualized his map of the buildings at the First Family. Like Charles Priest, he drew them in three-quarters perspective, taking them from the same viewpoint to the southwest of the village. Most of the buildings are represented from precisely the same angle, and with the same kind and amount of detail as in the earlier map (fig. 26, Pl. VI). Clearly, Br. George was working from the precisely drafted inventory of buildings drawn by Br. Charles three years earlier. Although he described each of them individually, and not in a numbered key, the labels on his buildings are consistent with Charles Priest's "explanation." His use of color also coincides precisely with the 1833 map.

While he used it as the basis for his own map, George Kendall by no means copied Charles Priest's drawing. Instead, he went on to develop his own map in a familiar style more appropriate to the needs of the Harvard Shakers. In responding to their needs for documenting the village, he turned his back on Charles Priest's technical innovation. Perhaps he was unable to imitate it; perhaps he did not understand it; perhaps it was just irrelevant to him. But in his own drawing he reverted to that peculiar, naive style that typifies the mainstream of Shaker mapmaking.

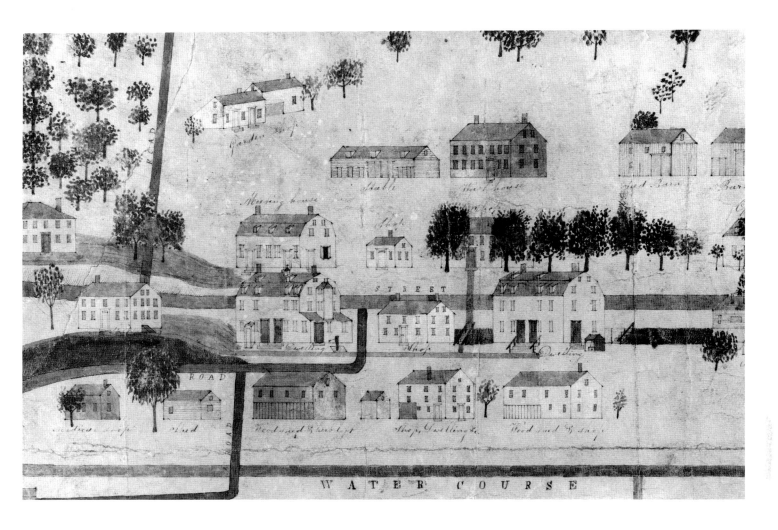

The 1836 "Plan of the First Family" represents more of the village than just the houses. Br. George saw fit to include its highways, labelled "Road" and "Street," and its waterways, labelled "Water Course" and "Ditch." These were irrigation channels, dug by the Shakers to drain the swampland around Bennett's Brook.[3] Now grassland, it is described in an arched title as the "Meadow," while other geographical features—the grassy bank next to the dwelling house, or the family's apple orchard—are illustrated as pictorial features.

Br. George was not the draftsman Charles Priest had proved himself to be. With no model to copy for his additions and alterations, his original contributions came out flat. Since he lacked the means to represent landscape perspective, his streams and lanes became a grid and skewed his map back into the familiar two-dimensional paradox. This is particularly apparent at the end of the road down the hill and across the stream to the west where the barns stood.

Charles Priest had drawn the great multi-level barn in alignment with the rest of the village structures, rising above the wind vane of the smaller tan house. George Kendall chose to alter the arrangement (fig. 27, Pl. VII). Though he copied the barn detail for detail, with its left-hand door swung open, he turned it at right angles, perhaps to better demonstrate how it was built against the western slope rising back up from the low meadowland. In so doing, he retained the existing per-

Figure 26. Detail of figure 25 showing Church Family buildings

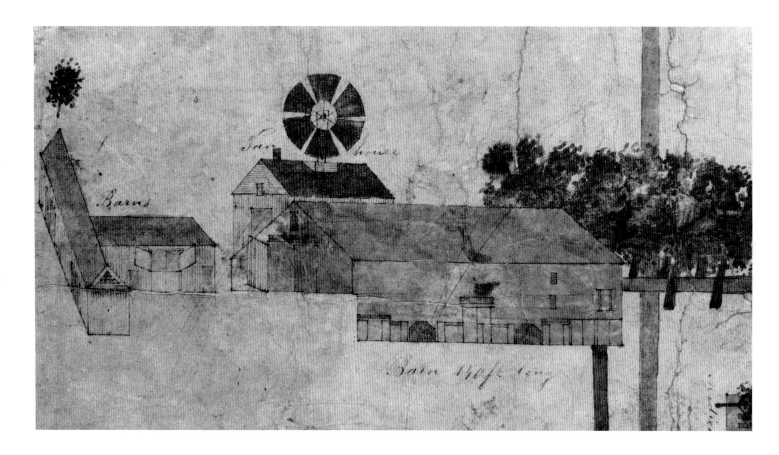

Figure 27. Detail of figure 25 showing tan house and barns

Figure 28. The Church Family at Watervliet, New York

By David Austin Buckingham (1803–85)

March 1838

Pencil and ink on paper

30 1/2" × 22" (77.5 × 55.9 cm)

Inscribed: "A Delineation or View of the Village Called the Church Family"

Collections of the New York State Museum, Albany, New York

spective and stood it on its ear, creating a strangely discordant element in an otherwise harmonious view. One benefit of his digression was the emergence of the tan house vane, looming improbably over the peak of the great barn roof. With its structural elements carefully outlined and its six ribs colored in red, it is one of the most prominent and attractive features of Br. George's map.

The next year George Kendall apostatized, leaving the Shaker village, and, as far as Shaker records are concerned, disappearing. Judging from its condition, his map saw long, hard service in the village, and was finally folded up and stored away. Early in the twentieth century it came to the attention of Clara Endicott Sears, who rescued it and placed it in the collection of her museum at Fruitlands, on nearby Prospect Hill.

At Watervliet, New York, the site of the Shakers' original settlement of Niskayuna, David Austin Buckingham drew a plan of the Church Family in 1838. His choice of the term "delineation" to describe the drawing (fig. 28) suggests that, like Br. Charles, he was familiar with certain artistic conventions. His delicate, precise drawing was plotted with meticulous care, and executed with the fine pen strokes of a practiced draftsman. Indeed, for years, Br. Austin was the schoolmaster at Watervliet, where he taught the fine calligraphy in which he excelled.[4] Two examples of his artistry with pen and ink are known to survive: an undated specimen of "spirit writing,"[5] and his 1838 map of the

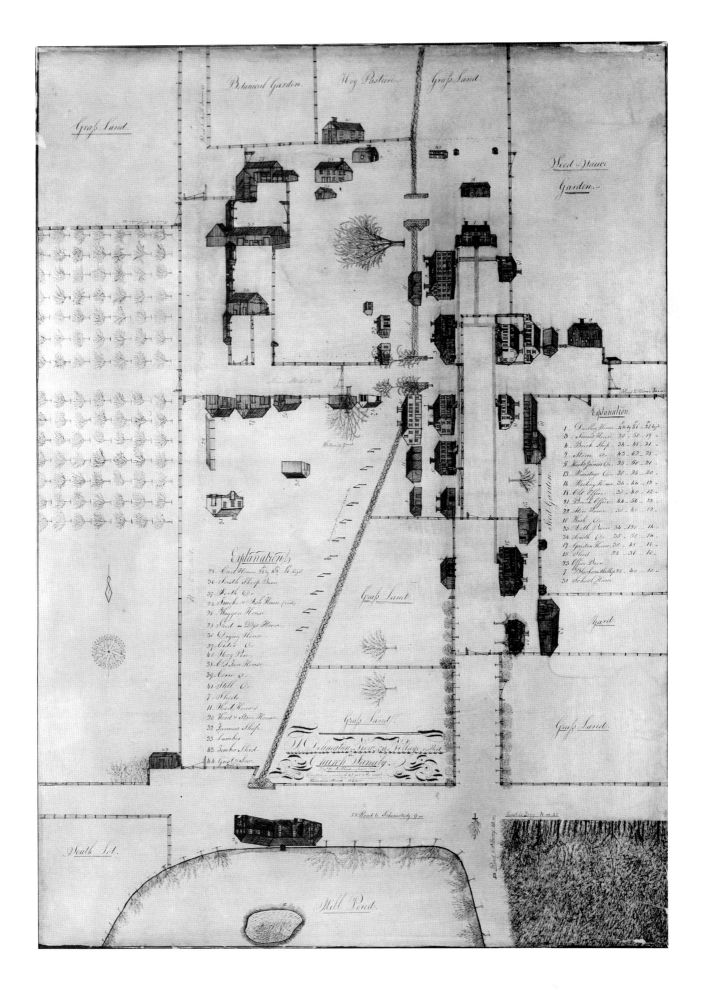

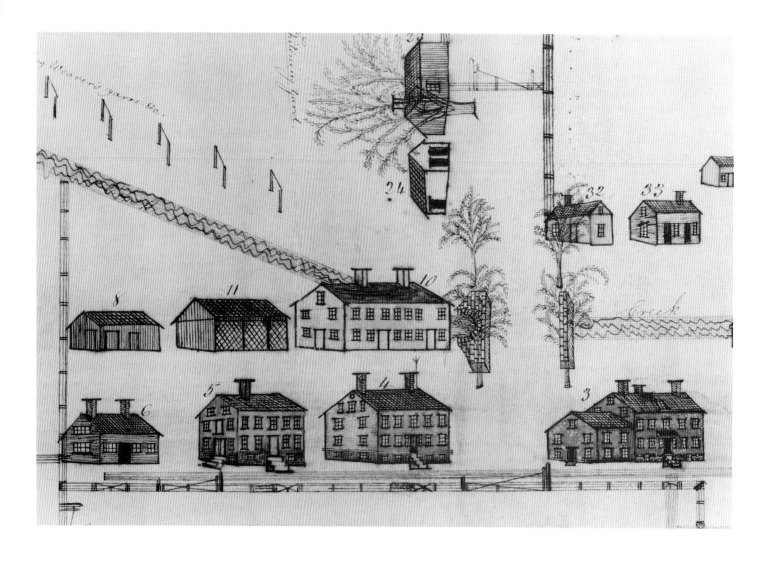

Figure 29. Detail of figure 28 showing Church Family buildings

Church Family. Br. Austin's delineation of Watervliet is composed of two distinct elements. First, like Br. Charles's architectural record of Harvard, it is an accurate inventory of the village structures. And second, it is a carefully surveyed map of the Church Family lands.

Below his title is Br. Austin's notation that the map was "Drafted on a scale of 62 feet to the inch." This odd ratio does not correspond to any traditional unit of measurement, and it is likely that the cartographer, after surveying the property and plotting the relative proportions for his map, expanded its scale to fill his broad sheet of paper. Thus, it seems that it was the size of the paper that dictated the unusual ratio of feet to inches.

A more conventional approach to cartography is found in the orientation of the map to the north. Shaker artists ordinarily arranged their maps the way they found most useful from the point of view of the community. As a result, Shaker village maps were not necessarily sited with north at the top. In fact, since most Shaker villages were laid out along a north-south axis, if a Shaker village map was designed to be approached from a single point of view and seen with a "right" way up, it was often sited with north at the side. This resulted in a horizontal drawing that could be viewed more conveniently, whether hanging on a wall or lying on a table.

Br. Austin's map is unusual in that its composition is vertical, and is consistently so—its major titles and explanations all read in the same

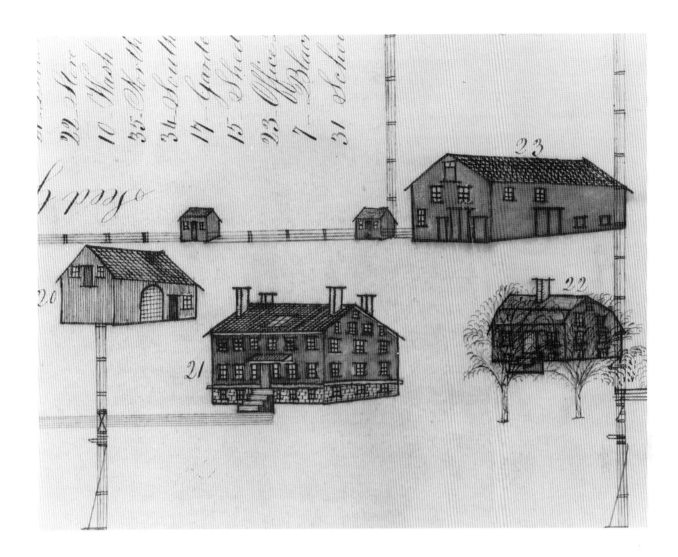

Figure 30. Detail of figure 28 showing Church Family buildings

direction. Presumably the artist decided to forego the Shaker practicality of a horizontal map in order to adhere to the worldly convention of siting north at the top.

Austin Buckingham plotted the lot lines of the pastures, hayfields, dooryards, and lanes at Watervliet. A large woodlot is illustrated at the southeast corner of the map. The millpond, the orchard, and three gardens—one for botanical herbs and two for producing preserves and garden seeds—are all outlined on the landscape. The fertile land did not contain enough loose rocks to build stone walls. Br. Austin drew the boundaries as four-rail fences, and lined the roadways with trees. The mill stream flowing through the village is a broad diagonal of wavy lines (fig. 29).

As with other Shaker cartographers, his interest in plotting the village was probably an expression of a personal need to bring order to his spatial world. But a letter he wrote to his Shaker brother Isaac N. Youngs at nearby New Lebanon, New York, around 1825 seems to suggest an historical interest in the community, as well.

Brother Isaac, Agreeable to your request I have taken considerable pains to find the ages of our buildings, but there being no account kept of them, it was difficult to get them all, however, I have noted the most part of them here, which I hope you will be able to understand as you are well acquainted with this place.

Please to accept all my best love and wishes, from Austin Buckingham.[6]

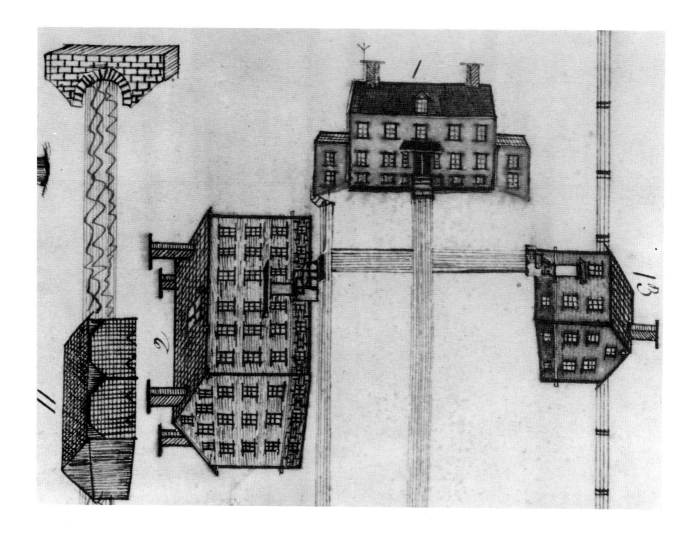

Figure 31. Detail of figure 28 showing
Church Family buildings

His accompanying list, divided into "Decayed Buildings" and "Build-
ings now in use," describes twenty-six structures built between 1778
and 1825.

Along the lanes of his 1838 village map he drew pictures of some
fifty-six buildings, ranging in size from the three-story stone shop to
the privies. The buildings were carefully drafted perspective eleva-
tions, plotted in pencil to recede to a vanishing point, and then out-
lined and colored in ink (fig. 30, Pl. IX). The sides he chose to illustrate
were the buildings' principal facades, and these faced the lanes, which
ran in four different directions. Unlike the plans of the lots, therefore,
the buildings shared no single orientation other than generally facing
toward the crossroads in the center of the village.

Br. Austin's fine delineation records the buildings in fastidious detail.
Individual blocks of cut granite can be distinguished in the foundation
of the stone shop. A four-tiered dove cote is shown in the gable end of
the south barn. A pointed picket fence surrounds the meetinghouse
yard. The concern for recording detail extends to other kinds of struc-
tures in the village. A birdhouse is perched on a pole across the street
from the milking yard. Stone bridge abutments span the stream (Pl.
VIII). On the bank of the mill creek are eleven large racks with the leg-
end "For Drying Weavers' Yarn &c." High atop the Church Family
dwelling is a three-pronged lightning rod (fig. 31).

In the crossroads outside the Great Gate is a lone shade tree, with a minuscule signboard attached to its trunk. On the roads surrounding it are inscribed "Road to Schenectady, 9 m," "Road to Albany, 6 1/2 m," and "Road to Troy, 4 m," each one accompanied by a tiny hand pointing the directions to those towns. Evidently the artist pictured the actual signboard hung on the tree ouside the village gate, but removed the legends painted on it to the roads themselves to better identify them on his map.

Since he had such an eye for minutiae and such a penchant for precision, it is not surprising that Br. Austin designed his directional arrow as a complex network of interlocking geometric patterns, forming a thirty-two point compass roseate. What is unexpected is to find it flawed. At one point his compasswork went awry, and the elegant geometry collapsed in disarray.

In the remaining space available to him, Austin Buckingham fitted in his "Explanations" of the buildings he had drawn. He described and numbered each one, and, fortunately for the historical record, listed its length, width, and height. Running out of room in the Seed Garden, he continued his explanation across the road, where, cutting diagonally across the pasture, the millstream created a trapezoidal lot. As the inventory of buildings progressed, the lot grew narrower, and unfortunately Br. Austin was ultimately forced to omit the measurements of the buildings for lack of room.

Squeezed into the bottom half of the adjacent "Grass Land" pasture, the elegantly-lettered title appears to have been an afterthought. Perhaps it was obvious to Br. Austin what the drawing represented. At any rate, once inserted, the title originally described the village only as "The Church Family." Subsequently, in a cramped hand and in a slightly different color ink, the artist inserted the information "Watervliet March—1838." Apparently this map was intended for use at home, and only later did Br. Austin feel it necessary to identify, sign, and date his work.

In the spring of 1925, when Albany County acquired the Watervliet Church Family as its county home for the elderly, Austin Buckingham's delineation was one of three Shaker maps discovered in the village. After displaying it for four years in his office in the new Ann Lee Home, Leo Doody, the County Commissioner of Public Charities, presented it to the New York State Museum.

One other Shaker village map survives from this period. Unlike the Priest, Kendall, and Buckingham drawings, it is unsigned and undated. In addition, it appears to have been originally untitled. It represents the community at New Lebanon, New York, and all evidence points to an origin there, sometime probably in the 1830s. An unidentified Shaker artist drew a "concentric" plan of the village at New Lebanon (fig. 32). It had no "right" side up; while a fanciful directional arrow indicated north, north was not necessarily supposed to be at the top. The map was designed to be laid flat on a table and approached from any of its four sides. Elevations of buildings—each one labelled with an identifying word or two—and the descriptions of the village's geographical features all face in to the lane passing through the center of the village. At some later time when a title was devised it was inscribed by a different hand in an available corner of the map. This had the effect of assigning a top to the picture. By so doing it changed the way in which the artist originally meant the picture to be seen and declared that the majority of the buildings were now upside down.

Like Austin Buckingham's plan of Watervliet, this drawing serves

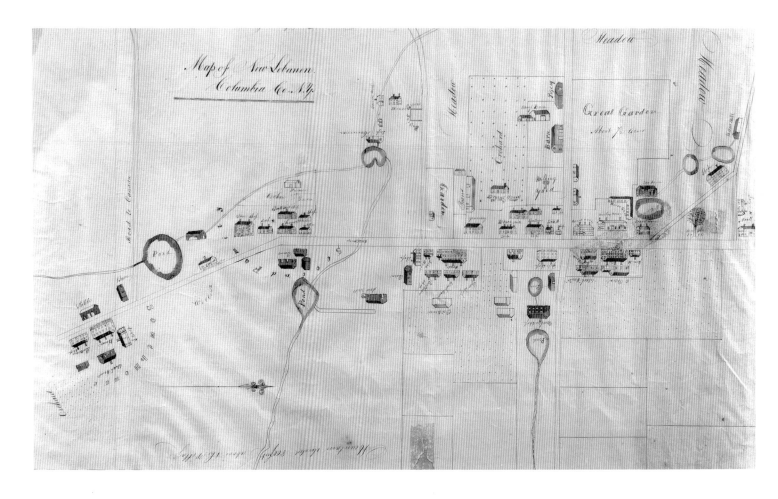

Figure 32. The Shaker Community at New Lebanon, New York

Attributed to Isaac Newton Youngs (1793–1865)

Ca. 1827–1839

Pencil, ink, and watercolor on paper

15 7/8″ × 24 5/8″ (40.3 × 62.5 cm)

Inscribed: "Map of New Lebanon. Columbia Co. N.Y."

Private Collection

principally as an inventory of buildings in the village. The need for such a visual inventory was apparent in a journal kept years later by Isaac N. Youngs, Br. Austin's correspondent and his counterpart at New Lebanon. In 1860, Br. Isaac felt it important to note that "Not a building remains as it was at the beginning of the present century, all have been rebuilt, reformed, or repaired, or demolished."[7] Though we can only guess at the extent of this artist's training, it is apparent that he did not share David Austin Buckingham's skill as a draftsman. In comparison with Br. Austin's elaborate delineation of nearby Watervliet, the map of New Lebanon is sketchy and generalized. In part, this lack of detail is a function of size. The New Lebanon map pictures three Families in an area over a mile in length, while the Watervliet map, on a sheet of paper twice the size, illustrates a single Family occupying an area less than half that size. In part, however, the style of this map suggests that the maker was less of an artist, less of an illustrator, and approached the task of representing the village in a different way.

His buildings are drawn as little boxes, distinguished from one another only by their shape and size, fenestration, and color (fig. 33, Pl. XI). No other visual characteristics, such as details of construction or materials, are offered to give them individual definition. Similarly, his orchards are just dots laid out in regular rows, his willow grove a ran-

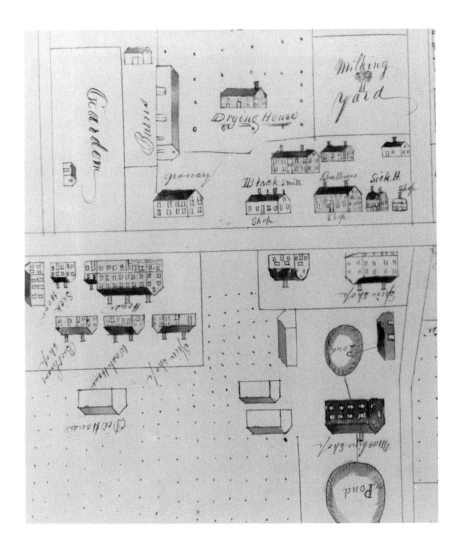

Figure 33. Detail of figure 32

dom scattering of points. Instead of illustrating the masonry construction where the road crossed over the mill stream, he printed the words "Stone Bridge" (Pl. X). Clearly this man did not see himself as an illustrator.

In fact, one of the distinguishing characteristics of this artist is his use of verbal descriptions throughout the map. With the exception of the millponds and waterways, which he seems to have plotted and articulated with special detail, he tends to use written explanations in conjunction with his pictures. He has labelled most of his seventy structures: "Drying House," "School House," "Poor House," "Pigery." In some cases, what he has written—"Trip Hammer" or "Carding Machine"—does not describe the structure he has drawn, but refers to the equipment used for activities carried on within it.

Sometimes the function or significance of a drawing is not made clearer by the description—for some unknown reason, a landmark maple tree at the North Family is singled out from all the other trees at New Lebanon, drawn larger than the largest building in the village, and labelled, mysteriously, only "maple tree" (fig. 34). Sometimes this situation is reversed—for instance, a simple sketch of a shade tree used to illustrate an enclosure near the Church Family cow barns gives no clue to the use of the plot of land. Although it may represent a tree ac-

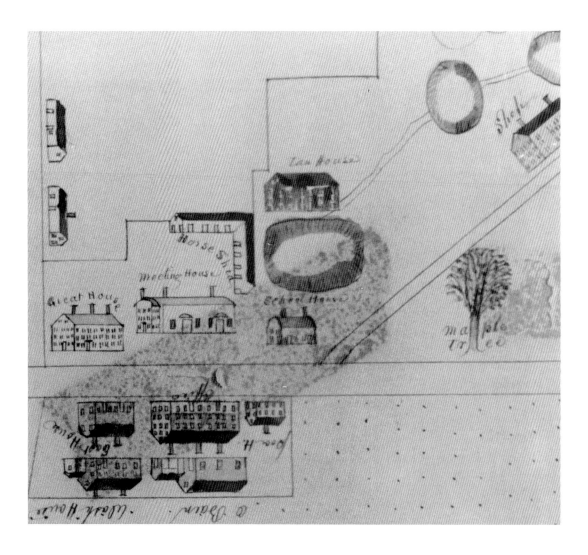

Figure 34. Detail of figure 32

tually standing there, the illustration serves no descriptive purpose. The plot can be identified as the "Milking Yard" only through the written description accompanying it.

This type of illustration disappears entirely when larger features are delineated, with the result that broad areas of the map are left blank. Three meadows and the "Great Garden / About 7 1/2 acres" are identified exclusively by verbal description, with no illustrative devices. The woodlots and pastures on the outskirts of the village occupy bare rectangles, with neither illustrations nor labels to identify them.

At the edges of the map are inscriptions meant to orient the viewer to the site. To the east is the Massachusetts / New York "State Line," and the notation "Mountain elevated 800 feet above the Village." To the west is the inscription "Valley 600 feet below the Village." These notations do more than fix the elevations; they are the kinds of descriptions one would provide for the benefit of someone personally unfamiliar with the actual topography of the site. The explicitness of this orientation, along with the wording of the title, which includes town, county, and state, suggests that the drawing was intended for use not at home, but in another Shaker settlement.

Though it was owned for many years by the pioneering Shaker collector William Lassiter, the early history of this map was not recorded, and it cannot be determined in which Shaker community it was used.

It is known, however, that in 1830 Br. Isaac Newton Youngs was working on such a map of New Lebanon for Br. Andrew Houston at South Union, Kentucky. "Likewise concerning said map, I can say but little more than I did last year," he wrote in response to Br. Andrew's inquiry, "and tho' I have made a small beginning I know not when I shall finish it."[8]

Only rarely was there more than one Shaker mapmaker in a single community. Given his recorded interest in documenting the built environment at New Lebanon, Br. Isaac seems the most likely candidate to have made this map. Though it took him four years, he made good on his promise of a map for Br. Andrew, drawing it during his trip to the Western Shaker societies in 1834.

Thursday June 5th, 1834: On the New York Canal. There seems to be enough at first to attract the attention; but after a while it becomes some more of an old story—but I can generally find something to do—and for one thing, after we had eaten our dinner I went to work on my map of Lebanon—once in awhile occasionally running up on deck to see what was to be seen.[9]

It was late in the spring that Brs. Isaac Youngs and Rufus Bishop set out from New Lebanon on a trip to visit the Ohio and Kentucky Shakers. For three months the brethren travelled among the western communities, and in every village Br. Isaac unrolled his manuscript map of the village at New Lebanon, displaying it to an audience eager for knowledge of that remote, mystical place, the spiritual home of Shakerism.

July 5th: Union Village [Ohio]. We went in to see the sisters, about 20 of them. Pretty sociable;—My map of New Lebanon . . . must be brot on to the table, which makes up quite a dish of discourse.[10]

It took Br. Isaac all summer and into the fall to complete the drawing. Not until their last stop at Union Village, as they were preparing for their homeward journey, did he put the last details on the map.

September 27: Union Village. After breakfast . . . I went to work finishing out the map of Lebanon that I brot with me partly finished; got it done and gave it to Andrew. . . .[11]

It is unlikely that the "Map of New Lebanon" illustrated here is the same one Br. Isaac left with Br. Andrew Houston. Although it has at one time or another been both rolled into a cylinder and folded into sections, it does not show the signs of wear one might expect to find on it after a rough trip by horseback and canalboat across the Appalachian Mountains. This one dates from about the same time, however. An analysis of the paper's watermark indicates that the drawing was most probably made between 1827 and 1839.[12] If it is not the same map described in his journal it is probably contemporaneous and might even have served as a model for the map he described in 1834. But whether it is by his hand or that of a second, unknown artist working there at the same time, this example represents the state of the art of mapmaking at New Lebanon in the 1830s.

4 MAPS OF THE WESTERN VILLAGES

On leaving each settlement of Believers, I drew a kind of map not
from any measures but merely from a general view and comparing
one thing with another. I think they will generally give a correct idea
of the buildings &c.

Br. Isaac Newton Youngs [1]

As the New Lebanon Shakers Isaac Youngs and Rufus Bishop made
their way West in the summer of 1834, Br. Isaac recorded his obser-
vations of the Ohio and Kentucky Shaker communities in a journal,
which he illustrated with sketches of each place he visited. After his
return to the East his journal was copied and circulated among the
Eastern Shaker societies. Although Br. Isaac's original journal is now
lost, a manuscript copy was saved at the Shaker village at Canterbury,
New Hampshire, and is now in the Emma King Library of the Shaker
Museum at Old Chatham, New York. At Harvard the maps illustrating
Br. Isaac's journal were copied separately by Br. George Kendall and
bound together in a booklet now in the Library of Congress.

The Kendall copies of Br. Isaac's drawings rank with the crudest of
any Shaker maps known today. Small, oversimplified, and often inac-
curate, they were obviously made as sketches or diagrams rather than
as independent pictorial works. But when they are examined along
with the journal that originally accompanied them, they are among the
most informative of all Shaker maps. Isaac Youngs's "Western" maps

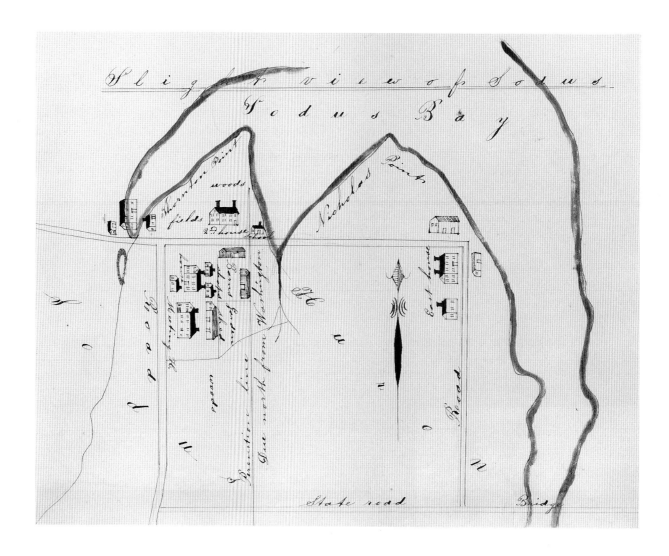

Figure 35. "Slight view of Sodus"

By George Kendall (b. 1813)

July 1835

After Isaac N. Youngs (1793–1865)

June 1834

Ink and watercolor on paper

7 3/4″ × 9 3/4″ (19.7 × 24.8 cm)

Library of Congress

were unique among Shaker village views, for they were designed to illustrate his verbal descriptions of the villages. Since other Shaker cartographers left no independent explanations of their maps, an understanding of their work depends solely on the interpretation of the viewer many years after the maps were drawn.

The maps from Isaac Youngs's journal reflect the Western Shakers' concern with outlining the physical characteristics of the landscape as a schematic site plan, detailing such topographical features as elevations of land and waterways and such geographical improvements as roads, orchards, and fields. The grids of these two-dimensional plans were then illustrated with elevations of standing structures, reflecting the Eastern Shaker cartographers' interest in making detailed records of the buildings they erected in their villages. Although George Kendall made these copies without having actually seen the sites, his ink and watercolor drawings are in most cases the only views known to record the Western Shaker villages at the height of their prosperity.

> July 8th, 1834. Brother Rufus Bishop and Isaac Youngs from
> N. Lebanon made us a good visit of four days and went on to visit all
> the western societies.
>
> *Sodus Bay Church Journal*[2]

After five days on the New York Canal, the travellers disembarked at

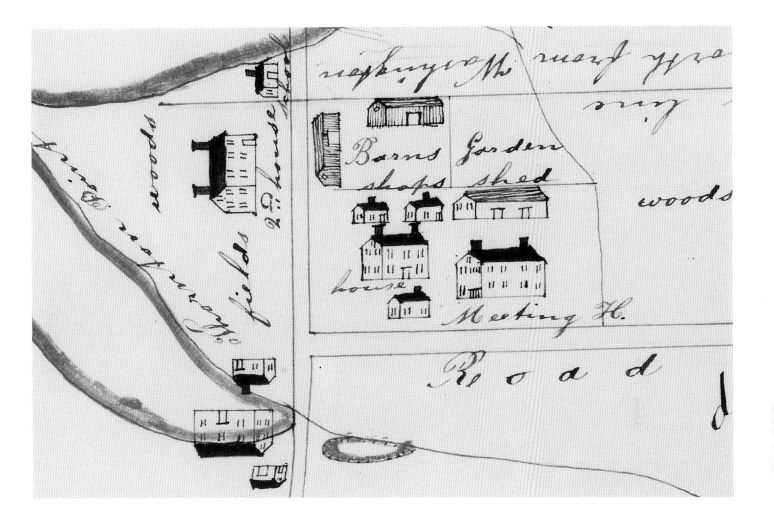

Figure 36. Detail of figure 35 showing
Church and Second Families

Lyons, New York, and rode eleven miles north to the shore of Lake On-
tario, where the Shakers had built a settlement at Sodus Bay. Two hun-
dred miles northwest of New Lebanon, the community provided a wel-
come stopping place for Shakers on their way to or from the Western
societies. The visitors were warmly received and after resting were
taken on a tour of the sights: the giant whitewood tree, fossils in the
rock cliffs. Then, after getting the lay of the land, wrote Br. Isaac, "I
attended some to making out a kind of map of Sodus"[3] (fig. 35). The
Shakers' land was on the lake shore, spanning the towns of Sodus and
Huron. A group of buildings near Thornton Point, which formed the
Church and Second Families, contained the newly erected dwelling-
house, the meetinghouse, and the mills and school (fig. 36).

I went up to the first family, & went to fixing an old time piece. Elder Jeremiah
went with me over to the school house; I staid awhile, heard the girls read some
&c, spake some to them, put up the time piece.[4]

Across Sawmill Cove in the town of Huron was the smaller East
Family, on Nicholas Point, which was named for the judge who sold
the Shakers their land in 1823. Unlike their other Eastern colonies, the
lakefront land at Sodus was already cleared and settled by the time the
Shakers purchased it. Br. Isaac's map of the village shows a formally
surveyed state road and bridge across the mouth of the Sodus River,

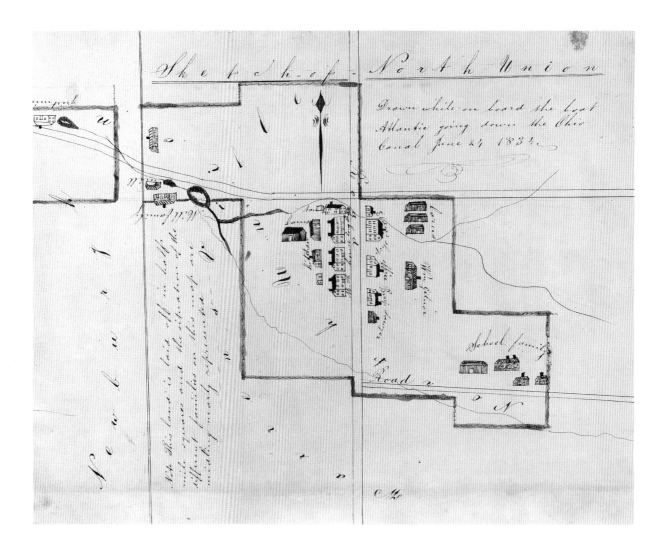

Figure 37. "Sketch of North Union"
By George Kendall (b. 1813)
July 1835
After Isaac N. Youngs (1793–1865)
June 1834
Ink and watercolor on paper
7 3/4″ × 9 3/4″ (19.7 × 24.8 cm)
Library of Congress

revealing how much the landscape had been shaped and developed before the Shakers' relatively late arrival and settlement there.

In George Kendall's copy of the map, Nicholas Point, Thornton Point, and the shores of Sodus Bay are heavily outlined in blue. In addition to the natural features, the town line is indicated, along with the notation "Peremtion line / Due north from Washington." The boundary between Sodus and Huron, which was established near the seventy-seventh meridian, also served as the preemption line, once the western frontier of formal land ownership. Beyond this line settlers at one time could claim land only by squatters rights, or "preemption." In the early nineteenth century the preemption line was erroneously thought to be a precise extension of the seventy-seventh meridian, which runs through the nation's capital. Br. Isaac, upon hearing this story, was evidently so impressed that he included it in his notation—next to his vernacular spelling of preemption.[5]

In this map a distinctive directional arrow points to the north. The most prominent single feature of the entire map, its elaborate ornamentation was probably the contribution of the copyist George Kendall. Directionals appear prominently throughout all Shaker village views; this particular idiosyncratic arrow, however, is used by Kendall in each of the maps in this series, as well as in his later work.

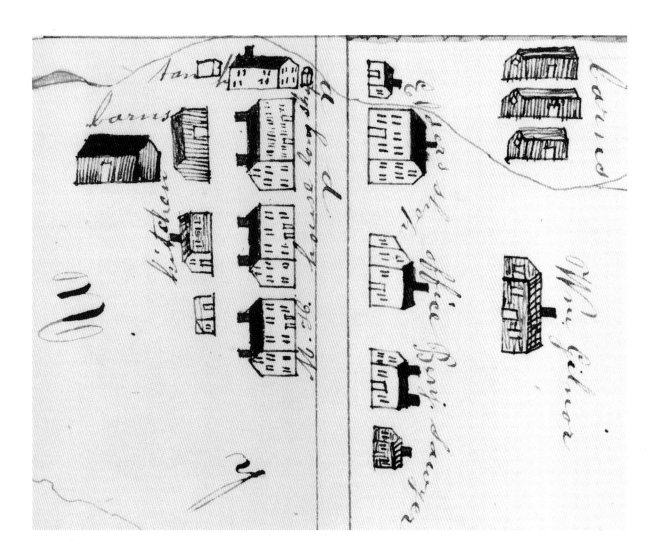

After a six-day visit to North Union, Rufus Bishop and Isaac Youngs boarded a packet heading down the Ohio Canal, where Br. Isaac, floating slowly along on the canal boat, conceived a map of North Union that faced four directions at once (fig. 37). Br. Isaac pictured North Union as a small community of three disparate families spread out over the Society's 1100 acres. Because the central lane through the Church Family did not lead directly to the other families, each group of buildings in this map faces a different road. Though the meandering words "North Union" are contained within the bright blue borders of the Shakers' land, the crescent names of Newburgh and Warrensville townships weave past the borders and interrupt the words. George Kendall's distinctive directional arrow does little to unify the points of view from which this confusing map was meant to be read.

At the Mill Family Br. Isaac admired the quiet precision of the grist mill's wooden gears. At the Church Family he visited the family of the early Shaker settler Benjamin Sawyer, whose house he illustrated in the center of the village (fig. 38). At North Union Br. Isaac encountered his first log cabins, which he decided to illustrate with dark horizontal lines.

Br. Rufus and myself went to the *log kitchen* where the Gothic style of matters might not seem exactly accomodating to our nice eastern sisters. . . . Hence we

Figure 38. Detail of figure 37 showing the Church Family

passed to what is called the school family. . . . Saw a number of the boys, & the grand log school house with a big dutch fireplace & a sort of ladder to go up stairs! Here we can occasionally take a peep out doors between the logs, & one, by being pretty careful, may walk across the floor without stubbing his toes very badly![6]

Before they resumed their journey, the visitors from New Lebanon took time to visit with each of the North Union Believers, exchanging pleasantries and relating the experiences of their trip, extending to everyone a sense of personal contact with the parent ministry in New York.

We went to see the sisters some more as there were a number we did not see yesterday. Here we saw Phila C., Phoebe A., &c, & many new faces. Showed them the map of New Lebanon, Sodus, etc.[7]

Rufus Bishop's and Isaac Youngs's arrival at Union Village was a momentous occasion, which they keenly anticipated during their seven-day journey from North Union. After New Lebanon, Union Village was the largest Shaker community, serving as the hub of Shaker activity in the West. Their visit to Union Village would be an important meeting between the two great centers of Shakerism. At Union Village the visit of two distinguished emissaries from New Lebanon was awaited with great excitement. The Western Shakers, Br. Isaac later recalled, gave "thanks for the good treasure of love from the *east* & the blessing of being visited at this time by some right from the centre of union." On a Sunday morning they rode into the village, past the meetinghouse, where the family was attending Sabbath meeting.

It seemed as if a shock passed thro the assembly, for I saw many faces turned towards the windows! Nathan escorted us along to the Ministry's Shop, where we gladly entered, to escape the ken of those staring eyes; but short was the silence. The Ministry left meeting and hastened to the shop, & joyful was this meeting.[8]

While Br. Rufus attended to spiritual matters, Br. Isaac investigated the temporal life of the community. Then together they toured the village, Br. Isaac making detailed notes on each of the nine families.

Br. Isaac's individual maps of Union Village were assembled a year later by George Kendall on three pages of his booklet. The arrangement of these drawings best illustrates the Shaker artists' unfamiliarity with contemporary cartographic convention. The most complex of the Youngs / Kendall works, the Union Village maps represent an original though awkward solution by naive artists to the problems of organizing pictorial information.

Br. Isaac laid out the large Centre Family across the top half of the first page, its title "Center of Union Village" sweeping in an arc through the drawing (fig. 39). He drew and labelled each of the buildings facing into the nearest road or lane. In order to present the majority of structures upright, the plan was oriented with east at the top. The designations "Pastures," "Meadows &c," "Garden," and "Corn field" all conform to this concentric orientation, and all face into the village center. The curious little semicircle of dots used to indicate north appears in a vacant corner almost as an afterthought.

The buildings Isaac Youngs illustrated at the Centre Family reveal evidence of substantial Shaker industry as well as domestic life. In addition to the Church Family's meetinghouse, office, and dwelling, the family supported a tin shop, cooper shop, dye house, and an enormous grain barn.

I went into Timothy Bonel's shop where he made chairs & wheels &c. I told him about our manner of fixing chairs with balls, &c &c.[9]

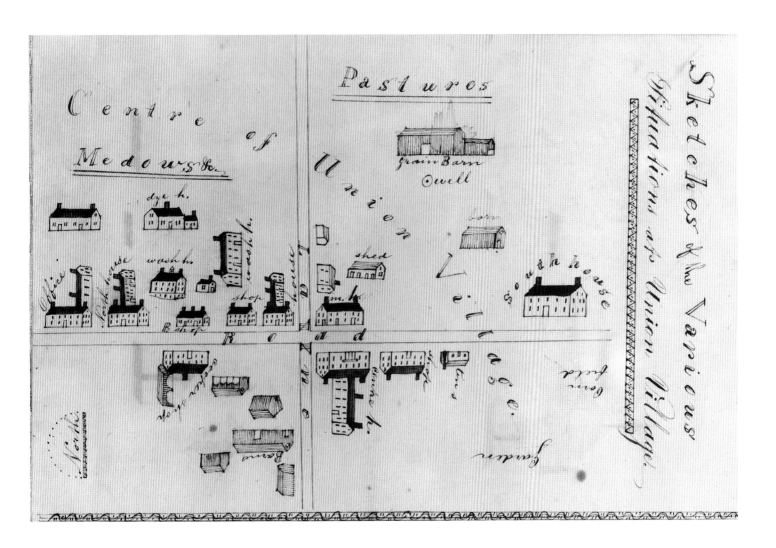

Here again Isaac Youngs's notes amplify his drawings. In his sketch of the Centre Family a horse shed is attached to the cooper shop. The interpretation of that unexplained addition comes from his account of visiting the buildings:

Went to the coopers shop where they do nearly everything about coopering by machinery, all driven by horses on an inclined wheel.[10]

He described such major events as construction on the brick dwelling house, and he also took the time to record incidental features that occasionally caught his fancy:

After breakfast Joshua and I took a walk to the new well the brethren have lately dug at the great barn S.E. of the meeting house. Here is an excellent fountain.[11]

An intricate border of double dots and weaving lines separates the drawings of the various families. The same border was used by George Kendall to highlight the cover of his booklet, and like the fanciful directional arrow, may be of his own design. In the map it subdivides the page into quadrants, where, drawn in much larger scale, are details of two smaller families, North Lot and South House. They fronted along the same road as the Centre Family, and though they were drawn at right angles to the adjacent sketch, they too were oriented with east at the top.

Figure 39. Sketches of the Various Situations at Union Village

Detail showing Centre Family

By George Kendall (b. 1813)

July 1835

After Isaac N. Youngs (1793–1865)

July 1834

Ink and watercolor on paper

7 3/4″ × 9 3/4″ (19.7 × 24.8 cm)

Library of Congress

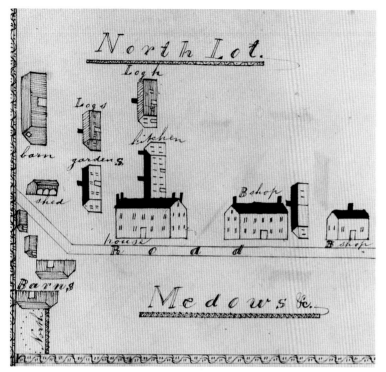

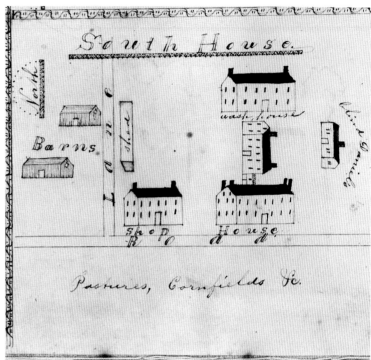

Figure 40. Sketches of the Various Situations at Union Village

Detail showing the north lot

Figure 41. Sketches of the Various Situations at Union Village

Detail showing the south house

"North Lot"

At the northern edge of the village the brethren visited the family known as the North Lot, where Br. Isaac identified two principal buildings as boys' shops. His drawing (fig. 40) gives no clue as to the nature of the industry carried on there, but, as always, he was interested in the mechanics of things and recorded his observations in his journal.

Here is what is called the Pleasant Spinner, a new fashion of spinning wheels.[12]

"South House"

One of the most prominent buildings at the South House Family was the wash house (fig. 41):

Here we saw a new fashioned wash-mill—a tub & cylinder, 3 1/2 feet diameter, & about as long—turned by a horse.

The southernmost building along the road was a tiny one-room cabin, of which Br. Isaac took special note. It is labelled "blind Daniel's."

Saw Daniel Stag, blind man, a sound believer; much pleased to *feel* us; can spin mop yarn, works a great deal in the kitchen; showed us how he went about with his little dog, with a strap around his neck, &c.[13]

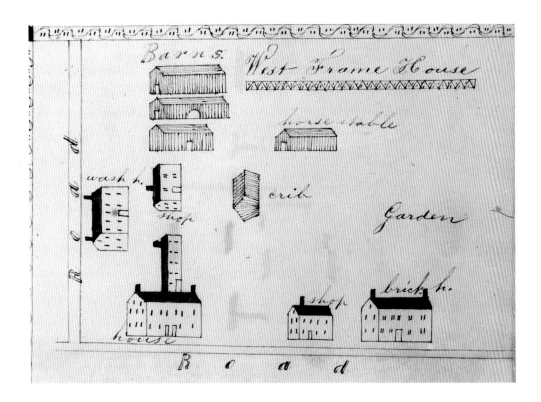

A second page of maps contains four more of Isaac Youngs's "Sketches of the Various Situations at Union Village." George Kendall's articulated border divides the page into quarters, each containing a plan of a separate family. Like those on the preceding page, these sketches are isolated details of the village, without any reference to their geographical relationship to one another. In fact, while the families actually faced various directions of the compass, here they have been aligned with the rectangular configuration of the page.

Figure 42. Sketches of the Various Situations at Union Village

Detail showing the west frame house

"West Frame House"

July 7th. Today we went in a wagon with E. Solomon, E. Rachel & Nancy to the West Frame House & stayed till after dinner. . . .[14]

On the southwest corner of the crossroad stood a large building, identified as a dwelling house by its distinctive double doorway (fig. 42). The family clustered around it was known as the west frame house Family. Br. Isaac noted that his comparative distances were distorted. A measure of this family's distance from the Centre can be judged by the fact that the visitors chose to ride there in a wagon.

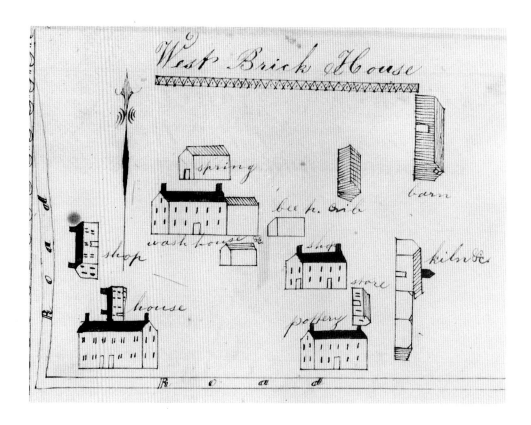

Figure 43. Sketches of the Various Situations
at Union Village

Detail showing the west brick house

"West Brick House"

After visiting for a while the travellers rode across the way to the west brick house, where Br. Isaac inspected the pottery. In his drawing (fig. 43) he shows a two-story workshop where the clay was prepared and formed into vessels. Behind it, shown with a massive central chimney, was the kiln.

Went to see the pottery, saw them turn a large vessel & a jug &c. Looked round and saw some of their crockery or earthern ware &c. . . . Saw the place where they prepare lead for glazing, the kiln where they burn earthenware.

Also saw a quantity of silk worms &c. Saw their spring house—a beautiful place for keeping Cream & butter &c. Saw the bee house. In the whole a very interesting interview.[15]

"Square House"

The upper dam on Shaker creek formed a small mill pond around which were clustered a saw mill, a clothiers' shop, and a tan yard. These industries were run by a separate mill family, whose dwelling was known as the square house (fig. 44). The visitors walked out to see them, to display Br. Isaac's growing portfolio of Shaker village maps, and to investigate their mills.

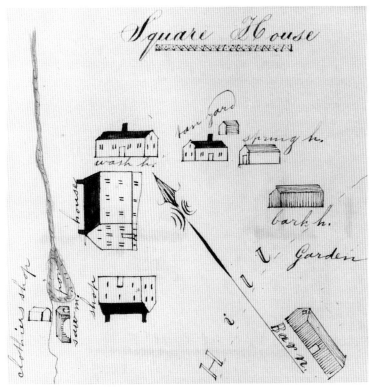

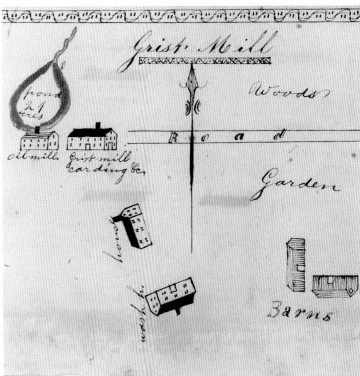

Showed the maps &c and conversed in various subjects. After this we went round a few minutes, first down to the sawmill pond, saw the sawmill—buzz saw &c, and went into the clothiers shop, here was something a little new; a thing, a sort of machine for grinding shears, saw also a sort of machine for boring fenceposts &c &c.

Among the rest was part of an old building which was partly carried off by a flood some years ago, when the dam was broke & much damage done. This piece of building stands in a shattered & deranged condition, as if stooping in memory of an ancient disaster.[16]

The derelict building does not appear on Br. Isaac's map. Not only was it insignificant to the family, but it was inappropriate for it to be standing at all, for its very presence violated Shaker law, which required neatness and order.

"Grist Mill"

Farther downstream was the Grist Mill Pond, a large reservoir of twenty-one acres outlined on the map in bright blue (fig. 45). Always a technical craftsman, Br. Isaac viewed it with a critical eye, being more impressed by the water supply than by the industry:

Viewed the gristmill all over, then the carding machine—then the oil works. No very new idea in these works. The pond is a noble one; but the mill & other works must fail before many years.[17]

Figure 44. Sketches of the Various Situations at Union Village

Detail showing the square house

Figure 45. Sketches of the Various Situations at Union Village

Detail showing the grist mill

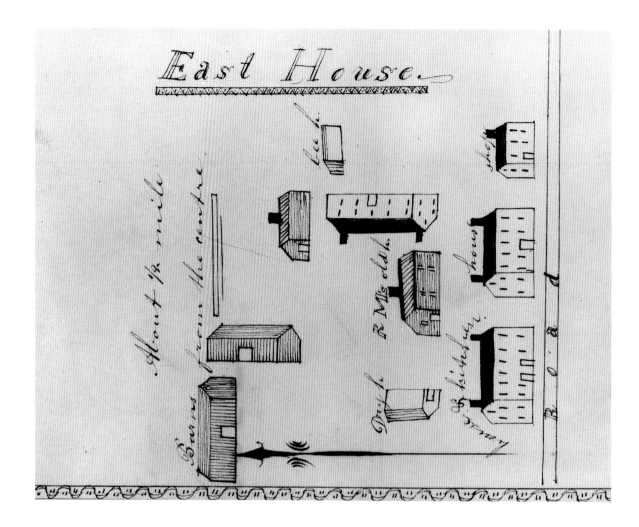

Figure 46. Sketches of the Various Situations at Union Village

Detail showing the east house

"East House Family"

Br. Rufus and I attended to cutting ourselves each a jacket . . . and then went over to the East house to visit there.[18]

The East House Family (fig. 46) grew up around the log cabin built by Richard McNemar, one of the first settlers at Union Village. Once the nucleus of the community, the buildings of the East House Family were now on the outskirts of the bustling village, down a lane half a mile from the Centre Family. The old log cabin still stood. Though it was the humblest structure at the East House Family, it had the greatest historical significance, and Br. Isaac took pains to illustrate and label it as "R.M.'s old h." It was the long Sisters' shop, though, that attracted Br. Isaac's greatest attention.

We saw the Elders a while and then walked round some. Saw a new thing about a loom, viz, a double box at one end of the lathe, so constructed as to raise the shuttles, of which there were two. When the box was up the lower shuttle would operate & when the box was down the upper shuttle would go &c.

We also saw the sisters reel silk. Saw a funny sort of washmill, a barrell hung on two gudgeons with two cranks.[19]

"West Lot Family"

Even more remote than the East House Family was a children's order called the West Lot Family. There was more than enough in the village

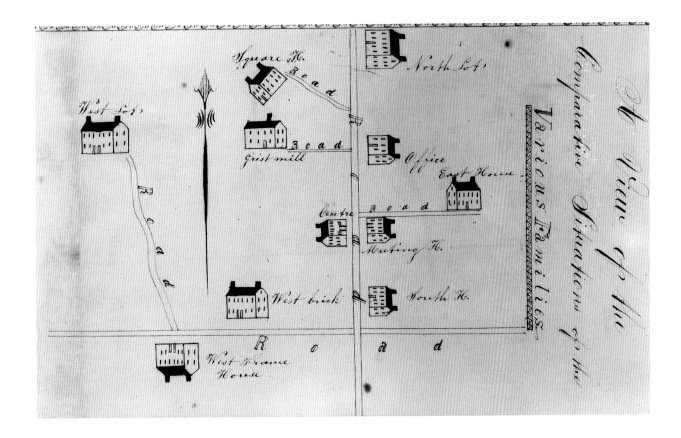

Figure 47. Sketches of the Various Situations at Union Village

Detail showing locations of the various families

center to occupy the travellers' attention, and two weeks had passed before they rode out to view that site.

Went in a waggon to the West Lot, young believers family. . . . Had our visit there & saw chief of the brethren & Sisters. About 40 in number. Did not go round any.[20]

No map exists of the West Lot Family. Br. Isaac was unimpressed by what he found there. Instead of making a sketch, he made the notation:

There is also what is called the *West Lot* but there are but a few buildings at that place and I did not take a sketch of them.

"A View of the Comparative Situations of the Various Families"

During his extended stays at Union Village Br. Isaac visited all nine families, stopping to inquire and examine everywhere he went. By the end of four weeks there he had learned a great deal about the way the village was organized. Scattered throughout three pages of his journal, however, Br. Isaac's sketches of the individual families appear disembodied, floating around without any relationship to one another. Apparently he realized this, for he drew one final map of Union Village (fig. 47), a diagram in which he reassembled the families in their geographical context, representing each one with an illustration of its

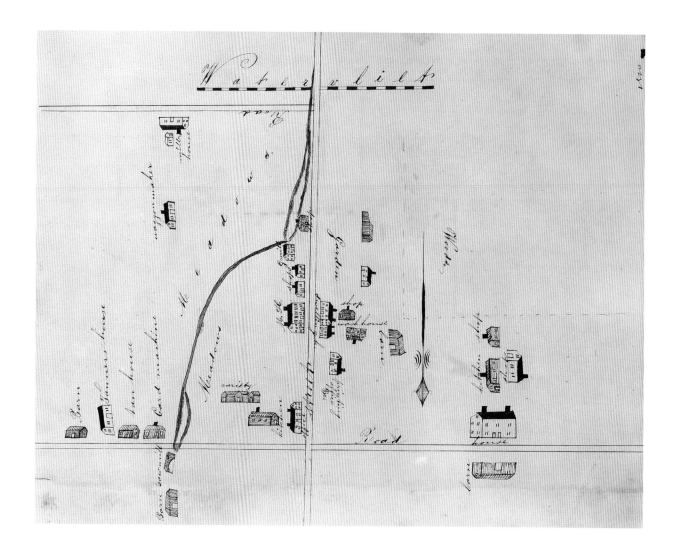

Figure 48. "Watervliet"

By George Kendall (b. 1818)

July 1835

After Isaac N. Youngs (1793–1865)

July 1834

Ink and watercolor on paper

7 3/4″ × 9 3/4″ (19.7 × 24.8 cm)

Library of Congress

principal structure. "A View of the Comparative Situations of the Various Families" provides the key by which a viewer can understand this most unorthodox of the Shaker village maps.

Near Union Village was the Shaker community at Watervliet, Ohio. Though it encompassed eight hundred acres, it was never very populous nor prominent, and Isaac Youngs's sketch (fig. 48) portrays it as a small village on an undistinguished landscape. The travellers arrived there after a half day's ride from Union Village.

First met Elder Issachar & pretty soon E. Eleazer. They were much pleased to see us, & hugged & kissed us; said they had orders to do so, right from Lebanon.[21]

Beaver Creek ran southerly through the meadows to the east of the village, powering a grist mill, a saw mill, and a wool carding machine. The community industries were grouped together to the east of the village. Br. Isaac pictured a wagonmaking shop and a tannery there, noting on his map that there were individual houses for the craftsmen.

Their miller is a world's man & their tanner, who does considerable, & brings in some profits. Their waggon maker is a world's man. . . . These 3 men with their little families, live in nice looking small houses, built by the believers on purpose for them.[22]

The Believers at Watervliet seemed to be more interested in tilling the soil. Br. Isaac noted the success of the large garden, from which the

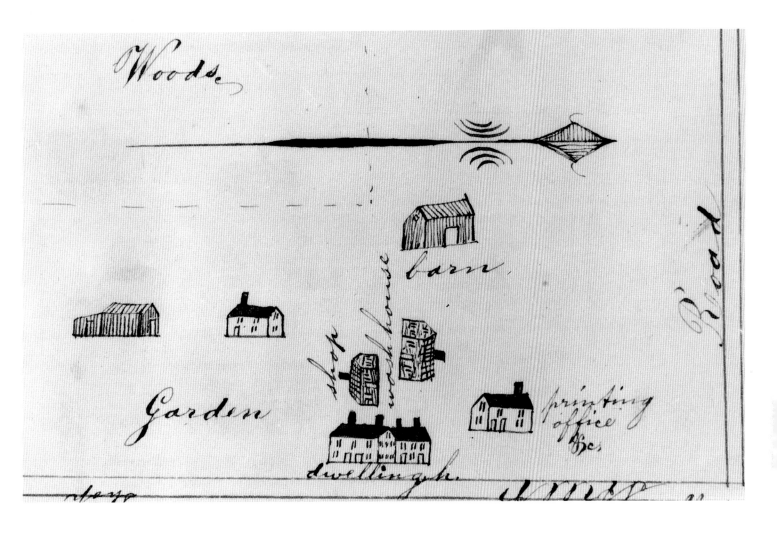

Woods

barn

shop

wash house

Garden

printing office &c

dwelling h.

Road

Figure 49. Detail of figure 48 showing the Centre Family

Centre Family produced enough vegetables to sell at the market in Dayton. He particularly appreciated the loving care with which Elder Issachar Bates kept his own small garden:

As Elder Issachar told it, an old Dutch woman came along & took some notice of the garden; & she spoke of it afterwards, & praised it up very much & said, "I to't by myselves, dat dis is de *baradise garden!*"[23]

The next day the visitors walked over to the West House Family, to eat supper with the children's order. On the map Br. Isaac drew the dwelling house where they dined, showing the log kitchen as a separate building behind it.

At the Centre Family the inscription "printing office &c" (fig. 49) identifies the workshop of Richard McNemar, the Shaker theologian, cartographer, and printer who moved to Watervliet in 1832. Known by his religious name "Eleazar Wright," this influential leader was responsible for the spiritual direction of that village. He also wrote and published the Society's religious, philosophical, and historical tracts. Br. Isaac and Br. Rufus visited him in his print shop.

This morning we spent some time at Eleazar's printing Office, saw his book of letters from various persons—heard him read his history of the rise & progress of the Society at this Watervliet, Ohio &c &c.[24]

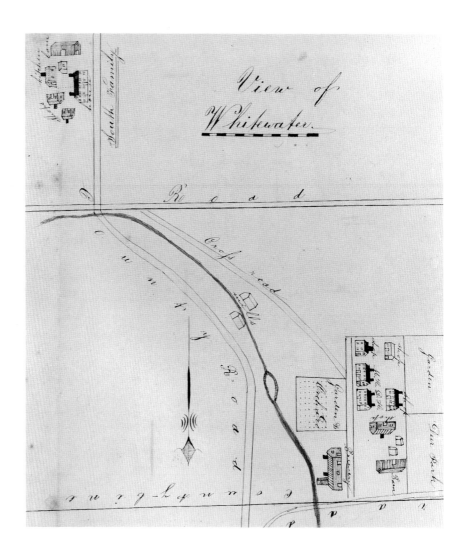

Figure 50. "View of Whitewater"

July 1834

By George Kendall (b. 1813)

After Isaac N. Youngs (1793–1865)

July 1835

Ink and watercolor on paper

9 3/4″ × 7 3/4″ (24.8 × 19.7 cm)

Library of Congress

Perhaps Br. Isaac was influenced by Elder Eleazar's example in creating a historical record, for that afternoon, he wrote, "I began to make out a kind of map of the place." It was not the physical grandeur of the site that impressed him, however, for the Shakers at Watervliet seemed to have concentrated less of their energies in their industrial and agricultural investments than did other Shaker communities. Instead of reports of technological achievements or prize cattle, Br. Isaac's journal refers to the feeling of religious love and spiritual grace that pervaded this unusually plain and serene Shaker village.

When Rufus Bishop and Isaac Youngs rode into the Shaker settlement at Whitewater, Ohio (fig. 50), the comparison with the prosperous villages they had just visited must have been surprising. Though it occupied the same number of acres as the Watervliet Shaker community, the village at Whitewater appeared sparse and rough.

Their buildings are poor log houses, mostly, excepting the meeting house & centre, & are about putting up a brick wash house this season. . . . The Meeting House & Centre dwelling house are brick.[25]

Several fine brick buildings distinguished the village (fig. 51). The Centre Family dwelling had been built to accommodate a large influx of Believers from the village at West Union, Indiana, which had been abandoned in 1827. Begun in 1832, the dwelling was still under construction two years later.

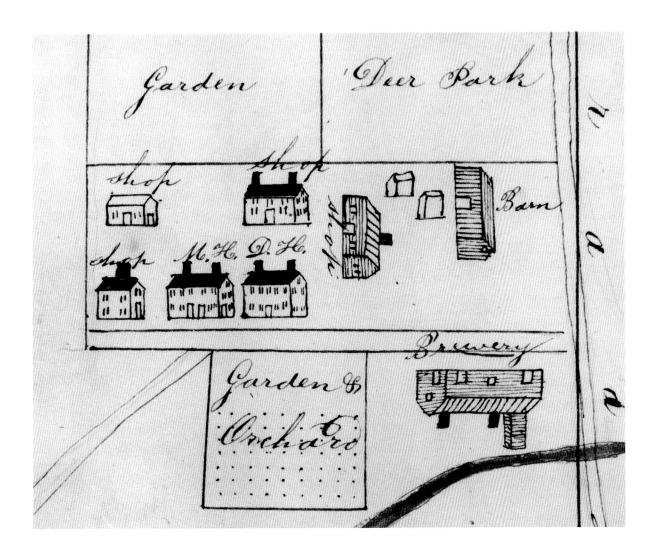

Figure 51. Detail of figure 50 showing the Centre Family

The sisters came together in the dwelling house in the hall, & we visited them some time; showed our maps, &c &c. Then we walked around thro the rooms, kitchen &c. A nice house of brick; pretty regular & convenient, excepting closets. The dining room is very nice, but the cooking has yet all to be done in it.[26]

Behind the dwelling were a garden and a deer park, where the Shakers penned up wild deer. The frontier practice of keeping deer for livestock was a novelty to Br. Isaac: "Walked out to view the deer that they keep here; a buck, 2 does, & one fawn; they look some funny."[27] Across the lane from the buildings of the Centre Family stood a peculiar log shop with an oversized vent stack. On Br. Isaac's map it is drawn in carefully, and labelled "brewery."

Their principal business for sale is making malt beer, which they sell round in various places in the County about them. Go to see the brewery. Here is a good deal crowded together in some little old log house; considerable entertaining to see the various vats, pumps, boiler sprouting place, drying room, &c. They make considerable extensive business at brewing malt beer, generally about fourteen barrels a week. Here is a pack of rude fellows of the world who had got together in the shade of the brewery house, & were shooting a mark, & said "they were shooting for beer"; one of them came in & told aged Joseph, they wanted a gallon of beer; but I did not stay to see whether they got any or not.[28]

The village lands flanked the White Water River. On one side of the river the county road ran from Oxford, south to New Haven, and on the other side the Shakers built a "cross road" through their own lands to

avoid the longer route around the river by way of the county's bridges. Below an island in the river the Shakers built their mills. The visitors planned a day at the South or Children's order, and stopped by the mills on their way down the road.

July 28th. Before breakfast Joshua & I went to the saw mill & grist mill. Middling good mill; two run of stones; an indifferent buzz saw works, in the same building.

We visited the sisters, a goodly number of promising looking sisters, chiefly young. We conversed a while, showed our maps, &c. . . . We ate supper about 5 *o'clk* in an old log cabin, partly a hen roost, but now adorned with a richly spread table, not lacking for faithful attendance.[29]

The visit was spent largely in conversation with the Whitewater Shakers, who expressed their gratitude for this visit from the New Lebanon Shakers. The visitors responded by displaying their maps of New Lebanon and describing the home of the parent ministry. On several occasions they showed their new drawings of the western Shaker villages as well. They stayed for five days in Whitewater before beginning their journey to Pleasant Hill. The inventory in Br. Isaac's laconic journal entry on his last day there reflects his impressions of the village at Whitewater.

35 of meadow stock	14 young cattle	45 hogs
4 oxen	7 calves	4 deer
19 cows	150 sheep	1 dog

The travellers spent four long days on the road from Whitewater to Pleasant Hill, plodding and picking their way through the rugged hill country of northern Kentucky. After sleeping at night in log taverns and wayside farmhouses they made their way to Lexington, where they were met by fellow Shakers who escorted them home.

The country & our road now become a little rougher as we approached the Kentucky River; this we reached about 2 o'clock. Here from the North eastern bank we could see across to Pleasant Hill, which appeared close by and nothing appeared in the way—but in a few rods further behold we were on the brink of a mighty gulf; & the little Kentucky river several feet below us! We descended the cliffs, which, tho on a steep side of the mountain, was not dangerous. Crossed the river, which was very narrow, say 30 rods, & ascended the opposite side. This was a majestic scene. This road was formed by the believers & was made in a surprising manner—winding along up the huge ascent, cutting in some places thro solid rock one side, & built up with high wall on the other. Still growing higher & higher as we proceed up the cliffs until it even seemed pokerish to look off on the downhill side.[30]

The visit of these exotic travellers from the East was the closest the Believers at Pleasant Hill had ever come to a personal association with the parent ministry at New Lebanon, by whom this village had been established a generation earlier.

We attended meeting with the society here. They sung a hymn, & then Elder Samuel spake considerable of . . . their having long desired the privilege of seeing some from the east, that now the time had come &c. . . . Br. Rufus then spake, giving out the love from all in the east. . . . I spake a few words in confirmation of what had been said, that it was a universal feeling in the east, to send their love, that it was not a mere ceremony, but substantial, to be felt from soul to soul.[31]

Pleasant Hill was the sixth Shaker village the brethren visited since leaving home, and by now Isaac Youngs's maps began to develop a certain idiosyncratic consistency. Perhaps it was just because the magnificent new stone dwelling was sited facing south along an east-west road, but now north could be found at the top of the page, along with

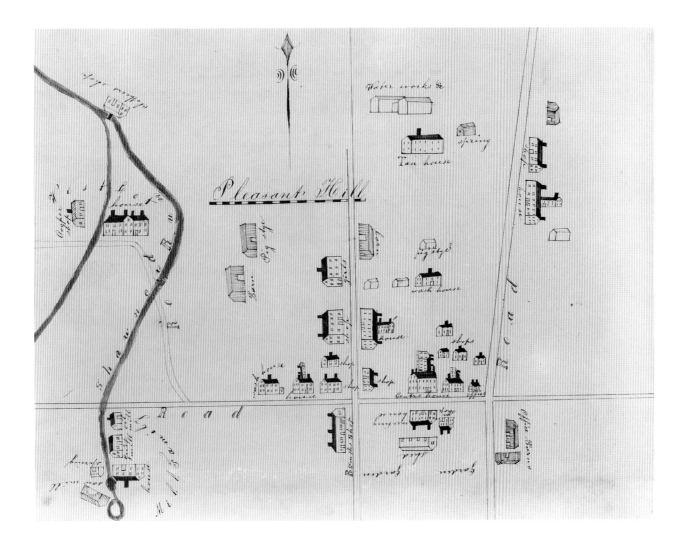

the title of the drawing (fig. 52), which was underlined with the distinctive broken line with which the artist had started to emphasize his lettering.

In 1834 Pleasant Hill was, after New Lebanon and Union Village, the third largest Shaker settlement. Even though it was not as large as Union Village, all of its roadways, waterways, five families, and forty-two structures were illustrated on a single page of the journal, leaving a picture of a heavily settled area. In this map the Centre Family is grouped towards the bottom of the drawing. As visiting dignitaries, the travellers would have been lodged there, in the second floor of the meetinghouse. After resting over the Sabbath and catching up on the journal, they went across the street to the new Centre House.

We spend the day in looking about the new centre house, which is not yet finished; They are painting the wood work &c & are expecting to get it ready to move in, perhaps in September or October. . . . Visited the Eldress . . . a while, then the sisters; showed the maps &c.

To the right of the Centre Family, Br. Isaac drew the four buildings of the East Family.

A while after breakfast we went to the east house to visit there. First saw the Elders a while, & then visited the sisters till near noon. Took dinner there, visited the brethren. All were very anxious to see the maps & get all the idea they could of Lebanon. After visiting the brethren, the kitchen sisters came to

Figure 52. "Pleasant Hill"
By George Kendall (b. 1813)
July 1835
After Isaac N. Youngs (1793–1865)
August 1834
Ink and watercolor on paper
7 3/4" × 9 3/4" (19.7 × 24.8 cm)
Library of Congress

see us, & also a number of others were pretty careful to get another chance. So passed a good portion of the afternoon.

The visitors wandered out in the fields behind the Centre Family, investigating the village.

We went on near to a watermelon patch; where we seated ourselves under the shade while a couple of the company went & bro't us some stately watermelons, which were devoured without much delay or remorse. . . . After supper we went down to see the water works, where the water is forced up, by machinery, for the use of the village. . . . Distance from the pumps at the spring to the reservoir 1800 feet. The water is raised from the cistern of supply to the reservoir, thro a perpendicular height of 130 feet. These water works they consider a very valuable accomodation. As formerly, they used to have to draw all the water up from this same spring by a team.

Saw also some new things in the tan works—particularly a windlass to raise the hides out of the [brine, the] handlers doing several hours' work in a few minutes.[32]

The next day, their rambles took them to the West Family, where again they were the object of great attention. After several days of these interviews, related Br. Isaac, conversation became predictable:

As we were unacquainted with them & they with us, & they knew but a few at the east, we had to pick up conversation as we could. . . . And the map of Lebanon, [as] always, furnished a good article of discourse.

After the general visiting we went round to several rooms, sometimes staying a few minutes. In one we saw Charity Green, blind sister, saw her braiding plait for hats. Does it very well.

Went out to the barn & thereabouts. Passed on to the wash house & thence to a shop, where they manufacture reed for sale. For this they have a curious machine, for filling or setting the reed, and various works for the business. Walked thro the garden; & went in the garden house or shed, & there had a great supply of watermelons.[33]

After their arduous journey getting there, their visit at Pleasant Hill was commensurately unhurried and relaxed. Six days had passed before they went down to investigate the mills (fig. 53).

After breakfast we went down to the mills, where there are 3 brethren and 3 sisters who live in a kind of log house and take care of the grist mill &c. We staid there a while & visited, then we walked out, viewed their spring house built of cedar logs, a nice place with a good supply of water. Walked up to the dam. Had some divertion with a large mud Turtle &c walked down by the race to the mill, this race to carry the water to the mill is perhaps 80 rods long, 2 or 3 feet deep, & as wide; a good part dug out of solid rock & partly walled up. Viewed the mill in its various parts—The lathe for turning broom handles, & buz saw, &c &c. Also the oil mill & works in a building for the purpose.[34]

The community at Pleasant Hill grew flax, from which it produced linen cloth and oil. Br. Isaac observed the great cast iron rollers used to brake the plant fiber, and the mill that pressed linseed oil from the seed. His quick sketch of the saw mill was the only picture ever to record that humble little building. He later noted:

On Saturday night last, the believers saw mill was burnt; the brethren ran to it, but could save nothing but some plank & a trifle of timber. It is not doubted but that some turn off did it. However, the mill was not worth a great deal.[35]

After viewing the mills, Br. Isaac recorded:

Returned to the house & took dinner, then had a visit with the Brethren & Sisters, showed our maps, &c &c. After this we had a good feast of Watermelons.

I walked round with Micajah Burnett to various shops & places—to the west house—thro cellars &c—saw the spinning jenney a while—also the reed

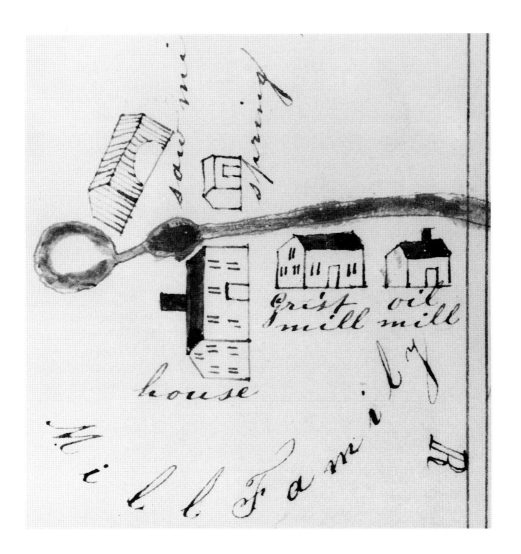

Figure 53. Detail of figure 52 showing the Mill Family

makers. . . . Today we have had to attend 3 or 4 times to eating watermelons, & these being pretty *good* hinders us a great deal.[36]

After breakfast I attended with Micajah, about making out some drawings of buildings &c. Was with him good part of the day. . . . Several times much hindered in attending to watermelons, a duty which was difficult to get by![37]

The lands surrounding Pleasant Hill produced great stands of red cedar, which the Shakers used as lumber, because of its water-resistant qualities. It was employed for fence posts and in building spring houses, and was used extensively in their coopering industry.

August 13th. A while after breakfast and after we had eaten a mess of watermelons we went over to the west lot family to visit them there . . . showed our maps &c. I walked round some with Gifford Runyon—went to see their fulling mill, carding machine, &c &c. Carding works pretty much run down. Near this building there is a noble spring of water which runs out of the bank.[38]

Labelled "Shawnee Run," the stream powers the mills, including the Cooper Shop, at the far left hand edge of the drawing.

Br. Isaac's journal goes on to recount excursions with his hosts, to the precipice to the Kentucky River, to the quarry where the Shakers cut stone for their buildings, to an old ferry once run by the Shakers. During their eighteen-day visit they explored the village and the surrounding landscape, though the features beyond the village proper were not

included in Br. Isaac's compact little map, and many of the Shaker sites he describes are not pictured. Among them is the spot by the river where he and Br. Micajah rested on one of their rambles. The description in his journal alone provides a picture of that scene:

Passed on for Cedar Run; went thro the garden, where we found a watermelon under a big cabbage; which we took by leave, as lawful plunder; tugged that along to the bank of Cedar Run, & there sat down & eat it.[39]

A three-day journey along passable roads brought Isaac Youngs and Rufus Bishop to the farthest reaches of their trip. Westernmost of the Shaker communities, the village at South Union was settled amidst a network of limestone caves running through Warren County. Br. Isaac observed this geological feature riding through the countryside and remarked upon it in his journal:

The country seems to have something very peculiar about it. The earth seems to be very full of caves, and water courses under the ground. A stream of water will be seen running above ground, sometimes some miles, and then will disappear, running under ground a few miles, and then coming out in sight again.[40]

For this mechanic and inventor, the availability of a regular supply of water to power the mills was a prime concern. Br. Isaac made a point of inspecting the mills in each of the Shaker societies and Western towns he visited. His fascination with the water supply at South Union is evident in the drawing he made of the community. He traced the spring, the river, the water courses, and the sinkholes throughout the village, highlighting them on his map in bright blue. Weaving across the page, they are its most prominent features.

Jasper Spring, their mill brook . . . runs under ground for an unknown distance, passes through a cave as before observed, and below their mills is called the clear fork of the Jasper River. A few miles below these mills it disappears. Along these subterraneous water courses there frequently are sink holes 10, 15, or 20 feet deep shaped like a tunnel.[41]

Beyond illustrating these waterways, however, Br. Isaac made no references to the Shakers' use of the landscape. There are no pastures noted here, no woodlots nor gardens, and none of the "extensive orchards" recorded by journalist Charles Nordhoff on his visit to the community in 1875.[42] The vast holdings of these Western societies must have impressed the visitors from the East, where the spaces were relatively confined. However, Isaac Youngs's map does not give any sense that the community encompassed five thousand acres. Although he recorded the extent of the land holdings in his journal, his map was principally concerned with the built environment. This orientation, which is characteristic of his observations throughout the trip, is nowhere more apparent than in his map of South Union (fig. 54). Instead of describing the lands of this agrarian Society, Br. Isaac sketched what he was accustomed to, what he could personally understand and absorb from this unfamiliar and unusual place. He drew the crook in the highway the visitors travelled on their way west from Bowling Green. He plotted five Shaker Families around the crossroads that formed the heart of the village. And, as was his custom, he drew detailed sketches of over fifty buildings he visited there.

With Elder Benjamin S. Youngs as their guide, the travellers toured the village. Their first foray took them out to see the mills.

Elder B. and we walked around some, walked down to the tan house and visited the premises there, then to the grist mill and saw mill, clothiers shop, and also the dam, where the brethren are now engaged in a great undertaking

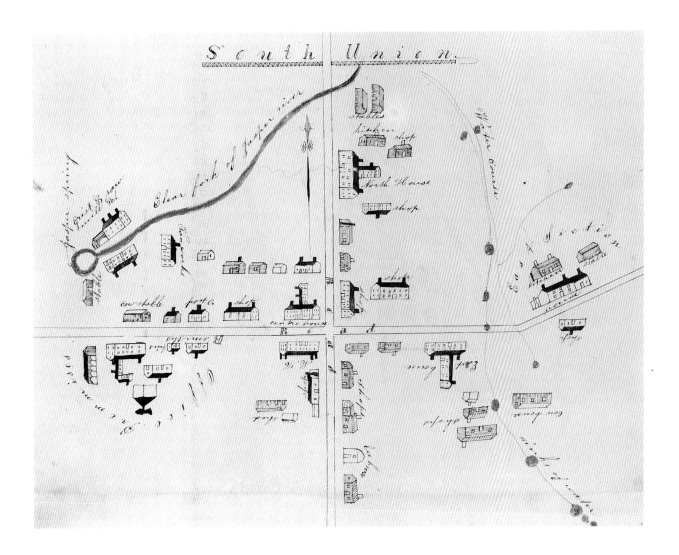

to repair the dam, there being a great difficulty in making a dam to continue good and tight, particularly on account of the crab fish and the condition of the rocks underneath, etc.[43]

When Shakers came to South Union, their mill stream was known as the Gasper River. But, like so many other things they encountered, they adapted that name to serve their own use.

Passing on from the dam we went up to the head of the pond, and there was the wonderful Jasper Spring which issues out of a rough group of rocks. Near this place, just on the banks, it was that one George Walls, just before the opening of the gospel, in the presence of a large assembly, took up a *clear stone* and referring to the Spring, said "This shall no longer be called Gasper—but *Jasper,* for here the Lord shall build the new Jerusalem." There is also an extraordinary spring that rises up in the midst of the pond. From here we returned to the house and took our letter to the P.O. and staid there some time to see how matters went there. Some entertaining.

In 1826 a post office was established at South Union, to serve the Shakers and their neighbors in outlying farms. The log house the Shakers moved out to the highway was one of the smallest buildings in the village, but its novelty there, and the recognition it brought to the community caused Br. Isaac to draw it standing disproportionately large. Across the street he drew another little building, also rendered conspicuous by his interest in its function.

Figure 54. "South Union"
By George Kendall (b. 1813)
July 1835
After Isaac N. Youngs (1793–1865)
September 1834
Ink and watercolor on paper
7 3/4″ × 9 3/4″ (19.7 × 24.8 cm)
Library of Congress

We had some watermelon, and then went out to see John Smith's Bee House. This was a curious sight. It is a round brick building two stores high and so constructed that one can go into the inside and see the bees to work in their places or boxes.

South Union stood midway along the great road from Bowling Green to Russellville, and, like the village at Pleasant Hill, it served as a stopping place for travellers. Unlike the offices at Eastern Shaker villages, where lodging was provided for visitors to the community, the office complex at South Union was used by the public as an inn, and by the Shakers as a source of income for their community.

We went to the office to see those who had care of strangers. We sat with them a while and conversed as usual, showed them our maps, etc. About 4 we took supper in their great dining room . . . After supper we sat 8 or 10 of us in the piazza in a delightful situation and conversed on various subjects . . . We took much satisfaction at this place. It is very neat and convenient and well adapted for a public house and they have a great deal of company, and some boarders who stay months and weeks. The stage also stops here and a negro is kept here in a snug house by himself for a hostler.[44]

Br. Isaac pictured the little open piazza out behind the office. He so enjoyed himself that evening that in his sketch, its fish weathervane looms as tall as any building in the village (fig. 55).

In contrast to his fascination with the small craft shops and utility buildings, Br. Isaac made comparatively little reference to the South Union Shakers' most prominent and costly structure. Built at the crossroads, the Centre Family dwelling dominated the village landscape, both socially, as the hub of secular life in the community, and visually, as its distinctive double chimneys rose above the other rooftops. Br. Isaac gave it but passing notice in his journal, and in his sketch he even misrepresented the double chimneys that distinguish its gable ends so clearly.

Perhaps the travellers had been on the road too long. By the time they reached South Union, Br. Isaac and Br. Rufus had been travelling for months and had visited all seven of the western villages. Possibly the freshness of the mapmaker's observation was dulled a little by the exhaustion of a long journey, and the originality of his maps was waning after having visited and drawn so many similar villages. This was the last of his maps, and the apex of his journey.

The visitors turned for home. Wending their way back to Union Village, they prepared to conclude their business in the West. In their last days, while Br. Rufus conferred with the Ministry, Br. Isaac "improved his time" by mending machinery, visiting with craftsmen, and at long last, finishing his map of New Lebanon.

After breakfast I went to the office to see E. Eleazar and went to working finishing out the map of Lebanon that I brot with me partly finished; got it done and gave it to Andrew and by that time it was near night and temporal things have to be laid aside.[45]

Before dawn on the first morning of October, they rode out of Union Village and headed for Cincinnati. An exhausting trip on river boats and stage coaches took them over the mountains to Baltimore, where they caught steamboats and railroad trains to New York. After eleven days of hard travelling and four months away from home, their carriage brought them down the lane and into the village at New Lebanon.

Through Br. Isaac's descriptions, hundreds of eastern Shakers were able to experience the western Societies that almost none of them would ever see. His journal was copied and circulated among the vil-

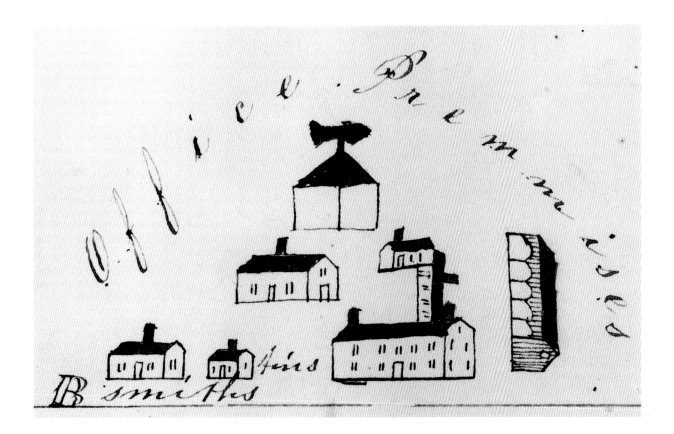

Figure 55. Detail of figure 54 showing the "Office Premmises"

lages, and within a year George Kendall had made his duplicate set. The Kendall copies are all that survive of Br. Isaac's maps, and they remain the best sources of visual documentation for most of the Western villages.

As for Br. Isaac, he maintained an interest in the places he had visited. Years after he returned to New York he continued to think about the western Shaker villages. In 1852 he wrote to South Union, asking what changes had occurred there since his visit in 1834. His letter was warmly answered by Br. John Eades.

We did not know, that among the many places, and the large multitude of Believers you had visited in the West, you had remembered us so vividly, and with so much kindness and affection. . . . I will undertake to answer in regard to buildings and improvements in the last 18 years.

Br. John proceeded to describe for his friend every residential, shop, and farm building and improvement he could imagine, along with their dimensions and precise locations in the village. Although he did not illustrate it, his letter serves as a word map for the appearance of South Union at mid-century. At the end of his long and elaborate letter, he said:

Dearly beloved, this may all be good so far as it goes, but how unlike the real, tangible presence of our brother! . . . The first opportunity, come over and make us a visit, and we will *show* you.[46]

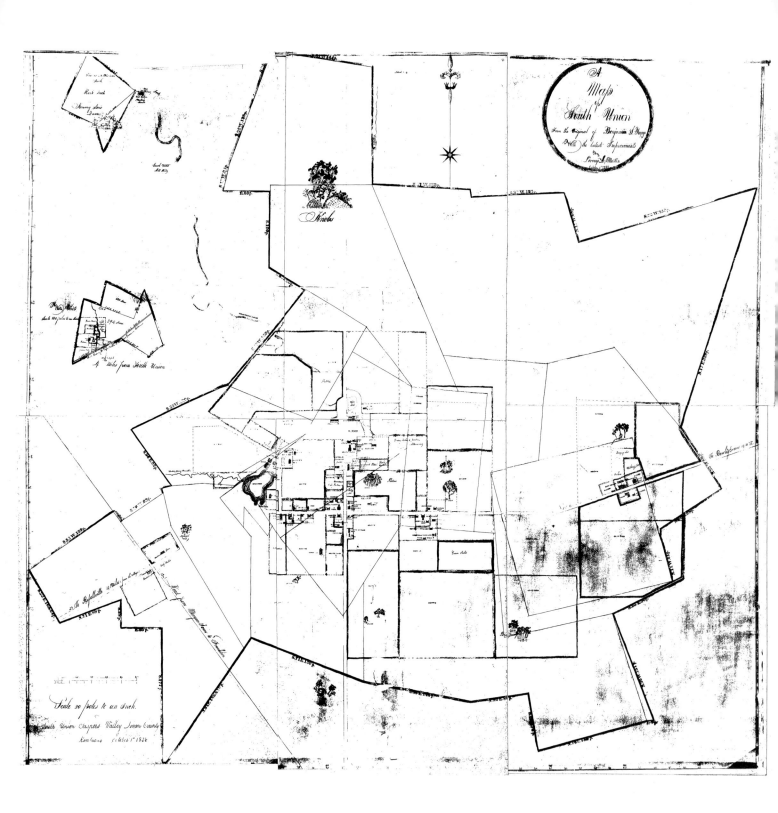

Br. Isaac never returned to the West. His duties kept him at the parent ministry at New Lebanon, where he lived a long and useful Shaker life. An original and inquisitive man, his works survive him in the form of his various mechanical creations, the sensitive observations of his journals, and a small group of village maps.

The only other map known of a western Shaker village was drawn by Br. Isaac's uncle, Benjamin Seth Youngs. An easterner by birth, Elder Benjamin travelled from Watervliet, New York, to the Ohio frontier with John Meacham and Issachar Bates in 1805 to spread the message of Shakerism. In 1811 he helped establish the Shaker community at South Union. Twenty-five years later, with South Union flourishing, he was called home from his labors.[47] Before he departed for New York, he composed a large surveyor's map of the community he knew so intimately (fig. 56).

It was Elder Benjamin who, two years earlier, had guided Br. Isaac on his rambles through South Union, answering questions and supplying information for his nephew to relay to the parent ministry. No doubt he had seen the small sketch Br. Isaac made of the village and had observed its limitations. Quite possibly this inspired him to create his own map to take back to New York, one which would refine and elaborate upon the picture provided by Isaac Youngs. The two maps could not be less alike. In contrast to the Easterner's preoccupations with the village structures, Elder Benjamin's drew South Union from the same perspective as Richard McNemar's 1808 map of Union Village. The western Shakers, like the rest of their frontier neighbors, perceived their communities more in the value of their lands than in their buildings.

Measuring four feet to a side, Elder Benjamin's map was large enough to include specific information about the entire five-thousand-acre tract. The irregular borders of the land holdings are defined with broadly inked outlines, precisely marked with compass coordinates and measured in sixteen-foot poles. These features are identified with letterpress type stamped in ink. Within this perimeter are scores of lots, labelled in the same lettering, with such designations as "Grain Field," "Peach Orchard," "Truck Patch," or "Grave Yard."

Minuscule buildings are placed throughout the village, drawn realistically in proportion to each other and to the landscape. In addition to those noted by Br. Isaac, there are two structures out on the crossroads of the highways to Russellville and Morgantown. In the laconic style used to annotate the maps of a familiar place, these buildings are labelled merely "Merchant's Store" and "rented to a Doctor."

Other illustrations are larger and more elaborate. Elder Benjamin drew an outline of the millpond at Jasper Spring and represented other water sites by drawing groves of trees, with the legends "Natural Well," "Pond Spring," and "Meadow Branch." Another sketch appears at the northern edge of the Society's lands (fig. 57). A group of trees is clustered upon a mound of stones. Below it is written the word "Knobs," the local term for isolated outcroppings of hillocks. In 1834 Br. Isaac Youngs had seen the knobs and described the visit in his journal.

> After breakfast four of us, viz David Smith and Lorenzo Martin as pilots and Br. Rufus and I mounted on horseback and rode off to what they call the nob about 1 1/2 mile north of the centre. It is a sort of Cobble hill, rough and stony, bare in places—about 175 feet higher than Jasper Valley. The brethren get some of their building stone here.[48]

Away by itself in the open spaces of the map, the vignette was labelled, not with the crude letterpress type used to identify features in the

Figure 56. The Shaker Community at South Union, Kentucky

By Lorenzo L. Martin

1836

After Benjamin S. Youngs (1773–1855)

Ink on paper

48 1/2" × 45 1/2" (123.2 × 115.6 cm)

Inscribed: "A Map of South Union From the Original of Benjamin S. Youngs With the latest Improvements By Lorenzo L. Martin October 1, 1836"

Collection of the Western Reserve Historical Society

Figure 57. Detail of figure 56 showing the "Knobs"

cramped confines of the village, but with a refined calligraphy reserved for the broader areas. This flowing hand was also used in the title and in the fleur-de-lis compass rose that indicated north.

Beyond the perimeter of the Shaker community are two discrete properties, representations of the Shaker land held outside the village. One, the "Knob Tract," was another quarry site for the Shakers' limestone. Elder Benjamin adorned it with another sketch of trees and rocks. The other property was a separate farm of 1050 acres that the South Union Shakers called Black Lick, the Sugar Maple Farm, or, after Elder Benjamin's home village in New York State, "Water Vliet." On his visit to the West, Br. Isaac had ridden out to Water Vliet and described it in his journal:

Soon after breakfast we started for Watervliet, in a waggon with the ministry. This is a place where the believers own a nice farm about 4 miles S.W. from the centre, and a few, i.e. three brethren and 9 sisters live and 5 boys and 1 girl. . . . When we arrived we were very gladly received by this little handful of lonely brethren and sisters whose lot it is to labor in the very remotest corner of the gospel vineyard, as it were in the very corner of the fence![49]

The great size of the out farm at Water Vliet should not be underestimated. Carefully plotted with the same surveyor's notations, it is drawn at one-fifth the scale of the lands surrounding the village. The sheer expanse of acreage at this single auxiliary farm could not have failed to impress the parent ministry in New York.

A week before Elder Benjamin started on his trip to the East, Br. Lorenzo Martin finished making his copy of the original map. Br. Lorenzo knew the territory well—he was Br. Isaac's guide to the Knobs—and had been chosen to update and refine Elder Benjamin's work. He did so, adding the legend "South Union, Jaspers Valley, Logan County, Kentucky, October 1st 1836." Because this identification would have been unnecessary on a map being used at South Union, it is likely that Br. Lorenzo's copy made the trip to New York and Elder Benjamin's original map stayed in Kentucky. In the early years of this century Br. Lorenzo's copy was acquired by Wallace Hugh Cathcart, who subsequently presented it to the Western Reserve Historical Society. No further evidence of Elder Benjamin's original map survives.

5 CARTOGRAPHERS AND ARTISTS IN NEW HAMPSHIRE

In the Shaker villages of New Hampshire, three men were at work drawing plans during the 1840s. The maps they produced are among the rarest type of Shaker artifacts—those signed and dated by their makers. Interestingly, while the men worked in the same place during the same time, the drawings made by David Parker, Peter Foster, and Henry Blinn reveal that they approached the task of mapmaking from widely different perspectives. More than any other, this group of documented drawings demonstrates that even geographical and chronological similarities among the makers did not ensure consistency in style and appearance. An examination of their drawings reveals that styles of Shaker cartographers and artists could vary significantly, depending upon individual experience and personal interests.

The Shakers' creative output flowered during the 1840s. It was a time of physical prosperity, accompanied by intense spiritual activity. The exhilaration and challenge of the early years had given way to communal feelings of solidity, and to a sense that the Society had matured. Throughout the years of the Society's physical expansion Shaker carpenters had been constantly at work, raising buildings to house the Believers and to furnish them with work places. When the population of the Shaker societies peaked in the 1840s, the existing buildings were sufficient in number to accommodate the Believers. Construction continued, however, as the villages were improved and updated. New

dwellings replaced worn-out houses. Bigger and more efficient barns were designed, keeping pace with developments in agricultural science.[1] Workshops adapted to the specialized needs of communal industries were erected. As established villages were being modernized, Shaker maps recorded the improvements.

One notable development was the introduction throughout the villages of running water. Several Shaker maps depict the design and construction of community reservoirs and the network of pipes that carried water to the buildings. The pipes ran underground as a matter of convenience and to protect them from freezing. Once they were buried, though, they were lost from sight. By necessity, the paths they took had to be recorded, starting from the time they were laid. As the original water systems continued in use, the pictorial evidence was updated or redrawn, generally by professional engineers or surveyors from outside the community, but the first plans of village waterworks were drawn by Shaker cartographers.

Br. David Parker came from Canterbury to the Shaker village at Enfield. His plan of the mountain reservoir there is the only Shaker map known from that community. In fact, while there is plenty of material evidence to record the history of the Enfield Shakers, this plan is one of the few written documents of any kind known to survive from that community. Given their experience as builders and not as record keepers, it is not surprising that this drawing depicts one of their many construction projects.

Because they settled their community on the shore of Lake Mascoma, the Shakers at Enfield never lacked for water. The wells they dug in the soft alluvial soil supplied them with all the drinking water they needed. Only one brook of any importance flowed down Shaker Mountain to the village, however, and as the community industries grew in size and sophistication, the lack of waterpower to turn the mills was increasingly seen as an impediment to progress. The Shakers had anticipated this problem and over the years had taken steps to alleviate it. At the Church Family, a swamp was dredged for a mill pond. A reservoir was dug in a field above the mills, and a wooden aqueduct was constructed by the coopers to carry the water directly to the mill wheels. In 1831 the Shakers even acquired water rights to the Mascoma River, across the lake in the village of North Enfield, where they located their factories and their grist mill, which catered to the townspeople on a daily basis.[2]

The ideal water source for the Enfield Shakers, however, was a small spring-fed lake called Lily Pond, elevated seven hundred feet above the Second or South Family, on the top of Shaker Mountain. To construct dams and sluices on the Mountain Pond, as it was called to distinguish it from the Church Family reservoir, and to channel its water almost a mile down the side of Shaker Mountain, required a large investment. It was not until 1838 that the South Family Shakers were ready to undertake the project.[3]

Trustee David Parker's plan of the Mountain Pond at Enfield (fig. 58) is distinctly different from the work of other Shaker cartographers. Dated April 27, 1840, it was made during the same period as the most illustrative Shaker maps. Br. David shared his brethren's motivation— to record the temporal progress and new construction in their villages. But the subject of this drawing is a departure from the Shaker maps that preceded it. Unlike other improvements in the Shaker communities, the pond could not be drawn in elevation. It appears in the map as a flat feature, with no distinguishing characteristics other than its

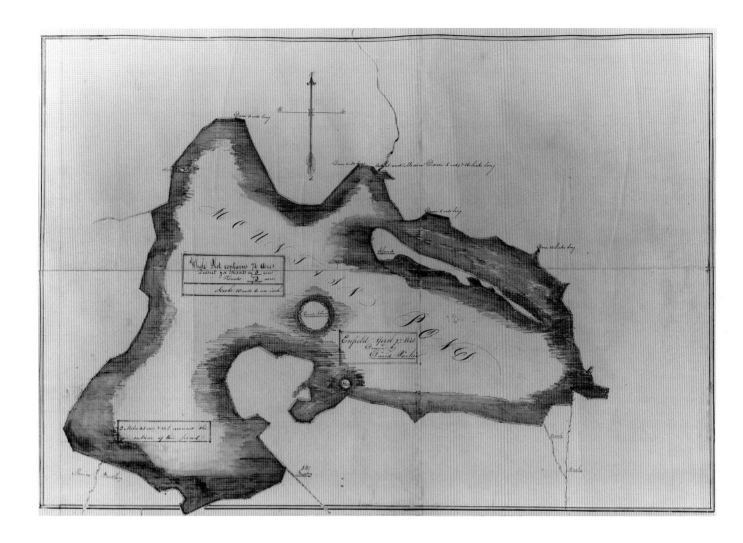

outline. No personal vision of the Shaker community accompanies it, no reference to Shaker life enlivens it. It is closer in appearance to the impersonal work of a trained surveyor than it is to the naive and idiosyncratic village plans of the other Shaker cartographers.

David Parker plotted the outline of the pond and noted the locations of its five dams: "Dam 8 rods long; Dam 13 links long; Outlet and Main Dam 5 rods & 16 links long." Below the dams are the "SW Brook" leading to the Church Family, and the "Maine Brook" leading down the hill to the South Family. Inside the pond are islands: "Ledge; Round Island" (fig. 59). Captions are also written there: "2 miles, 43 rods & 13 L around the outside of the pond. Whole plot contains 76 acres. Deduct for islands say 3 acres, Flowed 73 acres." When he finished, he framed the drawing with a border of black, yellow, and brown lines.

Br. David's technical skill in surveying and drawing can only have been learned at the Shakers: he came to live at Canterbury at the age of ten.[4] The knowledge required to create this precise, conventional plan must therefore have been available to the Shakers, even while the villages were being drawn in unconventional ways by untrained artists. Perhaps land surveying was considered a necessary skill and viewed in an entirely different light from the artifice of landscape illustration.[5]

Still, it seems unusual that such a precise plan was needed to map a

Figure 58. Plan of the Shaker Reservoir at Enfield, New Hampshire

by David Parker (1807–67)

April 27, 1840

Ink on paper

16 3/8" × 25 5/8" (41.6 × 65.1)

Inscribed: "Plan of the Mountain Pond at Enfield, New Hampshire"

Archives, Shaker Village, Inc., Canterbury, N.H.

Photography, Bill Finney

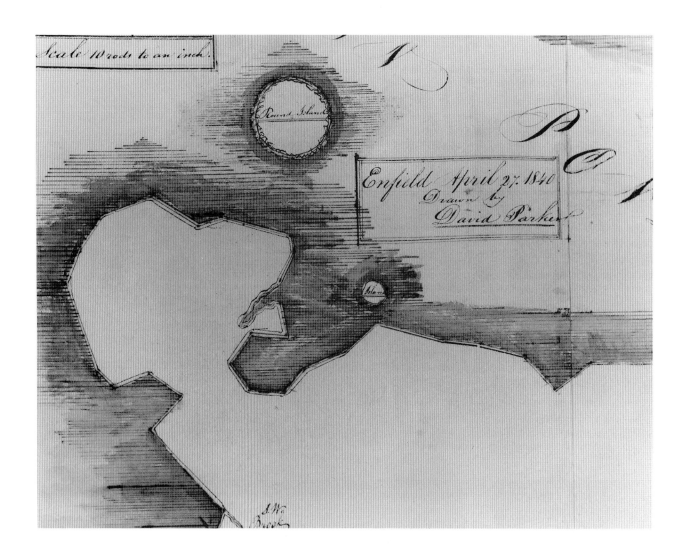

Figure 59. Detail of figure 58 showing islands and inscription

simple mountain pond. But a legal memorandum drafted by Br. David, still acting as trustee six years later, gives some sense of the importance of the Lily Pond to the Enfield Shakers. In the memorandum, the Church and North Families agreed to purchase water rights to the pond from the South or Second Family for one thousand dollars, good in perpetuity,

except when the water level is drawn down within twenty-four inches of the bottom of the flume, after which the said Sec Family shall have the exclusive right to all the water which may be left in said Lily Pond until the water again rises above the said twenty-four inches.[6]

The three-page agreement details numerous other conditions, most of which describe the rights and benefits of the South Family in its arrangements with the other two orders. Evidently they had solved the problem of Enfield's chronic shortage of water power, and with the aid of Br. David's detailed plan, could set their own terms for sharing it with their gospel kindred.

Forty years later, the dams at Lily Pond were leaking and the system needed substantial repair. Though steam engines were beginning to replace water power at Enfield, Elder William Wilson appreciated the value of his mountain springs. The family sold a farm it owned in New York State and with the proceeds cemented their reservoir together.

Elder William had iron pipes laid throughout the village, and, until its demise a few years later, the South Family had running spring water in every building.[7] When the South Family was sold in 1889, William Wilson brought the David Parker drawing with him to the Enfield Church Family, where he served as Elder until his death in 1907. Sixteen years later the Society was closed, and when its seven remaining members moved to Canterbury Br. David's map came with them. It is now in the archives of Canterbury Shaker Village, Inc.

Six months after he had completed his plan of the Mountain Pond, David Parker was working on a highway map of roads and bridges in the vicinity of the Shaker village at Canterbury, New Hampshire (fig. 60). Like the Enfield drawing, this plan is a precisely measured survey, annotated with scales and tables listing distances to the tenth of a rod and elevations to the inch. But the Canterbury map also includes evidence of a diverse cultural landscape: along its fifteen-and-one-half-foot length are illustrated rivers and ponds, bridges and roads, factories and farms, churches and stores, and even the gold-domed statehouse in the capital city of Concord.

The map seems to have been used by the Shakers and their neighbors for plotting the shortest and most level routes between Meredith Bridge, on the western shore of Lake Winnipesaukee, and the town center at Concord, twenty-two miles to the south. Elaborate tables detailing the variables are inscribed at each end: depending on the need, travellers could save tolls by taking the Free Bridge Route instead of the faster Eastman Route, or trade less change in elevation for greater distance by taking the Hollow Route instead of the Shaker Village Route. Pieced together from thirty-three separate sheets of paper, the map was evidently kept rolled in a scroll and was opened as needed to individual sections.

In the center of the map is a plan of the Shaker village. It cannot have served as a very useful guide to the community, whose three families are represented in a sketch less than 5 1/2" long (fig. 61). Only the most prominent buildings in the community are pictured, and these with rudimentary illustrations. None of the Shaker families is as boldly labelled as is the stone watering trough at the crossroads at the foot of the meetinghouse hill, which served as a resting place, landmark, and point of reference for travellers along the road from Meredith Bridge to Concord.

For present-day students, however, the map can be used to examine the Canterbury Shakers' relationships with their neighbors. To begin with, it was a collaborative project. The roads were surveyed by James Clark (1784–1861), a justice of the peace, registrar of probate for Merrimack County, and a distinguished surveyor from the neighboring town of Sanbornton, while the map itself was prepared by Br. David Parker.[8] In addition, the neighboring villages of Fellows Mills and Hills Corner are illustrated in the same fashion as the Shaker community, with pictures of a post office and a meetinghouse labelled at Hills Corner, and "Hunt's Shop" and a factory with a fine bell cupola at Fellows Mills.

Such landmarks are cited up and down the roads—"Marsden's Meadow," "Ambrose's store," "old School House," "old Chimney," "Pine at Brook," "Baptist Meeting House," "Black Smith Shop," "Perkins Tavern," "Methodist Meeting House"—from the sign post at Meredith Bridge, at which all measurements were started, to Greeley & Morrill's store on Main Street in Concord, where all were ended. It seems clear that while this map was made at the Shaker village, in 1840 the Can-

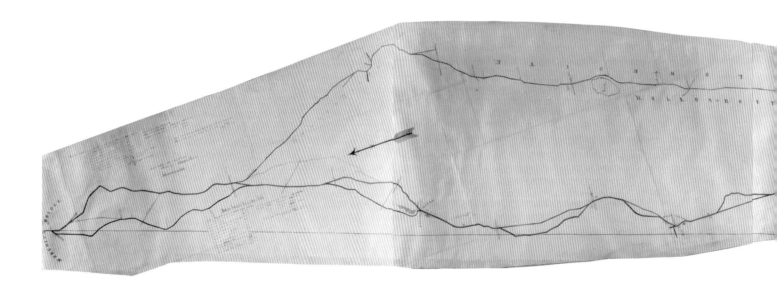

Figure 60. Highway Plan Near Shaker Village, Canterbury

by David Parker (1807–67)

November 4, 1840

Pencil, ink, and watercolor on paper

36″ (irregular) × 15′ 7 3/8″ (91.4 × 476 cm)

Inscribed: "Shaker Village NH Nov 4th 1840 Drawn by David Parker."

Archives, Shaker Village, Inc., Canterbury, N.H.

Photography, Bill Finney

terbury Shakers functioned as part of a larger community of neighbors who shared the same highways and encountered the same experiences travelling the road to town. Not surprisingly, this map did not remain with the Canterbury Shakers. Because of its wide usefulness, it made its way over time into the hands of neighbors who employed it in their logging operations. In 1985 it was discovered in the attic of a local farmhouse, rolled up and forgotten. It was consigned to auction and in 1986 was purchased by Canterbury Shaker Village, Inc.

Br. Peter Foster envisioned the Shaker village at Canterbury very differently than did the trustee-draftsman David Parker. Br. Peter's 1849 map of the Church Family at Canterbury (fig. 62), represents an area a few hundred yards square, and is illustrated with detailed sketches. Apparently it was created to document only selected village features, perhaps ones this cartographer was best qualified to interpret.

Like David Parker, Br. Peter had been the boys' schoolmaster at Canterbury, a position that helped develop his teaching and drawing skills, both of which were important in making illustrated manuscript maps.[9] But, unlike Br. Henry, he demonstrated little or no interest in surveying the property. Instead of linear notations, this map is concerned with building construction. For example, Br. Peter chose to define the spaces around his buildings within a system of roadways, pathways, and fences (fig. 63). The granite walks at Canterbury must have had

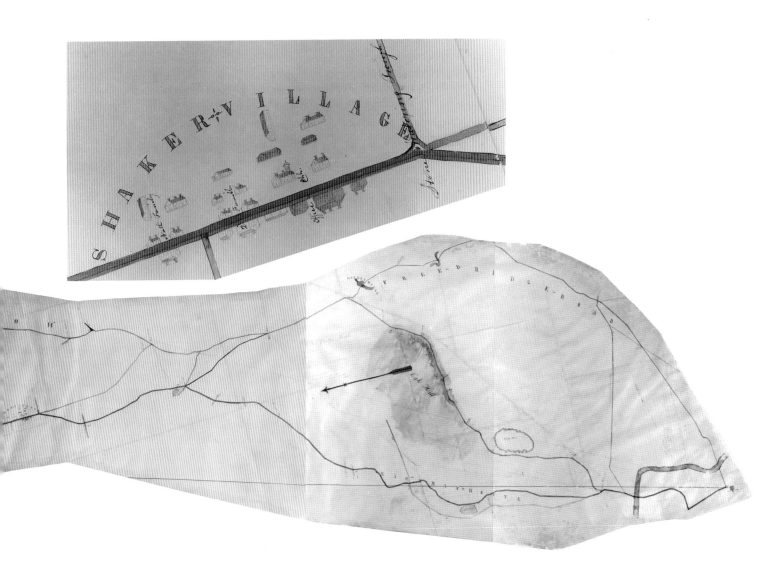

Figure 61. Detail of figure 60 showing Canterbury Shaker Village

special meaning for him. Identified with an individual label, drawn disproportionately wide, and distinguished with little flecks, some even bordered with rows of dashes for edging, they are among the most prominent features on the map. So, too, are the four-rail fences, with enormous gates hanging on cut-granite fence posts, the flecks of the granite and the wrought iron hinge pintles carefully articulated. Even the "Road 3 1/2 rods wide" merits a notation of its own. The attention he lavished on these village byways suggests that he had had a hand in building them, and that he viewed them from the perspective of an engineer.

We see the principal side of each of his buildings, fronting on the granite walks or on the roadway. Because the structures at the Church Family were built facing south to take advantage of the sunny hilltop exposure, Peter Foster was able to establish a single point of view for his map with north at the top, while portraying most of the buildings as standing upright. Consistent with contemporary descriptions of the village, the buildings are colored bright yellow, with red roofs, except for the brown barns and sheds, the red brick Trustees' office, and the meetinghouse, which appears as a creamy white, in accordance with Shaker rules. Br. Peter blocked out the main features of each structure and detailed the features that most interested him. On the Brethrens' shop he drew a second story porch. On the dwelling house he drew the

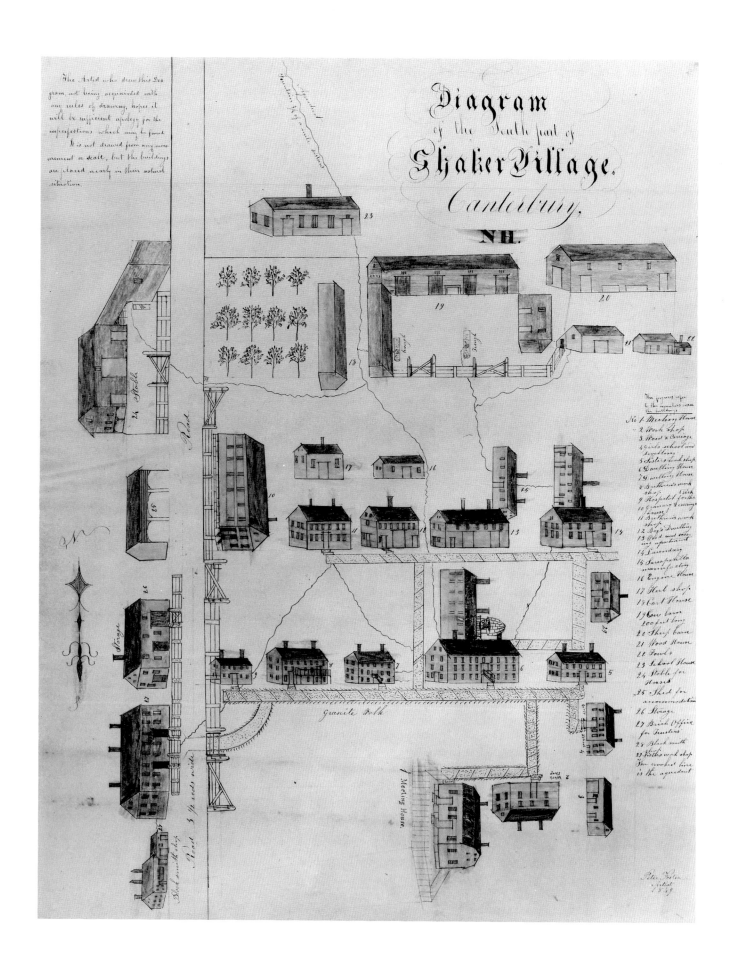

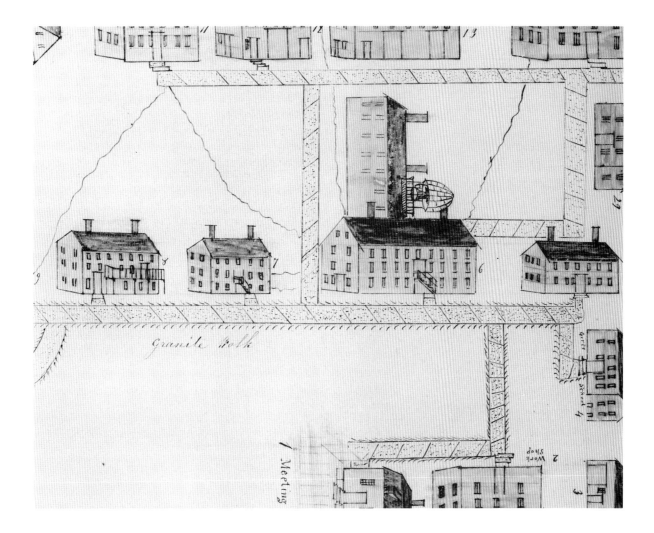

Figure 62. A Plan of the Church Family at Canterbury, New Hampshire

By Peter Foster (b. 1803)

1849

Pencil, ink, and watercolor

16 1/4" × 12 3/8" (41.3 × 31.4 cm)

Inscribed: "Diagram of the South Part of Shaker Village, Canterbury, N.H."

Collection of the Library of Congress

Figure 63. Detail of figure 62 showing walkways and buildings

cupola, with its bell cast by Paul Revere and its domed roof made of pieced and soldered tin sheets.

He then started to identify his sketches, though after the first three he discovered that he did not have room to write individual labels next to each feature. His solution was to number and identify them in a keyed explanation, which he squeezed in on the right hand margin. Unsure that his viewing audience would realize what he had done, he headed his list with the explanation "The figures refer to the numbers near the building." He followed this with a list of twenty-nine major structures, such as, "Hospital for the sick," "Sarsaparilla Manufactory," and "Cow Barn 200 feet long." The list ends with another explanatory note: "The crooked line is the aquaduct." And meandering through the village is a network of lines representing the lead pipes that carried the Society's water underground from building to building.

At the top of the map the line is identified in a separate note: "Aquaduct. Fountain 3/8 of a mile distant." As he did with the fences and walks, Br. Peter plotted the water lines, from their source at the spring to the dwellings, the laundry, the workshops, the sarsaparilla manufactory, and to the barns. Three branches end at stock watering troughs. Like the landmark stone basin at the foot of the hill, they were constantly replenished by the running water, and evidently attracted considerable interest in the village—though because his elevation draw-

ings were so incongruous they were recognizable only to those people who already knew what they were looking at. After sketching them, Br. Peter added the label "Trough" for the benefit of those who had never actually seen them, and who would undoubtedly be confused by the peculiar representation.

The title Br. Peter chose for his map of the Church Family suggests that it was not meant to be used at home. Not only did he identify Canterbury as a Shaker village, but he added the abbreviation "N.H."—two identifications wholly unnecessary were the map going to be kept in the Family. Clearly, the "Diagram of Canterbury" was headed out of state. At New Lebanon, Br. Isaac Youngs had also been inventorying the architecture and plotting the water lines. In 1841 he drew his own diagram there of the iron pipes that ran underground from building to building, and recorded it in a sketch entitled "A View of the Direction and Distance of the Iron Pipes which we have laid this summer." [10] It is at least possible that Br. Isaac had requested this diagram of the water lines at Canterbury, just as he had once requested Austin Buckingham to supply him with a written description of the buildings at Watervliet.

It is not just the features he chose to illustrate nor just his informal approach to surveying property that distinguishes Peter Foster's plan of Canterbury from the work of David Parker. An inscription added to the upper left hand corner of his drawing reveals that he saw himself in a fundamentally different light:

The Artist who drew this Diagram, not being acquainted with any rules of drawing, hopes it will be sufficient apology for the imperfections which may be found.

It is not drawed from any measurement or scale, but the buildings are placed nearly in their natural situation.

Peter Foster
Artist
1849

Unlike the Shaker mapmakers who preceded him, Br. Peter perceived himself as an artist. Not that his work was more sophisticated than his predecessors'—in fact, it is more limited than most in scope and imagination and is drawn in a stiff, self-conscious manner—but his introductory note reveals an awareness of worldly artistic convention and suggests a certain loss of artistic naivete. The artist apparently felt that drawings were made according to established rules, and moreover, he seems to have felt inadequate in meeting the standard. Although it was made during the same years as some of the most imaginative Shaker drawings, it shares little of the naive confidence, power, and directness one associates with them.

The subsequent history of Peter Foster's diagram is unknown. There is no evidence that it was ever used in the village; probably it was sent to the parent ministry at New Lebanon. As with many of the Shaker village views that were gathered by the New Lebanon ministry, it was given to the Library of Congress by an unknown donor in the twentieth century.

In comparison to David Parker's impersonal surveys and Peter Foster's self-conscious diagram, the three large village maps by Canterbury Shaker Henry Clay Blinn are among the most attractive and informative Shaker village views in existence. Large, colorful, and expressive, they reflect the confidence and spiritual vitality that pervaded the movement in these years. In particular, the narrative scenes and details with which he illustrated them reveal the historical and the practical interests of the horticulturalist, printer, and teacher who drew them.

Figure 64. The Shaker Village at Canterbury, New Hampshire

By Henry Clay Blinn (1824–1905)

1848

Pencil, ink, and watercolor

38 7/3″ × 81 1/8″ (98.7 × 206.1 cm)

Inscribed: "Plan of Canterbury by Henry Blinn 1848"

Archives, Shaker Village, Inc., Canterbury, N.H.

Around the year 1848, Br. Henry drew a map of his home village at Canterbury (fig. 64). Encompassing three families on two thousand acres, it is the largest and most elaborate map known of a Shaker village. He may not have originally intended it to grow so large. It started modestly, as a map of the Church Family. The artist pictured the structures there, the divisions of land, and the significant horticultural features, all in a scale large enough for his illustrations to be detailed and accurate.

Then, as David Parker had done with the highway map, he pasted on another sheet of paper and drew the Second Family, doubling the size of his map. Next came a piece with the hayfields and pastures to the south, and then one with the millponds to the east. He completed the map by attaching a large plan of the North Family, with its mills and orchards, and the mystical Holy Ground (Pl. XII). Then, to fill out his pastiche of drawings as an even rectangle, he fitted two long strips of paper into the areas where the individual sheets didn't quite meet.

This "cumulative" construction resulted in a map too large to be viewed from any one direction. To read it correctly, one must unroll it, lay it flat on a counter, and walk around it looking in, much as the Shakers could observe their lands by walking the perimeters. And looking in, one finds a remarkable array of joyful illustrations, elaborate lettering, and idiosyncratic cartoons.

Figure 65. Detail of figure 64 showing ornamental lettering

Thirty-five different features, ranging from a grove of "Chestnut Trees" to the "Turning Mill Pond" are labelled in a range of exotic and ornamental styles of lettering (fig. 65). The "Meeting House Field" is done in Old English Gothic. The "Upper Pond" is equally elegant in perspective lettering. The Church Family's "Vegetable Garden" is composed in a wheel with sprigs of foliage entwining the blocks of each letter. The lettering looks for all the world like a display of Victorian type faces—which it may well have been. "In the spring of 1843," wrote Br. Henry in his autobiography, "I was sent to the printing office to learn to set type and work the press." [11]

It was during that same season that Br. Henry became the boys' schoolteacher. In his autobiography he described himself as a small youth, unsuited to the trade of blacksmithing, but adept at his studies and imbued with a sensitivity toward the needs of young people. Like David Austin Buckingham, he made this map during his years as a teacher, quite possibly for use in his schoolroom.

In the style of his Shaker predecessors, Br. Henry drew elevations of the dwelling, shops, mills, and barns at Canterbury, splayed around the plan of his landscape (fig. 66, Pl. XV). These he identified in three separate keys, one for each family grouping. His buildings are merely inked outlines, nominally distinguished by the correct number of windows and doors, and colored yellow, brick red, brown or gray, with

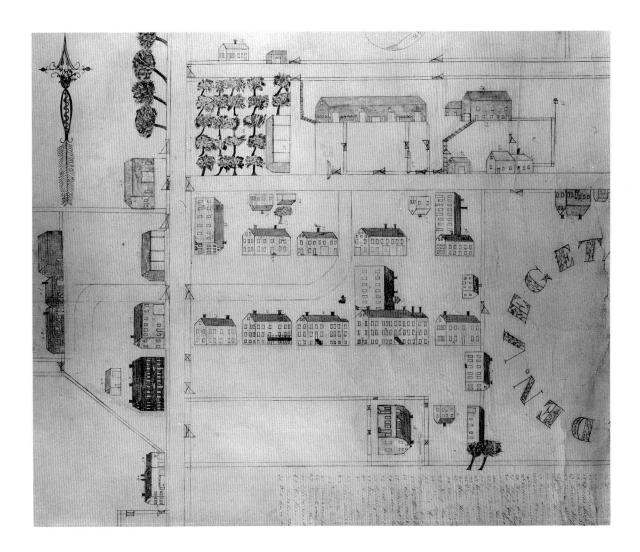

Figure 66. Detail of figure 64 showing buildings of the Church Family

roofs of cedar-brown shingles, or blue-painted sheet metal. Clearly, Henry Blinn was not an architect or builder like Peter Foster. Instead of articulating the buildings in his drawings, he poured his imagination into his numbered descriptions of them.

Some buildings are merely labelled: 54 is the cider mill, 35 is the distillery, and 36 is the "House for the Fire Engine." Some have multiple numbers: 19, the "Yellow Building," also contains "20. Garden Seed Room, 21. Granary, 22. Carriage House, 23. Wood Shop."

Next to 46, the "Hen House" and 47, the "Hen Yard" is number 48, "Peter Ayres' House." In 1848 eighty-eight year old Peter Ayres provided a link to the earliest days of Shakerism. After serving in the Revolutionary War he had been converted by Mother Ann Lee and had lived at New Lebanon until 1792, when he was called to organize the community at Canterbury with Father Job Bishop.[12] Br. Peter remained at Canterbury until his death in 1857 at the age of ninety-seven, the last of the Canterbury Believers to have known Mother Ann personally. Some sense of the veneration in which he was held can be inferred from the fact that his was the only name on Br. Henry's map to be associated with an individual building. In the prosperous community at Canterbury it was not a particularly prominent structure. Apparently its significance to the artist was not architectural or functional but rested in its historical association with the founding of Shakerism.

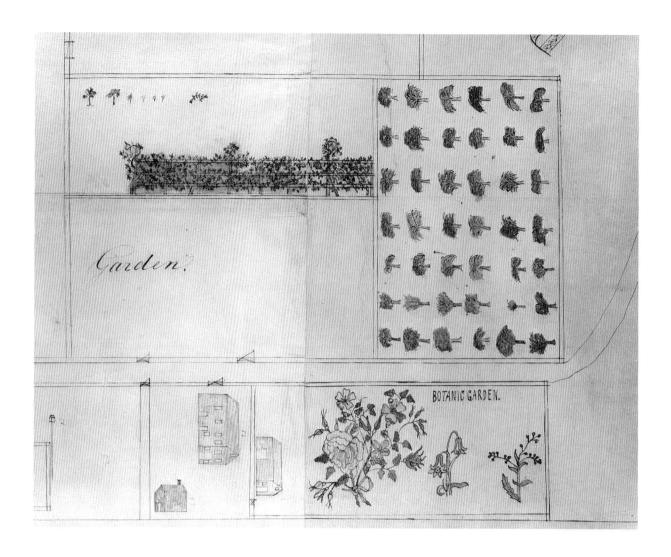

Figure 67. Detail of figure 64 showing trellises, orchard, and botanic garden

Some numbers relate not to buildings, but to features around the village that Br. Henry found personally significant: 34 was the "Steam Engine," 43 and 44 were the "Cow Watering Trough" and the "Ox Watering Trough," 51 was the "Bird House," and 37 was "Best of the Red-cheeks" apples. In fact, Br. Henry's heart lay with his orchards, arbors, and botanical gardens. A horticulturalist by avocation, Henry Blinn took pains to illustrate these features on his map. In the Church Family orchard is a grape trellis, with little studies of grapes sketched next to it. The "Botanic Garden" sports vignettes of wild roses, sweet peas, and lilies of the valley (fig. 67, Pl. XIV). His North Family apple orchard illustrates the precise number and arrangement of the trees, faithfully recording the failure of one with branches bare of leaves or fruit.

The subtle references of these minute details reveal Br. Henry's intimate knowledge of things that for one reason or another touched his life at Canterbury. Discovering them invites the closer examination of this mammoth map. And, upon examination, personal references abound. At its watering trough at the Church Family is a little picture of an ox; in the hog pen behind the office are little sketches of the Shakers' pigs. More pigs and sheep root and graze in the easterly pasture, and nearby a plow rests in the field. The Shaker "Burying Ground" is lined with a row of tiny, arched grave stones. At the crossroads to the southwest, in minuscule detail, is drawn the stone watering trough still found today at the foot of the hill. Beside it are two signboards,

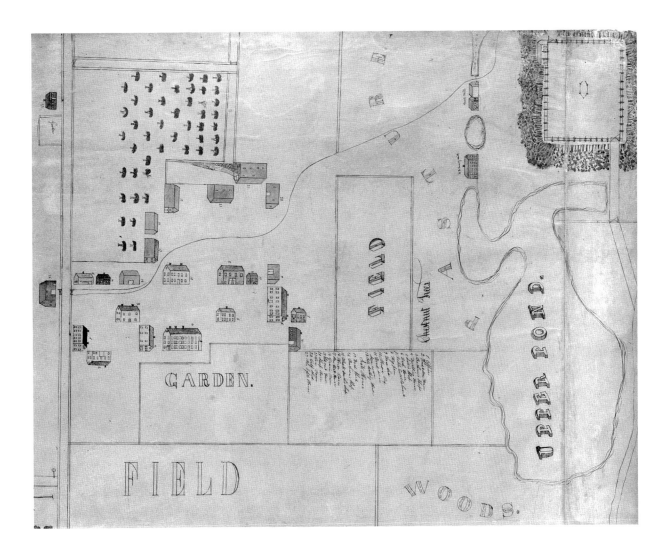

which, under magnification, actually read: "Shaker Mills, Loudon" and "Concord 12, Boston 75."

At the upper left-hand corner is a strange rectangular plot with a small building, enclosed by a rail fence and surrounded by a dense green hedge (fig. 68). Though it is one of the largest and most prominent features on the map, it is unidentified either by a label at the site or by an explanation in the numbered key. Perhaps Br. Henry found it self evident, and too obvious to require explanation. More likely, he regarded the site as too special and too spiritual a place to be labelled along with the rest of the village. The sketch is the only known representation of Canterbury's Holy Ground, the Shakers' sacred site of mystical worship. As with the other features of this map which he illustrated with particular attention, Br. Henry had a special association with the Holy Ground.

Several of the societies selected a place in the woods or fields to be used for divine worship. At Canterbury, the place was designated "Pleasant Grove," and was situated about three-fourths of a mile northeast of the Church Family. All who were able to assist in the work of clearing the land and preparing the place for religious gatherings, were expected to contribute the labor of a few days. The printers, after obtaining some hoes and shovels, were soon found among the zealous laborers. A building, 40 feet long, 15 feet wide and one story high, was built for the protection of the people if it should happen to rain during the time of the meeting. In 1847, a marble slab was purchased, six feet long, three feet wide and three inches thick. This was placed in the center of the enclosure. On

Figure 68. Detail of figure 64 showing the Holy Ground and the North Family

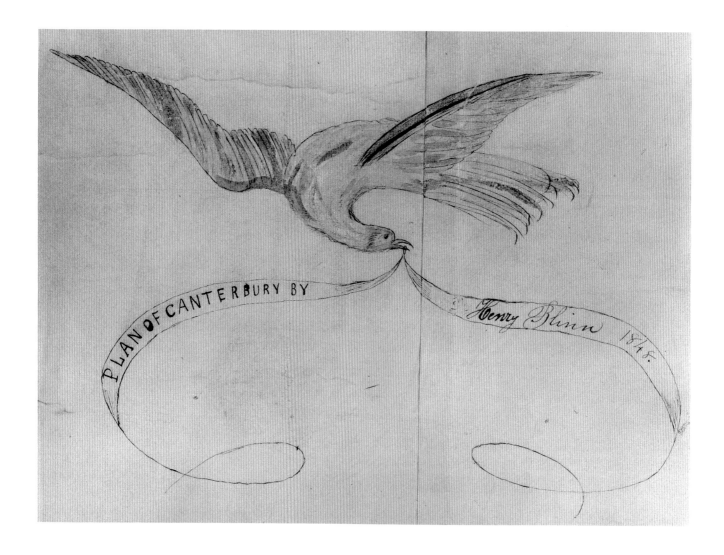

Figure 69. Detail of figure 64 showing inscription with title

one side of the marble was engraved the name of the place and the date of erection, while on the other side was an extended message or spiritual exhortation to those who visited the sacred place. Elder Joseph Myrick, of Harvard, Mass., was engaged to assist in preparing the marble, and several days were spent in polishing it, preparatory to the lettering. After imparting several lessons with reference to the use of the tools and the manner of engraving, he left the work in charge of the writer and returned to Harvard. The stone was erected, beautiful evergreens were planted around the place, and meetings were held frequently for several years. Subsequently, these meetings were discontinued and the house, fence, and marble slab were removed by the writer.[13]

As a decorative cartouche for the title of his map (fig. 69, Pl. XIII), Br. Henry drew a bird with a banner trailing from its beak, on which he lettered "Plan of Canterbury By Br. Henry Blinn 1848." His description of building the Holy Ground in 1843 and erecting the marble slab in 1847 seems to confirm this date—the sextagonal enclosure in the middle of the ground represents the fence surrounding the stone—though at the same time the map contains contradictory evidence. Two inscriptions subsequently penciled on the back of the map, both in the artist's own handwriting, read "Plan of Canterbury by Eld. H.C.B. 1845." However, this disparity in dates may merely reflect the length of time during which this enormous map was composed: the last increment to be added was the northern section containing the Holy Ground and the marble stone. Although the stone had not been let-

tered by 1845, when the map might have been started, it was in place and could be included by the time the map was finished in 1848.

The next year Br. Henry left the school room to devote full time to his printing, and in 1852 he was appointed to the Elders' lot at Canterbury. For the next half century his brethren and sisters called him "Elder Henry." He was revered and beloved at Canterbury, and in time came to be regarded as the august elder statesman of Shakerism. A measure of the esteem in which he was held can be found in a subtle alteration to his map. In later years, an unknown hand scratched the common designation "Br." away from the name he had signed with the title in the banner, out of concern that it might diminish the gentle Elder's stature. Until his death in 1905, Elder Henry kept the map in his Museum Room in the Brethren's South Shop. One of the most prized belongings of the Canterbury Shakers, it has never left their possession.

For over a century the Canterbury Shakers also owned a map of the Shaker village at Watervliet, New York (fig. 70). Its artist did not sign or date the work, and no records survive to explain when or why it came to New Hampshire. But when it is compared to Henry Blinn's great map of Canterbury, it appears so similar in style and construction that an attribution to the New Hampshire artist is plainly justified.

Like the "Plan of Canterbury," "The Plan of Watervliet" is a cumulative map, drawn in sections and combined to form a complete village plan. Evidently the artist visited each family and drew it independently of the others, on its individual sheet of paper. Then, building from the Church Family out, he pasted each one on as he finished it. In the end, as with the Canterbury map, he found that some pieces fell short, and had to be pieced out with narrow strips to connect all the edges. In all, this map is constructed of ten separate pieces of paper.

The principal sections of this plan illustrate the four families at Watervliet, and detail the buildings at each. As in the "Plan of Canterbury," they are simply drawn, their profiles traced first in pencil, then in ink, with bare rectangular outlines to represent windows, doors, or chimneys. More distinctive than the buildings themselves are those features that, for one reason or another, Br. Henry found particularly notable.

At the South Family, next to an "artificial" mill pond, he sketched two buildings with a mill race and an elevated flume, and labelled the scene "mill & machine to move the Wash mill" (fig. 71). At the Church Family dwelling house, at the head of the front walk, he drew a picture of a lantern mounted on a post, which he labelled simply, "Lamp" (fig. 72). As he did in the Canterbury drawing, he made special reference to his interest in horticulture. Four gardens are illustrated, surrounded by rail fences. At the Church Family his favorite, the "Botanical Garden," is distinguished from the others. Next to it, the apple orchard is illustrated with particular care. The two rows of trees are colored in different shades of green and brown and have different shaped trunks and crowns; Br. Henry took the pains to draw two distinct varieties of apples.

The most prominent features of this map are the boldly lettered titles, identifying the larger tracts of land. In elegant arcs and serpentines, the legends "Swamp, Wood, Pasture, Field," and "Saw M[ill] Pond" display the same love of ornamental lettering found on his map of Canterbury. Finally, such idiosyncratic devices as the directional arrow with its feathered shaft and the title of the plan inscribed on a banneret leave no doubt that Henry Blinn drew this map.

There is, however, some question as to when the map was actually

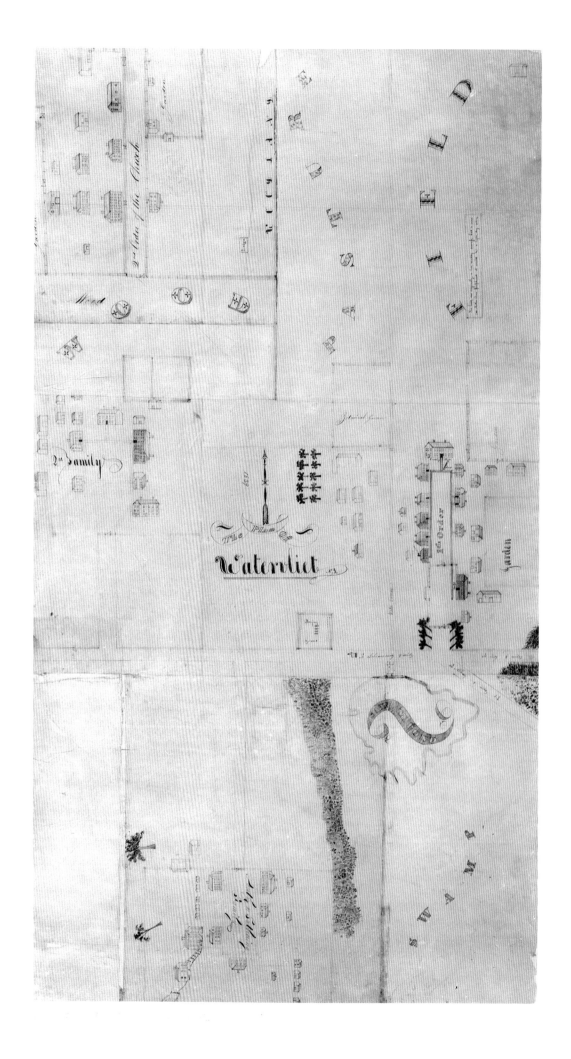

made. The date 1839 next to the arrow, which is penciled in different handwriting and facing away from the decorative cartouche of the title was evidentally added at some later time. In 1839 Henry Blinn was only fifteen years old, and, having lived with the Shakers only a year, would neither have acquired the skills nor been allowed the opportunity to make this map. It is more likely that he drew it in his years as a school teacher, when he had developed his interests in botany, printing, and water-powered mills, and after he was free to travel beyond the village at Canterbury.

In all probability, Br. Henry drew his "Plan of Watervliet" on a visit to New York State, sometime after February of 1842, when, at the age of twenty, he became the boys' schoolmaster. Though the Holy Ground was established at Watervliet in 1842, it does not appear on this map.[14] Perhaps Elder Henry's visit preceded its construction, or perhaps at first the mystical site was considered too sacred to be sketched on a village map along with the swamp and the wash mill. There is, however, an unexplained deletion from this drawing where the Holy Ground might have been. Across the road from the burying ground a small square has been sliced out of the map and the hole carefully patched with a new piece of paper. No traces remain of whatever was originally drawn on the site, but it quite possibly could have been a picture of the Holy Ground, deleted in later years in accordance with

Figure 70. The Shaker Village at Watervliet, New York

Attr. to Henry C. Blinn (1824–1905)

Ca. 1842–44

Pencil and ink

47 1/2″ × 26″ (120.7 × 66.0 cm)

Inscribed: "The Plan of Watervliet N.Y."

Collection of the Albany Institute of History and Art

Figure 71. Detail of figure 70 showing the South Family

Figure 72. Detail of figure 70 showing the First Order

the parent ministry's directive that worship there be abandoned and all traces of it be obliterated.

At any rate, the drawing must have been made before April of 1844, when, according to an entry in the journal of Watervliet Shaker Ann Buckingham, "Brethren raised bellfry on top of first house." Br. Henry pictured the First Family's dwelling house without a belfry, indicating that this map was drawn before that date.[15]

It would have made sense for Henry Blinn to spend some time while at Watervliet with David Austin Buckingham, as one Shaker schoolteacher visiting another. In doing so, Br. Henry may have learned some mapmaking skills from Br. Austin, or, at the very least, may have used the Buckingham map of Watervliet as a guide in preparing his own drawing. Like Br. Austin, Br. Henry took the unusual step of organizing his map on a vertical axis. Most of his inscriptions, and most prominently his flowery title, place north at the top—a rare occurrence in a Shaker map. To the southeast of the mill pond are the same dense woods sketched by Br. Austin, and inscribed in the roadway are the same signboards with travellers' directions, with the same tiny fists pointing the way. Br. Henry must have liked this last device, for it appears several years later in his 1848 map of Canterbury.

Despite the similarities, Br. Henry's "Plan of Watervliet" was an original drawing, encompassing far more than Br. Austin's 1838 map.

As a visitor, his intentions in making a map of Watervliet for the Canterbury Shakers would have been different from Br. Austin's straightforward approach in documenting the village. As the community settled by Mother Ann Lee herself, Watervliet had special meaning for the Shakers. Therefore, Br. Henry not only recorded the lands and buildings of each of the four families, but, in his rambles through the village, he noted points of historic interest. In the field to the north of the Church Family he noted: "This land was originally a low, muddy swamp, but it is now [as Mother Ann prophesized it would be] a light, dry soil." Still farther along, on the northeastern boundary of the Shakers' land, he wrote a second inscription at the edge of the map, now torn and partly missing.

. . . [Moth]er Ann was buried, but the land does not belong to believers . . . [deci]sion to have her removed & She was removed . . . [to land] belonging to the Society in the spring of 1835.

The burying ground containing Mother Ann's remains stood along the road in the center of the Society's lands. It was not included in Br. Austin's 1838 map, but Br. Henry took pains to draw the enclosure, surrounded by a rail fence and lined with a double row of trees. Inside, he drew four tiny grave stones, lettered with the initials JH, FW, MA, and ML. Among the many Shakers interred there, he had distinguished the graves of John Hocknell, Father William Lee, Mother Ann Lee, and Mother Lucy Wright, the founders and early leaders of Shakerism in America. In addition to making a map of the functional aspects of another Shaker village, Br. Henry was recording his pilgrimage to the Shakers' original community, and, just as he had distinguished the shop of the venerable Peter Ayres at Canterbury, was providing a link between his brothers and sisters at home and the spiritual origins of their faith.

Throughout his life Br. Henry kept the "Plan of Watervliet" at Canterbury. During the twentieth century it was rolled up, stored away, and forgotten. In the 1950s it was sold to a private collector who kept the map at Canterbury. In 1975 he sold it to the Albany Institute of History and Art, where it is now owned.

For all the interest the other Shaker societies expressed in having their own pictures of the village at New Lebanon, only two maps of that community are known to survive today. And although they are contemporaneous, they represent two different ways of seeing the community.

In the earlier drawing (fig. 32) individual aspects of the community are illustrated in such detail that the artist, presumed to be Isaac N. Youngs, must have lived there and have known the village intimately. By comparison, the other unsigned "View of N. Lebanon" is sparse and generalized, apparently the work of someone with less personal knowledge of the place. Most of his structures are unidentified, almost none of the land divisions labelled, and few local landmarks are illustrated. The little references and details that invariably signify personal experience in the life of the community are absent from this map. However, the elements of the landscape at New Lebanon that did catch the artist's eye, and the characteristic way in which he drew them, make it possible to attribute this map too to New Hampshire Shaker Henry C. Blinn.

Like Br. Henry's "Plan of Canterbury," the map is enormous, measuring over six feet in length (fig. 73). Like his other maps, it was never meant to be framed behind glass. Buildings stand precisely at the

Figure 73. The Shaker Community at New Lebanon, New York

Attr. to Henry C. Blinn (1824–1905)

Ca. 1842–48

Pencil, ink, and watercolor

26 1/2″ × 77 3/4″ (67.3 × 197.5 cm)

Inscribed: "View of N. Lebanon Columbia County, N.Y."

The Sherman Collection

John Miller Documents, 1987

edges of the paper, and mill streams and village lanes run right off the map, leaving no margin to be covered by the lip of a picture frame. Judging from the wear at each end, this map also was rolled into a scroll when it was not being used.

When the drawing is laid out flat, the village road runs along its length from left to right, connecting four Shaker families. For the most part the buildings are rudimentary, outlined in black ink, with red roofs and chimneys. Beyond the families' houses and shops, however, are the mills and gardens that appealed to Br. Henry. Mill ponds are carefully drawn, with concentric elevation lines to indicate their depth. He did label the buildings there: "Tan Yard and Mill," and "Machine Mills." The only lots of land he labelled were the burying ground, two orchards, and three gardens. Significantly, he illustrated the "Botanic Garden," as he did in his map of Canterbury, with a little sketch of its plants.

Br. Henry's enthusiasm for decorative lettering is also apparent on this map. The titles "North Family" (fig. 74) and "Church" are blocked out in large capital letters; and though the decoration was subsequently scratched out, there is evidence that they were originally embroidered with green foliage and little red petals. The designation "2nd order of the Church" is arched in a 90° crescent, precisely like the "2nd Family" on his map of Canterbury. Again, Br. Henry did not merely

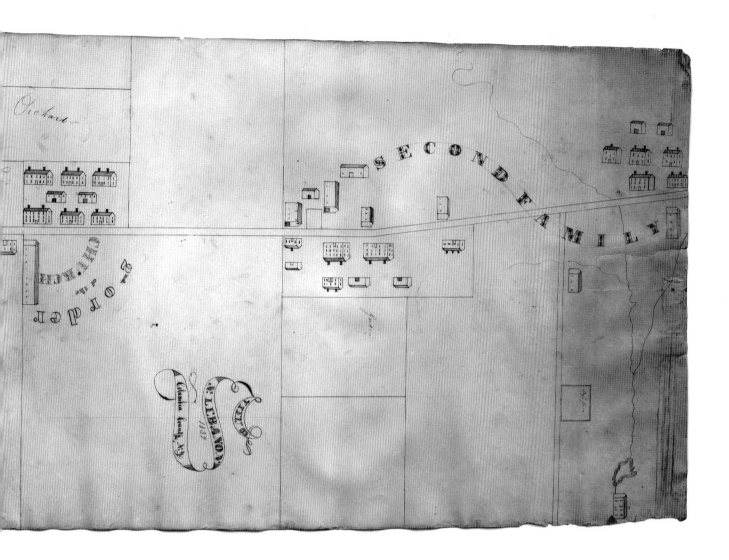

label the drawing, but inscribed its elaborate title on a flowing banneret.

As with the "Plan of Watervliet," the date 1839 was added to the title, penciled in after the tight, careful design was already complete. Although it is consistent with the 1838 watermarked on the paper in the year it was manufactured, the date is too early for Henry Blinn to have travelled to New York to draw the map.

It is possible, of course, that he could have drawn it in New Hampshire, using another map of New Lebanon as a guide. In fact, several similarities between the two surviving New Lebanon maps suggest that the earlier one may have served as a model for drawing Br. Henry's "View of N. Lebanon." In particular, by wording his title the way he did, and by labelling the hillside with both "Mountain" and "Lebanon Hollow," he seems to be making a distinct reference to the smaller map. But the presence of several original elements in his drawing suggest that it was made from life, on the scene in New Lebanon. His village roads are marked "To Albany 25 Miles" and "To Lebanon Springs 2 miles." His "North Family" is composed with buildings in entirely different places. It is far more likely that, if he referred to the earlier map at all, he saw it in New York, while visiting there and at nearby Watervliet.

In fact, despite the way the inscriptions "Mountain" and "Lebanon Hollow" seem to orient the map horizontally with north to the left, it

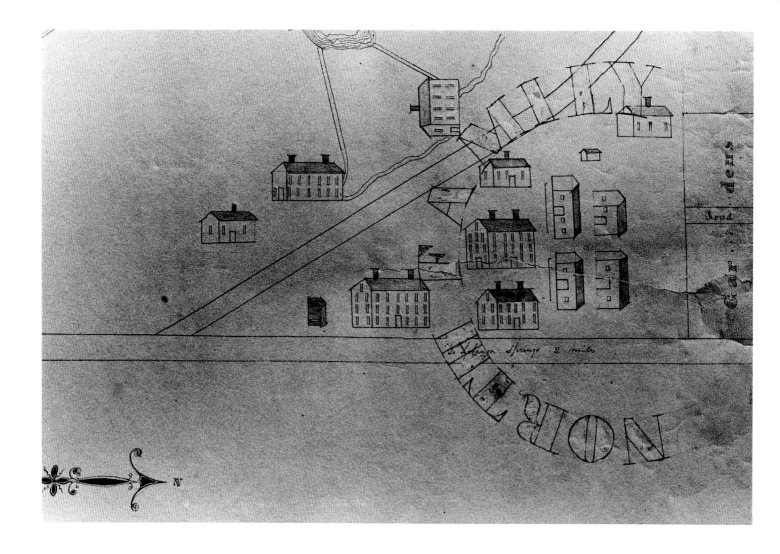

Figure 74. Detail of figure 73 showing the
North Family

has otherwise a vertical format. The title and most other inscriptions,
large and small, require that the viewer read this map lengthwise, with
north at the bottom. And in this respect, Henry Blinn's map of New
Lebanon is consistent in design with another map in this same style, of
the neighboring village at Watervliet. It may well be that Br. Henry vis-
ited New Lebanon after he drew his map of Watervliet, and brought to
bear in it the cartographic skills he had learned from Br. Austin.

Although Henry Blinn's maps were not concerned with the fine
points of Shaker village architecture, he did elaborate upon one build-
ing at New Lebanon. The 1824 meetinghouse, with its barrel roof,
is articulated in greater detail than any other structure in the map
(fig. 75).

The meeting-house is the most remarkable object, and in many respects sur-
passess every other edifice for divine worship in the country. It is very large on
the ground, convex, and covered (so we are told) with one entire sheet of tin,
the different pieces being soldered together into one.[16]

Unlike the artist of the earlier map of New Lebanon, Henry Blinn
counted the five meetinghouse windows correctly, and drew their indi-
vidual sash and mullions. Its tin roof is painted blue, and the pieces are
outlined along the edges where they were soldered together.

This building held special significance for the Shakers. It was their

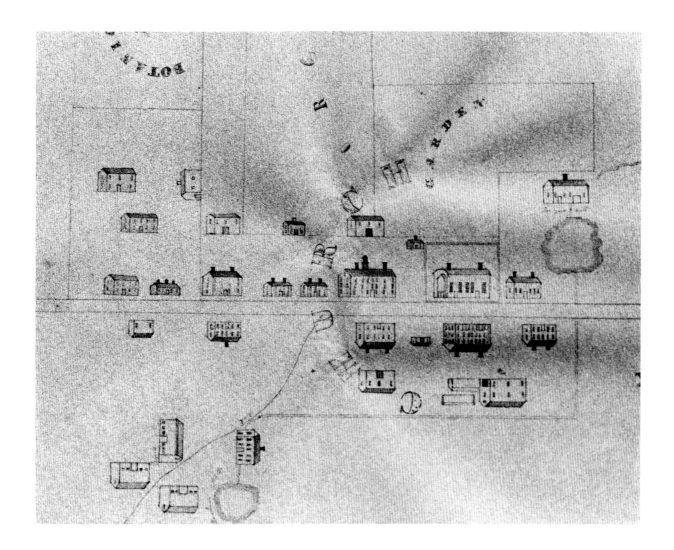

mother church, the spiritual home of their faith. Each community had tithed money to defray the cost of its construction and had contributed their housewrights and joiners to build it.[17] As he did with the graves of the founders, Br. Henry took pains to picture this building for the Believers in New Hampshire, who, though they would never see it themselves, felt very much attached to it.

Like Henry Blinn's maps of Canterbury and Watervliet, the "View of N. Lebanon" had a history of ownership by the Canterbury Shakers. It remained at the village until the middle of the twentieth century when it was purchased by a neighbor from Eldress Emma King's antique shop in the Canterbury school house. In 1978 it was sold again, this time to a private collector.

Figure 75. Detail of figure 73 showing the Church Family

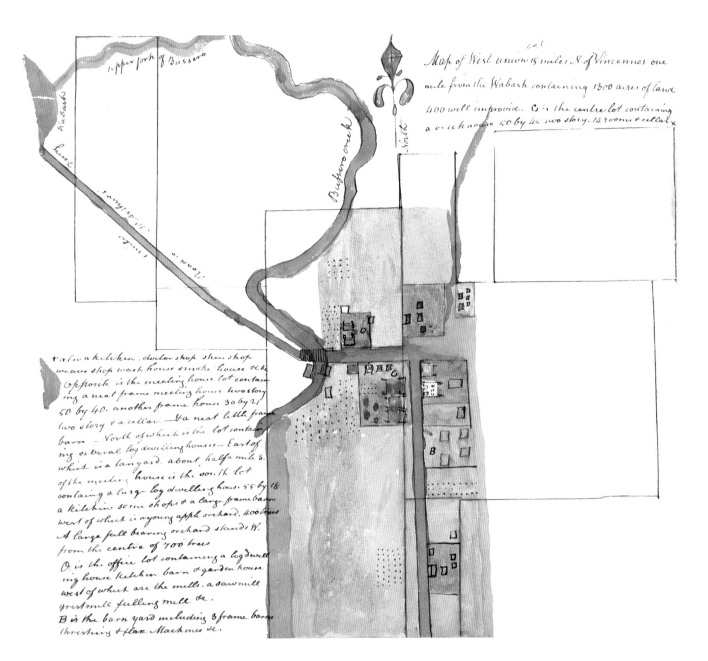

Map of West union 15 miles N. of Vincennes one
mile from the Wabash containing 1300 acres of land
400 well improvd. C is the centre lot containing
a brick house 50 by 44 two story. 14 rooms & cellar

upper fork of Bussero

Bussero creek

+ also a kitchen. doctor shop skin shop
weave shop wash house smoke house &c
Opposite is the meeting house lot contain
ing a neat frame meeting house two story
50 by 40. another frame house 30 by 21
two story & a cellar. & a neat little frame
barn. North of which is the lot contain
ing several log dwelling houses. East of
which is a tanyard. about half a mile S.
of the meeting house is the south lot
containing a large log dwelling house 55 by 18
a kitchin. some shops & a large frame barn
west of which is a young apple orchard. 400 trees
A large full bearing orchard stands N.
from the centre of 700 trees
O. is the office lot containing a log dwell
ing house kitchen barn & garden house
west of which are the mills. a sawmill
gristmill fulling mill &c.
B is the barn yard including 3 frame barns
threshing & flax Machines &c.

PLATE I The Shaker Community at West Union, Indiana
attributed to Richard McNemar, ca. 1824–27
Courtesy of the Western Reserve Historical Society, Cleveland, Ohio

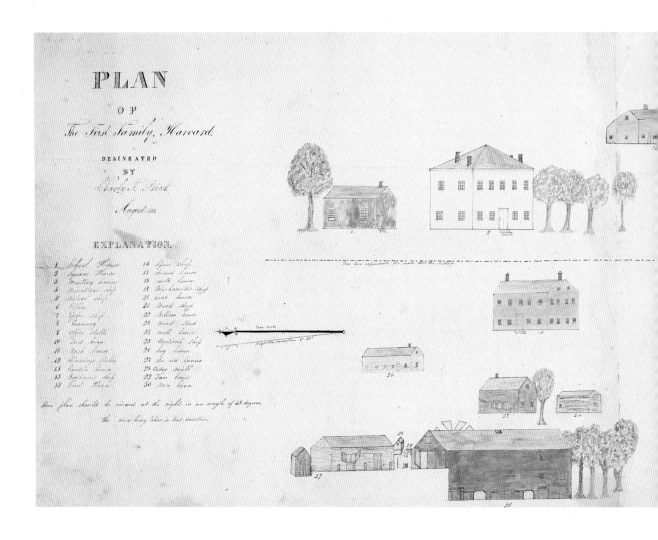

PLATE II (*top*) The Church Family at Harvard, Massachusetts
by Charles F. Priest, 1833
Collection of the Library of Congress

PLATE III (*bottom left*) The Church Family at Harvard, 1833
detail showing tan house and barns

PLATE IV (*bottom right*) The Church Family at Harvard, 1833
detail showing meetinghouse and dwellings

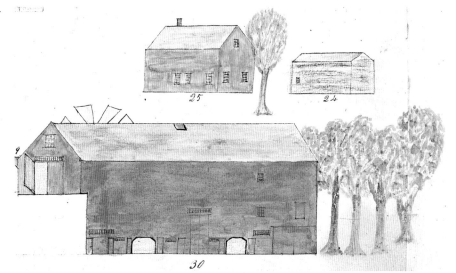

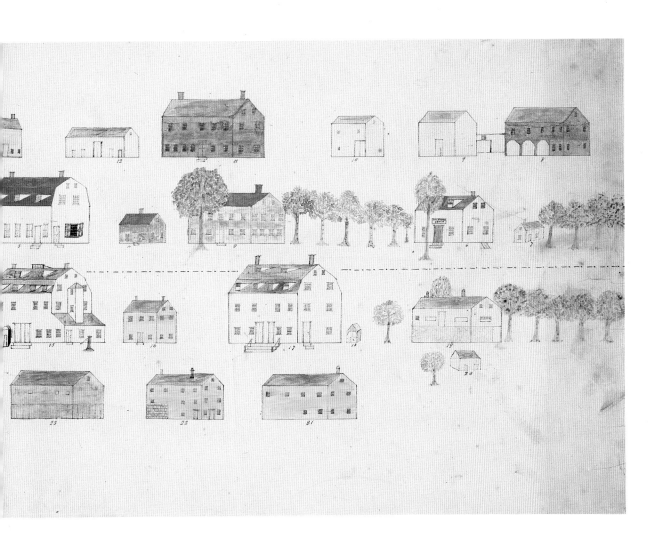

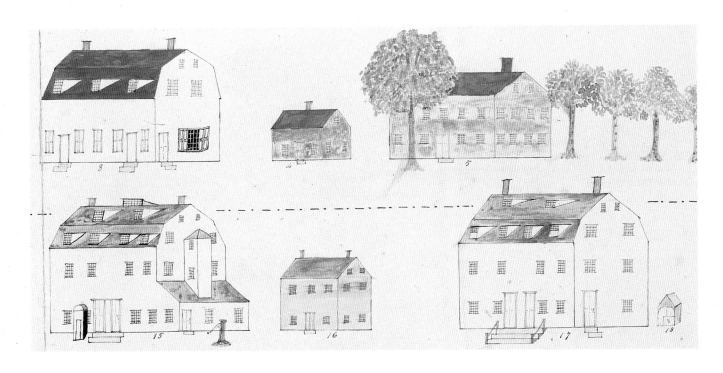

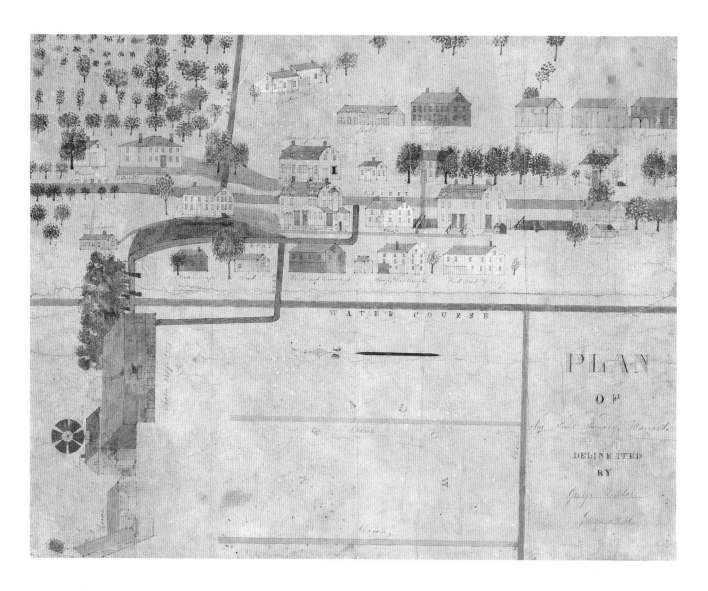

PLATE V The Church Family at Harvard, Massachusetts
by George Kendall, 1836
Courtesy of Fruitlands Museum, Harvard, Massachusetts
John Miller Documents, 1987

PLATE VI (*opposite, top*) The Church Family at Harvard, 1836
detail showing meetinghouse and dwellings

PLATE VII (*opposite, bottom*) The Church Family at Harvard, 1836
detail showing tan house and barns

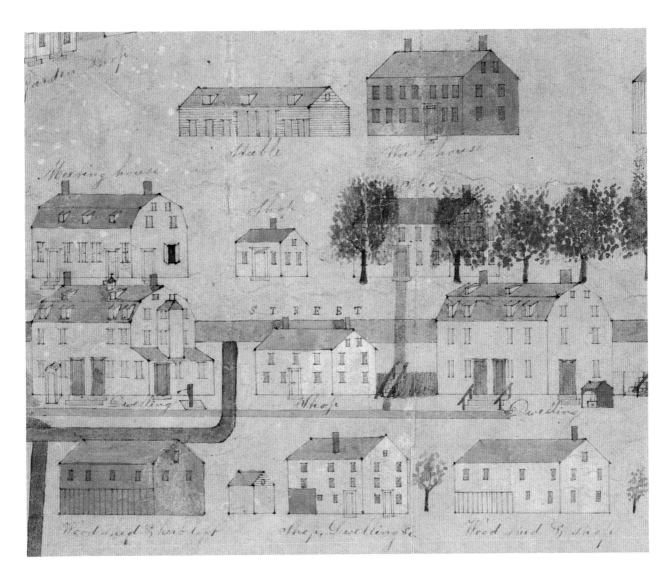

Stable Wash house

Meeting house Shop

STREET

Dwelling Shop Dwelling

Woodshed & houses &c. Shop, Dwelling &c. Wood shed & shop

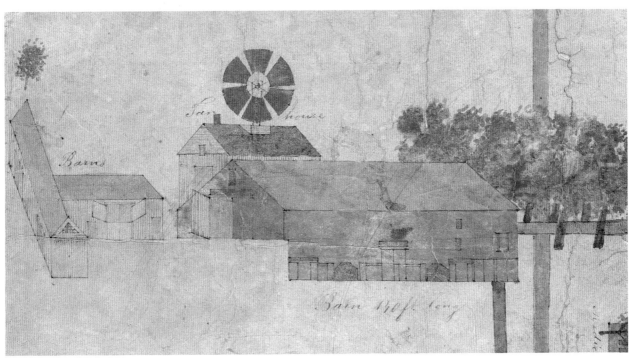

Barns Fan house

Barn 140 ft long

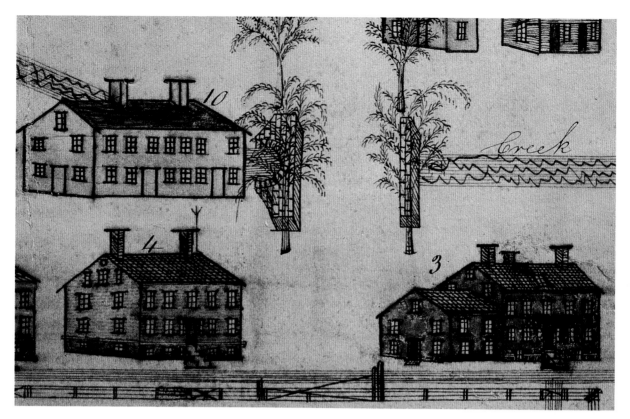

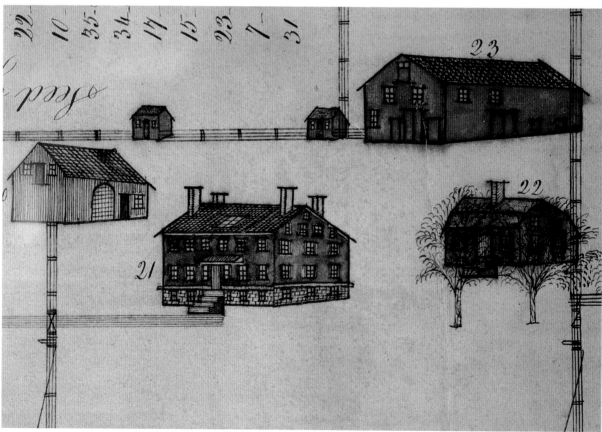

PLATE VIII (*top*) The Church Family at Watervliet, New York
by David Austin Buckingham, 1838
detail showing workshops and stone bridge
Collection of the New York State Museum

PLATE IX (*bottom*) The Church Family at Watervliet, 1838
detail showing Office buildings

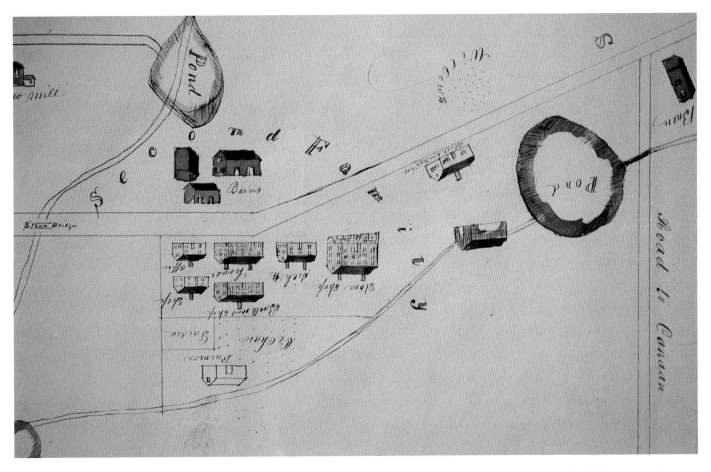

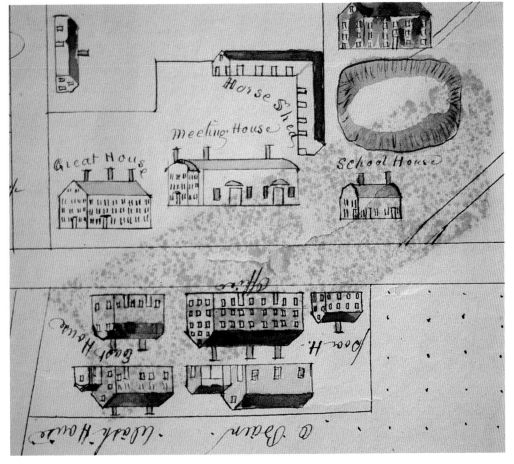

PLATE X The Shaker Community at New Lebanon, New York

attributed to Isaac Newton Youngs, ca. 1827–39

detail showing Second Family buildings

Private collection

PLATE XI The Shaker Community at New Lebanon, ca. 1827–39

detail showing Church Family buildings

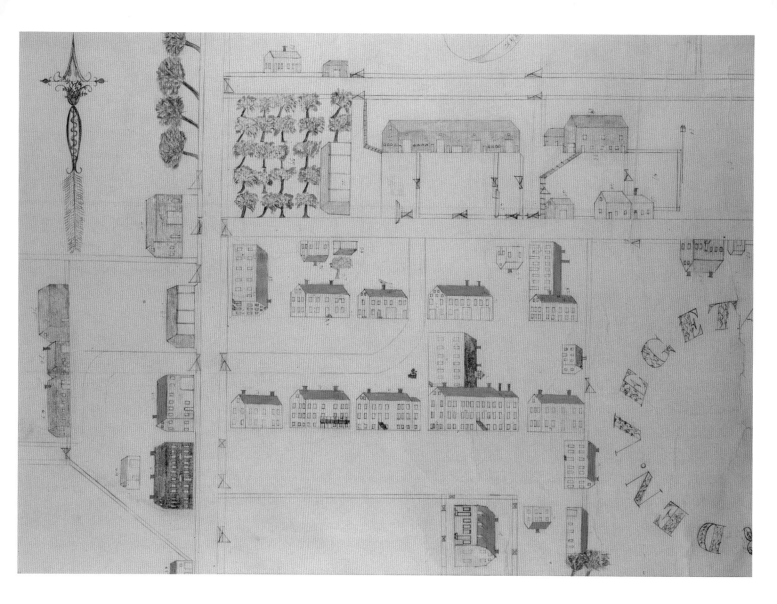

PLATE XII The Shaker Community at Canterbury,
New Hampshire
by Henry Clay Blinn, 1848
detail showing Church Family buildings
Archives, Shaker Village Inc., Canterbury,
New Hampshire

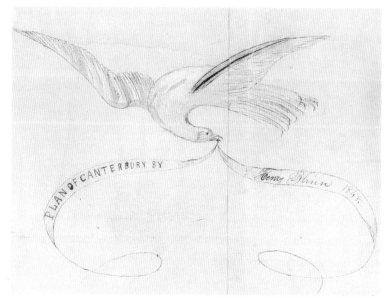

PLATE XIII The Shaker Community at
Canterbury, 1848
detail showing title

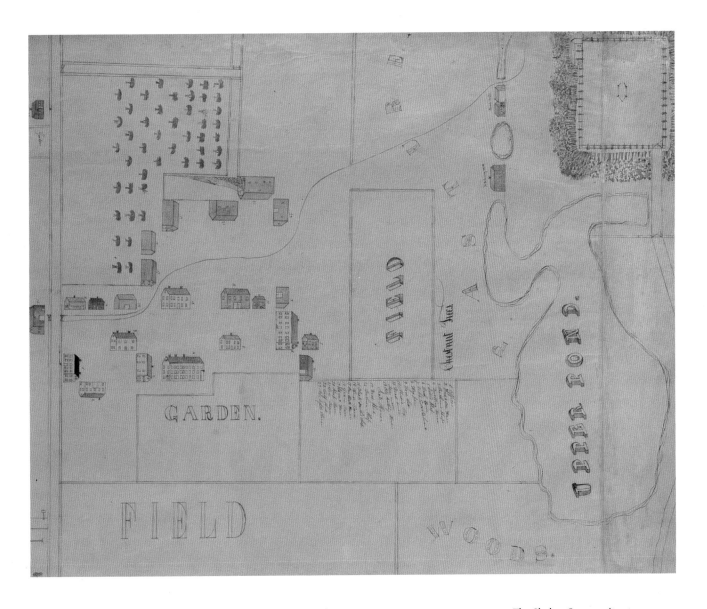

FIELD

GARDEN.

FIELD

Chestnut Trees

PASTURE

UPPER POND.

WOODS.

PLATE XIV The Shaker Community at Canterbury, 1848
detail showing North Family buildings

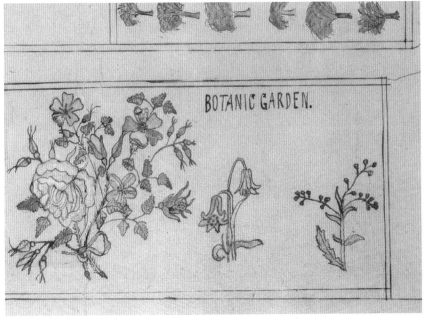

BOTANIC GARDEN.

PLATE XV The Shaker Community at Canterbury, 1848
detail showing Church Family gardens

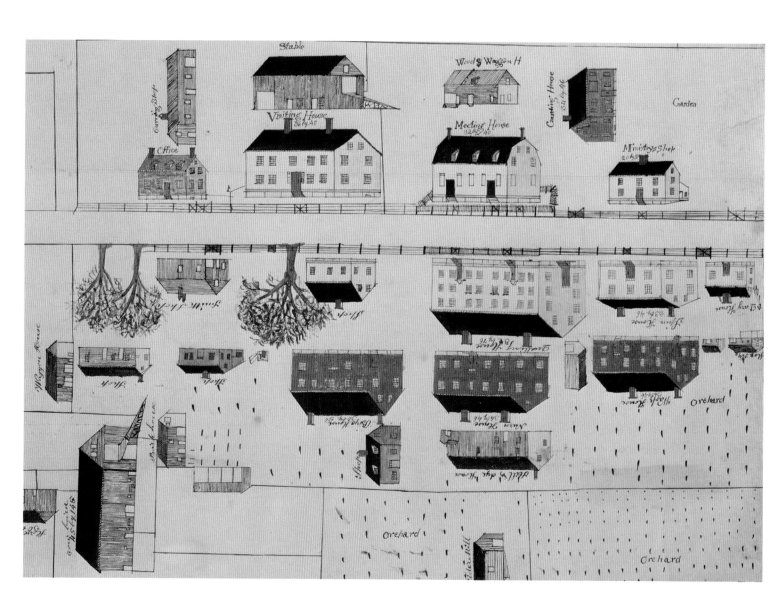

PLATE XVI The Shaker Village at Alfred,
Maine
by Joshua H. Bussell, 1845
detail showing Church Family buildings
Collection of the Library of Congress

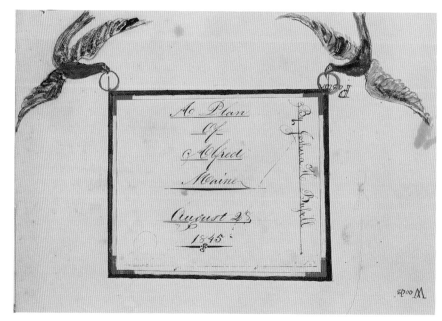

PLATE XVII The Shaker Community
at Alfred, 1845
detail showing title

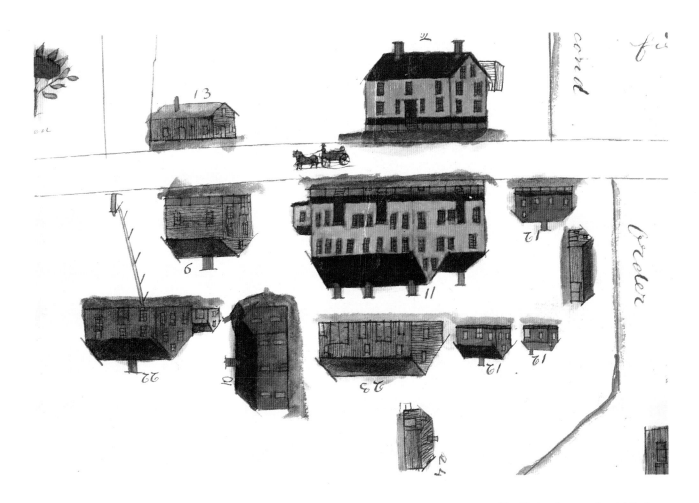

PLATE XVIII The Shaker Community at Alfred, Maine

by Joshua H. Bussell, 1846

detail showing horses and wagon passing Second Family

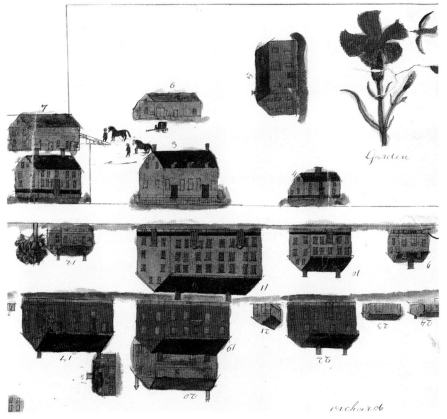

PLATE XIX The Shaker Community at Alfred, 1846

detail showing Church Family buildings with horses and carriage

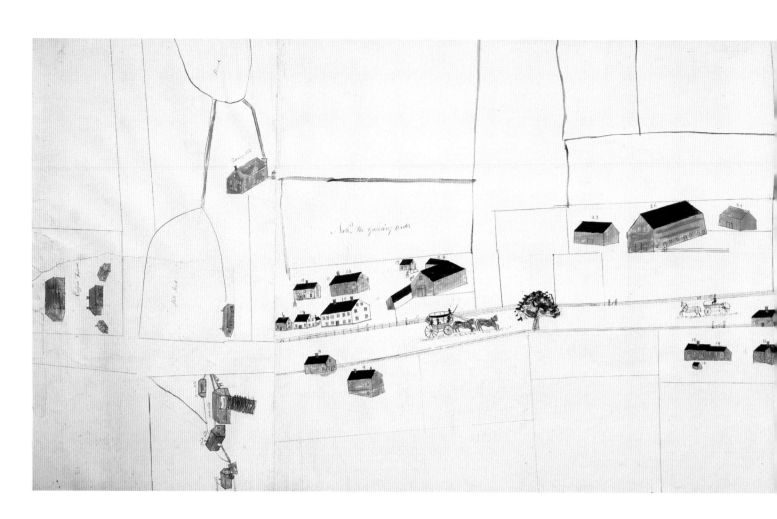

PLATE XX The Shaker Community at Alfred,
Maine
attributed to Joshua H. Bussell, ca. 1848
Courtesy, Museum of Fine Arts, Boston
Gift of Dr. J. J. G. McCue, 1978.461

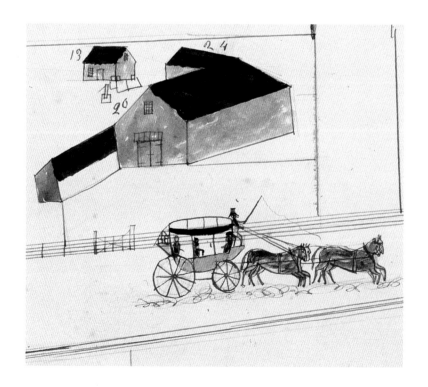

PLATE XXI The Shaker Community at Alfred,
ca. 1848
detail showing the horses and carriage

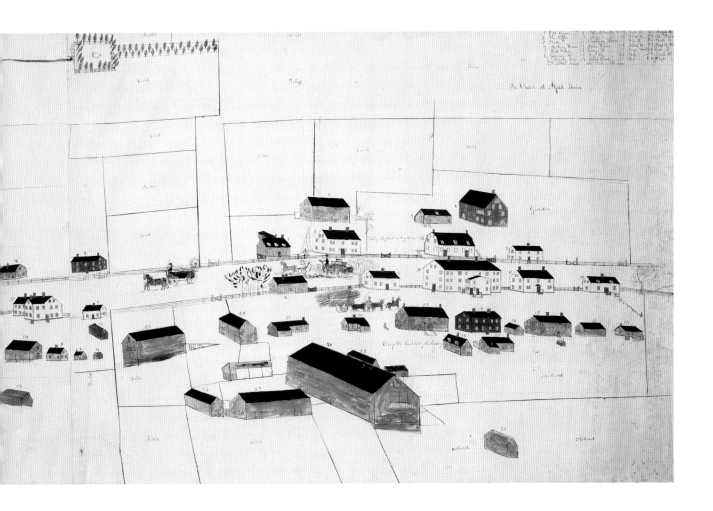

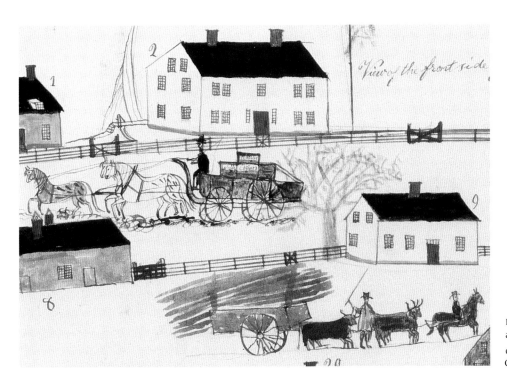

PLATE XXII The Shaker Village
at Alfred, ca. 1848

detail showing wagons at the
Church Family

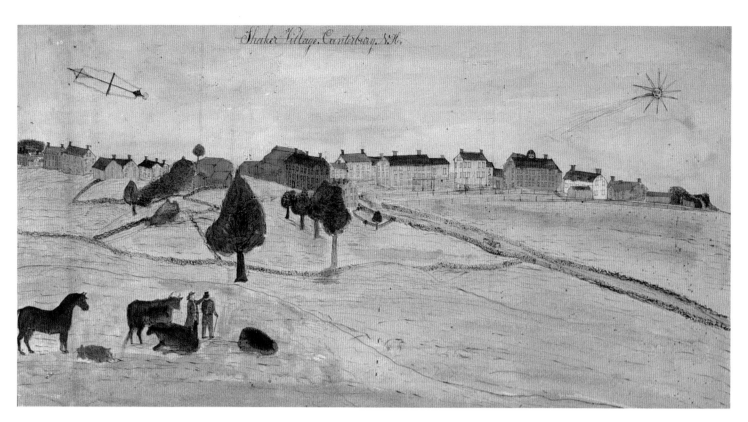

PLATE XXIII The Shaker Village at Canterbury,
New Hampshire

attributed to Joshua H. Bussell, ca. 1850

Courtesy, Henry Francis du Pont Winterthur Museum

Edward Deming Andrews Memorial Shaker Collection,
SA 1535

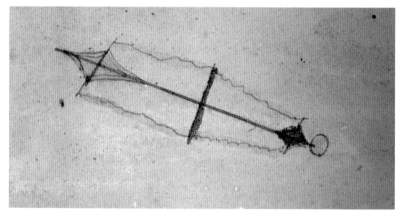

PLATE XXIV The Shaker Village at Canterbury,
New Hampshire, ca. 1850

detail showing directional arrow

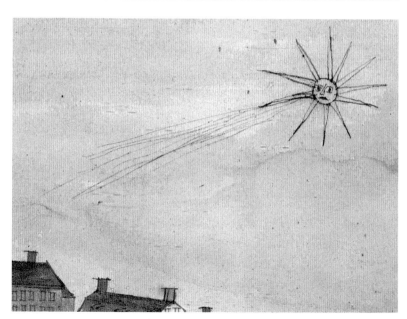

PLATE XXV The Shaker Village at Canterbury,
New Hampshire, ca. 1850

detail showing beaming sun

PLATE XXVI The Shaker Community at Poland Hill, Maine
by Joshua H. Bussell, ca. 1850
detail showing figures conversing in the village
John Miller Documents, 1987

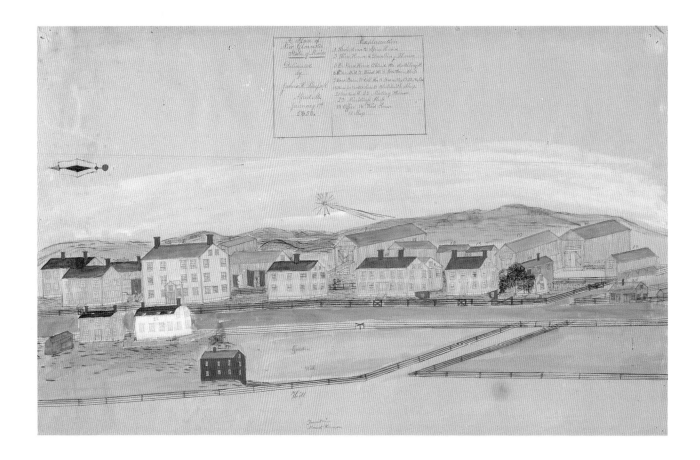

PLATE XXVII (*top*) The Shaker Community at New Gloucester, Maine
by Joshua H. Bussell, ca. 1850
Collection of the United Society of Shakers, Sabbathday Lake, Maine
John Miller Documents, 1987

PLATE XXVIII (*bottom*) A Northeast View of the Church Family at Alfred
attributed to Joshua H. Bussell, ca. 1880
Private collection

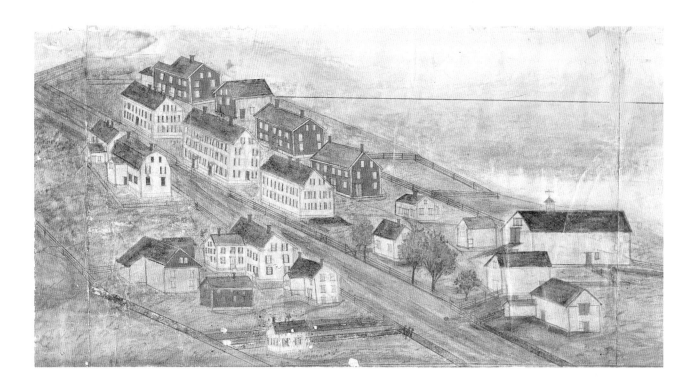

6 THE EARLY DRAWINGS OF JOSHUA H. BUSSELL

Joshua Bussell had just turned thirteen when, in the spring of 1829, he moved with his family from Portland, Maine, to the nearby Shaker community in the town of Alfred.[1] Communal life suited the boy well. In time he embraced the Shaker faith and grew to positions of responsibility and authority in the community. A cobbler by trade, he became a trustee, managing the Society's communal finances. He taught for a season in the Shaker school[2] and eventually served in the Elders' lot, overseeing the spiritual needs of the Second Family at Alfred. He was a lifelong Shaker, dying in the faith at the age of eighty-four. He is remembered as an imaginative and creative man who wrote hymns to be sung at Shaker services and drew maps of the Society's villages in Maine.[3]

Seventeen of those drawings are known today, almost half of the Shaker maps in existence. Made over the course of more than three decades, they can be divided chronologically into groups and interpreted by examining the sources of the artist's motivation and the influences that shaped his perceptions.

His first four maps were all pictures of home, the Shaker village at Alfred. Colorful, precise, and filled with the serendipity of his personal observations, these drawings illustrate the way Joshua Bussell gradually introduced a remarkable artistic vision to the task of mapping Shaker villages. So striking are his drawings that an analogy might be made to the painted furniture produced during this period by the

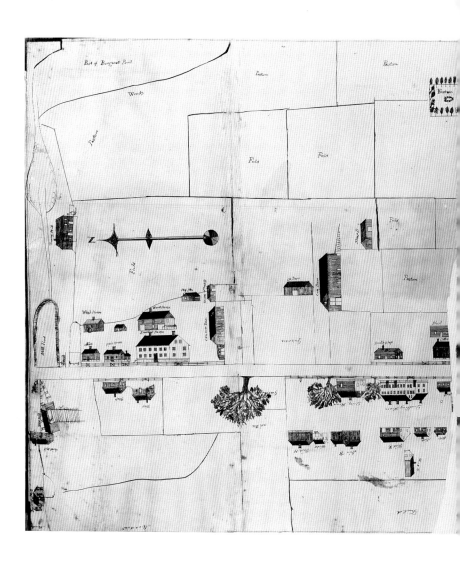

Figure 76. The Shaker Community at Alfred, Maine

By Joshua H. Bussell (1816–1900)

August 28, 1845

Ink and watercolor on paper

21 5/8″ × 39 3/8″ (55.0 × 100.0 cm)

Inscribed: "A Plan of Alfred Maine"

Library of Congress

Shakers' rural neighbors in southern Maine. Though their furniture was simple and utilitarian, it was occasionally painted with vivid colors and extravagant designs, and recent research suggests that the most exotic decoration came from areas associated with Maine's impassioned religious revivals.[4] It is not inconceivable that the exotic appearance of Joshua Bussell's early drawings was rooted in the same forces that impassioned his spiritual life. Without a doubt, his drawings are among the finest Shaker maps ever made.

The Shaker village at Alfred grew up around the old Barnes family farm, its three Families stretching for three-quarters of a mile along the road from Alfred to Waterboro. In 1845 Joshua Bussell drew the road as a straight, uninterrupted median, running north and south across the width of his map (fig. 76). On each side of the road he laid out the plan of the Shaker property, labelling the divisions of land: "Field," "Pasture," "Garden," "Meadow," "Orchard," "Part of Bunganut Pond."

Most of the Shakers' buildings faced the road, and the artist drew them as elevations. In the manner of the Shaker cartographers who preceded him, he sketched the principal facade of each one, with the inevitable result that half of the buildings were standing on their heads no matter which way the map was held (fig. 77, Pl. XVI). Like Br. Austin's pictures of the buildings at Watervliet, Br. Joshua's sketches are meticulously drawn, revealing a detailed knowledge of the village ar-

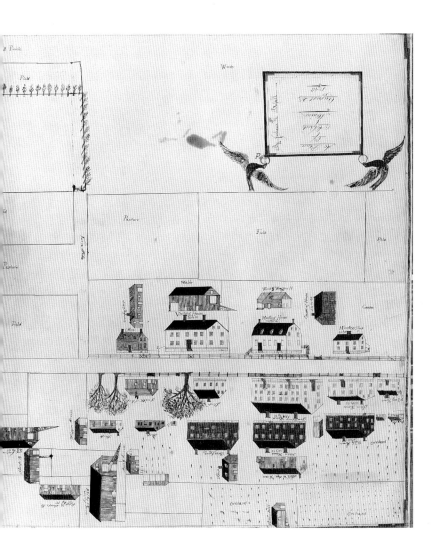

chitecture. The panes of individual window sashes are accounted for. Walled ramps to the main levels of the barn are illustrated, stone by stone. Vertical board siding on barns can be distinguished from horizontal clapboards on shops. The Church Family dwelling has door hoods over the entryways. On the first floor of the meetinghouse the windows have been shuttered.

Br. Joshua colored his buildings in vivid hues, with the same attention to detail. Along the lane, the major buildings are colored white with red doors, except for the meetinghouse, whose doors are blue. A thin line of light blue separates the white of their walls from the white of their cut-granite foundations. The community offices are painted green, the workshops red, and the barns and sheds brown.

He then identified the buildings as he did the lots of land, with individual labels. Along the roof tops of the Church Family structures are descriptions and measurements: "Nurse House 34 × 46," "Spin House 33 × 46," "Visiting House 36 × 40." None of the smaller buildings at the Church Family and none of the buildings at the Second and North Families rated measurements. These are described only as "Hog Sty," "Smith Shop," "Cider Mill." Altogether, his map provides a remarkably precise view of the buildings at Alfred.

Other structural features are noted as well. Pumps stand at wellheads in the yards of five buildings. Four-rail fences line the roads; a

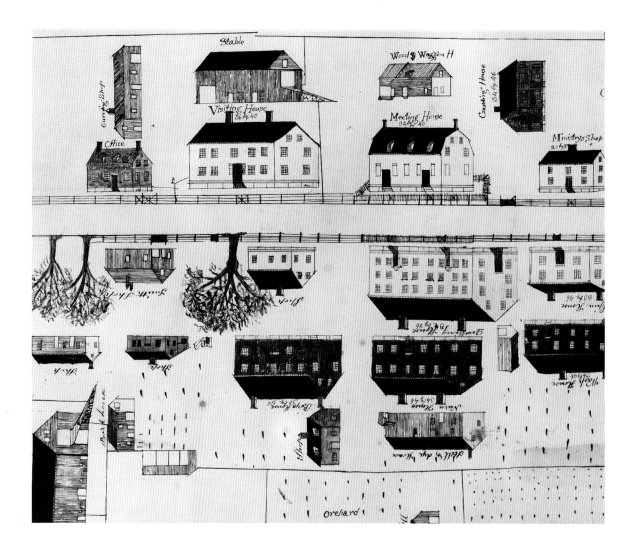

Figure 77. Detail of figure 76 showing Church Family buildings

picket fence surrounds the meetinghouse. At the top of the hill is the spiritual "Fountain" with its carved marble slab; a gate with a "Turn Pike" keeps the farm animals from wandering into the sacred site.

Br. Joshua represented trees in different ways. The only flora illustrated on this map, they apparently held various kinds of significance for him. Every tree in the apple orchard is marked with a dot to signify its place in row. Of the many shade trees that grew on the Shakers' land, he pictured only six, all on the west side of the lane. Only one is identified, and that only as an "ash tree." The cedars that lined the lane up to the "Pinicle" and surrounded the fountain ground are not drawn flat upon the hillside like the rest of the three-dimensional features, but are shown standing up in naturalistic perspective.

At Alfred the spiritual fountain was laid out on a hilltop high above the rest of the village. Representing this height of land posed a problem for the artist. Though it was a significant aspect of the way the village looked, he could not illustrate the elevation in his isometric plan. By experimenting with the artifice of perspective drawing, he made his line of cedars suggest the ascent up the farm lane, though he could not yet depict it in the same forthright, accurate way that his careful drawings recorded the buildings or plotted the outlines of the divisions of land.

In his early drawings Br. Joshua experimented with several approaches for resolving this artistic dilemma. The solution on this, his

first attempt, was to turn the map over and, in a companion drawing, make two sectional views to plot the profile of the hill in both north-south and east-west sections. These profiles are labelled at appropriate places: "Pasture," "Pinicle," "Buildings," and "Hill," "Plaines," "Burying Yard."

With room left over beneath these two diagrams, he redrew the path of the lane through the village. His outline of the "Shape of the Road from one bridge to the other" depicts it more accurately than the plan, as a gently curving lane interrupted by one abrupt turn. A note at that point explains why the shade tree at the North Family was singled out for special attention on the map. Br. Joshua's label reads "Crook in the road at the ash tree."

When he was through with his map, Br. Joshua gave it a title, dated it, and signed his name. He drew the title in an empty pasture, and, repeating the border that surrounds the entire drawing, enclosed it within a frame of red, green, and yellow lines. Not sure himself which way the map should be read, he faced his title to the east, although every inscription that surrounded it—including the word "Pasture," which it partially overlapped—faced downhill to the west. Finally, he suspended this colorful cartouche from the beaks of two soaring birds—interestingly, the same artistic device used by Henry Blinn three years later in his "Plan of Canterbury."

It seems likely that during this period the two Shaker mapmakers were sharing ideas about their drawings, for the birds are not the only feature common to both maps. Another familiar element in Joshua Bussell's drawing is his bold directional arrow (Pl. XVII). It was customary for Shaker cartographers to draw their directionals in complex and involved forms, but Br. Henry and Br. Joshua drew the most prominent arrows of all. In Joshua's case, this distinctive feature would become an extravagant and fantastic artistic conceit. The arrow he sketched on his first map of Alfred had a broad tip, and at the other end, a colorful disc. In the middle was his crossbar, shaped like a pivot point. Quite possibly, Br. Joshua modeled his directional after a barn weathervane. In later drawings he pictured similar devices mounted on barns and actually serving as weathervanes. But no matter what the source of inspiration, his arrow was of his own design. It is as distinct as his signature and can be used to identify the pictures he drew later in life, long after he stopped signing his work.

The way Br. Joshua phrased his title—"A Plan of Alfred Maine"—suggests that the map was intended for use out of state. While identifying the scene as a Shaker village was unnecessary, given the long distance from Alfred to New Lebanon and the infrequency of the Parent Ministry's visits to Maine, it could have been prepared for the church leaders in New York. It is part of a group of Shaker village views whose titles share this characteristic phrasing. Like many of that number, it was presented to the Library of Congress by an unknown donor early in the twentieth century.

A second drawing entitled "A Plan of Alfred Maine" (fig. 78) is dated November 20, 1846, the year after Joshua Bussell drew his first picture of the Shaker village at Alfred. It is not signed by the artist, but it is stylistically so similar to the 1845 drawing that it is safe to assume that it is Br. Joshua's work. The village had not changed much in a year. Whatever changes had taken place were noted principally at the Second Family. The buildings retained the same colors, except for the office, which was now painted white. A small shed had been built onto the ox barn. A water line had been run from the well to the wash house. Two shade trees are missing from the road, and some cedars

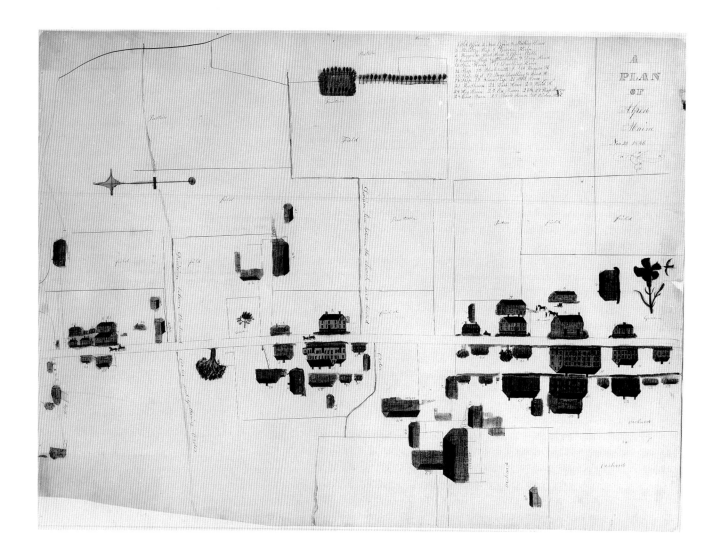

Figure 78. The Shaker Community at Alfred, Maine

Attr. Joshua H. Bussell (1816–1900)

November 20, 1846

Ink, watercolor, and gum arabic on paper

21 1/2" × 29" (54.6 × 73.7 cm)

Inscribed: "A Plan of Alfred Maine Nov 20 1846"

Collections of The New York State Museum, Albany, New York

from the lane to the fountain. There was no reason to have made a new map just to record these few changes; Br. Joshua probably drew it as a copy of the original, to send to another Shaker community. But the second map diverges from the first in other, significant ways. It has a different feeling about it. The changes that took place were not in the village itself, but in the way that Joshua Bussell perceived it.

First of all, the map is smaller, reduced more than ten inches in length from the original. In order to fit the same scene on this second map, the artist reduced the scale of the landscape. At the same time, however, he maintained the original scale of the Shaker buildings, thus further increasing the already disproportionately large ratio of the structures to the landscape. Having abbreviated the distance between the three families, Br. Joshua sought to clarify their actual situations in two ways. On the back of the map he copied his elevated cross sections, "View of the Hill East and West" and "View of the Hill North and South," illustrating the relative positions of the families. And on the grid of the landscape he had plotted on the front of the map, he distinguished the physical boundaries that separated them with red lines marked "Division line between the church and the Second Order" and "Division between the Second Order and Gathering Order."

The boundaries between the families, as illustrated in Br. Joshua's notations identifying them, ran perpendicular to the lane through the

village. In this copy map the orientation of those inscriptions seems incongruous, for by now Br. Joshua understood that his map should be read from a single direction. On both sides of the road, he arranged the labels on his lots of land with consistent orientation. "Field," "Pasture," "Orchard," and "Garden" can all be read in one direction, with the hill at the top of the page. The title shares this orientation, as does a feature newly added to this map; in a field next to the title is a numbered key listing thirty buildings at the Church Family, such as "Spin House," "Still House," and "Bark House." The same numbers are used to identify the fifteen buildings at the Second Family and the twelve buildings at the North Family. The Church Family designations did not always fit at the other orders: at the North Family, some buildings are numbered "21/6" (Wood House/Waggon House) or "25/28" (Ox Barn/Cow Barn). Ultimately, however, describing the buildings in a key was an improvememt over labelling them individually. By numbering the buildings, Br. Joshua avoided having to align the name of each one on the particular axis on which he drew it, thus maintaining a consistency of orientation in his inscriptions.

In contrast to the written descriptions, however, the buildings themselves are still pictured splayed to each side of the lane, the front of each one being illustrated regardless of the way it was sited in the village. There are differences between this map and the earlier one in the way he portrayed the buildings that make it apparent that Br. Joshua was experimenting with solutions to the dilemma he had created by drawing simultaneously in two and three dimensions. In order to unify his point of view, he drew the buildings of the Church Family from the north, illustrating their gable ends all facing inward to the left. At the other side of the map he drew the buildings at the Second and North Families, with their gable ends facing inward to the right. Presumably he sought to picture the buildings as he saw them from a single vantage point, while standing in the center of the village. Though the device does little to improve the awkward appearance of the upsidedown buildings, it reveals that Br. Joshua understood the limitations of his drawing, and, step by step, was working his way toward a more conventional style.

Another aspect of Br. Joshua's development as an artist can be observed in his movement away from literal representations to more generalized illustration when identifying a particular feature. One example is the way he portrayed the orchards and gardens in his second known map of Alfred. Instead of covering the orchard lots, as he had done previously, with rows of dots marking the sites of specific apple trees, this time he left the orchard blank, trusting the viewer to conclude that it contained apple trees. At the same time, he drew one enormous flower in the gardens of both the Second and the Church Families. Br. Joshua had learned that he could better illustrate what was growing somewhere in the manner of Henry Blinn, with a representative sketch, than he could by trying to depict each of the plants in detail.

The idea of illustrating his maps evidently appealed to Br. Joshua. The weathervane arrow so colorfully drawn on the 1845 map and the landmark ash tree at the crook in the road are both repeated here in a simplified form. The doves that held the first map's title are now recalled by a hummingbird sipping at the flower in the Church Family garden. Articulated directionals and illustrations of flowers and birds had appeared before in other Shaker village maps of the 1830s and 1840s, works that might have influenced the look of Br. Joshua's own

drawings. But now the Maine artist, working in a community far removed from the mainstream of Shaker thought—and far from the direct supervision and controls of the parent ministry—started to illustrate his maps with sketches without precedent in any other Shaker drawings.

In front of the Second Family office, a tiny Shaker brother drives a buckboard and team down the lane to the North Family (Pl. XVIII), where a similar figure rides past the Trustees' office. An empty carriage stands outside the Church Family wagon house, and in the field behind the new office two brethren in Shaker hats have unharnessed their horses and are walking them into the office stable (fig. 79, Pl. XIX).

Perhaps these figures represented brethren connected with the offices at the three families. Or, perhaps Br. Joshua included them to emphasize the fact that his foreshortened drawing actually showed a long stretch of road where a carriage and team might prove useful. At any rate, no matter how sprightly they appear, these vignettes do not seem to have been drawn capriciously. They may have been intended to signify some fact of Shaker life to the viewer—a message understood by the nineteenth-century Shakers but obscure to us today.

This copy of the Alfred map was sent to the Shaker village at Watervliet, New York, where it was kept until the close of the community. Over the years, the daubs of transparent gum arabic that Br. Joshua had used to seal his colors have darkened, turning all the buildings a golden yellow. Torn and faded, it was one of three Shaker village maps discovered in the abandoned buildings at Watervliet in 1926. In 1930 it was presented to the New York State Museum by the Commissioner of Public Charities at the Ann Lee Home, built on the site of the first Shaker community.[5]

After producing two plans of Alfred for presentation to his gospel kindred in other Shaker communities, Br. Joshua drew a third map of the village solely for the benefit of the Believers at home (fig. 80, Pl. XX). Since he intended this map to be seen and used by a limited circle of friends, his style was less self conscious, and his work was freer in expression. In this colorful and detailed map, Br. Joshua recorded his personal observations of daily life at Alfred.

Though the map is unsigned, Br. Joshua's style of drawing can clearly be recognized in it. And while it is undated, it appears to represent the next step in his artistic development. Evidently it was made soon after his 1846 plan. This time, however, he increased the scale of his drawing. Much as Henry Blinn had done in his maps of New York and New Hampshire, Joshua Bussell drew the families on three separate pieces of paper, pasting them together as he went along until his map was almost six feet long.

Instead of giving a single title to the entire map, Br. Joshua labelled each section as he drew it. First was the Church Family, which, in place of the elaborate inscription on his first two maps, was headed simply "The Church at Alfred Maine." As was his custom, he started by dividing the landscape into the familiar isometric grid of orchards, pastures, and woodlots. The way he pictured the family's buildings, however, marked a real turning point for Br. Joshua. With this map, he reveals that he had found a way to represent his three dimensional structures realistically. His solution was to remove his point of view from the lane in the center of the village to a vantage point outside the picture. The buildings now are viewed in three-quarters perspective from a vantage point somewhere high in the air over Massabesic Pond, directly west of the village.

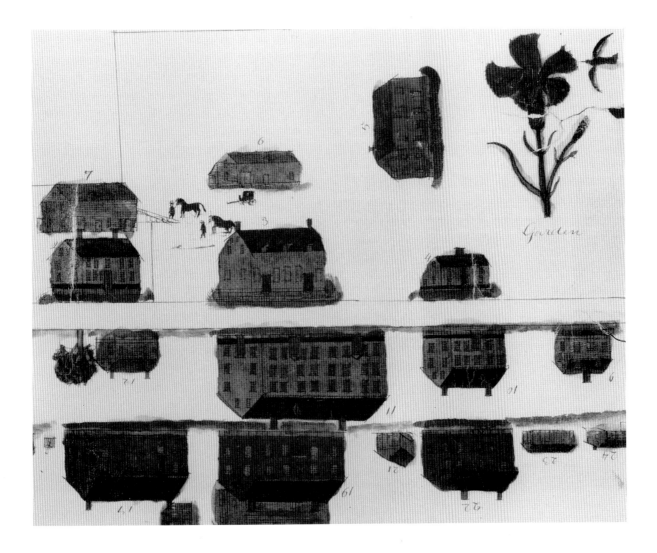

Figure 79. Detail of figure 78 showing
brethren with horses

In order to make this transition, Br. Joshua had to overcome his inclination to illustrate every one of his buildings from the front—even those that faced to the east, away from his vantage point. This must have been a revolutionary idea for him, and even after he drew the buildings he may have been a little unsure how successful this new technique would be. Feeling that he should explain his novel approach, he added inscriptions on both sides of the road: "View of the front side of the buildings" and "View of the back side of the buildings." Although the buildings to the east of the road looked about the same as they would from the lane, and as they had appeared in his earlier drawings, the buildings to the west were illustrated from an unfamiliar, and, indeed, an imaginary point of view. No such explanations accompany the buildings of the North and Second Families. They were drawn on a second sheet of paper, entitled "North, the Ga[t]hering Order." By the time he drew them, he was evidently more at ease with his new technique.

To the north, beyond the buildings of the North Family, were the mills and the Coffin Farm. These buildings are labelled individually, as none of the descriptions in the Church Family key applied to the situations there. Here, on the third section of the drawing, the unity of Br. Joshua's perspective fell apart. The buildings in this section were built along the mill stream and along Shaker Road, both of which ran at

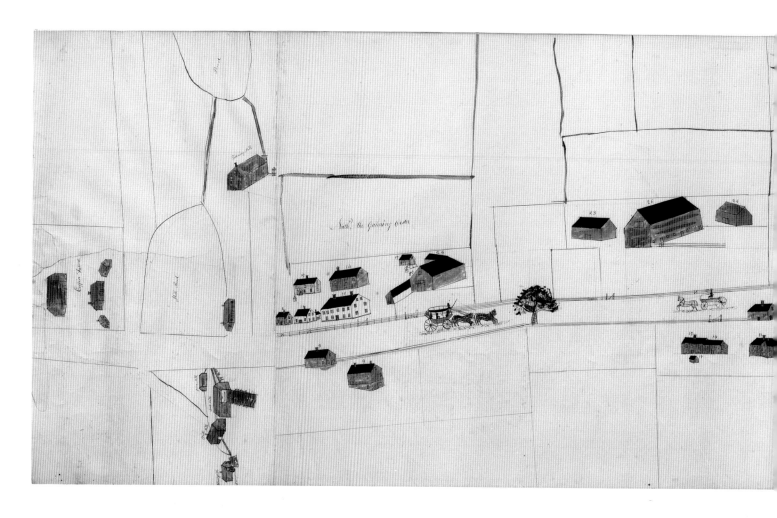

Figure 80. The Shaker Community at Alfred, Maine

Attr. to Joshua H. Bussell (1816–1900)

Ca. 1848

Pencil, ink, and watercolor on paper

21″ × 68 1/2″ (53.3 × 174.0 cm)

Inscribed: "The Church at Alfred Maine" and "North, the Gahering Order"

Courtesy, Museum of Fine Arts, Boston Gift of Dr. J. J. G. McCue, 1978.461

right angles to the lane through the village. Br. Joshua had learned to draw a building from its narrow or gable end—the barns of all three families are pictured in perspective for the first time in this drawing—but his perspective was employed only on the buildings, not on the landscape. The road up the hill to Bunganut Pond runs straight off the top of the paper; with the axis turned ninety degrees, Br. Joshua could not plot his buildings along the same horizon, and he reverted to his earlier style of standing them on their sides.

Although it was part of the isometric plan of the landscape, Br. Joshua drew the lane through the village as a three-dimensional feature by blocking the view with elevations of the buildings and trees, by lining the lane with fences, and by illustrating the rise and fall and the crooks and turns of the road. These techniques took the place of the pictures that he had drawn on the backs of the first two maps, showing the elevations of the hillside in section. With his new perspective, these supplementary elevations were no longer necessary, and they do not appear in his maps again.

Throughout the nineteenth century this lane was the main highway north from the town of Alfred, and Br. Joshua filled the road with little sketches of wagons and carriages passing through the Shaker village. These cartoons were more elaborate versions of the horses and wagons he pictured in the 1846 map. Having enlarged the scale of this draw-

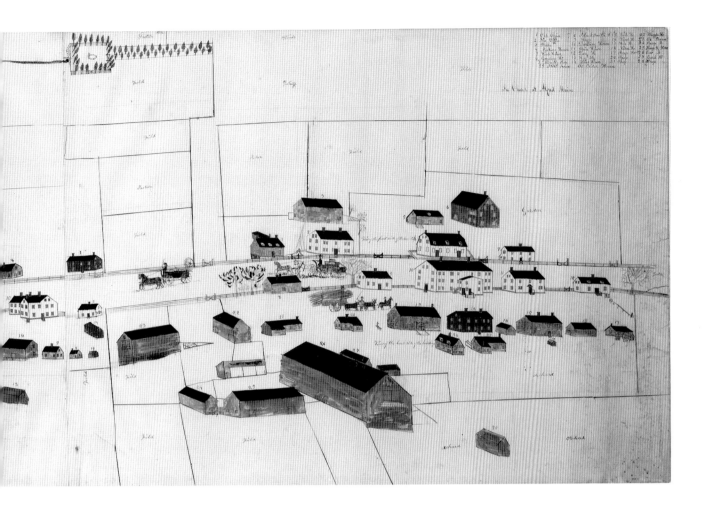

ing, he was able to illustrate the scenes in much greater detail. At the North Family, a team of four horses pulls a Concord coach with a driver and three passengers up the rise to the crook in the road at the ash tree (fig. 81, Pl. XXI). Approaching them from the other direction is a teamster riding in a light blue buckboard. Other freight wagons follow. At the Second Family office is a man clearly dressed in Shaker garb, hauling a load of the spinning wheels that were manufactured at Alfred for many years (fig. 82). Interestingly, Br. Joshua shows the three wheels standing up, fully assembled and hanging out the back of the wagon. This would be a precarious way to transport spinning wheels, and possibly it was meant as a stylized representation, pictured in this way only to illustrate the nature of the cargo. Indeed, Br. Joshua's illustrations had begun to function as narrative scenes.

Behind the spinning wheels comes a wagon with a load of boxes marked "whips," "matches," and "cigars" (fig. 83, Pl. XXII). Like the other wagons, this one was drawn passing the trustees' office, where the Shakers conducted their business with the outside world. Possibly the contents of the boxes were products of Shaker industry, made at the Church Family and sold by their trustees. While the references to matches and cigars is enigmatic, the whips might be explained by the fact that Br. Joshua was himself trained as a cordwainer and contributed to the family's production of leather buggy whips.

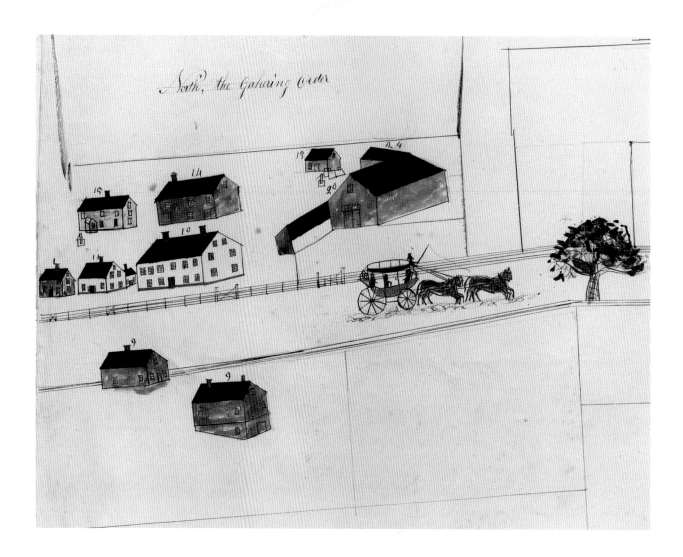

North, the Gahaing Order

Figure 81. Detail of figure 80 showing a coach at the North Family

The most elaborate vignette appears in the yard behind the blacksmith shop, where two Shaker brethren are hauling a dumpcart load of poles. The driver, in his drab-colored cloak, is standing in the correct position next to the team, with his goad in the hand next to the nigh ox. The oxen's yokes are linked with chains, though the whipple-tree that connects them to the lead horse is harnessed with leather tugs. All these details are consistent with nineteenth-century teamster practice. Although the scene is only about one inch high, this vignette is accurate in even its most minute details, and serves as an indicator of the verisimilitude of the drawing as a whole.

The buildings at Alfred were painted in a variety of colors—brown for barns, red for workshops, green for offices, and white for dwellings, the meetinghouse, and some of the shops that lined the road. This liberal use of white paint appears to run contrary to the Millenial Laws of 1845, which specified that "No buildings may be painted white, save meeting houses."[6] But in each of Br. Joshua's drawings of Alfred, the same buildings are consistently pictured in the same colors, suggesting that the map accurately represents the appearance of the village, and that the Believers at Alfred felt free to decide for themselves what colors to paint their dwellings and shops.

The brilliance of the original colors of this drawing has survived, due in part to the fact that it was not kept displayed in the sunlight. In-

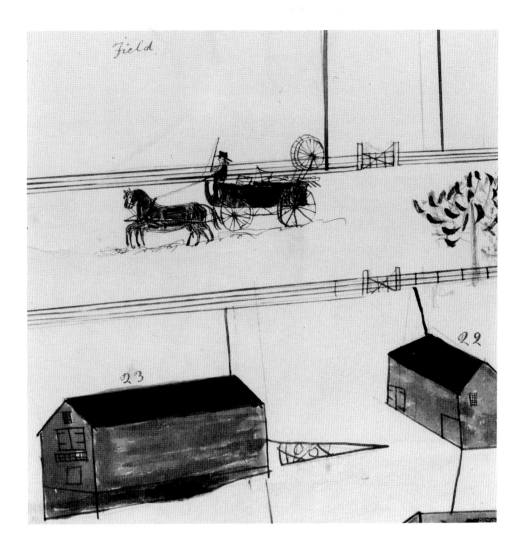

Figure 82. Detail of figure 80 showing a
Shaker brother driving a wagon-load of
spinning wheels

stead, it was stored away from the light: the soiled margin along its left
or southern edge reveals that it was rolled into a scroll and put away
when not in use.

On the back of the scroll are two penciled inscriptions. One is the
artist's name: "Joshua Bussell Alfred Me." The other reads "Otis Sawyer
New Gloucester." Elder Otis served in the Maine ministry and oversaw
the communities at Sabbathday Lake, in the town of New Gloucester,
and at Alfred, beginning in 1859.[7] Apparently this drawing was sent to
him at Sabbathday Lake some time before his death in 1884. It re-
mained there until 1951, when it was given to a private collector, who
donated it to the Museum of Fine Arts, Boston, in 1978.

By the time he drew his fourth picture of the Shaker village at Alfred
(fig. 84), Joshua Bussell had found the solution to making his pictures
look more conventional. Having already learned to illustrate his build-
ings from a vantage point outside the locus of the picture, he now dis-
covered how to draw the landscape from the same point of view. The
title he chose to describe this painting suggests that he understood that
his artistic skills were becoming more sophisticated. The "Southwestly
View of Shaker Villege Alfred" marked a turning point in his transfor-
mation from cartographer to landscape artist.

To be sure, Br. Joshua did not discard his customary grid of pastures
and woodlots. It can be recognized in the hedgerows, stone walls, and

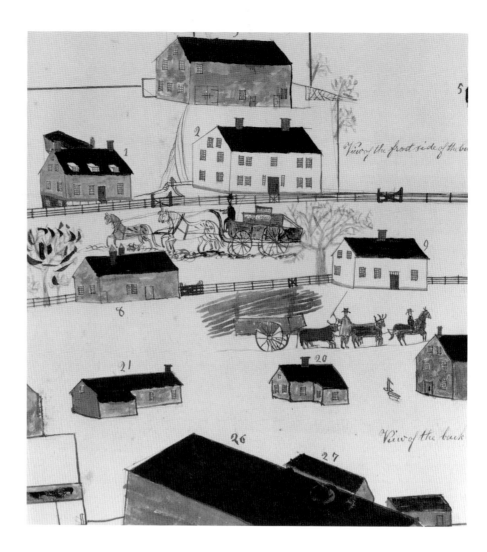

Figure 83. Detail of figure 80 showing a freight wagon and a Shaker brother driving oxen

rail fences. But by laying this plan back against the hillside, and by drawing the lot divisions as elevated sketches of actual features instead of his customary flat outlines, he created the illusion of depth that he had been trying to achieve. Finally the hill rose above the shores of Massabesic Pond to a pinnacle on the horizon against the eastern sky.

In part, the illusion of a third dimension succeeds because of all the little features Br. Joshua illustrated as elevations on the landscape. Most prominent are the buildings. They are all shown in three-quarters perspective, including a new barn now added at the North Family—though Br. Joshua was still wrestling with the perspective of buildings that stood with their narrow gable ends to the road. He handled the smaller features better, however. The orchards full of apple trees, and the horses and cows grazing in the pastures help to interrupt the flatness of the landscape. Above the horizon a smiling sun beams down upon the pinnacle. At the bottom of the drawing, the waters of Massabesic Pond are illustrated, enlivened with two boatloads of Shakers rowing about (fig. 85).

Though he had noted the skyline and the pond in diagrams showing the profile of the hill, this was the first time Br. Joshua ever illustrated them. This time, the format he used gave him plenty of room to do so. He retained the proportions he had developed in his long map of the

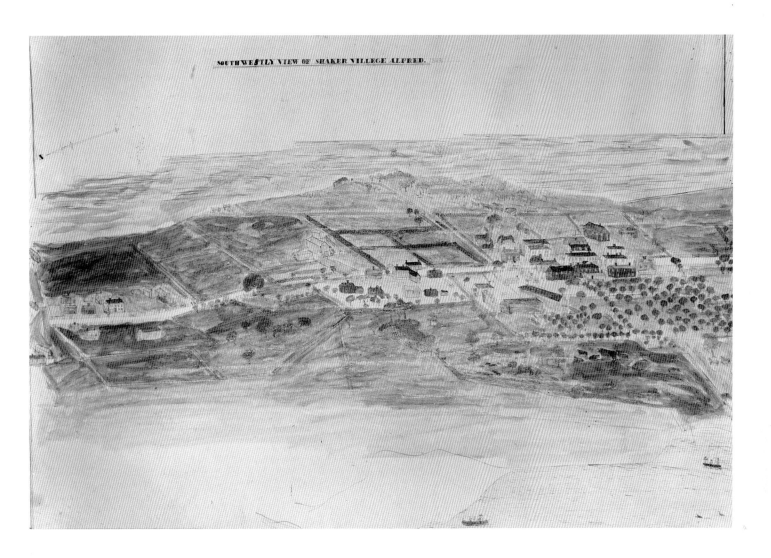

SOUTHWESTLY VIEW OF SHAKER VILLEGE ALFRED.

village, spacing the three families accurately along the lane. But he reduced the length of this drawing by more than half, while at the same time keeping its height the same. As a result, the compact scene extends beyond the right and left edges of his outlined borders while large areas of the map are left blank at top and bottom.

Now seen from afar, the details of the village are less distinct. The buildings blend together; the fountain ground has settled onto the shoulder of the hill. For the first time, the landscape is colored; washes of green watercolor take the place of the labels "Pasture" or "Field." There is no key to this drawing as there would be in a map, and no numbers or labels on the buildings. A few inscriptions can be found in the sky above the horizon, so faint they might be easily overlooked. Vestiges of his earlier style of drawing village maps, the words "Pinicle" and "Fountain," are lightly penciled in. At the fountain ground, just barely legible, is the inscription "Phileamon's Stone," a reference to Philemon Stewart, the inspired visionary from New Lebanon who in 1843 directed that the fountain ground be established on the pinnacle.[8]

It is not clear just when this view was drawn. When the title was first laid out in pencil it included the date "1849." But when Br. Joshua went back over it and traced the title in ink, he omitted the date. However, he did leave it clearly visible in pencil, to the right of the word

Figure 84. The Shaker Community at Alfred, Maine

Attr. to Joshua H. Bussell (1816–1900)

Ca. 1849–51

Pencil, ink, and watercolor on paper

22" × 29 3/4" (55.9 × 75.6 cm)

Inscribed: "Southwestly View of Shaker Villege Alfred. 1849"

Collection of the Henry Francis du Pont Winterthur Museum, The Edward Deming Andrews Memorial Shaker Collection (SA 1531)

Figure 85. Detail of figure 84 showing
Shakers boating on the lake

"Alfred." Perhaps he considered it unimportant to highlight the date of
the drawing. Perhaps several years had elapsed while he was working
on the view, and since the date was appropriate only to the year he
started it, he left it, but only in pencil. And perhaps a solution to this
small puzzle lies in the cartoons at the bottom of the page.

At the lower center is another narrative scene. A Shaker brother is
taking two Shaker sisters for a boat ride around the pond. On the lower
right are three more brethren, rowing and fishing (fig. 85). In this boat
the figures are identified as "F.W.," "JG." and "WN." Clearly, Br. Joshua
intended these cartoons to commemorate some occasion, very likely
the visit of Elder Freegift Wells from the Shaker village at Watervliet,
New York, late in the autumn of 1851. In the journal of his trip to Al-
fred, Elder Freegift recorded that when he arrived in Portland on No-
vember 22, he "found Br. Joshua Bustle ready to convey me to Alfred."
It was late in the season for a boat ride, and the visiting Elder did not
mention rowing on the lake. He did say, however, that "The day has
been uncommonly beautiful & pleasant," [9] and it is entirely possible
that Freegift Wells was the F.W. identified in the cartoon. This inter-
pretation would explain the inconsistency of the dates: in 1851 Joshua
Bussell may have added the cartoon figures to a drawing he started
in 1849.

The story of that boat ride may be lost in the past, for relatively little is known of the history of Alfred. In 1902 the Church Family dwelling and meetinghouse were destroyed by fire, and with them were lost many of the community's records.[10] This drawing was spared, evidently kept apart from the formal documents. After the community closed in 1931, it was acquired by the early Shaker collectors Edward Deming Andrews and Faith Andrews. It remained in their collection until 1969, when it came to the Winterthur Museum.

7 NEW HORIZONS AND LANDSCAPE VIEWS

Within the space of four or five years Joshua Bussell's Shaker village drawings evolved from the kind of isometric plans delineated by his Shaker brethren to limner-like landscape views. Though the change came gradually, each new picture demonstrated his growing awareness of artistic convention and understanding of perspective drawing. Within a few short years his style of drawing had changed completely.

Such stylistic development is typical of self-taught artists, who progress through trial and error and learn by observing the examples of others. The handiwork of Shaker artisans reflects this kind of development—the objects they created to fill their villages were originally no different from the corresponding forms they found in the world beyond their communities. But they simplified and refined their furniture, their textiles, their metalwork, and even their buildings, until, through years of innovation and experimentation, they achieved a fine balance between grace and utility.

As a graphic artist, however, Br. Joshua was in a unique position: beyond a certain point he could not profit from this communal experience. True, Shaker village maps served a practical purpose in documenting the lands and buildings of a community, and similarities in the work of several Shaker cartographers indicate that they shared information about their methods and styles of drawing. Landscape

views, however, were a different matter. They were less useful as documentary drawings and came close to violating the Shakers' prohibitions against worldly and superfluous ornament. Apparently, there was no Shaker model for a landscape view. Therefore, when he wanted to draw more convincing pictures of Shaker villages, Br. Joshua could not rely on a body of Shaker secular art for the same kind of guidance that he could have when he was composing a song or crafting his leatherwork. When he started to experiment with drawing landscape views, he forged into new territory beyond any existing Shaker tradition.

Left to his own devices, Br. Joshua copied the style of drawing he had observed in a contemporary landscape view. The various restrictions on worldly pictures detailed in the Millennial Laws suggest that popular prints were not generally available in Shaker communities. But there were undoubtedly exceptions to this prohibition; one was a small wood engraving by an unknown artist of the Shaker village at Canterbury, New Hampshire. Joshua Bussell acquired this print, studied it at length, and then used it as the basis of a watercolor drawing.

From this exercise he discovered that there was a more sophisticated way to draw a landscape view and realized that his previous work must have appeared childlike and naive. This discovery marked a turning point for Br. Joshua; with this loss of artistic naiveté, he became exclusively a landscape painter, never returning to the precise delineations that typified his earlier style as a documentary cartographer.

Of Joshua Bussell's seventeen surviving drawings, all but one picture Shaker villages in the state of Maine. The remaining drawing is a landscape view of the community at Canterbury, New Hampshire (fig. 86, Pl. XXIII), one he copied from the published wood engraving. Though it is unsigned by the artist, it bears his distinctive marks. His colorful directional arrow floats in the sky above the North Family, its tip, tail, and crossbars now strung together like a kite (Pl. XXIV). Next to it, the title "Shaker Village. Canterbury. N.H." has a familiar ring: it is phrased in the same words as Br. Joshua's "Southwestly View of Shaker Villege Alfred" (fig. 84). Indeed, the laughing sun on the hilltop (Pl. XXV) and the horse and cows at the lower left appear in both paintings, which suggests that the two views were done at about the same time.

Across the horizon, from the Second Family office to the Church Family carriage house, the buildings are painted yellow and brown. Two exceptions are the brick structures, which are colored red, and the meetinghouse, which was painted white—the accuracy of which is confirmed by descriptions recorded by visitors to the village in the mid–nineteenth century. The buildings are drawn in their actual positions and are illustrated with accurate details, such as the belfry on the 1796 dwelling house, or the porch on the front of the brethren's shop. But there is no record that Br. Joshua visited at Canterbury in these years, and in all likelihood he could not have drawn this scene from life.

The inspiration for this drawing was the first view of a Shaker village ever published, a small wood engraving showing the village from a vantage point in the pasture to the southwest (fig. 87). This same scene was copied by a host of other illustrators, and throughout the nineteenth century it appeared in numerous variations, illustrating encyclopedias, weekly newspapers, and sales brochures. The unmistakable similarities between the original woodcut and Br. Joshua's drawing indicate that he copied directly from the printed source.

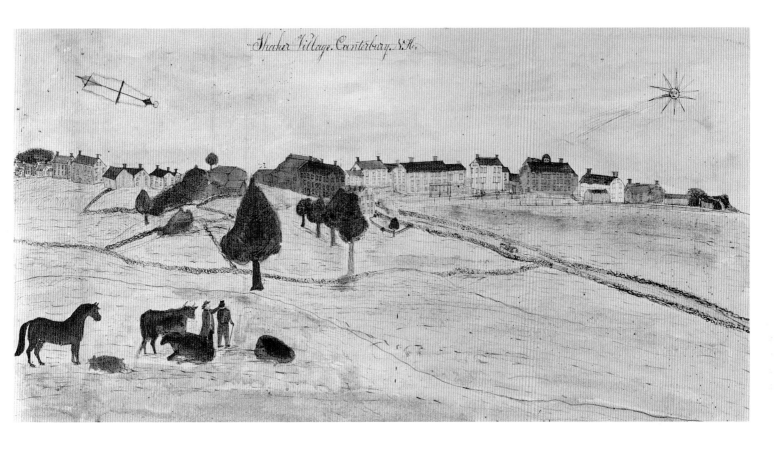

Figure 86. The Shaker Village at Canterbury, New Hampshire

Attr. to Joshua H. Bussell (1816–1900)

Ca. 1850

Pencil, ink and watercolor wash on paper

12 3/4″ × 21 1/2″ (32.4 × 54.6 cm)

Inscribed: "Shaker Village. Canterbury. N.H."

Collection of the Henry Francis du Pont Winterthur Museum, Edward Deming Andrews Memorial Shaker Collection (SA 1535)

The engraving was first published in the November 1835, issue of the *American Magazine of Useful and Entertaining Knowledge,* to accompany an essay about the Canterbury Shaker village.[1] It seems that the attitude toward popular magazines was unusually liberal at Canterbury— Henry Blinn recalled that in 1834 he was permitted to read the *Penny Magazine*[2]—and because the bulk of the article in the *American Magazine* was written by Canterbury trustees Francis Winkley, Israel Sanborn, and David Parker, it was probably considered appropriate reading matter, not only there but in other Shaker communities as well. At Alfred that fact gave Br. Joshua what may have been his first opportunity to study the technique of drawing landscape views. With this popular print of a Shaker landscape scene having gained the community's approbation, he could proceed to experiment with his own style of landscape drawing.

In the foreground of the Canterbury engraving, a Shaker brother in his long frock coat points out the buildings of the village to a worldly visitor sporting a walking stick and top hat (fig. 88). Prints like these of the Shaker villages at Enfield, Connecticut; Hancock, Massachusetts; and New Lebanon, New York, were made by Connecticut artist John Warner Barber in the 1830s and early 1840s for his historical gazetteers of those states. Drawn in more or less the same style as the Canter-

THE VILLAGE OF THE UNITED SOCIETY OF SHAKERS, IN CANTERBURY, N. H

Figure 87. "The Village of the United Society of Shakers in Canterbury, N.H."

Unidentified artist

1835

Wood engraving

4" × 5 3/4" (10.2 cm × 14.6 cm)

Private collection

bury woodcut, Barber's landscape views tended to be small and plain, with human figures in the foregrounds to give a sense of proportion and scale to the picture. But a direct comparison of the Barber views (figs. 118, 119, 120) with the Canterbury engraving clearly demonstrates two different artistic styles. At any rate, no evidence has come to light linking Barber with the Canterbury engraving, and his own notes record that in 1834 and 1835—that is, the eighteen months preceding the publication of the Canterbury engraving—he was travelling though Connecticut, engrossed in preparation for his *Connecticut Historical Collections.*[3]

It is more likely that this engraving is linked in some way to Nathaniel Hawthorne. In fact, it seems to illustrate the young author's description of his introduction to the village in August of 1831: "I walked to the Shaker Village yesterday, and was shown over the establishment," he wrote to his sister Louisa. "It is immensely rich. Their land extends two or three miles along the road, and there are streets of great houses painted yellow and topt with red."[4] Later that year Hawthorne used his detailed notes on the village and its inhabitants to describe the Shaker hillside in his short story "The Canterbury Pilgrims." Again, the scene bears interesting similarities to Hawthorne's narrative:

. . . two figures appeared on the summit of the hill, and came with noiseless footsteps down towards the spring. . . . One, a young man with ruddy cheeks,

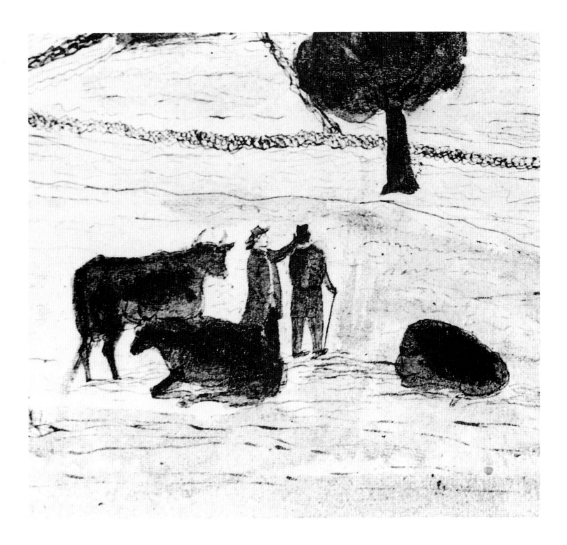

walked beneath the canopy of a broad-brimmed gray hat; he seemed to have inherited his great-grandsire's square-skirted coat, and a waistcoat that extended its immense flaps to his knees. . . .

"Is that white building the Shaker meeting house?" asked one of the strangers. "And are those the red roofs of the Shaker village?"

"Friend, it is the Shaker village," answered Josiah, after some hesitation.[5]

In 1832 Hawthorne sold "The Canterbury Pilgrims" to his publisher Samuel Goodrich, who published it that fall.[6] Three years later, Goodrich helped to found and publish *The American Magazine of Useful and Entertaining Knowledge,* in which the wood engraving of Canterbury was first illustrated. Hawthorne was not only familiar with *The American Magazine;* two months after the Shaker landscape view and article was published, he became its editor.[7] Given his interest in the Canterbury Shakers, it is possible that he had a hand in preparing the Shaker article and designing the illustration for it. Indeed, it is pleasing to speculate that the figure of the visitor in the top hat and cane might be drawn from Nathaniel Hawthorne's descriptions, and might represent the young author himself being introduced to the village.

None of this mattered to Joshua Bussell. By copying the woodcut he learned what he needed to know about drawing landscape views, and there is no evidence that he took any further interest in it. In fact, his interpretation of the scene gives his picture a vitality lacking in the

Figure 88. Detail of figure 86 showing figures in the foreground

modest antecedent print. Primary colors and bold forms dominate the painting. The streaming sun invigorates the scene with its beneficent smile. His directional arrow has become so abstracted that it looms overhead like some fantastic comet. This peculiar device might even be attributable to the influence of Halley's Comet, which attracted considerable attention when it appeared in the skies over New England in the winter of 1835.

Br. Joshua's watercolor painting of Canterbury remained at Alfred until that community closed in 1931, when it was taken, along with other selected possessions, to the village at Sabbathday Lake. There it was discovered among a group of his drawings rolled in a scroll and stored in a barn by the early collectors Edward Deming Andrews and Faith Andrews, who owned it for many years before it was acquired by Winterthur Museum in 1969.[8]

At about the same time that he drew his Canterbury view, Br. Joshua also drew two pairs of landscape views of the Shaker villages at New Gloucester and at Poland Hill, Maine. Although the scenes were made at various times in various years, all four were boldly and confidently inscribed "January 1st, 1850." Apparently, reaching the midpoint of the nineteenth century must have held some special significance for Joshua.

These village views represented a departure from Br. Joshua's previous work, not only in style, but also in scope. By studying and copying the print of the hilltop village at Canterbury, he had taught himself to draw a landscape in perspective. Now he was able to demonstrate that skill in an original work. This time he was not drawing another version of the familiar surroundings of his home at Alfred. He had travelled to a different community to make a drawing that would capture a sense of two villages he did not know as well as his own.

By and large, he succeeded in his new role as a visiting landscape artist. He still clung to a perception of himself as a village cartographer, labelling his drawings as "Plans," numbering the buildings he drew, and then identifying them in a keyed "explanation." But these pictures have vast, open horizons, and their lands are colored by gentle gradations of watercolor washes. They reflect the artist's newfound skills and his new ways of looking at the landscape.

On the back of Br. Joshua's watercolor drawing of the Canterbury Shaker village is a pencil sketch of four buildings. Though they are unidentified, they can be recognized as the main dwelling and the adjacent shops of the Shaker village at Sabbathday Lake, in the town of New Gloucester, Maine. Drawn at twice the scale of his other village views, this was evidently a preliminary exercise in plotting perspective. He did not finish this drawing, but turned the paper over and drew his landscape view of Canterbury. Thus it can be inferred that at about the same time he was working on his view of Canterbury, Br. Joshua was preparing to make an original drawing of New Gloucester.

As was the case at Alfred, the village at New Gloucester was settled on a hillside above a lake, with its buildings facing inward to a road passing north-south through the middle of the community. Unlike the situation at Alfred, however, almost all of the buildings stood on the eastern side of the central lane and faced uphill to the west. For Br. Joshua, this orientation determined his point of view in composing the drawing. He could illustrate the principal facades of most buildngs in the village simultaneously, merely by climbing the hill and sketching the scene as it actually appeared to him. The problem with this perspective soon became apparent: as they actually appear to do in real

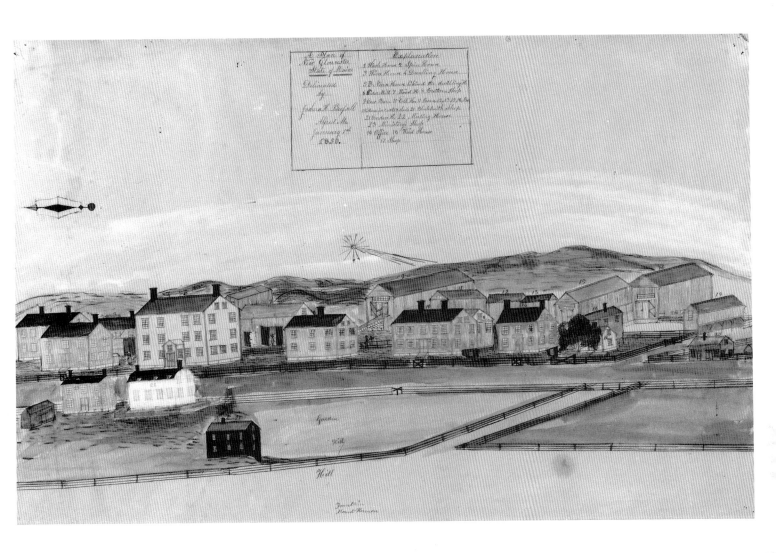

life, the large buildings along the road blocked the view of the smaller ones behind them on the lower slopes of the hillside. Had he not determined to picture those west-facing buildings from the front he could have placed himself in the sky to the east of the village, as he had at Alfred, and pictured each one of the buildings from the rear as they rose on the hillside before him.

That imaginary approach would have required a familiarity with the village that Br. Joshua did not possess, as well as the leisure to experiment over time that a visitor could not afford. As it turned out, he drew the village from the vantage point on the hill. This easterly view (fig. 89) depicts a string of buildings densely grouped along the road. Since the village was rendered so compact through this downhill perspective, Br. Joshua attempted to distinguish each of the buildings by carefully illustrating its individual characteristics. Those facing the road are colored a mustard yellow, except for the meetinghouse, which is painted white. Beyond them the barns and sheds are brown, their vertical board siding detailed in thin pencil lines (fig. 90). Individual stones can be seen in the wagon ramp leading up to the barn door. Each pane of glass is articulated in the windows of each building throughout the village, except for those in the meetinghouse, where the blinds are shuttered. And above the door to the trustees' office is a

Figure 89. View of the Shaker Community at New Gloucester, Maine

By Joshua H. Bussell (1816–1900)

Ca. 1850

Pencil, ink, and watercolor on paper

22″ × 35″ (55.9 × 88.9 cm) (irregular)

Inscribed: "A Plan of New Gloucester, State of Maine Delineated by Joshua H Bussell, Alfred Me. January 1st, 1850."

Collection of The Shaker Library, the United Society of Shakers, Sabbathday Lake, Maine

John Miller Documents, 1987

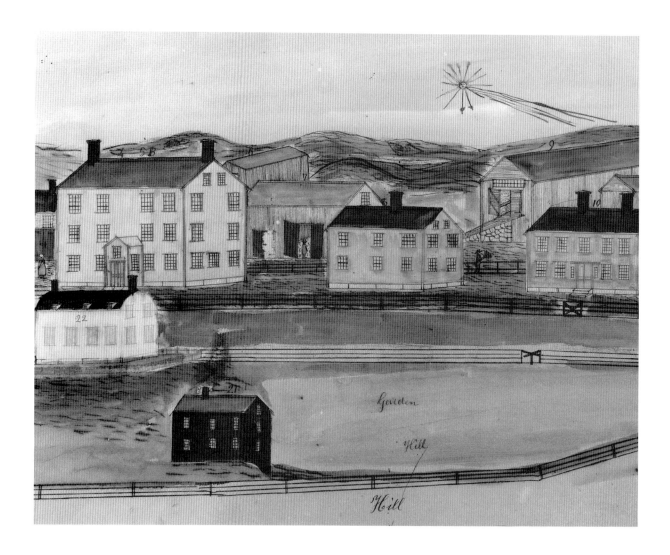

Figure 90. Detail of figure 89 showing
Church Family buildings

John Miller Documents, 1987

sketch of the sign that actually hung there, the only one in the village. On it, printed in small letters, is the word "Office," as it actually appeared to travellers driving down the road.

As detailed and realistic as it appeared, however, the view did not serve as a practical map to the buildings. And so Br. Joshua labelled his landscape view as he had labelled his village plans. He numbered the buildings he had sketched and described them in a keyed "explanation," which he drew in the sky above the village. Numbered from left to right, they read "Wash House," "Spin House," "Wood House," "Dwelling House." The next building was the nurse house, entirely hidden from sight behind the dwelling. This was the very problem that Br. Joshua was experimenting with in his preliminary sketch—how to raise his perspective enough to catch a glimpse of the nurse house. He apparently could not think of a way to make it work from his vantage point on the hillside, and so, in the sky above the building, he just wrote the number "5B." There is no "5A"; apparently "B" stands for "Back" or "Behind." In the key "5B" is described as "Nurse House behind the dwelling H." A "Wood House" is the only building to wear a written inscription; nestled behind the Ell House, it apparently escaped Br. Joshua's attention until he had finished drawing the explanation. The buildings also block the view of the village lands behind them to the east. The tiny farms sketched in the hills on the horizon are in the town of New Gloucester, some five miles away.

In the foreground, however, the land can be seen divided into neat lots surrounded by board fences. A turnstile leads into the garden lot. While adjacent lands are colored green, this plot has been plowed up and is colored a light brown. Therefore, it is not altogether clear when Br. Joshua drew this view. Although it is dated "January 1st, 1850," it is not a winter scene. No snow covers the ground, the pastures are green, and the shade tree next to the office is in full leaf. A tiny Shaker sister walks from the spin house to the dwelling, a brother stands in the open doorway of the wood house, and another brother rakes leaves behind the brethren's shop. It is not January in Maine.

Though the specific day and month he described may be more symbolic than literal, it appears that Br. Joshua intended this drawing to represent the appearance of the village at mid-century. In the chronology of his stylistic development, that seems appropriate. The laughing sun and the fantastic directional arrow are elements found in his other drawings from this period. Certainly it cannot have been drawn much later than 1850; at the bottom of the drawing is the hilltop site of "Mount Hermon," the mystical fountain ground at Sabbathday Lake. In the 1850s the Shakers' fervor for outdoor worship began to wane, and some time around 1854 the use of these holy meeting grounds was abandoned.[9] Rather than being allowed to fall into disuse, they were deconsecrated and the vestiges removed. This drawing was made before that happened.

In all likelihood, this drawing returned to Alfred with Br. Joshua. Shaker sisters recall seeing his pictures displayed in the village until 1931, when the community was closed and its possessions removed to Sabbathday Lake. Br. Joshua's "Plan of New Gloucester" is still owned by the Sabbathday Lake Shakers.

Soon after he finished his "Plan of New Gloucester," Joshua Bussell drew a second version of the view (fig. 91). It was customary for Shaker cartographers to copy one another's work, making duplicates of a village plan for use in some other community. Indeed, Br. Joshua's 1846 "Plan of Alfred" is a revised copy of the drawing he himself made the year before. Unlike previous copies of Shaker maps, however, this view of New Gloucester appears to have been produced contemporaneously, as the second one of a pair.

His second drawing was made on the same kind and size of paper as the first one. It is composed in the same way, and painted in the same watercolors. It is titled, signed, and dated precisely the same as the original. However, it is not quite the same as the original. Given Br. Joshua's penchant for refining his work, it is not surprising to find that in the second drawing he had resolved several problems that he had encountered with the first one. As a result, this version displays technical improvement, though it was achieved, like all deliberate copies, at the cost of the spontaneous, naive quality that makes Br. Joshua's drawings so appealing.

For instance, the designation "5B" has been dropped from the explanation. Instead, Br. Joshua elevated the nurse house until it emerged from behind the dwelling, just high enough to be visible and identified like the other buildings. The numbering then proceeds across the village in a systematic order, this time with all of the buildings accounted for in turn.

Although Br. Joshua was no stranger to New Gloucester, he had made numerous small errors in his first drawing. Making the second version gave him the opportunity to revise or correct several little details (fig. 92). The two-story portico on the 1795 dwelling house now

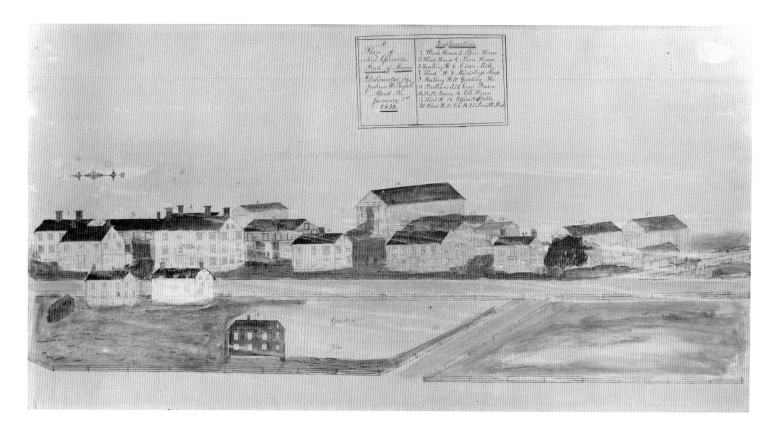

Figure 91. A View of the Shaker Community at New Gloucester, Maine

By Joshua H. Bussell (1816–1900)

After 1850

Pencil, ink, and watercolor on paper

25 5/8″ × 35 1/4″ (60.0 × 89.4 cm)

Inscribed: "A Plan of New Gloucester. State of Maine. Delineated by Joshua H. Bussell, Alfred, Me. January 1st, 1850"

Collection of the Henry Francis du Pont Winterthur Museum, Edward Deming Andrews Memorial Shaker Collection (SA 1533)

reaches the second floor. There are three windows in the back of the gambrel-roofed meetinghouse, not four. The woodshed behind the shade tree has acquired shingled siding, and the 1816 wood house now has windows on the second floor.

There were deletions from the drawing as well. Some of these were intended as technical corrections: the hills in the distance beyond the lake have disappeared, relieving the impression that they rose directly behind the barns. The inscription "Fountain/Mount Hermon" is missing from the hill in the foreground—presumably this copy was made after the Holy Ground was abandoned around 1854.

Other omissions reflect something about the artist's changing style. The laughing sun is gone from the sky, and the directional arrow, if not exactly prosaic, has become less exuberant than its predecessor. Perhaps it was a function of the time that had elapsed between making these two pictures that Br. Joshua's second drawing became a little more conventional. In the future such idiosyncratic elements would disappear from his work altogether. This drawing seems to have been made as a copy for the Shakers at either New Gloucester or Poland Hill. It was among the group found at Sabbathday Lake by the Andrews and was subsequently acquired by Winterthur Museum.[10]

The Shaker village at Poland Hill, Maine, was the North Family of the society at New Gloucester. Though it could be seen on the next hill-

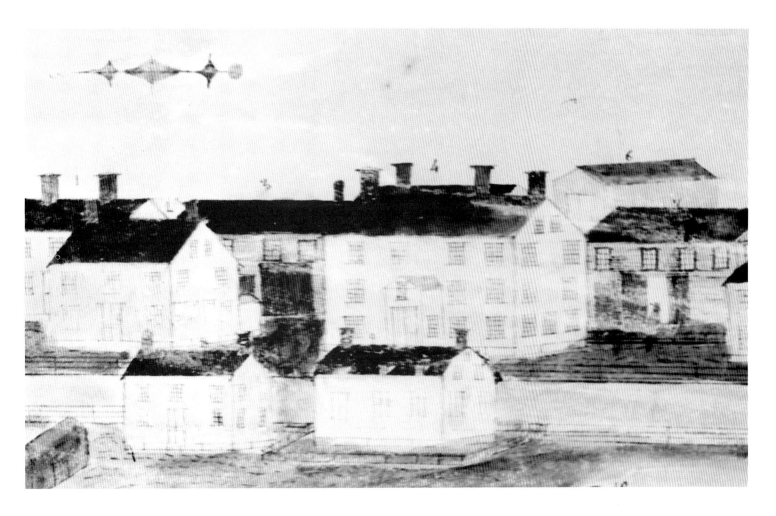

Figure 92. Detail of figure 91 showing Church Family buildings

top, just a mile up the road from the Church Family, it lay across the county line in the neighboring town of Poland, and through longstanding tradition was referred to not as a dependency, but as a separate Shaker village.[11] In practice, however, it served as the novitiate order for the society at New Gloucester, and in 1850, when Joshua Bussell came to visit the community, he drew pictures of both its villages as they appeared at the mid-point of the century (fig. 93).

The distance between the North and Church Families was too great for Br. Joshua to draw them together, as he had at Alfred. Instead, he chose to picture them separately, in a pair of village views. He chose the same form of title for his "Plan of Poland" as he had for his "Plan of New Gloucester," and dated it with the same "Jany 1st 1850." These he included, along with the same numbered key to identify the buildings, within a border in the sky above the village.

The air over Poland Hill was again full of Br. Joshua's cartoon vignettes. The beaming sun shone forth upon the village; a bird soared over the wash house; above the garden was an arrow so fantastic and elaborate that it could be mistaken for a kite or a comet. The vignettes on the ground are no less remarkable. The dooryard is peopled with Shaker brethren and sisters in various sizes, walking to and fro. In the lane through the center of the village a wagon is arriving at the office, loaded with barrels and boxes. A stage coach is leaving, headed north

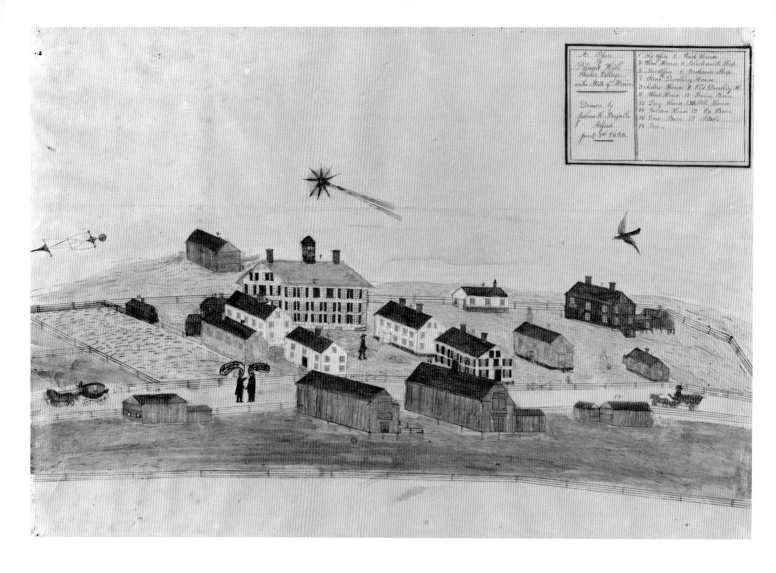

Figure 93. View of the Shaker Village at
Poland Hill, Maine

By Joshua H. Bussell (1816–1900)

Ca. 1850

Pencil, ink, and watercolor on paper

23 5/8″ × 34 1/4″ irregular (60.0 × 87.0 cm)

Inscribed: "A Plan of Poland Hill Shaker
Village in the State of Maine. Drawn by
Joshua H. Bussell, Alfred Jany 1st 1850"

Collection of the Shaker Library, the United
Society of Shakers, Sabbathday Lake, Maine

John Miller Documents, 1987

past the "Burring Ground." Between the two vehicles are two familiar figures (fig. 94, Pl. XXVI), the Shaker brother and the worldly gentleman from the woodcut view of Canterbury in the *American Magazine of Useful and Entertaining Knowledge* (fig. 87). Even their gestures are the same, though this time the Shaker artist has given them speech. "What village is this?" asks the tophatted visitor, pointing toward the buildings of the North Family. "Shaker Village, Poland," replies the Shaker.

As at the Church Family, most of the buildings at Poland Hill stood to the east of the road, allowing Br. Joshua to use the same perspective for his drawings of both villages. He pictured the North Family from a vantage point above the village and to the west. Unlike the Church Family site, however, there was no rise of land from which he could look down upon the village. Though it matches his "Plan of New Gloucester," in this drawing the artist's point of view is entirely theoretical.

No forested hills interrupted the background of Br. Joshua's landscape view. On a clear day, the Believers could look in one direction from their hilltop village to see the White Mountains and in the other to see the Atlantic Ocean. Br. Joshua drew the buildings of the North Family as they actually appeared, silhouetted against the skyline of Poland Hill.

The buildings are drawn in detail, first in pencil, then in ink, and then individually colored in watercolor and covered with an overlay of

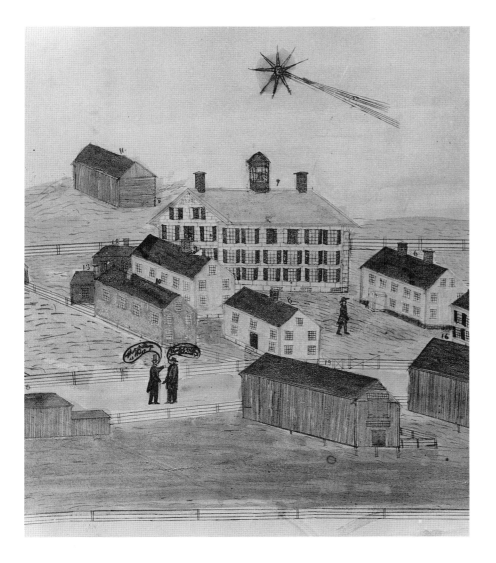

Figure 94. Detail of figure 93 showing figures in the foreground

John Miller Documents, 1987

gum arabic. Br. Joshua recorded such features as the individual shutters on the new office, some open and some closed, and the small entryways on the wash house and the brethren's shop. He corrected his work as he went along. The board fence behind the wash house was erased and redrawn when Br. Joshua reviewed his work and discovered that the fence actually cut across the corner of the back yard. At the roofpeak of the stone dwelling, the cupola was similarly altered, its northern side erased to make it appear narrower.

On the gable end of the stone dwelling, the date "1854" is shown carved in a granite block, clearly an anachronism in a drawing purportedly made in the year 1850. It is characteristic of this group of drawings, all of which bear this date, that the mid-century date carried a symbolic rather than a literal meaning.

When was this drawing made? Probably not on January 1; for one thing, like the drawing of New Gloucester, it is not a dead-of-winter scene. For another thing, on the first of the year not even the cellar hole had been dug for the new dwelling, and Br. Joshua would have had a hard time imagining it there in the middle of the village. By the end of the summer of 1850, though, a site had been determined for the new stone building and its outline had begun to take shape. On September 20, a visitor to Poland Hill recorded seeing the quarry

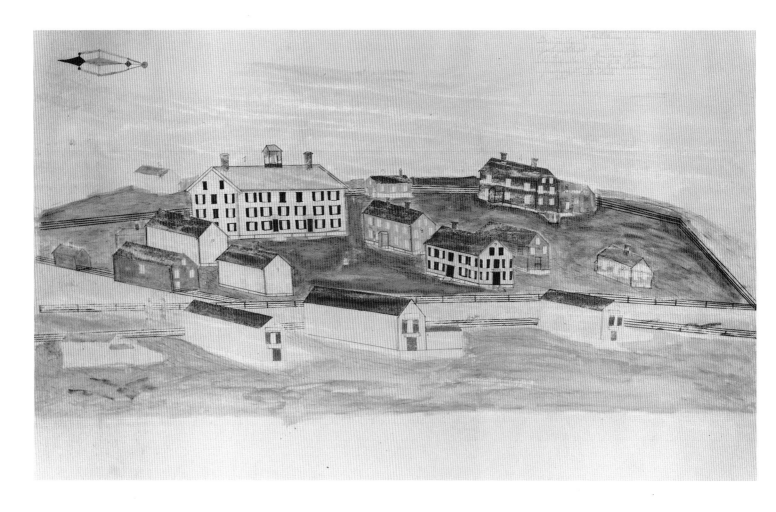

Figure 95. A View of the Shaker Village at Poland Hill, Maine

By Joshua H. Bussell (1816–1900)

Ca. 1850–53

Pencil, ink, and watercolor on paper

25 1/4″ × 34 3/4″ (64.1 × 88.3 cm)

Inscribed: "A Plan of Poland State of Maine Drawn by Joshua H. Bussell, Alfred Me. January 1st 1850"

Collection of The Henry Francis du Pont Winterthur Museum, Edward Deming Andrews Memorial Shaker Collection (SA 1532)

where they are getting out stone for a new dwelling house. The cellar is dug and part of it walled with heavy granite—wall 4 feet thick. The building is to be 70 feet long & 48 wide & three stories high—a great undertaking for a family of 34 or 5 members.[12]

It is likely that Br. Joshua drew his "Plan of Poland Hill" at this point, when he knew roughly what the stone dwelling was going to look like, but before it was actually built, for his representation of the new building was grossly and uncharacteristically inaccurate. It had too few windows and too few chimneys, and all were drawn in the wrong places. It had no doors at all. Apparently Br. Joshua wanted to make the drawing during his visit to new Gloucester in 1850 but did not want to omit a picture of the North Family's monumental granite building. He included it prematurely, and in 1854, when he learned that the structure had been finished, he conscientiously penciled in a date stone.

Filled with these images of paradox and fantasy, Br. Joshua's drawing was treasured by the Shakers at Alfred for over eighty years. When their community was closed in 1931, it was among those possessions brought with them to New Gloucester, where it is still owned by the Sabbathday Lake Shakers.

Br. Joshua made a second version of his "Plan of Poland" (fig. 95) to accompany his copy of the companion drawing of New Gloucester.

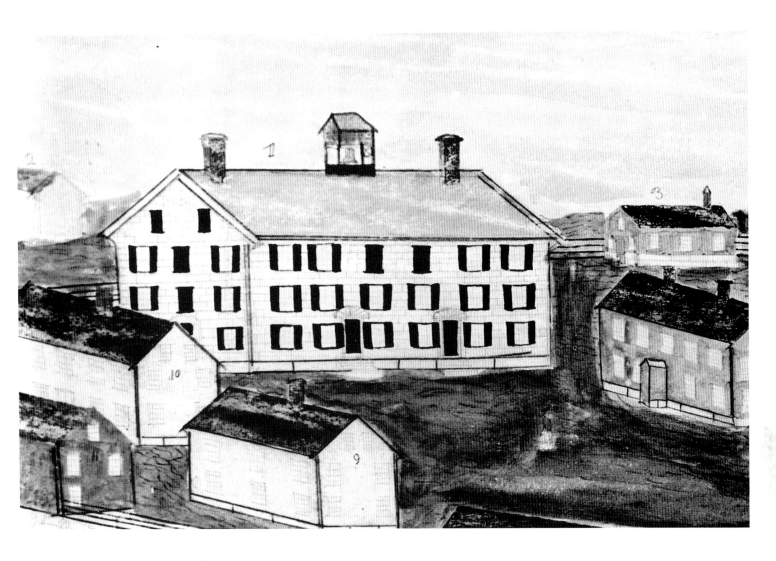

Figure 96. Detail of figure 95 showing the stone dwelling

Like the other three in this group, he signed and dated this one on the first day of the year 1850. Chances are that it was not copied simultaneously, either, for it looks different from the first drawing of Poland Hill both in substance and in style.

The second drawing reveals changes, including additions and deletions. Although the artist used the same perspective, he placed his buildings in slightly different positions, uncovering some buildings and obscuring others. There have been some alterations. The southeast barn is gone, replaced by a larger structure more like the adjacent ones. The still house next to the garden has disappeared altogether. The sisters' shop has more windows. And the stone dwelling now has a pair of doors in the western side, crowned with fan-light windows (fig. 96). These variations were both the result of his correcting mistakes in the original drawing, and of his updating the changes that had taken place since it was made. Like the second version of his drawing of New Gloucester, this was a revised and edited work.

But the different appearance of the two versions is not due entirely to substantive changes. In addition, it reflects the style of a more sober, deliberate artist. His beaming sun and soaring bird have disappeared, and his directional arrow has become tame by comparison. The wagon and coach are gone from the road, and the only remaining vignette is of the two men in the lane. Originally the most prominent feature in the

drawing, they are now rendered only as faint pencil sketches. The effect is not so much subtle as it is indistinct.

Indeed, many of the features that gave the original drawing a sense of liveliness, clarity, and detail, if they are present at all, are copied here only in pencil and not outlined in ink. The fence defining the foreground of the picture to the west of the barns is merely penciled in. The individual mullions and sash in each of the windows can hardly be seen. Though the dooryard and sky and the sides of the buildings are all colored in strong hues, the second "Plan of Poland" is a curiously lifeless scene, virtually devoid of flora or fauna, and unlike any other picture Br. Joshua is known to have drawn. Perhaps he was tired of making copies and lacked the motivation to recreate his inspired visions. Or perhaps his ideas about landscape drawings had evolved to the point at which all the limner-like detail of physical features and the joyful cartoons of Shaker life were no longer appropriate to his vision of village views.

The drawing could not have been made too many years after the original, for by 1853 he would have known what the stone dwelling actually looked like. It was a long time in construction: in July of 1851, the Ministry at New Gloucester wrote to the Ministry at Harvard: "Br. Isaiah has commenced laying up the walls of his house, has set the underpinning stones, and made a beginning on the wall."[13] It was not until October of 1853 that they could report that "Br. Isaiah has about finished the outside of his stone house. The windows are in, the doors hung, the steps set, &c."[14] By then Br. Joshua would have known that there was only one door on each side of the dwelling, and that none of them was crowned by a fan light. There were six windows on the ends and eight on the sides, spaced so close that there was no room for shutters between them. There were four chimneys, and the octagonal cupola was punctuated by gothic bays with pointed arches. The building was so entirely different from the way Joshua Bussell conceived of it, that his drawing of Poland must surely have been made in anticipation of actually seeing it raised.[15]

In the twentieth century this drawing was first recorded by Edward Deming Andrews and Faith Andrews, who saw it in a barn at Sabbathday Lake. It is now in the Andrews Collection at Winterthur Museum.[16]

8 THE REVIVAL OF SHAKER VILLAGE VIEWS

Most Shaker village views were made in the 1830s and 1840s and picture communities in the flush of growth or at the height of their prosperity. Joshua Bussell's plans of New Gloucester and Poland in the early 1850s represented the end of an era. Shaker villages had matured to a stable appearance, and new drawings were no longer required to record constant developments in the community. Some time around 1880, however, Joshua Bussell returned to his drawing board. Now an Elder at the Second Family at Alfred, he started making entirely new pictures of the Shaker villages at Alfred and New Gloucester after a hiatus of a quarter of a century.

Elder Joshua seems to have been the only Shaker cartographer to continue drawing Shaker village views, motivated, apparently, by circumstances unique to the society at Alfred. There was a need for new views; in contrast to many other Shaker communities, Alfred was undergoing substantial renovation and it was time for some up-to-date documentation.

In 1871, the Alfred Shakers decided to sell off eight hundred acres of timber land.[1] This did not directly affect the appearance of the village, for the tract lay in the adjoining town of Waterborough. But the Shakers used the proceeds from the sale to modernize their buildings. Construction proceeded for years, through every part of the community, and when the work was finished the ministry sought to record its new appearance in new village views.

By this time, of course, photographers had started to visit Shaker villages, capturing their images accurately and instantaneously on their glass plate negatives. Shaker subjects made popular themes for picture post cards and stereopticon views, and photographs of Shaker villages soon abounded. In fact, the Shakers themselves used these photographs to illustrate their own monthly publication. Line engravings copied from photographs of Shaker villages appeared in every issue of *The Manifesto* from 1878 through 1885. Presumably the Alfred Shakers could have recorded the changes to the village just as easily in photographs as in landscape drawings.

But the Society chose to have Joshua Bussell draw pictures of the village. He knew the community intimately and was able to illustrate in detail specific features that he considered particularly significant. Indeed, this seems to have been one of his functions in the village. A journal entry in 1883 noted:

Elder Joshua took a plan of the Grave Yard to mark the place where each one was buried, that the grave stones may be removed and the ground graded and improved.[2]

Elder Joshua also possessed the ability to picture the village from imaginary viewpoints, an advantage no photographer could match. He constructed detailed models of its principal buildings as they appeared after the renovations of the 1870s[3] and was apparently able to assemble them to form a miniature Shaker village that he could use as a basis for organizing his drawings. He could and did rearrange features in the village model to compose a view more effectively.

In the final analysis, however, the community's preference for Joshua Bussell's pictures may have had nothing to do with practical considerations. The Alfred Shakers were familiar with the distinctively personal drawings that Elder Joshua had made a generation earlier. Many of them could still be found around the village, and they probably elicited a personal response from the Believers that a photograph could never have evoked. In addition to being satisfactory records, Elder Joshua's drawings had become a part of their common experience at Alfred, and the Shakers may have seen no reason to change.

Already we see in the last five years much needed important and expensive repairs made on several buildings namely the Sisters Shop, the Ministry's neat Cottage, the Office, the Stable, New building for storage, and conveniences for the Office with expenditures more or less on nearly all the buildings in the place. It is plainly evident that repairs and paint have materially changed and improved the exterior aspect of the village.

Elder Otis Sawyer, Alfred, Maine, 1876[4]

Throughout the 1870s the Ministry's journals describe renovation, repairs, and improvements to the Shaker village at Alfred. Chimneys were added, roofs replaced, windows moved, and conveniences installed. Buildings were painted, and fences whitewashed. By the time the work ceased the village had assumed an entirely different look. When all the renovation had been completed, Joshua Bussell produced two landscape views of the Church Family, made from his customary viewpoint to the southwest of the village. They are essentially the same picture, probably made at about the same time, although they were finished in different ways. A comparison indicates that Elder Joshua's two versions were apparently tailored to two different audiences.

The first view of the Church Family (fig. 97) is neither dated, titled,

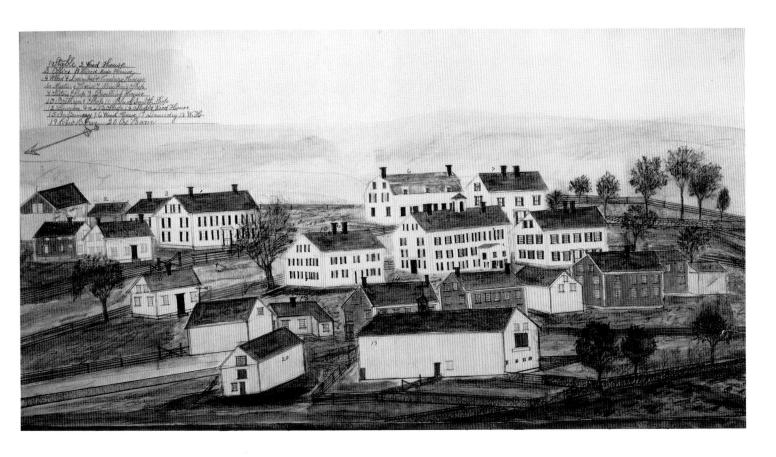

nor signed. Apparently he intended it to be viewed by people who understood the subject of the picture. But it was not without information to orient the viewer and explain the situation. His directional arrow floats in the sky above the road, mimicking the form of the two barn weathervanes below. In addition, returning to a cartographic tradition now long out of date, the artist numbered his buildings and identified them in a keyed list.

The village buildings had indeed changed. There were new workshops for the brethren and the sisters (fig. 98). Other barns and shops had disappeared. The central dwelling boasted a new bell cupola. Most buildings were now painted white, and many had new green shutters. Around the village, other details are less distinct. Dooryards and barnyards are defined by board fences and stone walls, lined by occasional shade trees, but individual lots of land are distinguished only by different shades of green watercolor wash, and the hillside rising above the village is illustrated only in a lightly penciled profile. A lone horse, sketched standing in the road in front of the office, was subsequently erased. These elements of the drawing stand in sharp contrast to the detailed features of the architecture. It is clear that the purpose of this view of the Church Family was to identify the new look of the buildings.

In the twentieth century this drawing was one of a pair of Elder

Figure 97. The Church Family at Alfred, Maine

Attributed to Joshua H. Bussell (1816–1900)

Ca. 1880

Pencil, ink, and watercolor on paper

17 1/2″ × 27 1/2″ (44.5 × 69.9 cm)

Private Collection

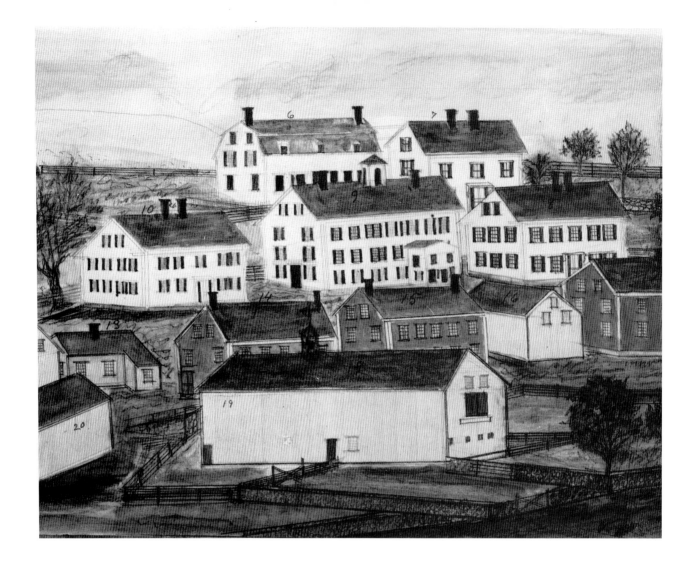

Figure 98. Detail of figure 97 showing
Church Family buildings

Joshua's Shaker village views owned by the Hancock Shakers, pre-
sented to Eldress Caroline Hellfrich by Alfred Elder Henry Greene. It
remained at Hancock until 1935, when it was given to a young woman
who had grown up with the Shakers, as a memento of her years in
the village.[5]

An alternate version exists of this southwesterly view of the Church
Family at Alfred (fig. 99). In the second one, Elder Joshua elevated his
point of view and rearranged some of his buildings. By shifting the
cow barn and the ox barn slightly, he was able to illustrate better the
wood house and the two shops to the north and the west of it. He in-
serted some windows in the office stable, and omitted a cupola from
the great cow barn. Though a modified hill now rose above the village
to the east and the lane was planted in shade trees, the look of the fam-
ily had not changed very much from the other drawing (fig. 100). In
both, the emphasis was on illustrating the detail of the buildings.

Except that they marked structural alterations, these views were
conceived in much the same way as their predecessors a generation
earlier. This arrangement, with the buildings stretched along a road-
way running horizontally across the middle of the paper, was the only
way that Joshua Bussell had ever drawn the village at Alfred. The real
indicator of how much time had passed came as he finished up the pic-

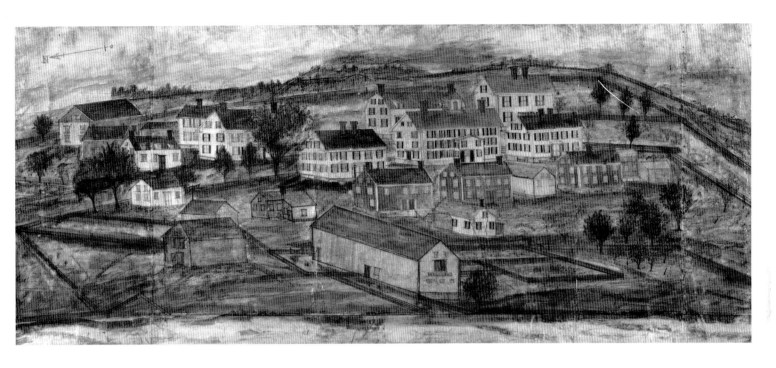

ture. What is different about this version is the *tromp l'oeil* frame that surrounds it.

On this version Joshua Bussell painted a yellow band around the scene and enclosed it with a dark brown border, making a conscious attempt to simulate a mahogany picture frame with a gilt liner. The 1845 prohibition against "Pictures or paintings set in frames with glass before them"[6] was forgotten now. The new aesthetic was clearly revealed by Henry Blinn while on a journey to Kentucky in 1873. In the journal he made of his trip he noted with admiration that some "beautifully framed pictures hung from the walls"[7] of the Springfield Armory. How far Elder Joshua had come since the 1840s, when he inserted the explanation "View of the Back Side of the Buildings" on his picture "The Church at Alfred" (fig. 80), to avoid deceiving his audience with the artifice of perspective drawing. A generation later, he hoped his brown border would resemble a mahogany picture frame.

It should be noted that this version stayed at home. No label, title, signature, or explanation was needed to accompany it. Unlike the more traditional and conservative version of the pair, this drawing was kept by the Maine ministry. It is still owned by the Sabbathday Lake Shakers.

During the years following the renovations at Alfred, Joshua Bussell is known to have made at least eight new landscape drawings of the

Figure 99. The Church Family at Alfred, Maine

Attributed to Joshua H. Bussell (1816–1900)

Ca. 1880

Pencil, ink, and watercolor on paper

21 1/2″ × 41 1/8″ (54.6 × 104.5 cm)

Collection of the Shaker Library, the United Society of Shakers, Sabbathday Lake, Maine

John Miller Documents, 1987

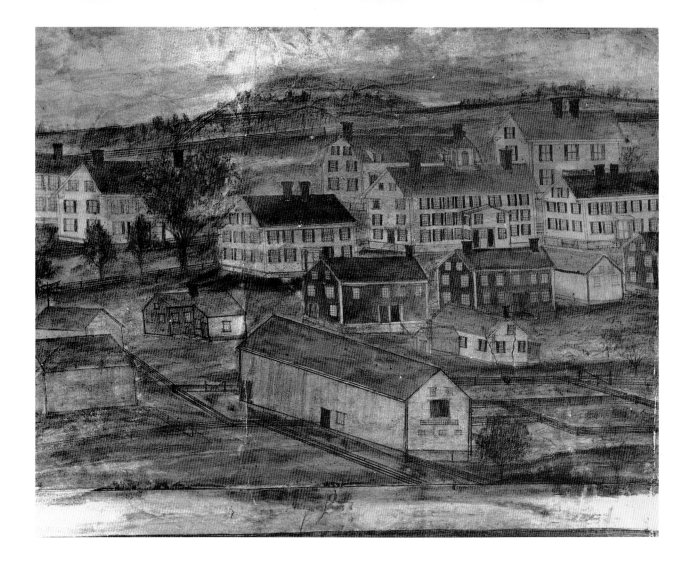

Figure 100. Detail of figure 99 showing
Church Family buildings

John Miller Documents, 1987

Maine Shaker villages. As it happens, the number might not have been
so great were it not for an event entirely unrelated to the improvements
to the buildings. In the winter of 1879–80 a commercial landscape art-
ist visited the Maine Shaker societies and drew bird's-eye views of
both New Gloucester and Alfred. Not only were his drawings well re-
ceived by the Shakers, but meeting the artist and observing his work
apparently helped to revive Joshua Bussell's interest in the art of draw-
ing landscape views. This inspiration, combined with the opportunity
to employ his skills recording the new appearance at Alfred, resulted
in a second group of drawings almost as large as the body of work he
had created in the 1840s and 1850s.

The visiting artist bore the distinctive name of Phares F. Goist. He
had come to sketch the villages for illustrations to accompany the his-
torical accounts then being prepared of Maine's York and Cumberland
Counties. These works were part of a series of local histories under-
written by the subscription of area residents but produced by a Phila-
delphia publisher. For his illustrations, the publisher dispatched art-
ists to make drawings of civic landmarks and the homes of prominent
citizens, and for his text he relied on the town's centennial histories
and on essays contributed by the subscribers.

The time was ripe for such endeavors. Alfred Elder Otis Sawyer had

recently prepared a history of Shakerism in Maine. His 1876 manuscript "History of Alfred Maine" begins with the foreword:

In this great Centennial year we propose to comply with the recommendations of the American Congress, which is brought more particularly to the notice of the inhabitants of the nation, by a Proclamation from the President of the United States, for all the towns and Counties of the several States in the Union to employ some person to collate facts and give a brief historical account of the settlement, its progress & present status and all matters of interest pertaining to the history of the town.[8]

In the fall of 1879 Elder Otis supplied the editor with his history of the Shaker society at New Gloucester, and in January of 1880 with an account of the history of Alfred. Both the Cumberland County and the York County volumes were quickly prepared, and when the Shakers ordered illustrations to accompany their entries, Phares Goist was sent with his *camera obscura* to make a landscape view of each place.

The Sabbathday Lake Church Journal for 1879 records that Joshua Bussell's visits to New Gloucester did not coincide with Phares Goist's appearance there.[9] Neither is there any proof that Elder Joshua ever personally encountered the travelling artist on his visit to Alfred. But it is logical to assume that they met there and that they inspected the village together. Certainly the man responsible for documenting the appearance of the Maine Shaker communities would be the appropriate person to show the visiting landscape artist around the community he had known for over fifty years. What can be proven is that Elder Joshua knew Phares Goist's sketches well, for soon thereafter his own work began to resemble them. In his drawings of Alfred he began to adopt the commercial artist's perspective and his bird's-eye view. His drawings of New Gloucester are virtual copies of the sketches Goist made there in 1879.

When Elder Joshua drew another picture of the Church Family at Alfred (fig. 101), the community looked much the same as it did in the pair of Church Family views he had recently drawn from the southwest (figs. 97, 99). This view had a different appearance, though, from the pictures the artist had previously drawn. What had changed was not the village itself, but the perspective from which the artist chose to portray it. Instead of representing the land and buildings in a combination of rectangles aligned with each other and with the borders of the drawing—in the manner of his previous compositions, which had evolved from isometric village plans—he turned this view forty-five degrees, until the lane through the village ran diagonally across the paper and the buildings receded in the distance. This represented a sophisticated new step in his artistic development, as important as his revelation when he encountered the woodcut view of Canterbury a generation earlier. Like that other major turning point in his style, this change can be traced to the influence of a worldly landscape artist.

The Alfred Church Journal records on January 29, 1880, that "Phares F. Goist the *artist* came to day and took a Birds-eye view of our beautiful Shaker Home which is to be inserted in the forthcoming History of York Co."[10] Tracing the image projected through the lens of his *camera obscura*, the artist made a pencil sketch of the Church and Second Families. He soon finished, packed up his easel, and repaired to his drawing board, where he prepared a finished sketch. Four days later he returned to the village bearing a presentation drawing for the Family's approval.

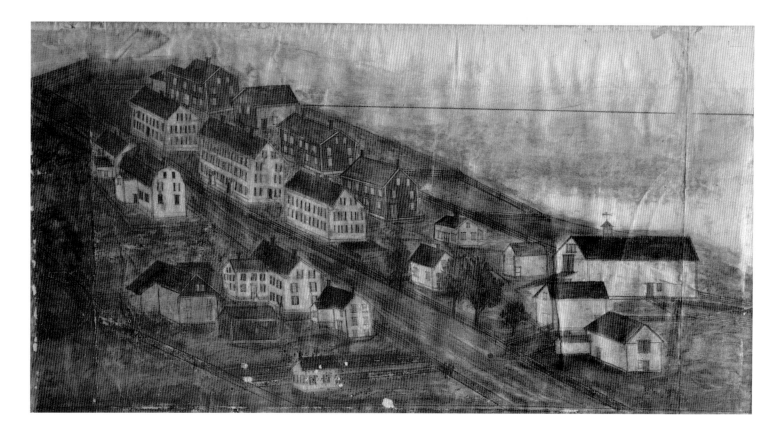

Figure 101. A Northeast View of the Church Family at Alfred

Attributed to Joshua H. Bussell (1816–1900)

Ca. 1880

Pencil, ink, and watercolor on paper

17 1/4″ × 29 3/4″ (43.8 × 75.6 cm)

Private collection

John Miller Documents, 1987

The Artist Phares Fulton Goist, who came on the 29th last to take a picture of our Village, came this afternoon with it perfected. It is correctly and beautifully executed and we all admire it.[11]

Incredibly, the book was in print three weeks later.

The Agent distributing the *History of York County* came to day, and Elder John took two copies, and 200 views of our Village agreeably to the promise made when he subscribed.[12]

Thus Goist's sketch of Alfred, seen first in its original form as a presentation drawing and subsequently as a widely published lithograph (fig. 102), was well known in the village. Its relationship to Joshua Bussell's new style of drawing is unmistakable.

As the journalist noted, Goist had drawn a "Birds-eye view" of the village. The term was a common one, with a precise and specific connotation. Throughout the second half of the nineteenth century, perspective views of towns across America were published as lithographs and purchased by proud inhabitants of the places they pictured.[13] These popular images were composed from an imaginary point of view in the sky beyond the town, so that the scene could be viewed at an oblique angle. From this elevation the artist was low enough to picture individual buildings, while at the same time high enough to see beyond them to their neighbors. This was the approach taken by Goist in

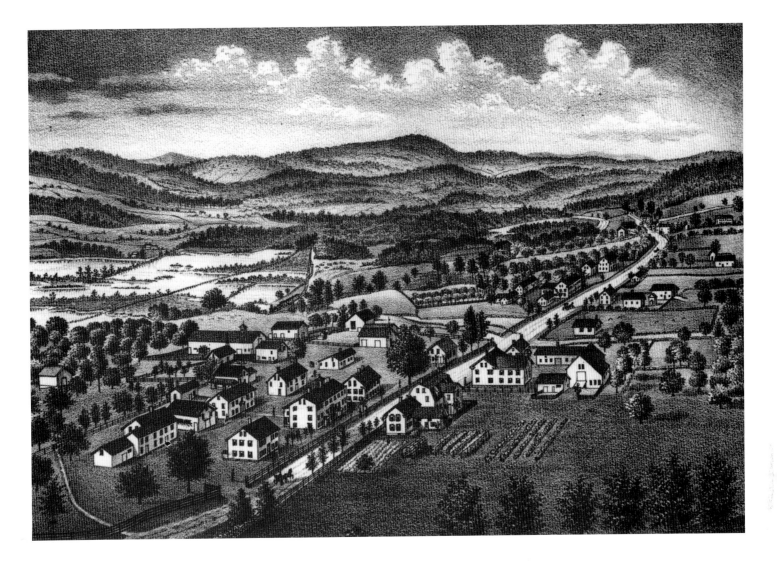

his view of the Alfred Shaker village. For essentially the same reason, he took a point of view diagonally across the village. This orientation allowed him to picture each building in three-quarters perspective, and then, by shading one of its two sides, to contribute to the illusion of depth.

It was a standard technique for the artists of these popular landscape prints, but for Elder Joshua it was a revelation. Although in his own interpretation of the scene (fig. 103) he approached the buildings from the opposite direction, so that he could better illustrate the barns and distinguish the new office from the hired men's house, this new orientation—from an oblique elevation, from a diagonal perspective, and from the eastern side of the road—can be attributed to the influence of Phares F. Goist.

To the north of the office, at the bottom of the drawing, stands the Shakers' schoolhouse—a small, one-storied building. At the eastern end a chimney for venting the wood stove can be seen rising above the roof. In the middle of the roof is another projection: Elder Otis noted proudly, "The house is ventilated by one of Emerson's ventilating scrolls."[14] The school was built in 1861 to accommodate the growing number of children being brought up in Shaker villages, and to keep pace with a more regulated system of education than had existed when Joshua Bussell was the schoolmaster forty-five years earlier. The Shaker

Figure 102. "Shaker Village, Alfred, Maine."

After a drawing by Phares Fulton Goist

1880

Lithograph

7 1/8″ × 10 1/16″ (18.1 cm × 25.6 cm)

Private Collection

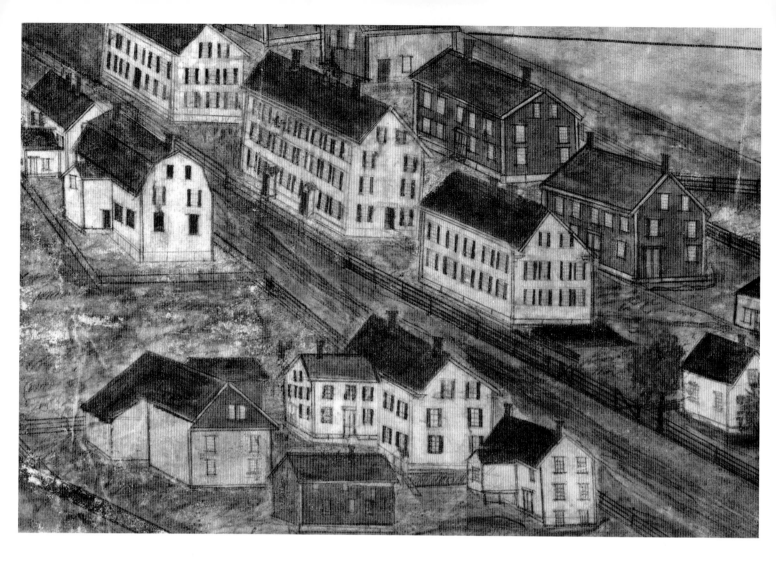

Figure 103. Detail of Figure 101 showing
Church Family buildings

school was now a public school, taught by the Shakers, but overseen
by the town school committee. In 1931 the schoolhouse was presented
to the local chapter of the American Legion and moved three miles
down the road, where it stands today.[15] Elder Joshua's drawing came
with the Alfred Shakers to the community at Sabbathday Lake, where,
in 1951, it was sold to a private collector.

Although Joshua Bussell continued to experiment with his land-
scape drawings of Alfred, every one of them from this point on re-
flected the influence of the bird's-eye view lithograph. Another version
of the Church Family scene (fig. 104) is made from approximately the
same direction as the Phares Goist sketch. The same one-horse carriage
appears in the road (fig. 105) and in the foreground are the same ar-
bors and trellises in the Ministry's garden. But for this drawing, Elder
Joshua lowered his perspective until the rooftops were silhouetted
against the horizon.

By taking a lower vantage point, the artist lost the means to depict
the second range of buildings, which were now obscured behind
the sisters' shop, the brethren's shop, and the dwelling house. In so
doing, however, he avoided having to draw the topography of the back-
ground—always a difficult problem for Elder Joshua. Instead, by in-
troducing a clear western sky, he created a neutral field on which he
identified the hidden buildings. The numbers "1" through "9" are pen-

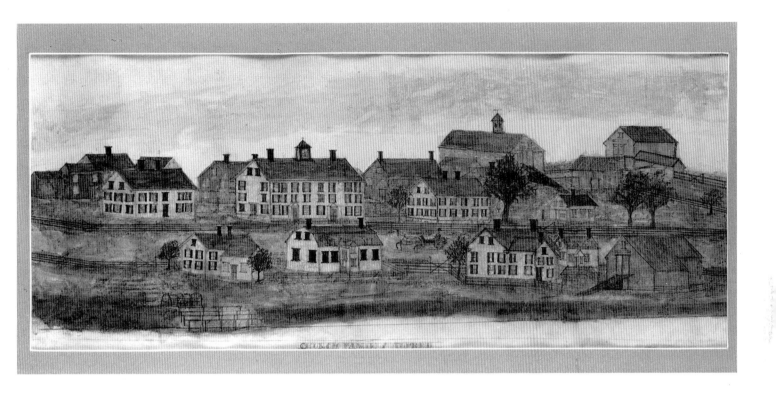

ciled from left to right in the sky just above buildings. No correspond-
ing numbered key accompanies this drawing, though perhaps one
originally existed and was later trimmed off. The top edge of this draw-
ing has been cut in an irregular line, varying in height almost three-
quarters of an inch, which suggests that it was altered with a less care-
ful hand than the one that drew it. It is possible, though, that Elder
Joshua never even added a keyed explanation to the drawing. Over the
years he had come to think of himself as a landscape artist, and that
unidentified row of numbers was one of the last vestiges of his role as a
cartographer.

Elder Joshua blocked out a title for the scene in capital letters at the
bottom of the drawing. This was a new way of identifying a village
view, inspired by the similar caption of Phares Goist's lithographed
view. But while his style was becoming more sophisticated, he re-
tained his idiosyncratic spelling. Throughout a knowledgeable and cul-
tured life he always spelled "family" with an "e."

This drawing and a view of West Gloucester (fig. 114) are thought to
have been gifts to the Shaker ministry at Harvard from the ministry in
Maine. Both drawings are now in the collection of Hancock Shaker
Community, Inc.

A companion drawing to the "Church Famiely Alfred" (fig. 106)
shows the buildings of the Second Family from a similar point of view,

Figure 104. A Northwesterly View of the
Church Family at Alfred

Attributed to Joshua H. Bussell (1816–1900)

Ca. 1880

Pencil, ink, and watercolor on paper

9 1/4″–9 7/8″ × 23″ irregular (23.5 × 58.4 cm)

Inscribed: "CHURCH FAMIELY ALFRED"

Collection of Hancock Shaker Village, Inc.

Figure 105. Detail of figure 104 showing horse and wagon at the Church Family

Figure 106. A Northwesterly View of the Second Family at Alfred, Maine

Attributed to Joshua H. Bussell (1816–1900)

Ca. 1880

Pencil, ink, and watercolor on paper

13 1/4″ × 19 1/4″ (33.6 × 48.9 cm)

Inscribed "SECOND FAMIELY ALFRED ME."

Collection of the Western Reserve Historical Society

Figure 107. Detail of figure 106 showing dwelling house and shops

looking across the road to the northwest. Although it is undated, it is apparent from the title "Second Famiely Alfred Me." that it was made in conjunction with the view of the Church Family, and presumably at about the same time. The Second Family looked to the Church Family for spiritual guidance but it had its own social and economic order, under the supervision of its own leadership. It was here that Joshua Bussell served as an elder.

On the west side of the lane were the Second Family's most prominent buildings, the dwelling and the dairy house (fig. 107). Behind them were the family workshops, including the shoemaker's shop where Elder Joshua plied his craft. Across the street to the east was the Second Family office, and behind it the sheep barn and garden house, with their gable ends facing to the road. Elder Joshua composed his drawing to show these buildings in three-quarters perspective, while at the same time choosing the vantage point that gave him the best view of the dwelling house.

Because Shaker custom held that buildings used by both brethren and sisters should be divided into separate and equal halves, Shaker dwelling houses and meetinghouses were generally symmetrical, with double doorways, stairways, and balanced floor plans. With its irregularly spaced windows, its off-center chimney, and an ell attached to its southern end, the Second Family dwelling was an anomaly. It had

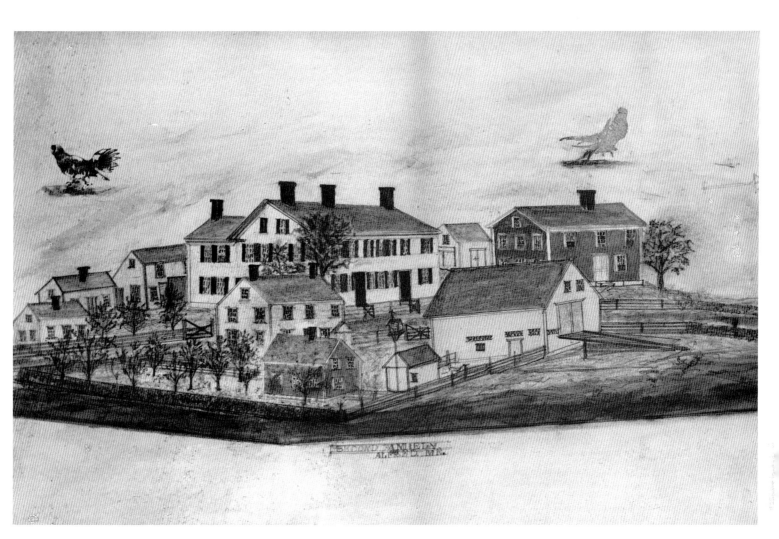

SECOND FAMILY.
ALFRED, ME.

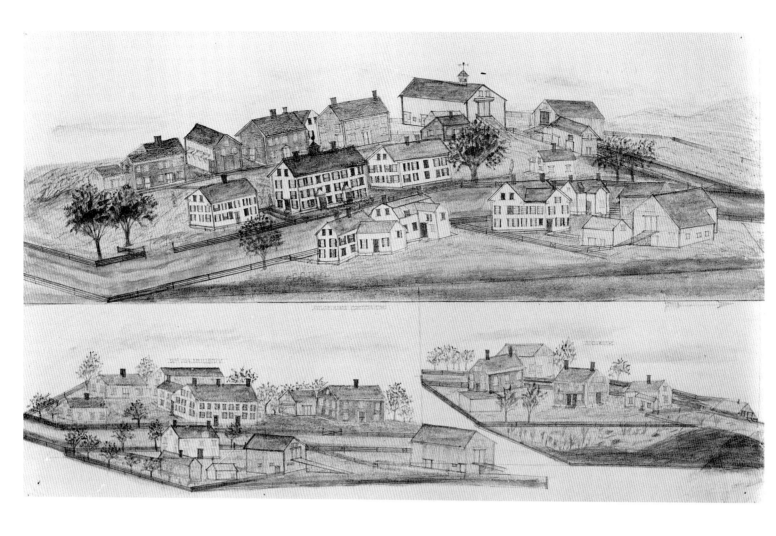

Figure 108. Views of the Three Shaker Families at Alfred, Maine

Attributed to Joshua H. Bussell (1816–1900)

Ca. 1880

Pencil, ink, and watercolor on paper

17 7/8″ × 27 7/8″ irregular (45.4 × 70.8 cm)

Collection of the Henry Francis du Pont Winterthur Museum, Edward Deming Andrews Memorial Shaker Collection (SA 1534)

originally been built as a farmhouse by Benjamin Barnes, one of the early converts to Shakerism at Alfred. When he consecrated his property to the Society, his end chimney house was extended along the road by several more bays, and a third chimney was erected. An ell was then added to the back and double doors to the front. The renovated dwelling may not have been symmetrical, but it worked according to Shaker custom. Each door had its own stone walk leading to the lane. Elder Joshua drew two bright red gates in the white board fence in front of the house.

A directional arrow is penciled faintly in the sky above the lane. With the new perspective from the east, north now appears on the right. Sharing the sky with the arrow are transfer decals of two brightly colored parrots, added to the picture at some later time by the children at Alfred. Perhaps this was a conscious imitation of the birds Elder Joshua had drawn on the title of his 1845 "Plan of Alfred Maine." Or perhaps someone at the Second Family had some special fondness for birds. Early photographs of the village show nesting boxes attached to the trees along the lane,[16] and in fact, Elder Joshua drew an elaborate birdhouse mounted on a pole next to the sheep shed in the foreground of the picture.

In 1918 the Second Family was closed, and its few remaining members consolidated with the Church Family. The buildings were sold to

an antique dealer who removed the woodwork.[17] None of the structures stands today. Elder Joshua's drawing of the site was acquired by the early Shaker collector Wallace Hugh Cathcart who gave it to the Western Reserve Historical Society sometime before his death in 1942.

There is one last drawing of the Shaker village at Alfred (fig. 108), which is different from any other view known of that community. In it the Church, Second, and North Families are separate and unrelated scenes, grouped together in a three-part composition. But while this is a unique way of representing the village, the style of the artist is unmistakable. It is the work of Joshua Bussell, who, in the best tradition of Shaker artisanry, was tinkering with his technique, experimenting, refining, and continually searching for ways to create a better picture.

By separating the families, Elder Joshua avoided the problem of having to link them in a continuous drawing. Through experience he had found that this could be done only two ways—either on a long, unwieldy scroll, or on a piece of drawing paper of a more manageable size from a perspective so distant that he could not represent the buildings in any detail. For this reason, since his recent return to drawing Shaker village views he had pictured only one family at a time, in long, horizontal views with a great deal of open sky at the top and a wide margin at the bottom. Now, by combining the sketches of the families in a single drawing, he was able to use the blank areas of his paper, and thus avoid making three separate pictures.

For fifty years Joshua Bussell had known the village as a continuous stretch of land and buildings, sharing a common lane broken only by the internal distinctions applied by the Believers themselves. It was still one Shaker village, and to represent it as three disjointed places was contrary to his personal experience and to the artistic methods he had once been taught. It is here that the influence of the lithographed views becomes apparent. Faced with the similar problem of simultaneously portraying Poland and New Gloucester, Phares Goist had represented the Novitiate Order in a separate sketch, which he inserted in his drawing as a discrete vignette. Observing this novel solution evidentally broke one more barrier for Elder Joshua, who, from this example, realized another way in which the views he was now drawing of the Shaker families need not be confined by the cartographic conventions of traditional village plans.

Other influences of the commercial landscape view of Alfred can be recognized in this last drawing. In the "Alfred Church" the elevated perspective allows us to see beyond the first range of white painted buildings, and into the red-painted shops and barns behind them. Here a feature rendered indistinct in the Phares Goist sketch is clarified by the Shaker artist who knew the village so well. Behind the central dwelling stood the kitchen woodshed, shown here with a row of apple-drying racks mounted on its southern wall. During the day they were used to dry fruit from the nearby orchard. At sundown, when the apples were gathered, the props were removed and the racks were collapsed for the night.

Again, the lane runs diagonally across the drawing paper. While in this version no carriages appear in the roadway, Shaker sisters can be seen walking from the dwelling to the sisters' shop, and from the sisters' shop to the laundry. Across the road at the ministry's shop, in faintly penciled lines, are the same group of arched structures seen in figures 103 and 104. Were it not for the lithographed view, they might be mistaken for the grave stones that stood in the Shakers' burying ground farther up the lane. By comparing this drawing to the commer-

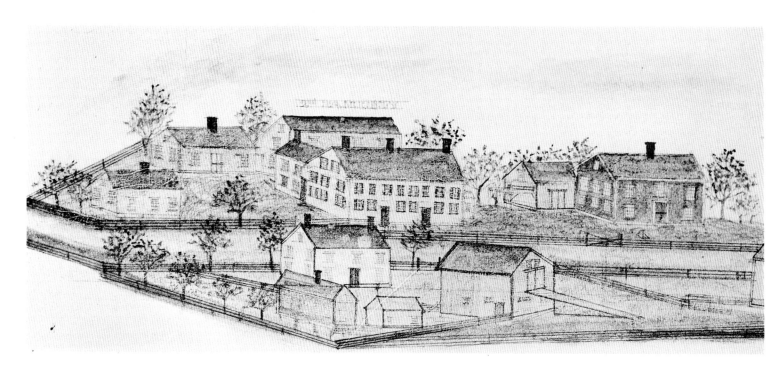

Figure 109. Detail of figure 108 showing the Second Family

cial artist's print, however, those indistinct features can be identified as an arbor in the ministry's garden.

Elder Joshua used the same elevated perspective in his view of the "2nd Famiely" (fig. 109). Here he rose above the roof of the trustee's office to give a clearer view of the dwelling across the street with the ell and the off-center door that were added to its southern end. This time, by extending the drawing to the right, the artist was able to include the Second Family cow barn standing across from the dairy. Otherwise, it is much the same as his other separate view of the Second Family, complete with the tiny birdhouse fastened to the roof of the sheep shed.

The bottom half of this drawing is divided into two blocks, one for each of the two smaller families at Alfred. As it turned out, the left hand box was not large enough to contain the buildings of the Second Family. To the east, the sheep barn, the sheep shed, and the garden house fall below the clearly penciled bottom line, and to the north, the cow barn lies almost entirely to the right of it. The greatly diminished North Family, however, stood easily within its confines.

The drawing of the North Family was a rudimentary sketch of six simple buildings (fig. 110). Elder Joshua had no model for this drawing. In Goist's lithograph the Family appeared as an indistinct group of structures in the distance beyond the crook in the road. Unlike the other Families in this view, he chose to picture it from a northeasterly

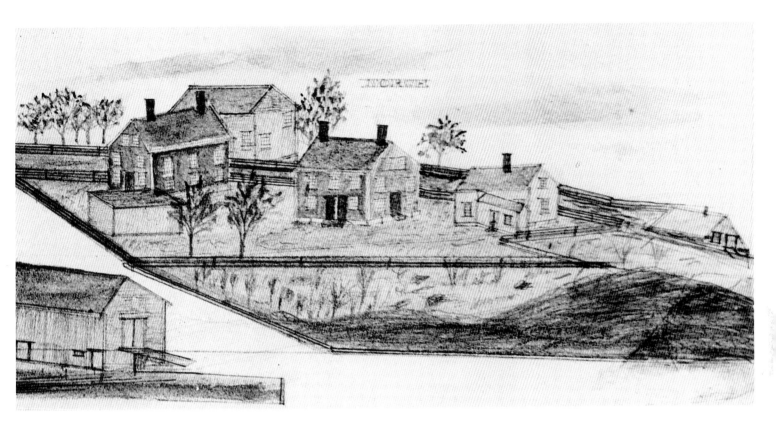

perspective, and unlike his other sketches, it was curiously imprecise. In the center, the dwelling house had shrunk from six bays to three; at the right, the spin house ell appeared at a distorted and unconvincing ninety degree angle. Elder Joshua drew this family as if he were a stranger there.

In a sense, he was. The Society had closed the North Family in 1857.[18] Elder Joshua had returned to the site to record buildings no longer used by the Shakers. Thus, this view of the Shaker village at Alfred was a retrospective drawing of a community that had not contained three Families for almost a quarter of a century. His mission had changed indeed during his career as an artist, from mapping the development of a growing community to preserving its image in a look backwards.

Of the nineteen buildings that once stood at the North Family, only the ruins of the mill race remain today. Elder Joshua's view of these three Families made its way to Sabbathday Lake, where it was found by Edward Deming Andrews and Faith Andrews.[19] It is now in the Andrews Collection of the Henry Francis du Pont Winterthur Museum.

Like the Shaker village at Alfred, the community at New Gloucester had experienced renovations since Joshua Bussell pictured it in the early 1850s, though the changes were nowhere near as extensive. In 1876 the original wooden shingles on the gambrel-roofed meeting-

Figure 110. Detail of figure 108 showing the North Family

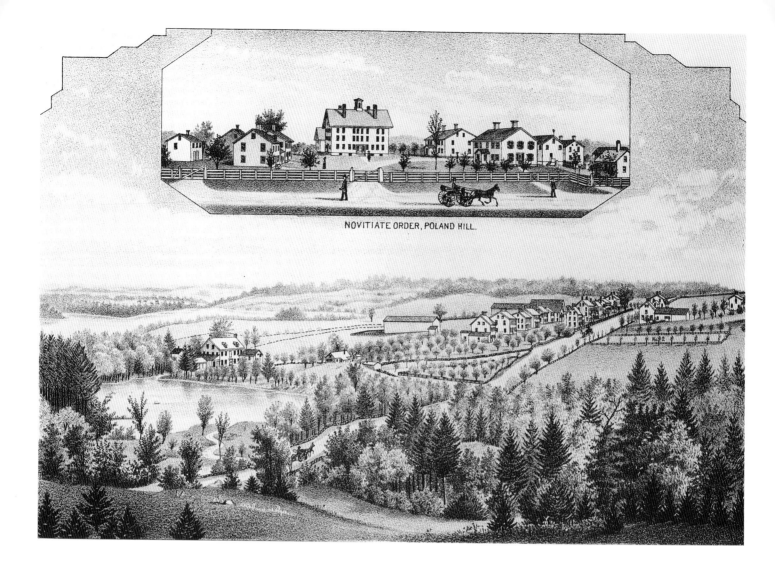

NOVITIATE ORDER, POLAND HILL.

Figure 111. "'Shaker Village,' View from the North West, West Gloucester, Maine."

After a drawing of 1879 by Phares Fulton Goist

1880

Lithograph

7 1/16″ × 10 1/8″ (18.0 cm × 25.7 cm)

Private Collection

house were taken off and replaced.[20] The 1839 ministry's shop had its end chimneys removed and replaced with a central flue. An ell was added behind it. The buildings had been repainted, and many of them were now white. As with the drawings of Alfred, the change was apparent less in the characteristics of the village than in the artist's style of portraying it.

December 17, 1879. Elder Otis has arrived late in the evening with *an Artist* who has come to take a view of our Village to insert in the forth coming *History of Cumberland County.*

December 18, 1879. *Phares Fulton Goist,* the Artist, drew a picture of the Church and the Village on Poland Hill.

December 19, 1879. Elder Otis returned to Alfred by noon train. The Artist completed drawing the picture of our lovely Villages and returned to Biddeford by evening train. It was a splendid picture.[21]

Once again, a "splendid picture" by Phares Goist (fig. 111) served as the model for Joshua Bussell's landscape views. In this instance there was no need to return with a presentation drawing. The commercial artist spent two days and two nights at the Shaker village, refining the details of his drawing. When the *History of Cumberland County* was published a month later, the Shakers liked the picture so much that they bought a second copy of the book.[22]

The lithograph of New Gloucester and Poland Hill was not composed

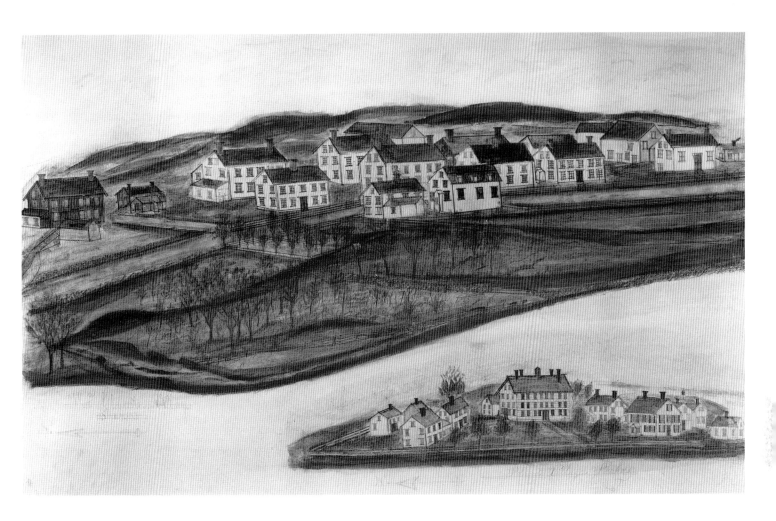

Figure 112. A Northwest View of the Shaker
Village at New Gloucester, Maine

Attributed to Joshua H. Bussell (1816–1900)

Ca. 1880

Pencil, ink, and watercolor on paper

14 1/2″ × 23 1/2″ (36.8 × 59.7 cm)

Inscribed: "West Gloucester Village of
Shakers" and "Poland Village of Shakers."

Private Collection

as a bird's-eye view. Instead, Goist made his sketch from a prospect to the northwest, on a hillside across the millponds and on a rise only a little higher than the village. From there he could actually draw the buildings in three-quarters perspective without having to conceive of such a scene from the air. Because he drew the village from this distance, most of the Shakers' buildings appear clustered together, overlapping and indistinct. However, on the millpond in the foreground is the great mill, built in 1853 as a sawmill, grist mill, and machine shop.[23] It was the hub of the Shakers' manufacturing enterprises, and its prominent depiction in the drawing probably compensated for the indistinct appearance of the rest of their buildings.

As Joshua Bussell had concluded a generation earlier, the North Family on Poland Hill was too far removed to be included in the same view. In this case, Goist employed the stock solution of the commercial maker of town views. Within the borders of the village view of New Gloucester he inserted an enlarged vignette of the buildings of the Novitiate Order. Unlike his other views, this drawing was made by facing the buildings directly, with the perspective leading the eye straight across the dooryard to the stone dwelling.

Joshua Bussell found this combination of the two scenes to be a practical device, and he copied it in his own view of the community (fig. 112). In fact, some sense of his reliance on the lithograph can be

inferred by his use of the title "West Gloucester." Although the Postal Service had established a post office by that name in 1824 for the convenience of the Shakers and their neighbors, the term referred to a district of the town, and not to an actual village. The Shakers tended to refer to their community as "Sabbathday Lake" or "New Gloucester," the town in which the community was located. The Postal Service's designation "West Gloucester" never really caught on. Until it was abandoned in favor of "Sabbathday Lake" in 1894, it was used principally by people who were unfamiliar with that lakeside village.

By adopting this view from the northwest, Elder Joshua was able to picture the buildings at New Gloucester in three-quarters perspective. Unlike Goist, however, his intention was not only to portray the landscape. In the tradition of the other Shaker village artists, he was interested primarily in recording the appearance of the buildings. In his own version, therefore, he moved around to the west and closed in on the scene. This change meant deleting the seed house from the far right, and bringing the great mill up into the village from the left, but he was able to achieve the kind of attention to detail that was lost in the distance of Goist's lithographed view.

On the other hand, he found the vignette of Poland to be so satisfactory, both in detail and in the way it was interposed into the scene, that he used it virtually unchanged (fig. 113). Although his perspective is elevated and dramatized, the view is clearly a copy of the Phares Goist sketch. This scene was drawn at an auspicious time for the North Family; after laboring for years to finish the interior of their house, they had completed it and moved in only in 1879.[24]

Though great changes were yet to come at New Gloucester—later in 1880 a school house would be built at the Church Family,[25] and in 1883 the old central dwelling would be replaced by a grand brick structure[26]—this drawing recorded only the improvements originally pictured by Goist in December of 1879. It was sent to the Ministry at Hancock along with a companion view of Alfred, where it remained until 1935.[27]

Joshua Bussell drew a second version of the views of New Gloucester and Poland (fig. 114) based on Goist's lithographed sketch. This one was a summer scene, with shade trees in leaf, corn growing in the fields, and cartoon figures of Shakers standing out of doors. Evidently some time had passed since he had made the first drawing, during which he had a chance to reflect on its composition and to review the accuracy of his work. There was no shoemaker then among the Shakers at New Gloucester, and Elder Joshua had begun to spend several weeks a year in residence both at the Church Family and at Poland Hill, mending shoes for the Believers living there.[28]

In this version of the scene the buildings are shown to better advantage and numerous small details about the village are corrected. By elevating his perspective, Elder Joshua rose above the meetinghouse and Ministry's shop for an unobstructed view of the buildings across the road. Now the second house was clearly visible, and for the first time the double doors of the dwelling house—one for the brethren and one for the sisters—could be seen. He silhouetted the rooftops by dropping out the hills in the background and by omitting the cow barn altogether. But, even though he stretched its height, he still could not extract the nurse shop from behind the three-story dwelling. For a solution, he reached back to his earliest days as a cartographer, and labelled it "Infirmery" in the sky just above its roofline.

Figure 113. Detail of figure 112 showing the Shaker village at Poland Hill

Figure 114. A View of the Shaker Village at New Gloucester, Maine

Attributed to Joshua H. Bussell (1816–1900)

Ca. 1880

Pencil, ink, and watercolor on paper

15" × 24 1/4" irregular (38.1 × 61.6 cm)

Inscribed: "West Gloucester" and "Poland"

Collection of Hancock Shaker Village, Inc.

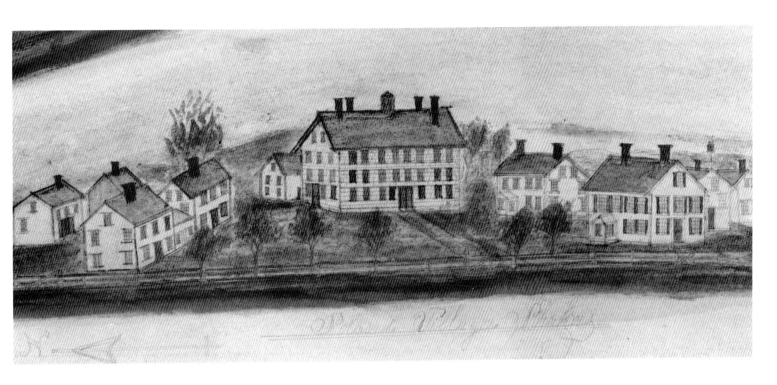

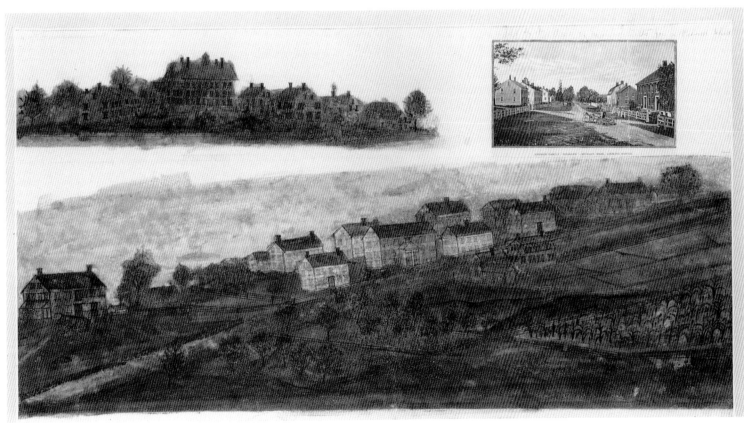

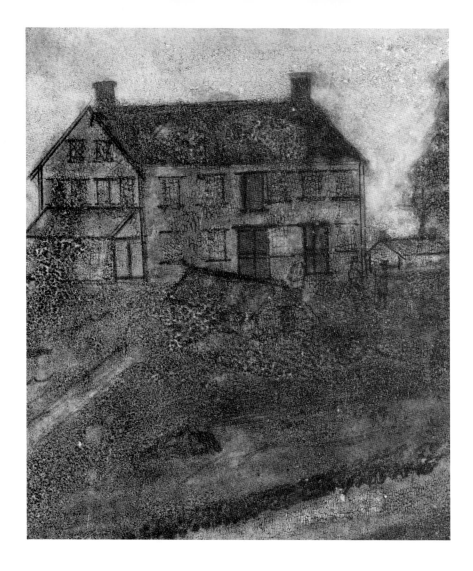

Figure 115. Detail of figure 114 showing figures at mill buildings

As was his practice in the second versions of his village views, Elder Joshua went through the drawing and corrected his work. The central chimney on the girls' shop was removed and replaced with end chimneys, while on the boys' shop he made just the opposite change. The lean-to shed was taken off the front of the sisters' shop and placed on the back. Two dormers were added to the attic loft of the great mill.

Although the 1794 gambrel-roofed meetinghouse was originally identical to the one raised in 1793 at Elder Joshua's home village of Alfred, over the years they were altered separately, and in different ways. At New Gloucester, an exterior stairwell had been added to the north gable end of the building, while at Alfred it had been added to the back. Because he was less familiar with the church at New Gloucester, the artist misunderstood the enclosed external stairway he saw in Goist's sketch. In his first drawing he interpreted it as a one-story vestibule. In the second version he corrected this, raising its peaked roof to the second floor. While he opened the meetinghouse shutters in this summer version, however, he still gave the building only three windows. With the back of his own meetinghouse altered, he never realized that the churches were originally five bays of windows long.

To the north of the meetinghouse lay the Church Family burying ground, where, in the nineteenth century, the Shakers' graves were marked with individual stones. Elder Joshua added the slate markers

to this version, and, copying the way Goist had drawn the shade trees lining the enclosure, drew the stones with little shadows falling next to them.

Such subtle elements as the gravestones and shadows help give the second version of this view a more personal and relaxed feeling. Indeed, even the brevity of the titles "West Gloucester" and "Poland" sound less formal and self conscious than the elaborate titles in the previous drawing. Nowhere is this sense better expressed than in a little narrative scene at the left of the drawing, in the yard of the 1853 great mill (fig. 115). In a late reference to the cartoons that so enlivened his early drawings, Elder Joshua included three tiny figures standing there. Though the scene is indistinct, the men are evidently examining the piles of newly sawn lumber stacked in the millyard. It is small amenities like these that give special meaning to a scene that would otherwise be just an ordinary view of a country village.

Similar figures can be seen in the view of Poland, which is interposed as a vignette in the sky above New Gloucester. These figures—Shakers walking among the buildings, a carriage and other pedestrians in the road—were taken directly from Goist's lithographed view. In fact, the lithographs of both Shaker villages are illustrated with similar cartoons. Though entirely conjectural, it is pleasing to speculate that the little vignettes in Elder Bussell's early drawings might have influenced Goist as he studied them in preparation for making his own sketches of the villages.

In 1887 the Novitiate Order was closed and the Poland Hill Family merged with the Church Family at New Gloucester. Two years later the hilltop village was sold to the owners of the resort at nearby Poland Spring. Eventually the buildings were all razed, even the grand stone dwelling, which was burned to the ground in 1955. As the Church Family grew smaller, its buildings were no longer needed, and they, too, were razed, one by one, until it was reduced to the seventeen buildings that now compose the Sabbathday Lake Shaker National Historic Landmark.[29]

Elder Joshua's drawing was one of a pair sent to the Ministry at Harvard, Massachusetts. After the dispersal of that community in 1918, they were acquired by a private collector. In the manner of the vignette of Poland, in the upper right corner she pasted a line engraving made from a photograph of the village at nearby Shirley, Massachusetts, penciling in the inscription: "Sold to the State of Massachusetts for a Reform School." In 1973 the drawing was acquired by Hancock Shaker Village, Inc.

9 EPILOGUE

One Shaker village view seems to stand apart from the Shaker tradition of illustrated maps and landscape drawings. Indeed, it is wholly without precedent or comparison among other Shaker village views. It depicts a community not otherwise represented in landscape drawings, in a style unlike that of any other Shaker artist. It is neither signed nor dated, and its known history does not predate the early twentieth century, when it was first recalled hanging on the second floor of the brick dwelling at Hancock. It stayed there until 1935, when it left the village with a young woman departing the Shaker life. It has since returned to Hancock, and is now in the collection of Hancock Shaker Village, Inc.[1] In light of what is known about Shaker village views, this last drawing raises many questions. Because almost nothing is known about how or when it was made, the answers must come entirely from the visual evidence contained in the document itself.

The Hancock Shakers' 1830 brick dwelling house was the center of activity at the Church Family. Built to house one hundred Believers, it contained communal rooms for food preparation and dining, and for religious and social meetings, as well as individual "retiring" rooms. This watercolor view of the three-and-one-half story building (fig. 116) illustrates its relationship to the rows of workshops to the east and the way it dominated the appearance of the village. In fact, the artist of this drawing has used those flanking buildings to emphasize the impor-

tance of the dwelling in his composition. By creating a dramatic perspective of all the other features in the drawing—fences, walks, trees, and buildings—the artist leads the viewer across the yard and up to the massive brick house.

The elongated perspective used in this drawing is so exaggerated that it distorts the scene. The shops are artificially tall, and the figures in the foreground are diminished in size at a rate disproportionate to the rate at which the buildings are reduced. However ineptly employed, though, it does demonstrate that the artist was at least aware of the mechanics of perspective drawing. Other incidental details apparent in the drawing support this indication of the artist's exposure to worldly artistic convention. The elevated features—buildings, trees, and human figures—all cast shadows to the northeast. The blue of the sky is reflected in the window glass. Smoke from the chimneys drifts away to the west. This drawing is evidently the work of a practiced, if amateurish artist. But the view is unsigned, and, without any remotely similar pictures by which to suggest an attribution, the identity of the artist remains a mystery.

There are some indications that it was painted by a Shaker. The inscribed title "East View of the Brick House, Church Family Hancock," indicates a familiarity with the Shaker community, and thus an assumption that no more formal explanation was needed. This sense that the artist was personally acquainted with village life is supported by small visual details as well. The Shaker brother standing by the well house is dressed in correct costume. Another brother drives three sisters in cloaks across the yard in the Family's "carryall" (fig. 117).

On the other hand, the vague, undefined landscape across the road to the right is incongruously unrealistic. Not only is the topography represented as a valley instead of a hillside, but the meetinghouse and the Ministry's shop, two of the most important buildings in any Shaker village view, have been omitted altogether. This could have hardly been the perception of someone who knew the village well, and it raises another possibility—that the drawing might just as easily have been made by a visitor to the village without a real sense of what lay beyond his immediate view.

Might it have been a visiting Shaker? Perhaps, though no other drawings in this worldly style are known by a Shaker artist. The white rectangular blocks in the foreground, at the near end of the stone walk, may provide a clue here. They are the granite steps of the 1852 trustees' office, where visitors who had business in the village were received. By including the steps in this picture, the artist pinpoints the location from which the drawing was made. Interestingly, it was the only building in the village that was open to visitors.

It is difficult to know just when this drawing was made. Despite the naive style of the artist, typical of a less worldly time earlier in the nineteenth century, the presence of the trustees' office in the picture places it after 1852. Ordinarily, one could assign a date to such a drawing by noting the styles of individual features depicted in it. But the style of the Shakers' architecture, their dress, and their carryall, all remained largely unchanged until at least the last quarter of the nineteenth century. Two other features can provide clues to dates, however. Around 1875 the enclosed stairwell at the west of the brick dwelling was raised to four stories. Here, it is only two stories high. Therefore this drawing represents the village as it looked before that alteration. Because the young maple trees in the yard were not planted until after the Civil War, this drawing could not have been made much before

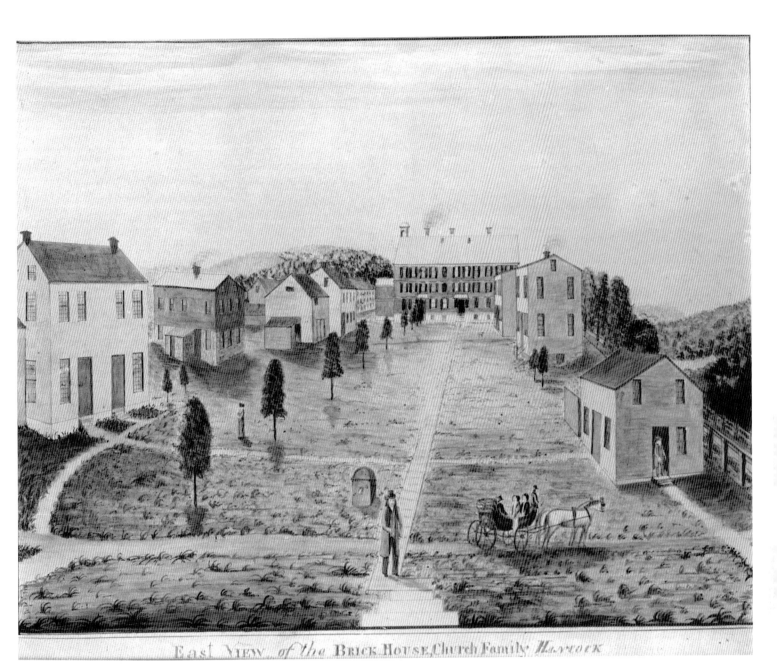

Figure 116. East View of the Church Family
Dwelling at Hancock

Unidentified Artist

Ca. 1870–1875

Ink and watercolor on paper

11 1/2″ × 14″ (29.2 × 35.6 cm)

Inscribed: "East View of the Brick House,
Church Family Hancock"

Collection of Hancock Shaker Village, Inc.

1870—in other words, it was drawn after photography had been introduced to the village.

Although it brings us no closer to identifying an artist, the discovery that the "East View of the Brick House, Church Family Hancock" was made relatively late in the nineteenth century can explain why it looks so different from other Shaker village views. The scene is deceptively old-fashioned. None of the industrial turmoil in the world beyond the village is evident here; indeed, none of the Shakers' own steam-powered mills intrude upon this quiet scene. The Church Family appears to have changed little since the brick dwelling was built in 1830. What makes this view different, then, is its narrow focus, which takes in only some of the buildings, and almost none of the landscape.

In the beginning, it was just the opposite. Shaker village maps recorded entire Shaker communities, detailing both the built and the natural environment. As they came to be used as architectural records, the drawings illustrated every facet of every building, stretching the length of the village. It was not until Joshua Bussell's 1850s views of the communities at New Gloucester and Poland that the scope of these drawings was scaled down to represent the scene an artist could actually envision from a single vantage point. His last view of Poland has the narrowest field of vision, restricted to even less than the human eye is accustomed to seeing. It is no coincidence that this scene was the one that Elder Joshua copied from a lithograph made by a commercial artist. This was the view one could see through the lens of a *camera obscura*. Thus, over the years, the scope of Shaker village views was reduced from the 360° range of the cartographer's all-seeing eye to the 47° or 50° field of vision of the camera's lens.

The "East View of the Brick House, Church Family Hancock" represents the next step in this progression. It does not give the 360° range of vision of a village map. It doesn't even show the 180° expanse encompassed in a landscape view. It incorporates only what one would see of the village if one stood on the steps of the Trustees' Office and looked through the lens of a camera. Just as Joshua Bussell's last drawings of the Shaker villages in Maine were influenced by commercial art drawn in 1880, this view of the Church Family seems to have been drawn in imitation of a photograph.

This would explain why the artist could have omitted the meeting-house, the Ministry's shop, and off to the left, the Hancock Shakers' most notable building, the 1826 round stone barn. His perspective was restricted to a camera's range of vision. It could explain how a chance visitor could capture details within the village so well, yet misunderstand so completely the landscape in the background. The former fell within his field of vision, and the latter did not. It could explain how the granite steps, looming awkwardly in the foreground for no apparent reason, found their way into the watercolor drawing: they showed up in the photographer's lens.

Unfortunately, there is no proof that this drawing was made from a photograph. Perhaps there was once a photograph, a unique image like a daguerreotype or a tintype, which was long since destroyed. Perhaps there is somewhere yet an unknown photograph of this scene, which will one day be discovered. Perhaps there was never an actual photograph, and the scene was drawn directly through a lens with the aid of a *camera obscura*.

Whatever the source, and in spite of its being unique among Shaker village views, this watercolor drawing does have a familiar look to it. It resembles Phares Goist's sketch of the stone dwelling at Poland, flanked

Figure 117. Detail of figure 116 showing
figures in foreground

by the workshops and with a carriage in the foreground (fig. 111). It also resembles James Irving's ca. 1870 photograph of the Church Family dwelling at Watervliet, flanked by its workshops, with Shakers in the foreground.[2] It is apparent that in one way or another, the appearance of this view was dictated, not by the person who drew it, but by an existing tradition generated from outside the community at Hancock.

Thus, in the end, it doesn't matter who drew it. In the last quarter of the nineteenth century the Shakers became less self sufficient, and, as they developed closer relationships with the world's people, the distinction between the objects they created themselves and the objects they acquired from others became less important. It was at about this time, for example, that the Pleasant Hill Shakers acquired two pencil sketches depicting their village, complete with numbered buildings in the Shaker tradition, but drawn and signed by the German-American artist Godefrey Zollinger.[3] The Shakers' greatest period of artisanry and ingenuity had passed, and now they looked beyond their communities for direction in their material creations. Whether the drawing of Hancock was made by a Shaker, by a visitor to the community, or just by someone looking at a photograph of the village, it would have looked the same.

The disappearance of distinctive and recognizable traits extended to many aspects of Shaker life. It became harder to live apart from the mainstream in post–Civil War America, and the Shakers' furniture, architecture, diet, schools, and speech came increasingly to resemble their neighbors'. The separate identity and purpose of Shaker culture depended on the self sufficiency of the community for its independence and on its rural setting for seclusion from worldly distractions. That life was disappearing in America.

The times were changing around the Shakers, and many of their communities were in decline. By the time these last drawings were made at least one had closed. Others were to follow. By 1925 only six of the Shakers' eighteen major communities were still active. Various factors were responsible for the survival of these communities—the persistence of a local agrarian economy, strong leadership, or just the momentum of amassed capital—but in one way or another they adapted to the twentieth century.

In all six of these last communities there were illustrated maps and landscape views depicting Shaker villages at the height of their prosperity. They must have been strange and poignant reminders of a bygone era, of a happier time in the Society's history. Some were tucked away and forgotten. Others were discarded, sold, or given away.

At Sabbathday Lake and at Canterbury a few Shakers preserved the very best of these village views and exhibited them in displays about the history of Shakerism at those sites. In time the unpretentious drawings of these self-taught artists were gathered into major museums and private collections. These illustrated maps and landscape views can now be seen as among the richest and most revealing documents of the Shakers' communal religious life in nineteenth-century America.

APPENDIX: SHAKER VILLAGE VIEWS THROUGH THE EYES OF THE WORLD

Starting in the 1830s, commercial artists began to make landscape views of Shaker villages. Unlike the Shakers' own drawings, which were intended for use only within the Society, these sketches were reproduced as illustrations in gazetteers and popular magazines. Until the advent of photography, these drawings shaped the way that the world's people perceived Shaker villages. In time, when they found their way into Shaker villages, they shaped the way that Shakers saw themselves.

The original illustrations were pencil or watercolor sketches, which were then reproduced as wood cuts, steel engravings, or lithographs by a second group of artisans, engravers who in all likelihood had never seen the scene they were picturing, and relied on the illustrators' notes to create a realistic scene. Some of these views are known today from the drawings of the original artists, and some only from the engravers' interpretations of those drawings. Both forms are included in the following checklist of Shaker village views drawn by commercial artists of the nineteenth century.

A CHECKLIST OF SHAKER VILLAGE VIEWS BY COMMERCIAL ARTISTS OF THE NINETEENTH CENTURY

I: Historical Views by John Warner Barber (1798–1885)

1. "Shaker Meeting House, Enfield" (fig. 118)

 Ca. 1834–36

 Pencil sketch on paper with title added in ink

 4 5/8" × 6 7/8" (11.1 × 17.5 cm)

 Sketch # 116 from "Drawings made for the *Connecticut Hist. Coll.,*" Collection of the Connecticut Historical Society, Gift of Houghton Bulkeley, 1953–5–88.

2. "Shaker Meeting House, Enfield, No 2" (fig. 119)

 Ca. 1834–36

 Pencil sketch on paper with title added in ink

 4 5/8" × 6 7/8" (11.1 × 17.5 cm)

 Sketch # 117 from "*Drawings made for the Connecticut Hist. Coll.*" Collection of the Connecticut Historical Society, gift of Houghton Bulkeley, 1953–5–88.

3. "Shaker houses, Enfield" (fig. 120)

 Wood engraving, ca. 1836.

 2 3/8" × 3 13/16" (6.0 × 9.7 cm)

 Connecticut Historical Collections (New Haven, 1836), 85. (Richmond #1819).

Two pencil sketches of the Shaker community at Enfield, Connecticut (figs. 118, 119), are probably the earliest Shaker village views to be made by a commercial artist. They are the work of John Warner Barber, who, according to his biographer, "travelled in a one-horse wagon, collecting materials and making sketches for the two hundred illustrations" for *Connecticut Historical Collections,* which he published in 1836.[1] According to the notes accompanying Barber's working drawings, he made 234 sketches "from July 7th 1834 to July 1st 1836 (beginning at Norwalk, ending at Smithville, now Birmingham.)" His sketches of the Shaker village at Enfield were made halfway through this project, probably in the summer of 1835.

The notes the artist penciled on both these drawings reveal that they were preliminary sketches, which he intended to develop more clearly once he returned to his desk. In the sky above the dwelling is the memorandum "Church Family live men & women about 100," and in the yard next to it is written "walk to door." Notes like these were also useful reminders in writing the accompanying text. They would be used to prepare the final drawing and to share with the engraver, who would need to know that the dwelling should be "Broader" and the meetinghouse was "not high enough" as he transferred the sketch to a wood block for printing the cut (fig. 120).[2]

Accompanying the description of the Enfield Shaker village was a small wood engraving entitled "Shakers, dancing," showing religious services at the Shaker village in New Lebanon, New York. No original sketch exists for this cut; it was obviously derived from one of several variations of that scene in print in the 1830s. Likely candidates for the antecedent view are George Gilbert's 1830 engravings entitled "Sabbath of the Shaking Quakers" (Richmond #2999) and "Shaker's Worshiping, (exercise)" (Richmond #3715). Another one of Barber's engravings appears in an album of Gilbert's engravings published by the American Sunday School Union, suggesting that the two men may have been familiar with each other's work.[3]

4. "Shaker Village in Hancock."

 Wood engraving, ca. 1839

 2 1/16" × 3 13/16" (5.3 × 9.7 cm)

 Historical Collections, Being a General Collection of Interesting Facts of Every Town in Massachusetts (Worcester, Mass., 1839), 74.

 (Richmond #1820)

5. "Shaker Buildings in New Lebanon"

 Wood engraving, ca. 1841

 1 1/2" × 3 3/4" (3.8 × 9.5 cm)

 Historical Collections of the State of New York with Geographical Descriptions of Every Township in the State (New York, 1841), 78.

 (Richmond #1823)

John Warner Barber continued to write and illustrate historical descriptions of the New England and mid-Atlantic states, using the same pictorial formula. In his volumes on Massachusetts and New York he illustrated the Shaker villages at Hancock and at New Lebanon with the same little cuts he used for the neighboring towns, showing the major buildings of the communities and adding a few human figures in the foreground to provide some balance and scale to the scene. Barber's interest in the Shakers seems to have been limited to these village views, which were made as part of pictorial histories of entire states. Though they were descended from the same seventeenth-century Connecticut family, he was no near relation to the New Lebanon Shaker artists Eliza and Miranda Barber.[4]

II: Canterbury Views: The Evolution of A Shaker Village Scene

6. "The Village of the United Society of Shakers, in Canterbury, N.H."

 Wood engraving, ca. 1835

 Unidentified artist

 4" × 5 3/4" (10.7 × 14.6 cm)

 The American Magazine of Useful and Entertaining Knowledge 2 (November 1835): 133.

 (Richmond #1675)

7. "The Shaker Settlement, at Canterbury"

 Wood engraving ca. 1847

 Attr. Benson John Lossing (1813–91)

 4 7/8" × 7 7/8" (12.4 × 23.8 cm)

 New Pictorial Family Magazine, 4 (New York, 1847): 278.

 (Not in Richmond. See Richmond #2684)

8. "Shaker Village at Canterbury, N.H."

 Electrotype of wood engraving ca. 1853

 By William Rickarby Miller (1818–93)

 6" × 9 3/8" (15.3 × 23.8 cm)

 from "Rambles Among the Shakers," *Illustrated News* 1 (October 29, 1853), 245.

 (Richmond #3562)

9. "Shaker Village, Canterbury, New Hampshire."

 Electrotype of wood engraving, second state

 By William Rickarby Miller (1818–93)

 5" × 9 3/8" (12.7 × 23.8 cm)

 "Shaker Village in Canterbury, N.H.", *Ballou's Pictorial Drawing-Room Companion* (July 19, 1856): 37.

 (Richmond #3668)

10. "Shaker Village"

 Stereoscopic photograph, ca. 1870.

 By Howard Algernon Kimball (1845–ca. 1930)

 3 1/8" × 3 1/8" (7.9 × 7.9 cm)

11. "Canterbury, N.H."

 Steel plate engraving after H. A. Kimball

 Unidentified engraver

 1 3/4" × 3 1/8" (4.5 × 7.9 cm)

 The Shaker Manifesto 8 (January 1878): cover illustration.

 (Richmond #988)

Figure 118. "Shaker Meeting House, Enfield"

By John Warner Barber (1798–1885)

Ca. 1834–36

Pencil sketch on paper with title added in ink

4 5/8″ × 6 7/8″ (11.1 cm × 17.5 cm)

Collection of the Connecticut Historical Society, photograph by Robert J. Bitondi

Figure 119. "Shaker Meeting House, Enfield, No 2"

By John Warner Barber (1798–1885)

Ca. 1834–36

Pencil sketch on paper with title added in ink

4 5/8″ × 6 7/8″ (11.1 cm × 17.5 cm)

Collection of the Connecticut Historical Society

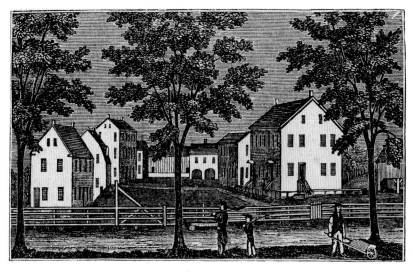

Figure 120. "Shaker houses, Enfield"

Wood engraving after drawings by John Warner Barber

2 3/8″ × 3 13/16″ (6.0 cm × 9.7 cm)

Private Collection

12. "Shaker Village, Merrimack County, New Hampshire"

Wood engraving ca. 1879

The Photo Electrotype Company, Boston.

2 1/4″ × 4 1/2″ (5.7 × 11.4 cm)

The Shakers' Manual (Concord, N.H., 1879): cover

(Richmond #184)

The first view of a Shaker village ever published was a small wood engraving by an unidentified artist of the Society at Canterbury. If an original sketch had survived it might be possible to identify the artist and date the drawing, but the scene is known only through the engraver's version, which appeared in *The American Magazine of Useful and Entertaining Knowledge,* a popular illustrated magazine, in the fall of 1835. The view is roughly similar to the work of John Warner Barber, though it is unlikely that Barber took time out from preparing his *Connecticut Historical Collections* to travel to New Hampshire. It is more likely that it was drawn by another artist working at the same time. After the *American Magazine* ceased publication in 1836 its printing plates were acquired by John L. Sibley and James B. Low, who reprinted the entire run of the magazine in two bound volumes, in several editions starting in 1839. By 1851 the plates had been acquired by Walter Percival, who republished the entire magazine virtually unaltered under the title of *The Pictorial Library of Useful Information.*[5]

Though this much-published scene was only one of several nineteenth-century views to picture the hilltop village from a pasture to the southwest of the Church Family, it was the only one to be drawn from life. The first imitation, which appeared in 1847, was probably the work of Benson J. Lossing, who was then the chief wood engraver for Robert Sears's *New Monthly Family Magazine.*[6] This version is a little larger; though he used a pantograph to trace the woodcut to precisely the same size, Sears's engraver expanded its borders to lift its figures off the bottom edges of the picture, creating a light and airy vignette. Like its predecessor, this view was also widely republished. It appeared the next year in Sears's *A New And Popular Description of the United States* (1848) (Richmond #2684) and thereafter in Sears's *A New and Popular Pictorial Description of the United States* (1854).

Next in line was William Rickarby Miller's 1853 interpretation of the scene for P. T. Barnum's *Illustrated News.* Rather than trace the scene, the artist redrew it entirely. In this version the two figures conversing in the foreground are gone, replaced by a single cowherd standing beneath an elm tree. Miller misunderstood what he was copying: here the stone walls become picket fences, the modest buildings of the North and Second families rise like grain elevators, and the gambrel-roofed meetinghouse looms as high as the 1793 dwelling. He made no reference to the rustic fence introduced in the 1847 version, however, and it is obvious that he, too, used the original 1835 print as his source for this illustration.

Engraved in enlarged dimensions, Miller's drawing made an attractive and decorative print, and on the following page of the *Illustrated News* Barnum advertised that "Electrotype plates of all engravings which appear in this paper may be purchased at reasonable terms."[7] No individual prints of this Shaker scene have yet been located, but any of the special electrotypes that Barnum may have produced would have been an insignificant increase over the edition of seventy thousand he claimed as the paper's circulation. By November of 1853, when Barnum sold the *Illustrated News* to Boston publisher Frederick Gleason,[8] William Rickarby Miller's version of the Canterbury view had a far greater distribution than all its predecessors combined.

Boston-based *Gleason's Pictorial Drawing Room Companion* was even more popular, and in 1855, when Gleason in turn sold the paper to his editor Maturin M. Ballou, he claimed a circulation of over one hundred thousand.[9] It was to this reading public that *Ballou's Pictorial Drawing Room Companion* presented a short article on the Canterbury Shakers in October of 1856. It was illustrated with William Rickarby Miller's engraving of the Canterbury view, whose woodcut engraving block had been acquired along with the ownership of the *Illustrated News.* An interior scene entitled "Shakers at Prayer," which had accompanied the Canterbury view in the *Illustrated News,* was acquired also, and was reprinted separately by Ballou in 1858 (Richmond #3256).

Although he used the same cut, Ballou altered the picture slightly when he printed it. Newly entitled "Shaker Village, Canterbury, New Hampshire," its high billowing clouds had been cropped. Thus by 1856 four different versions of the same hillside view had been widely published as engravings. They were now established, both in the village and in the world beyond it, as the ideal representations of the community.

Around 1870 a local photographer named Howard Algernon Kimball recreated the scene as a photograph, which itself was reproduced as a line engraving, and illustrated in several states on the covers of *The Shaker Manifesto* starting in 1878. The scene even found its way into the Canterbury Shakers' commercial advertising. Around 1879 one last version was employed to illustrate sales brochures for Br. Thomas Corbett's Shaker Syrup of Sarsaparilla. Crudely reproduced by the Photo Electrotype Company of Boston, the cut would be almost unrecognizable were it not for its similarity to the series of landscape views that preceded it.

III: Benson John Lossing's Pictures of New Lebanon

13. "Northern Portion of the Shaker Village"

14. "The Office and Store"

15. "The Meeting House"

16. "The Herb House"

17. "Extract House"

18. "The Tannery"

19. "The Seed House—Ancient Church"

Wood engravings, 1856

By Benson John Lossing (1813–91)

From "The Shakers," *Harper's New Monthly Magazine* 86 (July 1857): 164–77.

(Richmond #3385)

In August of 1856 Benson John Lossing visited the Shaker village at New Lebanon, New York, and made a series of pencil and watercolor sketches of scenes about the community. The following year *Harper's New Monthly Magazine* published seventeen of his drawings as wood engravings by William Barritt. Lossing sketched interiors of rooms, Shakers at work and at worship, examples of Shaker costume, and details of machinery used in the medicinal herb industry. While his illustrations of six buildings can be classified as village views, only his "Northern Portion of the Shaker Village" provides a panoramic look at the community at New Lebanon. The influence of Loss-

ing's illustrations was considerable: the first drawings to picture aspects of Shaker life other than religious worship, they were used to illustrate Charles Nordhoff's 1875 study *The Communistic Societies of the United States* (Richmond #2517) and since have been widely reprinted. Benson Lossing's visit to New Lebanon is described and his original watercolor drawings are illustrated in an unpublished manuscript by Don Gifford in the files of Hancock Shaker Village, Inc., *Benson John Lossing: "The Shakers"* (Richmond #2166).

IV: Marginally Out of Doors

There are three groups of drawings that illustrate Shaker life in the nineteenth century but do not include a panoramic view of a Shaker village. They are so renowned, however, that they are listed here for the record.

David R. Lamson's 1848 book, *Two Years' Experience Among the Shakers* (West Boylston, Mass. [Richmond #855]), includes three wood engravings by an unidentified artist. Two of them, "The Whirling Gift" and "The gift of the Father and Son," depict religious dance, presumably at Hancock, where the author lived from 1841 to 1843. The other, "Mountain Meeting," is a narrow view of the Holy Ground, illustrating only the small shelter and the inscribed stone surrounded by a board fence.

In 1870 English illustrator Arthur Boyd Houghton (1836–75) travelled to America on assignment for the *London Graphic* to make sketches for the series "Graphic America." Five of his illustrations were reproduced that May in the *Graphic* (Richmond #3679). "Dinner-Time at Mount Lebanon," "Shakers at Meeting. The Religious Dance," and "Shakers at Meeting. The Final Procession," are all interior scenes, and while "Shakers Going to Meeting" and "A Shaker Sleighing Party" are out of doors, Houghton's depiction of the village is nondescript.

Probably the best known illustrations of Shaker village life are the fourteen drawings made by Joseph Becker (1841–1910) for *Frank Leslie's Illustrated Newspaper*. They were published in four installments during the year 1873 (Richmond #3707, #3708, #3729), and then twelve years later were reprinted in *Frank Leslie's Popular Monthly* (Richmond #3701).[10] Like Arthur Boyd Houghton's drawings of New Lebanon, most are interior scenes, entitled:

"Singing Meeting"
"A Shaker Schoolroom"
"Business Office of the Shakers"
"Entrance to the Shaker Women's Rooms"
"Entrance to the Shaker Men's Rooms"
"Sleeping-Room of the Men Shakers"
"The Shaker Ironing Room"
"The Dining-Room of the North Family"
"Girls' Clothes Room in the Church Family"
"A Mender of Clothing at the Church Family"
"The Kitchen of the Church Family"
"Cutting Bread"
"Religious Exercises in the Meetinghouse"

Only "New York—The Shakers at Lebanon Enjoying A Sleigh-Ride" illustrates a scene out of doors, and then, again like Houghton's drawing, the subject is the figures in the sleigh and not the landscape. By the 1870s these illustrators were competing with the camera and found themselves at a disadvantage in making landscape views. Their forte was in sketching interior scenes or in capturing quick vignettes of human character. By 1896, when the next Shaker article appeared in *Leslie's Weekly*,[11] it was illustrated with photographs (Richmond #3534).

V: Villages on Stone

20. "Shaker Village, Alfred, Maine:
 Lithograph, 1880
 By Phares F. Goist
 7 1/8″ × 10 1/16″ (18.1 × 25.6 cm)
 History of York County, Maine (Philadelphia, 1880), 265.

21. "'Shaker Village,' View from the North West, West Gloucester, Maine," and "Novitiate Order, Poland Hill."
 Lithograph, 1880
 By Phares F. Goist
 7 1/16″ × 10 1/8″ (18.0 × 25.7 cm)
 History of Cumberland Co., Maine (Philadelphia, 1880), 328.

In December of 1879 and January of 1880 a landscape artist named Phares F. Goist visited the Shaker villages in Maine. Unlike the other commercial illustrators of Shaker village views, he had not been dispatched by an editor to sketch scenes of life in a Shaker community. Rather, he was working his way through the towns of southern Maine, making drawings of the homes of prominent residents to be printed as lithographs in historical gazetteers. The Shaker villages were just two of many residences included on his itinerary.

The Shakers approved of Phares Goist's drawings, and they soon appropriated them for use in their own publications. Both views were used, in smaller format and with slightly different titles, to illustrate historical accounts of the communities in *The Manifesto*, and were again reproduced, in 1884 in Giles Avery's *Sketches of Shakers and Shakerism* (Richmond #57), and in 1892, in Charles Edson Robinson, *A Concise History of the United Society of Believers Called Shakers.* (Richmond #1249) A photograph of the Alfred lithograph was used in *Shakerism, Its Meaning and Message* (Richmond #1447),[12] and the view of West Gloucester was reproduced as a print in the same size as the original by the Sabbathday Lake Shakers in 1966.

22. "The Home of the Society of Christian Believers Vulgarly Called Shakers. Sonyea, Livingston, Co, N.Y."
 Lithograph, ca. 1881
 By John Lyth (1846–1910)
 9″ × 13″ (22.9 × 33.0 cm)
 James Hadden Smith, *History of Livingston County, 1687–1881* (Syracuse, 1881), 358.
 (Richmond #2776)

23. "The Home of the Society of Christian Believers Vulgarly Called Shakers. Sonyea, Livingston, Co, N.Y."
 Lithograph, second state, ca. 1884
 By John Lyth (1846–1910)
 2 1/2″ × 6 1/2″ (8.2 × 16.5 cm)
 Giles Avery, *Sketches of Shakers and Shakerism* (Albany, 1884).
 (Richmond #57)

In much the same way that views of the Shaker villages at Alfred and New Gloucester were included in the country histo-

ries of Maine, the Shaker village at Groveland was illustrated in a centennial history of Livingston County, New York. In the latter case, however, one author compiled the history and one artist made all the drawings. Although the view of Groveland is unsigned, the obituary of New York artist John Lyth records that he was responsible for every illustration in the book.

The artist employed a standard formula for his scene, depicting the village in a panoramic view with figures in carriages and a rail fence in the foreground to provide a sense of scale to the buildings. This was not a bird's-eye view, however, and many of the buildings were obscured in his eye-level prospect. Like the Shaker artists, he solved this problem by numbering each building in the sky overhead and then identifying each of them in a numbered key flanking the title in the border below the scene. In addition to these verbal descriptions, two of the more prominent buildings are illustrated as vignettes in the sky above the village.

Like the lithographs of the Maine Shaker villages, the view of Groveland was used by the Shakers themselves. A variant appears in Giles Avery's *Sketches of Shakers and Shakerism* (Rich-

mond #57), reduced in width and with the top third of the sky cropped to remove the vignettes. In yet another revival, a photograph of the original lithograph appears among a group of illustrations in *A Report of the State Board of Charities on the Selection of a site for the Organization of an Epilectic Colony* (New York, 1893). In this version the original title and numbered key have been cropped from the bottom and the words "East House Group" have been inscribed across the pine trees at lower left. The publisher also had the scene silhouetted above the horizon, eliminating the vignettes, the clouds, and, because they no longer had a corresponding description, the numbers in the sky over the buildings.

In the 1870s, as travelling photographers brought their bulky view cameras to Shaker villages, photographic views were made of virtually every Shaker site, and were widely distributed as stereopticon views and picture post cards.[13] They were also reproduced as line engravings for publication in books and periodicals. Because these engravings were copies of photographs they should be considered in a different category from original Shaker village views.

NOTES

1. INTRODUCTION
(pages 3–30)

1. Daniel W. Patterson, *Gift Drawing and Gift Song: A Study of Two Forms of Shaker Inspiration* (Sabbathday Lake, Me., 1983), 4–5.

2. Jules David Prown, "Mind in Matter," *Winterthur Portfolio* 17, no. 1 (Spring 1982):2.

3. Testimony of Thankful Barce in Seth Y. Wells and Calvin Green, eds., *Testimonies Concerning the Character and Ministry of Mother Ann Lee and the First Witnesses of the Gospel of Christ's Second Appearing* (Albany, 1827).

4. Though the name "Lee" is traditionally used by the Shakers, recent research indicates that during her lifetime Mother Ann was known by her family's name of "Lees." It was not until after her death in 1784 that the name became shortened. (Personal communication from Br. Theodore E. Johnson, Sabbathday Lake, Me., July 22, 1984.)

5. Thomas Low Nichols, *Forty Years of American Life, 1821–1861* (New York, 1937), 236.

6. For an analysis of the physical structure of Shaker villages and a comparison with other communitarian societies, see Dolores Hayden, *Seven American Utopias: The Architecture of Communitarian Socialism* (Cambridge, 1976).

7. Benson J. Lossing, "The Shakers," *Harpers New Monthly Magazine* 15 (July 1857):166.

8. "The meeting house was raised . . . patterning the old Dutch style then in vogue in New York, which was imitated by all the Shaker societies in the New England States." Elder Otis Sawyer, "Shaker Village," in *History of Cumberland Co., Maine* (Philadelphia, 1880), 328.

9. Marius B. Peladeau, "The Shaker Meetinghouses of Moses Johnson," *Antiques* 68 (October 1970):594.

10. Isaac N. Youngs, "A Concise View of the Church of God and Christ on Earth, Having its foundation in the Faith of Christ's First and Second Appearing," New Lebanon, N.Y., 1858–60, MS The Edward Deming Andrews Memorial Shaker Collection, Winterthur Museum (SA 760).

11. Letter from Nathaniel Hawthorne to Louisa Hawthorne, August 17, 1831; quoted in Seymour L. Gross, "Hawthorne and the Shakers," *American Literature* 29 (January 1958):458.

12. This interpretation of color symbolism is described in Calvin Green, "Biographic-Memoir," Lebanon, N.Y., 1861, MS, Cathcart Shaker Manuscript Collection, The Western Reserve Historical Society VI:B–28. Relevant passages from Elder Calvin's memoir have been published in Diane Sasson, *The Shaker Spiritual Narrative* (Knoxville, Ky., 1983), 189–208.

13. For information about house painting in early nineteenth-century New England, see Richard Candee, "The Rediscovery of Milk-based House Paints and the Myth of Brickdust and Buttermilk Paints," *Old Time New England* 68 (Winter 1968): 79–81; and "Preparing and Mixing Colors in 1812," *Antiques* 113 (April 1978): 849–53.

14. For a description of the history and evolution of the "Millennial Laws," see Theodore E. Johnson, ed., "The 'Millen-

nial Laws' of 1821," *Shaker Quarterly* 7 (Summer 1967): 35–58.

15. The Millennial Laws of 1845 are published in Edward Deming Andrews, *The People Called Shakers: a Search for a Perfect Society* (New York, 1953), 243–89. All references to the laws of 1845 are quoted from this transcription.

16. Lossing's sketches were the basis for the wood engravings by William Barritt published in "The Shakers," *Harpers New Monthly Magazine* 15 (July 1857): 164–77.

17. Quoted in Charles Nordhoff, *The Communistic Societies of the United States* (New York, 1875), 164–65.

18. The original drawing, with its inscribed message, is in the collection of Hancock Shaker Village. It is reproduced in Edward Deming Andrews and Faith Andrews, *Visions of the Heavenly Sphere: A Study in the Shaker Religious Art* (Charlottesville, 1969), 71.

19. Patterson, *Gift Drawing*.

20. Letter from Br. Samuel Turner for the Ministry at Pleasant Hill, Kentucky, to the Ministry at New Lebanon, New York, May 1, 1823. Collection of the Western Reserve Historical Society IV: A–53.

21. Patterson, *Gift Drawing*, 43.

22. In eighteenth-century records, this name is variously spelled as "Wild," "Wilds," and "Wildes." The form used here is the one used in "Names of People Forming the Church in 1793," in "A Shirley Account Book, 1815–1835" (MS in the collection of the Fruitlands Museums).

23. Ethel Stanwood Bolton, *Shirley Uplands and Intervales* (Boston 1914), 183–86.

24. For a discussion of eighteenth- and early- nineteenth-century maps and townscapes, see Peter Benes, *New England Prospect: A Loan Exhibition of Maps at the Currier Gallery of Art* (Boston 1981), 103–13.

25. On a visit to Harvard and Shirley in July of 1795, William Bentley admired and purchased several Shaker-made articles. See William Bentley, *Diary [1784–1819]*, vol. 2 (Gloucester, Mass., 1962), 150–55.

26. John White's drawing, reproduced as an engraving by Theodor de Bry in Plate XX of *America* (Frankfurt, 1590), is illustrated in Steven D. Neuwirth, "The Images of Place: Puritans, Indians, and the Religious Significance of the New England Frontier," *The American Art Journal* 18 (Spring 1986): 46.

27. The definitive study of urban American views during this period is John W. Reps, *Views and Viewmakers of Urban America 1825–1925* (Columbia, Mo., 1984).

28. Donald E. Pitzer, "The Harmonist Heritage of Three Towns," *Historic Preservation* 29 (October–December 1977): 5–12.

29. Merle Glick, "A Prairie Vision: The World of Olof Krans," *Historic Preservation* 34 (October–November 1982): 35–41.

30. An 1879 map of the Shaker village at Union Village, Ohio, now in the collection of the Western Reserve Historical Society, is labelled "for the Use of Mount Lebanon."

31. Isaac Newton Youngs, journal entry for June 5, 1834, in "Tour thro the states of Ohio and Kentucky." Collection of the Emma B. King Library, The Shaker Museum, Old Chatham, New York.

32. Patterson, *Gift Drawing*, 15.

33. The "Millennial Laws" of 1845 specifically list these subjects as appropriate for students in Shaker schools.

34. Andrews, *Visions of the Heavenly Sphere*, 63.

35. Letter from the Ministry at Sabbathday Lake, Maine, to the Ministry at Harvard, Massachusetts, January 19, 1848. MS, The Western Reserve Historical Society.

36. Peter Foster inscribed this note on his 1849 "Diagram of the South Part of Shaker Village, Canterbury, N.H." now in the collection of the Library of Congress, and shown as figure 62.

37. Ruth Wolfe, "Hannah Cohoon," in Tom Armstrong and Jean Lipman, eds., *American Folk Painters of Three Centuries* (New York, 1980), 64.

38. For example, the Greek Revival architect Ammi Burnham Young designed the Church Family dwelling house for the Enfield, New Hampshire, Shakers. A set of architectural drawings now in the Andrews Collection at Winterthur Museum and in the library of Hancock Shaker Village may represent an early version of that project. See Robert P. Emlen, "The Great Stone Dwelling of the Enfield, New Hampshire Shakers," *Old Time New England* 69 (Winter–Spring 1979): 72. Another instance of the Shakers' exposure to delineators' skills is reported in "Rambles Among the Shakers," *Illustrated News* 1 (October 19, 1853): 245, whose unidentified author mentions that professional surveyors were hired to measure Shaker land at Canterbury, N.H. In 1834 Isaac Newton Youngs while on a visit to the Shaker village at Union Village, Ohio, noted that he "Saw, in one of the Office rooms, the books, writings, and drawings of one of the canal engineers, who makes it his home here to conduct the new canal they are making from Lebanon to the Dayton Canal." (Journal entry for July 3, 1834, "Tour thro the States of Ohio and Kentucky," in the Emma B. King Library, the Shaker Museum, Old Chatham, N.Y.)

39. The concept of worldly influence on Shaker design is explored in Mary Lyn Ray, "A Reappraisal of Shaker Furniture and Society," *Winterthur Portfolio 8* (Charlottesville, 1973), 107–32; and Theodore E. Johnson, "Shaker Victorian," *Maine Antique Digest* 2 (July 1974): 25–26.

40. For a discussion of the ways since prehistoric times in which people have represented tracts of land lying within their direct experience, see P. D. A. Harvey, *The History of Topographical Maps: Symbols, Pictures, and Surveys* (London, 1980).

41. Nordhoff, *The Communistic Societies of the United States,* 70–78.

42. Untitled article from *Reynold's Miscellany* (London) 25 (September 15, 1860): 180.

43. Elder Henry C. Blinn, "Notes by the Way While on a Journey to the State of Kentucky in the Year 1873," quoted in Theodore E. Johnson, ed., "A Journey To Kentucky in the Year 1873," *The Shaker Quarterly* 5 (Spring 1965): 13.

44. Personal communication from Eldress Bertha Lindsay, Canterbury, N.H., January 3, 1977. Personal communications from Sr. Elsie McCool and Sr. Eleanor Philbrook; and from Sr. R. Mildred Barker and Sr. Minnie Green, Sabbathday Lake, Me., August 1974. June Sprigg, *The Gift of Inspiration* (New York, 1973), 47.

45. Patterson, *Gift Drawing,* 7.

46. This drawing, entitled only "Pen Scetch by Chas. A. Sturr," is now in the collection of the Western Reserve Historical Society, catalogued as representing the Shaker village at Watervliet, Ohio (XIV: 29). It is now thought that the cataloguer's added inscription "Watervliet, Ohio" is an error, and that the sketch actually depicts the neighboring Shaker community at Whitewater, Ohio. (Personal communication from Melba Hunt, Director, Kettering-Moraine Museum, July 22, 1984.)

2. VILLAGES ON THE LANDSCAPE
(pages 31–46)

1. Dorothy M. Filley, *Recapturing Wisdom's Valley: The Watervliet Shaker Heritage, 1775–1975* (New York, 1975), 11–12.

2. Hazel Spencer Phillips, *Richard the Shaker* (Lebanon, Ohio, 1972).

3. Ibid., 53.

4. "June 24, 1912. To Mr. J. P. McLean, Franklin, Ohio, for a Pen Drawing of Union Village: $5.00." (Order number 188712, Archives of the Library of Congress, Geography and Map Division)

5. Letter from Brother Samuel Turner, Pleasant Hill, Kentucky, to "kind and respected Brother Rufus Bishop," New Lebanon, N.Y., March 5, 1821. Western Reserve Historical Society, IV: A−53.

6. Letter from the Ministry at Pleasant Hill, Kentucky, to the Respected Ministers, New Lebanon, N.Y., May 1, 1823. Western Reserve Historical Society, IV: A−53.

7. Letter from Brother Samuel Turner, Pleasant Hill, Ky., to Brother Rufus Bishop, New Lebanon, N.Y. Western Reserve Historical Society, IV: A−53.

8. Mary Lou Conlin, "The Lost Land of Busro," *The Shaker Quarterly* 3 (Summer 1963): 44−60.

9. Unpublished research by John Martin Smith quoted in a letter to the author, October 2 1985.

3. PLANS, VIEWS, AND DELINEATIONS
(pages 47−64)

1. "The Ministry were at the Second Family yesterday. They established Joseph Parker in the Elders Order in the place of Charles F. Priest who lately decest" (Entry for March 12, 1842, in "A Journal Containing some of the most important events of the day kept for the use and conveniance of the Brethren in the Church in union with the Ministry & Elders—Harvard Nov^m 1840." MS, Collections of the Fruitlands Museums).

2. "Charles F. Priest to work here putting up pins &c at the new Office" (Entry for December 23, 1840 in ibid.).

3. Edward R. Horgan, *The Shaker Holy Land: A Community Portrait,* (Harvard, Mass., 1982), 51.

4. "Br. Austin B. & W. Green went to see the school commissioner to get a certificate" (Entry for January 15, 1846, in "The Diary of Sr. Ann Buckingham." MS, Shaker Collection, New York State Historical Collections).

5. This writing is illustrated as figure 14 in Daniel W. Patterson, *Gift Drawing and Gift Song: A Study of Two Forms of Shaker Inspiration,* (Sabbathday Lake, Me., 1983), 30.

6. "Buildings at Watervliet" (Undated letter from Austin Buckingham to Isaac N. Youngs, ca. 1825. MS, Collection of the Western Reserve Historical Society).

7. Isaac N. Youngs, "A Concise View of the Church of God" (December 31, 1860, p. 485. MS, Edward Deming Andrews Memorial Shaker Collection [SA 760], Winterthur Museum Library).

8. Letter from Isaac Newton Youngs to Andrew Houston, August 6, 1830 (MS, Western Reserve Historical Society [V: A−35]).

9. Isaac Newton Youngs, journal entry for June 5, 1834, "Tour thro the States of Ohio and Kentucky; By Rufus Bishop and Isaac N. Youngs, in the Summer of 1834" (MS, The Emma B. King Library, The Shaker Museum, Old Chatham, New York).

10. Ibid., July 5, 1834.

11. Ibid., September 27, 1834.

12. The watermark "R AMIES & C° N° 2" appears on this map in four different places. According to Thomas Gravel, *Catalogue of American Watermarks 1690−1835* (New York, 1979), the same watermark is found on a letter dated in 1833. It is estimated that in this period 96 percent of all watermarked paper was used within six years of manufacture. If 1833 fell at the end of the six-year period, the watermark might be dated 1827−33. If it fell at the beginning, the dates might be 1833−39. But without knowing where it fell, the possible span of dates for this map must be considered to be 1827−39.

4. MAPS OF THE WESTERN VILLAGES
(pages 65−92)

1. Preface to the journal of Isaac Newton Youngs, "Tour thro the States of Ohio and Kentucky during the Summer of 1834." Collection of the Emma B. King Library, The Shaker Museum, Old Chatham, New York. Hereafter referred to as "Youngs."

2. "A History of the Society of Believers at Sodus and Port Bay, N.Y., 1822−1838" 60. Collection of the Western Reserve Historical Society, V−13:22.

3. Youngs, June 9, 1834.

4. Ibid., June 11, 1834.

5. Herbert A. Wisbey Jr., *The Sodus Shaker Community* (New York, 1982), 7.

6. Youngs, June 19, 1834.
7. Ibid., June 18, 1834.
8. Ibid., June 29, 1834.
9. Ibid., September 22, 1834.
10. Ibid., July 3, 1834.
11. Ibid.
12. Ibid., July 4, 1834.
13. Ibid., July 5, 1834.
14. Ibid., July 7, 1834.
15. Ibid., July 8, 1834.
16. Ibid.
17. Ibid., July 18, 1834.
18. Ibid., July 9, 1834.
19. Ibid., July 15, 1834.
20. Ibid., July 17, 1834.
21. Ibid., July 10, 1834.
22. Ibid., July 15, 1834.
23. Ibid., July 11, 1834.
24. Ibid., July 14, 1834.
25. Ibid., July 25, 1834.
26. Ibid., July 28, 1834.
27. Ibid., July 26, 1834.
28. Ibid.
29. Ibid., July 28, 1834.
30. Ibid., August 2, 1834.
31. Ibid., August 3, 1834.
32. Ibid., August 4, 1834.
33. Ibid., August 5, 1834.
34. Ibid., August 8, 1834.
35. Ibid., August 18, 1834.
36. Ibid., August 11, 1834.
37. Ibid., August 12, 1834.
38. Ibid., August 13, 1834.
39. Ibid., August 15, 1834.
40. Ibid., September 11, 1834.
41. Ibid.

42. Charles Nordhoff, *The Communistic Societies of the United States* (New York, 1875), 208.

43. Youngs, August 26, 1834.

44. Ibid., September 4, 1834.

45. Ibid., September 27, 1834.

46. Letter from Br. John Eades, South Union, Kentucky, to Br. Isaac N. Youngs, New Lebanon, New York, August 6, 1852. Collection of the Western Reserve Historical Society, IV−A:62.

47. Julia Neal, *The Kentucky Shakers* (Lexington, 1982), 22.

48. Youngs, September 9, 1834.

49. Ibid., September 3, 1834.

5. CARTOGRAPHERS AND ARTISTS IN NEW HAMPSHIRE
(pages 93−118)

1. For an admiring description of the modern efficiencies in "the most expensive barn in America," the 1854 Cow Barn at the Shaker village in Enfield, New Hampshire, see "A Barn," *Ohio Farmer, Mechanic's Assistant,* July 15, 1854, 109.

2. Henry Cumings, "A Sketch of the Life of Caleb M. Dyer," *The Enfield Advocate,* December 30, 1904.

3. Henry Cumings, "Some Early Industries and Inventions of the Shakers," *The Enfield Advocate,* March 31, 1905.

4. Henry C. Blinn, "David Parker," *The Manifesto* 14 (January, 1884): 9−10.

5. Among the surveyors' plans owned by the Enfield Shakers was "A Plan of the Town of Enfield by Ebenezer Williams, Surveyor, Enfield, N.H., December, Anno 1826." A copy is now in the collection of Canterbury Shaker Village, Inc.

6. Henry C. Blinn, "Historical Notes Having Reference to the Believers in Enfield, New Hampshire," 1897, 244−47. MS, Canterbury Shaker Village, Inc.

7. Henry Cumings, "The Passing of South Family Shaker Property," *The Enfield Advocate,* August 21, 1907.

8. M. T. Runnels, *History of Sanbornton, New Hampshire,* vol. 2 (Boston, 1881), 136, 37. The design of this map cannot be credited to Shaker ingenuity. Similar maps are known by contemporary surveyors. See, for example, "A Map of the Blackstone Canal & Its Appendages As Constructed in the Year 1828. Compiled from actual surveys by Ed. D. Phelps," a folio of thirty-two contiguous watercolor and ink maps in the collection of the Rhode Island Historical Society, plotting the course of the Blackstone Canal and illustrating the mill villages that flanked it.

9. Henry C. Blinn, "Journal," 2 (1836). MS, Canterbury Shaker Village, Inc.

10. Isaac Newton Youngs, "Journal for 1841," appendix. MS, New York State Library, Albany.

11. Henry C. Blinn, "Autobiographical Notes," in *In Memoriam Elder Henry C. Blinn 1824–1905* (Concord, N.H., 1905), 28.

12. Charles Edson Robinson, *A Concise History of the United Society of Believers Called Shakers* (East Canterbury, N.H., ca. 1893), 29–30.

13. Blinn, "Autobiographical Notes," 29–30.

14. Dorothy M. Filley, *Recapturing Wisdom's Valley: The Watervliet Shaker Heritage,* (New York, 1975), 60.

15. Ann Buckingham, "Journal," entry for April 25, 1844. MS, Shaker Collection, New York State Library, Albany.

16. Undated newspaper article in *The Berkshire American,* quoted in Seth Chandler, *History of the Town of Shirley* (Shirley, Mass., 1883), 34.

17. William Lawrence Lassiter, *Shaker Architecture,* (New York, 1966), 65.

6. THE EARLY DRAWINGS OF JOSHUA H. BUSSELL
(pages 119–36)

An early version of this chapter appeared in *Antiques* 113 (March 1978): 632–37.

1. "Elder Joshua Bussell says it is fifty years ago today since he left Portland and joined the Shakers." "Alfred Church Record II," May 14, 1879. MS The Shaker Library, Sabbathday Lake, Maine.

2. Otis Sawyer, "History of Alfred, Maine," 73. MS, The Shaker Library, Sabbathday Lake, Maine.

3. Theodore E. Johnson, *Hands to Work and Hearts to God: The Shaker Tradition in Maine* (Brunswick, Me., 1969), note to pl. 2.

4. Edwin A. Churchill, *Simple Forms and Vivid Colors: An Exhibition of Maine Painted Furniture 1800–1850* (Augusta, Me., 1983), 17–18.

5. Accession records of the New York State Museum record a 1930 gift by Leo M. Doody of three Shaker village views, including "a plan of the village by Alfred Maine."

6. "Section IX. Concerning Building, Painting, Varnishing, and the Manufacture of Articles for Sale, &c, &c.," quoted from the transcription of the Millenial Laws of 1845, in Edward Deming Andrews, *The People Called Shakers: a Search for a Perfect Society* (New York, 1953), 285–86.

7. Otis Sawyer, "Shaker Village," in *A History of Cumberland County, Maine* (Philadelphia, 1880), 330.

8. Giles Avery Bushnell, "Journal of a Trip to the Eastern Societies," (1843), MS 12744, Emma B. King Library of the Shaker Museum, Old Chatham, New York.

9. Freegift Wells, "Journal of a visit to New Gloucester by Way of Enfield, Canterbury, and Alfred, 1851," entries for November 22 and 23, 1851. MS V:B–337, The Western Reserve Historical Society.

10. Mary C. Richmond, *A Shaker Bibliography* (Hancock, Massachusetts, 1977), xxiv, and R. Mildred Barker, "A History of 'Holy Land'—Alfred, Maine," *The Shaker Quarterly* 3 (Fall 1963), 90.

7. NEW HORIZONS AND LANDSCAPE VIEWS
(pages 137–52)

1. "The Village of the United Society of Shakers, in Canterbury, N.H.," *American Magazine of Useful and Entertaining Knowledge,* 2 (November 1835): 133.

2. Henry C. Blinn, "Autobiographical Notes," in *In Memoriam Henry C. Blinn 1824–1905* (Concord, N.H., 1905), 27–28.

3. John Warner Barber, "Drawings made for the *Connecticut Hist Coll* by John Warner Barber from July 7th 1834 to July 1st 1836." MS 1953–5, Connecticut Historical Society.

4. Letter from Nathaniel Hawthorne to Louisa Hawthorne, August 17, 1831, quoted in Seymour L. Gross, "Hawthorne and the Shakers," *American Literature* 29 (January 1958): 458.

5. Nathaniel Hawthorne, "The Canterbury Pilgrims," *The Token and Atlantic Souvenirs* (Boston, 1832), 153–55.

6. Gross, "Hawthorne and the Shakers," 457.

7. Arlin Turner, *Hawthorne As Editor* (University, La., 1941), 1–2.

8. Edward Deming Andrews and Faith Andrews, *Fruits of the Shaker Tree of Life: Memoirs of Fifty Years of Collecting and Research* (Stockbridge, Mass., 1975), 70.

9. Edward Deming Andrews and Faith Andrews, *Visions of the Heavenly Sphere* (Charlottesville, Va., 1969), 110.

10. Andrews, *Fruits of the Shaker Tree of Life,* 70.

11. Poland Hill was settled in 1819 by members of the short-lived Shaker family at Gorham, Maine. See R. Mildred Barker, "A History of Union Branch, Gorham, Maine, 1784–1819" *The Shaker Quarterly* 7 (Summer 1967): 64–81.

12. "Journal of a Trip to the Eastern Societies," September 20, 1850. MS SA 800, The Edward Deming Andrews Memorial Shaker Collection, The Henry Francis du Pont Winterthur Museum Libraries.

13. Letter from the Shaker Ministry at Holy Land to Elder Grove Blanchard and the Ministry at Lovely Vineyard, July 6, 1851. Collection of the Western Reserve Historical Society, IV A–56.

14. Letter from the Shaker Ministry at Holy Land to Elder Grove Blanchard and the Ministry at Lovely Vineyard, October 7, 1853. MS IV A–56, The Western Reserve Historical Society.

15. A photograph of the stone dwelling is illustrated in Marius B. Peladeau, "The Shakers of Maine," *Antiques* 107 (June 1975): 1152.

16. Andrews, *Fruits of the Shaker Tree of Life,* 70.

8. THE REVIVAL OF SHAKER VILLAGE VIEWS
(pages 153–76)

1. Otis Sawyer, "The United Society of Believers, Called Shakers," *History of York County, Maine* (Philadelphia, 1880), 269.

2. Journal entry for 27 May, 1882, in "The Alfred Church Journal." MS, the Shaker Library, Sabbathday Lake, Me.

3. A scale model of the Church Family Dwelling is now in the collection of the Shaker Museum, Sabbathday Lake, Maine. According to the Sabbathday Lake Shakers, it is the sole surviving building from a miniature village created by Joshua Bussell. (Personal communication from Br. Theodore Johnson, director, The Shaker Library, Sabbathday Lake, Me., August 1974).

4. Otis Sawyer, "History of Alfred, Maine," 95. MS, The Shaker Library, Sabbathday Lake, Me.

5. June Sprigg, *The Gift of Inspiration,* (New York, 1979), 45.

6. Section X of the Millennial Laws of 1845, "Orders Concerning Furniture in Retiring Rooms," from Edward Deming Andrews, *The People Called Shakers: a Search for a Perfect Society* (New York, 1953), 271–72.

7. Henry Clay Blinn, quoted in Theodore E. Johnson, ed.,

"Journal to Kentucky in the year 1873," *The Shaker Quarterly* 7 (Spring 1965): 13.

8. Sawyer, "History of Alfred, Maine," 5.

9. Journal entry for 17 September, 1879, "The Sabbathday Lake Church Journal." MS, The Shaker Library, Sabbathday Lake, Maine.

10. Journal entry for January 29, 1880, "The Alfred Church Journal." MS, The Shaker Library, Sabbathday Lake, Maine.

11. Ibid.

12. Ibid., February 2, 1880.

13. These nineteenth-century town views are catalogued and described in John W. Reps, *Views and Viewmakers of Urban America, 1820–1920* (Columbia, Mo., 1984). For a sampling of the similarly proud reactions of the Shakers' neighbors upon seeing views of their own towns, see Christine B. Podmanicsky, *Through a Bird's eye: Nineteenth Century Views of Maine* (Rockland, Me., 1981); and David Ruell, *The Bird's Eye Views of New Hampshire: 1875–1899* (Concord, N.H., 1983).

14. Otis Sawyer, "History of Alfred," 74. Although Elder Otis recalled only that the schoolhouse was constructed some time in the 1860s, it is pictured in photograph 122:235 in the Shaker collection of the Western Reserve Historical Society and in a photograph illustrated in Sr. R. Mildred Barker, "A History of 'Holy Land'—Alfred, Maine," *The Shaker Quarterly* 3 (Winter 1963): 112, with a painted sign on the front reading "District No. 6 1861."

15. Barker, "A History of 'Holy Land'", 112.

16. One of these is illustrated in Marius B. Peladeau, "The Shakers of Maine," *Antiques* 107 (June 1975): 1149.

17. Edward F. Dow, "The Millennial Church of Shakers," *The Maine Bulletin* 34 (August 1931): 35.

18. Barker, "A History of 'Holy Land'," 120.

19. Edward Deming Andrews and Faith Andrews, *Fruits of the Shaker Tree of Life: Memoirs of Fifty Years of Collecting and Research* (Stockbridge, Mass., 1975), 70.

20. Otis Sawyer, "Shaker Village," in *A History of Cumberland County, Maine* (Philadelphia, 1880), 329.

21. Journal entries for December 17, December 18, and December 19, 1879, "The Sabbathday Lake Church Journal."

22. Ibid., December 31, 1879.

23. Letter from the Ministry at Holy Land to Elder Grove Blanchard and the Ministry at Lovely Vineyard (Harvard), October 7, 1853. MS, The Western Reserve Historical Society.

24. Peladeau, "The Shakers of Maine," 1151.

25. Ibid., 1150.

26. The construction of the brick dwelling in 1883 is chronicled in Elsie McCool, "A Brief History of the Central Dwelling, Sabbathday Lake," *The Shaker Quarterly* 1 (Summer 1961): 71–76.

27. June Sprigg, *The Gift of Inspiration* (New York, 1979), 45.

28. "Elder Joshua Bussell returned to Alfred. He has spent his time on Poland Hill making and mending shoes." (Journal entry for 18 April 1881, in "The Sabbathday Lake Church Journal." Similar entries can be found for the years 1876, 1879, 1882, and 1883.)

29. Peladeau, "The Shakers of Maine," 1144.

9. EPILOGUE
(pages 177–82)

1. June Sprigg, *The Gift of Inspiration* (New York, 1979), 47.

2. Two versions of this photograph are recorded. They are reproduced in A. D. Emerich and A. H. Benning, *Community Industries of the Shakers: A New Look* (Albany, 1983), 1; and Dorothy Filley, *A Future For Wisdom's Valley: The Watervliet Shaker Heritage, 1775–1975* (New York, 1975), back cover.

3. These sketches, made in 1887, are now in the Western Reserve Historical Society, IA: 13 and 122:498.

APPENDIX
(pages 183–88)

1. W. J. Linton, *The History of Wood Engraving in America* (Boston, 1882), 11.

2. Barber's description of the Shaker village at Enfield is cited as entry #1823 in *Shaker Literature: A Bibliography,* comp. Mary L. Richmond, 2 vols. (Hancock, Mass., 1977), hereafter referred to in the text as "Richmond."

3. Sinclair Hamilton, *Early American Book Illustrators and Wood Engravers,* vol. 2 (Princeton, 1968), 83.

4. Daniel W. Patterson, *Gift Drawing and Gift Song: A Study of Two Forms of Shaker Inspiration* (Sabbathday Lake, Me., 1984).

5. Frank Luther Mott, *A History of American Magazines, 1741–1850,* (Cambridge, Mass., 1938), 364.

6. Ibid., 364.

7. *Illustrated News* 1 (October 29, 1853): 247.

8. Frank Luther Mott, *A History of American Magazines 1850–1865* (Cambridge, Mass., 1938), 44.

9. Ibid.

10. *Frank Leslie's Illustrated Newspaper* 35, no. 902 (January 11, 1873): 286–87, 292; 36, no. 936 (September 6, 1873): 416–18; 37, no. 937 (September 13, 1873): 12–14; 37, no. 944 (November 1, 1873): 124. *Frank Leslie's Popular Monthly* 20 (December 1885): 660–61, 72.

11. *Frank Leslie's Illustrated Weekly* 82, (June 25, 1896): 435.

12. *The Manifesto* vol. 14, no. 2:35; 3:53. Giles Avery, *Sketches of "Shakers and Shakerism"* (Albany, 1884), 24. Charles Edson Robinson, *A Concise History of the United Society of Believers Called Shakers* (East Canterbury, N.H., 1893), 77, 87. Anna White and Leila Sarah Taylor, *Shakerism, Its Meaning and Message* (Columbus, Ohio, 1904), 370.

13. For a discussion of early photographs of Shaker villages, see Elmer R. Pearson and Julia Neal, *The Shaker Image* (Boston, 1974).

INDEX

Numbers in italics refer to figures.